The Language of Images

The Language of Images

Edited by W. J. T. Mitchell

The University of Chicago Press
Chicago and London

The University of Chicago Press, Chicago 60637
The University of Chicago Press, Ltd., London

Library of Congress Cataloging in Publication Data
Main entry under title:

The Language of images.

 Includes bibliographical references and index.
 CONTENTS: Introduction.—Nemerov, H. On poetry
and painting, with a thought of music.—Argan, G. C.
Ideology and iconology.—Taylor, J. C. [etc.]
 1. Arts—Addresses, essays, lectures.
I. Mitchell, W. J. Thomas, 1942–
NX60.L33 700 80-5225
ISBN 0-226-53215-1

Contents

	1	INTRODUCTION
Howard Nemerov	9	On Poetry and Painting, With a Thought of Music
Giulio Carlo Argan	15	Ideology and Iconology
Joshua C. Taylor	25	Two Visual Excursions
Elizabeth Abel	37	Redefining the Sister Arts: Baudelaire's Response to the Art of Delacroix
Ernest B. Gilman	59	Word and Image in Quarles' *Emblemes*
Leo Steinberg	85	The Line of Fate in Michelangelo's Painting
Gerald Mast	129	Kracauer's Two Tendencies and the Early History of Film Narrative
Christian Metz	151	*Trucage* and the Film
Rudolf Arnheim	171	A Plea for Visual Thinking
E. H. Gombrich	181	Standards of Truth: The Arrested Image and the Moving Eye
Joel Snyder	219	Picturing Vision
John R. Searle	247	*Las Meninas* and the Paradoxes of Pictorial Representation
Robert P. Morgan	259	Musical Time/Musical Space
W. J. T. Mitchell	271	Spatial Form in Literature: Toward a General Theory
	301	INDEX

Introduction: The Language of Images

One of the most striking features of modern culture has been the intensive, almost compulsive, collaboration between practitioners of the word and practitioners of the image. We inhabit a world so inundated with composite pictorial-verbal forms (film, television, illustrated books) and with the technology for the rapid, cheap production of words and images (cameras, Xerox machines, tape recorders) that nature itself threatens to become what it was for the Middle Ages: an encyclopedic illuminated book overlaid with ornamentation and marginal glosses, every object converted into an image with its proper label or signature. The quintessential modern experience of this new "book of nature" is the stroll through the scenic wonders of a national park with a plastic earphone that responds to electronic triggers embedded at strategic locations along the path. A recorded commentary provides a continuing gloss on what is an exclusively visual experience (since printed signs remind you not to go beyond the margins of the path or to touch anything). This experience is in a very real sense a "pictorializing" of nature; the technology was first developed for conducting tourists through picture galleries, and the electronic guides often assist the tourist by telling him which spots in the park are ideal for taking snapshots.

The sort of collaboration which has produced our modern, secular, and profane book of nature has its more sophisticated counterpart in the worlds of art and literature. We have not quite reached the state described by Robert Browning ("Does he paint? He fain would write a poem—/Does he write? He fain would paint a picture"), but we do find what amounts to a symbiotic relationship between verbal and pictorial modes in modern art and literature. "Modernism" in literature has, since the beginning of this century, been haunted by the spirit of "imagism," and the modern criticism of literature has been dominated by spatial, synchronic, architectural models such as formalism and structuralism. Modern painting, on the other hand, while it has ostensibly sought to create nothing more than the "pure" image—abstract, nonverbal, free of representation, reference, narrative, and even the contamination of a verbal title—has in fact become more dependent on an elaborate verbal apologetics, the ersatz metaphysics of "art theory."

It is no wonder that, in this climate, art historians and literary critics have begun to collaborate as well. This collaboration generally has, at least in its most fruitful moments, little to do with any programmatic "interdisciplinary" designs but is more likely the result of following out

the imperatives of a problem central to a single discipline. E. H. Gombrich did not turn to psychology because he wanted to set up some sort of comparison with the arts but because the problem of pictorial illusion required this sort of move. If some of the barriers between art history and literary criticism seem to be falling in the spate of recent publications on "interrelationships of the arts," it is not because either discipline has forfeited its claim to territorial rights or rigor but because scholars have found themselves straying onto common—if sometimes disputed—ground in the pursuit of their disciplines. The encounters have not always been peaceful: art historians tend to regard literary critics as victims of the tyranny of the word who babble incomprehensible jargon and neglect the silent, wordless immediacy and presence of the art object; literary critics see art historians as slaves to the tyranny of the eye who fuss over brushstrokes and color fusion while ignoring the really important question of what a painting *means.* Nor do scholars from either field look with particular favor on their own members who venture abroad; at worst they are regarded as renegades or apostates, at best as curiosity seekers who are interested in exotic, marginal subjects. Despite these prejudices, however, there are venerable precedents in both fields for the kind of apostasy we are describing here. The notion of pure "autonomy" has never really had the kind of hold over literary criticism that might be suggested from the amount of publicity it has received, and the greatest art historians of the twentieth century, Panofsky and Gombrich, have been exemplary renegades. Their example has given courage to scholars and critics such as those included in the following collection who have found themselves exploring the no-man's-land between the realms of word and image.

There comes a point, of course, when the no-man's-land between disciplines becomes so heavily cultivated that it begins to look like a "field" in its own right. It would be tempting to label this as the domain of aesthetics, the study of "art in general," but that would be to lose the particular topic which these essays have in common. The topic is the image, and the field which seems to be emerging from it is an expanded version of the discipline which Panofsky called "iconology," the historical study of the logic, conventions, grammar, and poetics of imagery. Iconology thus contains its tributary discipline, iconography, in the way that philology contains lexicography, the study of meanings of individual words. The following essays are united by a concern with the rules for encoding and deciphering imagery in the various arts and in the structure of perception and consciousness. They investigate the ways we interpret imagery, from representational or illusionistic picturing to abstract patterning (what Adrian Stokes called "the image in form"), from imagery in the literal sense (graphic or plastic artifacts such as pictures, statues, buildings, ornamental designs) to the various metaphoric extensions of the concept of imagery in literature, music,

and psychology. They are also concerned with the ways imagery interprets us, in the sense that our attempts to understand the world and our own creations are organized by tacit images, subliminal structures by which we represent to ourselves the orders of time, space, and language.

By the "language of images," then, we mean three sorts of things: (1) language *about* images, the words we use to talk about pictures, sculptures, designs, and abstract spatial patterns in the world, in art, and in the mind; the interpretive discourse a culture regards as appropriate to its image systems; (2) images regarded *as* a language; the semantic, syntactic, communicative power of images to encode messages, tell stories, express ideas and emotions, raise questions, and "speak" to us; (3) verbal language as a system *informed by* images, literally in the graphic character of writing systems or "visible language," figuratively in the penetration of verbal languages and metalanguages by concerns for patterning, presentation, and representation.

It is readily apparent that the second and third meanings of the language of images (images "as" and "in" language) entail what logicians might call a category mistake. The realms of language and imagery, like Lessing's poetry and painting, and Kant's time and space, are generally regarded as fundamentally different modes of expression, representation, and cognition. Language works with arbitrary, conventional signs, images with natural, universal signs. Language unfolds in temporal succession; images reside in a realm of timeless spatiality and simultaneity. To speak of "imagery" or "spatial form" in temporal arts like music or literature or to claim that imagery has temporal or linguistic power is to commit a breach in decorum or, to put it more positively, to make a metaphor. But the metaphor is hardly a daring or novel one. On the contrary, it is one of the most familiar tropes in the criticism of the arts, a sort of institutionalized violation of common sense whose most famous and enduring formulation was crystallized in the tradition of *ut pictura poesis*. The interesting question, then, is why common sense keeps violating itself this way, erecting barriers between different symbolic modes only to find more ingenious ways of transgressing them. A corollary to this question is the problem of discriminating the various ways in which the barriers are erected and transgressed and determining whether these activities have a history.

We begin with three essays that address these questions in very broad terms. Howard Nemerov's "On Poetry and Painting, With a Thought of Music" locates the affinities of language and imagery in "the silence behind language," a silence which is figured historically in the originary unity of writing and drawing in the evolution of graphic signification, psychologically in the mental "hieroglyphics" which underlie our perception of form in music. Giulio Carlo Argan, by contrast, is less concerned with the problem of unity and difference in verbal and pictorial modes and focuses instead on the institutionalized unification

of word and image in the discipline of iconology. Argan asks whether it is possible to compose a history of images and concludes that the first premise of any such history must be an understanding of "the problematic of art as that of linguistic structures." The consequence of this premise is not what might be expected, a linguistic version of *ut pictura poesis* which finds "syntax" and "grammar" in pictures, but rather a philological study of the conventional and ideological character of image systems. The object of study for iconology is not simply the content or the form of the image but the assumptions which underlie its production and use. Thus, canons of proportion, norms of perspective, the "images" which govern our sense of conceptual structures, even the picture we have of the intellect itself (including, presumably, things like Nemerov's mental hieroglyphics)—all these become the object of the cultural and historical criticism which Panofsky founded under the name of iconology.

For Joshua Taylor, one suspects, the iconological method would itself become a chapter in a historical and anthropological survey of the ways in which language has invaded the realm of imagery. Taylor examines two examples of verbal aggression and pictorial resistance: the distortion of "exotic" or "primitive" art by the vocabulary of Western classical aesthetics and the incursion of "literary values" into the realm of painting. Taylor seems resigned to the fact that we will talk and write about images in inappropriate ways; what he recommends is a certain self-consciousness about the verbal translations we construct in interpreting images. We cannot hope to see Northwest Indian pottery through the eyes of its original maker or consumer, but we can become aware of a difference, which is also a connection, between its sense of form and ours. We cannot hope, except in (especially in!) artists' manifestos, to purge painting of all verbal contamination; what we can do is to examine the ways in which different genres of writing (lyric poetry, narrative, legendary, scientific, or personal history, psychology, philosophy, ultimately "art history" itself) have historically contended with one another for the right to speak for images.

These general explorations of the language of images are followed by a pair of essays which examine the literary-pictorial nexus in particular art forms under specific historical conditions. Elizabeth Abel's "Redefining the Sister Arts" suggests through a close analysis of Baudelaire's writing on Delacroix how certain key assumptions of the *ut pictura poesis* tradition were abandoned in the nineteenth century and what new sorts of affinities between verbal and pictorial art emerged to take their place. Ernest Gilman explores a similar problem in his study of a composite poetic-pictorial form: the seventeenth-century English emblem book, which, far from being merely derivative of its continental predecessors, redefines the relation of word and image in ways that reflect the iconoclasm and mistrust of idolatry in English Protestant culture. Both Abel

and Gilman show decisively that there can be no general, theoretical understanding of "the" relationship of linguistic and pictorial representation and that this relationship, like its constituent elements, has a history of shifting balances of power.

At the center of our collection is an essay by an art historian who is known not for his theoretical reflections on the relations of literature and the visual arts but for his subtle and learned "readings" of masterpieces from several periods and for his highly literate approach to the art of seeing and writing about art. Leo Steinberg shows us how to read a body of pictorial art which has probably been "looked at" (without being truly seen) by more viewers than anything else in the canon of Western masterpieces. Steinberg's basic strategy for helping us to see past the literary commonplaces which obscure Michelangelo's *Last Judgment*, his Sistine ceiling, and the *Crucifixion of Peter* is to expose us to a body of criticism "more telling than anything dreamt of in contemporaneous writing"—the criticism of one image by another which occurs in the process of copying. Steinberg compares Michelangelo's originals with early copies in order to reveal deviations which reflect critical attitudes and to restore our sense of the precise character of the original as "a thing done" with exact intentions. The thing that Steinberg finds Michelangelo doing in these works is constructing "inside," often autobiographical, narratives adumbrated by "lines of destiny" which cut diagonally across and link the disparate images in his compositions. Steinberg's discovery of these "moral-theological vectors" in the spatial-temporal fabric of Michelangelo's painting becomes, in addition, a part of yet another narrative evoked by these works: the story of the way great works of art gain and lose meanings under generations of interpretation, their original sense often being recaptured by "amateur" readers who stand outside the professional institutions of interpretation.

It is the cinema, of course, which more than any other art reveals the power of the image to express temporal, narrative, and discursive orders. Gerald Mast and Christian Metz approach this topic from contrasting and perhaps mutually illuminating positions. Mast criticizes the tendency in film criticism to polarize the world of cinema between the photographically realistic claims of Lumière and the "formative" fantasies of Méliès. Mast suggests that the "realism" of film has less to do with photographic fidelity to visual appearances than it does with the psychological realism of narrative, understood in a dramatic, Aristotelian sense. Thus, the formative energies of film tend, in Mast's view, to be directed toward artful syntheses of "natural" and "conventional" symbols: our acceptance that film presents a world that resembles the real physical and social world (the "natural" symbol) is coupled with conventions, often adapted from stagecraft, of presenting narratives in these worlds. Metz, on the other hand, comes to film from a semiotic perspective which stresses the role of *trucage,* the special effects, tricks, or

"film magic" with which the filmmaker manipulates appearances, and thus emphasizes the importance of fantasy and wish fulfillment, the "formative" tendency which Mast traces to Méliès. As Metz demonstrates, these "tricks" have a way of moving from the margins of filmmaking to its very center, becoming the basic devices and conventions (fade, dissolve, slow or fast motion, control of focus and depth of field, superimposed imagery, even montage) by which film becomes articulate and tells stories, realistic or otherwise.

One thing that Mast and Metz would surely agree on is that the cinematic image is not simply the object of our vision and interpretation but comes "prepackaged" in ordered relationships (*trucage,* narrative devices, assumptions about visual and spatial order) that control our reading of them. These devices are not themselves images, as Metz observes, but are something that is done to or with images, something that may involve what we used to call imagination. The next section of our anthology presents four essays which talk about the things we do with images, particularly in the acts of perception, cognition, and cogitation. Rudolf Arnheim takes up this subject with "A Plea for Visual Thinking," arguing against the tendency to separate perception and thinking in psychology and in favor of the cultivation of vivid and concrete mental images as aids to intuition and intellection. Arnheim's statement serves here as a prelude to three essays which deal with the epistemological status of imagery and particularly with the notoriously complex problem of perspective and the claims of pictorial realism and naturalism.

In "Standards of Truth" E. H. Gombrich explores the intricate, teasing borderlines between the image regarded as an objective record of optical facts, constructed in accordance with an innate, instinctive, "natural" understanding of the visual world, and the contrary view of the image as a subjective evocation of optical impressions, constructed in accordance with changing conventions of representation that are artificial and learned rather than innate. Gombrich's essay is followed by one which approaches the conflicting claims of "natural" and "conventional" accounts of realistic imagery in a rather different way. Joel Snyder argues that the notion of a "natural or privileged or unreasoned relation" between realistic pictures and the real world is irrational and ill founded, and yet it persists as a basic assumption about many different kinds of pictorial representation. Snyder traces the genealogy of this belief by examining the nature and history of the camera in relation to early theories of perspective and concludes that "there are no end runs that get us out of language or depiction to the really real"—though that may not prevent us from persisting in believing that some pictures perform precisely this feat. This sort of capacity for paradox in discussions of perspective and pictorial realism becomes the central topic of the final essay in this group. John Searle analyzes the famous paradoxes of Velázquez's *Las Meninas,* showing that the methods of a philosopher of lan-

guage can at least clarify these paradoxes if they cannot explain them away.

We conclude the volume with a pair of essays that examine the function of imagery, primarily as pattern, structure, or form—Nemerov's "psychological hieroglyphics"—in the temporal arts of music and literature. Robert Morgan discusses acoustical, tonal, textural, and notational space in music, arguing that "the most salient characteristic of musical time, as distinct from ordinary, 'psychological' time, is precisely its pronounced spatial—that is, structured—quality." My essay on "Spatial Form in Literature" reopens Joseph Frank's classic notion of literary space, not, however, as a peculiar property of modernist literature but as a general condition of reading and textuality. Spatiality seems to pervade the experience and analysis of literature at the level of the material text, in the world described or projected by the text, in the formal order which controls the sequence of elements, and in the semantic orders which emerge in acts of interpretation. With these concluding essays we bring the notion of a language of images full circle, treating imagery not as the object of a verbal, narrative, or temporalizing interpretation but as itself the interpretive framework which spatializes the temporal arts of music and literature. If Leo Steinberg can find narratives in the hidden geometry of Michelangelo's painting, it seems only fair to look for a latent geometry in literary narrative. At the very least it seems to satisfy our craving for rhetorical symmetry.

It is a fixed convention of this sort of preface to register an apology for the incomplete and miscellaneous character of the anthology which it introduces. I would like to reverse this custom by engaging in some restrained boasting. Two things should be clear from the present volume: first, that there is no consensus and nothing approaching a general theory of the image which can unite all these essays; second, that there is a family of related problems which centers on the phenomena of image production and interpretation and which radiates outward into all forms of art, all modes of representation and signification. The study of the image has taken a quantum leap in the last fifty years (largely because of the work of people like Gombrich and Arnheim) which has removed it from the custody of art history and made it a general problem in the natural and human sciences. We have nothing in this volume on architecture, sculpture, theater, or television, nothing on graphs, maps, diagrams, geometry, writing, or typography, nothing on experimental studies of image recognition, storage, and retrieval in psychology, nothing on computer coding and deciphering of pictorial information, nothing on the "acoustic images" of linguistics. What we do have is a sense of what is missing, and thus a glimpse of outlines of a new, more general version of a very old field of historical and critical inquiry—a new iconology. I trust it is clear that the boundaries of this field, much less its methodology, are not yet defined nor its value and validity dem-

onstrated. Is this a sterile formalism, an elaborate intellectual form of iconophilia and idolatry? Or is it a genuinely historical and critical discipline in search of shareable data, verifiable (and falsifiable) hypotheses, a method, perhaps, of demystifying the subliminal images which determine our patterns of thought—even our methods themselves—and a way of restoring liminality, the aura of the sacred, to those images which, upon reflection, seem worthy of it?

Acknowledgments

More than most anthologies, this one is the product of collective energies and intelligence. I would like first to thank all the members of the Laocoön Group at the University of Chicago whose discussions generated the idea for this volume, and some of whom appear in its pages: in particular, Elizabeth Abel, Becky O'Connor Chandler, Joseph Connors, Elizabeth Helsinger, Margaret Olin, Sanford Schwartz, and Joel Snyder. Special thanks is due to Toby Rachel Gordon, Janet Silver, and Mark McLaughlin of *Critical Inquiry* for their expert and tireless assistance with editing and to all the authors and publishers who allowed us to reprint their essays here. All the essays in this volume first appeared in the Spring 1980 issue of *Critical Inquiry* or in earlier issues, except Howard Nemerov's, which is reprinted, with our thanks to the author and to David R. Godine, Publisher, from *Figures of Thought* (Boston, 1978), and E. H. Gombrich's which is published here for the first time.

W. J. T. Mitchell

On Poetry and Painting, With a Thought of Music

Howard Nemerov

There are affinities between poetry and painting, and perhaps the words
"image" and "language" will help focus these as well as the differences.
Painters make images, poets make images; the painter too has language,
though not perhaps in so explicit a sense as the poet does; the palette for
a given landscape, say, acts as a negative kind of syntax, excluding cer-
tain colors from the range of possibility; and as a positive kind as well,
indicating the possibilities of gradation in getting from earth through
river through forest tō sky.

Both poet and painter want to reach the silence behind the lan-
guage, the silence within the language. Both painter and poet want their
work to shine not only in daylight but (by whatever illusionist magic)
from within; maybe even more from within than by daylight, for many
of their works in times now past had not the object of being viewed in
daylight but went to do their magic in caves, in tombs, among the dead,
and maybe as a substitute for daylight.

The poet walks through the museum and among so many and so
diverse conceptions and manners of treatment he sees, he hears, espe-
cially two things: silence and light. Viewing the picture frames as win-
dows, he looks into rooms, out of rooms into landscapes—what the
Chinese call "mountain-water pictures"—and knows from the silence
that he is seeing the past, the dead, the irrevocable; and he knows
something else, that what he sees is not only the past, the dead, the
irrevocable, but something that had the intention of being these things
from the moment of its conception: something that is, so to say, past

From *Figures of Thought* by Howard Nemerov. Copyright © 1978 by Howard Nemerov. Reprinted by permission of David
R. Godine, Publisher, Inc.

9

from the beginning. Hence the great silence common among so many differences of subject and execution; hence, too, the solemnity of the museum, crowded with solitudes; the dignity of painting, that stands in a sort of enchanted space between life and death.

He sees also that the light in these rectangles appears to come from within. In the work of an unknown master he sees the thin veil of a small waterfall in sunlight—amazing! He leans in to look closer, the threads of water become white paint mixed with a little gray on a gray ground—amazing again, not quite in the same way, that crossing-point, that exact distance, within which illusion becomes paint, beyond which paint becomes illusion again. Whereas in the painting of a river by Vlaminck, the thin, pale surface of the water, bearing the thinnest and most shivering of pale reflections, is made by means of the heaviest, thickest, grossest applications of paint, made with a virtuosity that is able to make colored dirt produce effects of light. Amazing again.

His own art, in the comparison, begins to seem the merest pitifullest chatter, compounded of impatience and opinion. On thoughts like this, the poet finds it best to hasten from the museum, that marvelous tomb-temple wherein the living are privileged to look so deeply into what is no more, experiencing their own mortality as a dignified silence not without its effects of grandeur and austerity; though all this *looking deeply,* that so magicks the beholder, is done on a plane surface.

Out in the day again, he thinks about the matter some more. First about some poems of his own time, especially some he cares for, that have a relation with painting or drawing. There is Auden's "Musée des Beaux Arts," with its reflections that rely on Brueghel, on *The Fall of Icarus* and on the *Massacre of the Innocents.* There is John Berryman's "Hunters Returning at Evening," also referring to Brueghel; there is Randall Jarrell's emblem drawn from Dürer's *Knight, Death, and Devil;* there is even one of his own, composed and called after René Magritte's *The Human Condition (I).* These things have a relation to painting, and they are not painting. It would be interesting to speculate what that relation might be.

It is not, certainly, that the poems speak about the paintings they refer to; no, for the poems offer relatively bare and selective descriptions; no art student sent to the museum would dare come back with such descriptions, which sometimes hardly serve to identify the paintings. No, the poems speak about the silence of the paintings; and where the poet was lucky his poem will speak the silence of the painting; it too will say

Howard Nemerov received the National Book Award and the Pulitzer Prize for poetry in 1978 for his *Collected Poems.* The present essay is part of *Figures of Thought: Speculations on the Meaning of Poetry & Other Essays.*

nothing more than: It is so, it is as it is. The poem, too, when it works, is a concentrated shape illuminated by an energy from within; its opinions do not matter, but it matters. Here, too, he observes, all that happens happens while the poem, like the painting, lies flat on a plane surface, the surface of the page.

From the other side, he is reassured to think, ever so much of painting comes from poetry, refers to poetry, and is poetical in its own nature as well as in its subject matter. Not only the biblical subjects, for example, but the various conceptions and styles that transfigure the subjects, that poetize upon the Crucifixion, say, with respect to an eternal glory in so many medieval masters, a superhuman grandeur in Michelangelo, a bitter suffering in Grünewald, the light of an ordinary day in Brueghel.

So both painter and poet are makers of images, and traditionally there is a connection between the images they make. And when we say they *make* images, we do not seek to distinguish, for the present, the component of invention from that of discovery.

And both painter and poet write in languages. This seems at first to mark a decisive and unbridgeable difference, the difference in their languages. But it invites a little further thought.

Surely the painter's language has the dignity of being the oldest ever written down. Minerals, plants, the liquids of the body even to blood, all gave up their substance many thousand years ago to the representation by signs of perceptions based upon fear, desire, hunger, dreams, and a certain decorative and geometrizing distance from all these, a certain coldness. Whereas writing came much later. Writing in an alphabet wholly independent of pictorial elements is usually dated not much earlier than the middle of the second millennium B.C.

Perhaps nothing in the alphabet cannot also be seen in nature: O in a hole, W or M in a distant flying bird, Y in the branching of a tree, and so on. But that's not pertinent. What really matters is that no alphabet could exist as long as these signs were seen exclusively as belonging to nature; they had to be got out of nature, so that you could write C without any thought of the curve of the shoreline, S without thinking about snakes, any letter without thinking of it except as a letter— something that had never before been, something in effect literally "nonsensical" that yet could "make sense" of the realms to which its immense range of combinations was applied. If the conservative element in society got as mithered as it did at the advent of "abstract art" at the Armory Show of 1913, imagine its probable resentment at so great an innovation as the alphabet: "It don't look like anything I ever seen," "A child could do stuff like that if he thought it worth the bother," and so on.

With respect to painting, E. H. Gombrich, who has written so beautifully against the grain of an abstract age about the miraculous thing

that is representation, suggests that perhaps painting too arose out of coincidences in nature—as the alphabet did, but in the opposite direction. The earliest cave drawings might have been, he speculates, those in which a peculiar form of the rock itself was first *recognized* as resembling an animal, and then modified by artistic means with a view to increasing the degree of this resemblance; rather as the earliest portrait statuary, too, employed the human skull itself as armature—a thought that even yet retains a depth of sinister magical intent.

And the development of painting might be conceived of as having three main branches. The first would be in the direction of greater fidelity to appearances, ending in the peculiar magic of the waxworks, which so clearly and instantly distinguishes itself from the magic of art. The second would be in the direction of ornament, rhythm, pattern, figuration, of an abstract character. And the third would be in the direction of language, of alphabet and the codifying of signs, ending in the magic of writing; the process is indeed perceptible in the history of Chinese writing; while in Egypt, though writing and painting were clearly distinguishable, yet writing remained a species of representational drawing, though abstract and conditioned by the introduction of specifically linguistic and nonrepresentational signs.

It will be worthwhile to remember here Coomaraswamy's demonstration that in traditions of sacred art, the medieval Christian as much as the Hindu, painting was treated as linguistic;[1] the characters of iconography were dictated at least as much by the codified formulas of priesthoods as by any free observation of the visible world; which offers an answer, and a good one, to the question of how, in a world without photography, the features of gods and saviors become so quickly fixed and invariant.

In both languages, then, of writing and of painting, the shapes and substances of the earth rose up and assumed a mental and a spiritual quality, conferring upon the mind that brought them forth a thrilling if somewhat frightening power of detachment from the world as viewed by the prehuman mind, or at least the mind that was before these things were.

Maybe the comparison has to end there. For push and pull as we may, writing and painting *did* separate off from one another. Might they ever come back together? Ought they ever to come back together? If their very different but immense powers were to fuse into something not really much like either—what then?

We do already have an instance in which this happens: the making of maps, charts, diagrams, blueprints . . . where the representing of the visible, at which painting is supremely capable, is accomplished in paral-

1. Ananda Kentish Coomaraswamy, *Christian and Oriental Philosophy of Art* (New York, 1956).

lel with the strict and abstract syntax of writing able without modification of its own nature to transmit an indefinite variety of messages, which is the supreme contribution of written language. Might this somewhat elementary compound of writing and painting have still some way to go in the world?

I should like to make a rather wild leap at such a question, and hope to be going in a forward direction. Writing and painting could come together, though I don't know in the least what their offspring would look like. (Possibly it would not *look* at all.) It is here that I get the vaguest glimmer of a hint from music, or from some thoughts about music. Proust touches the thought, but almost at once lets it go:

> And just as certain creatures are the last surviving testimony to a form of life which nature has discarded, I asked myself if music were not the unique example of what might have been—if there had not come the invention of language, the formation of words, the analysis of ideas—the means of communication between one spirit and another. It is like a possibility which has ended in nothing.[2]

Another writer, François le Lionnais, also encourages this sort of speculation, also without demonstration, when he says that certain music—his examples are the Elizabethan virginalists, J. S. Bach, Schumann, Anton von Webern—"consists not only of fluctuating sound patterns capable of delighting the ear but also of psychological hieroglyphics not yet decoded."[3]

The vaguest glimmer of a hint, and one which I am, at least at present, unable to take any further, though perhaps some of my readers may. For this of "hieroglyphics" and "decoding" has its charms, because the arts have always had, in addition to their popular side, their deep affinity for mystery and the esoteric, for the secret which is also the sacred.

2. Marcel Proust, *The Remembrance of Things Past*, trans. C. K. Scott-Moncrieff, 2 vols. (New York, 1934), 2:560.

3. François le Lionnais, *The Orion Book of Time*, trans. William D. O'Gorman, Jr. (New York, 1966), p. 108.

Ideology and Iconology

Giulio Carlo Argan

Translated by Rebecca West

Is it possible to compose a history of images? It is obvious that history can be composed only from that which is intrinsically historical; history has an order of its own because it interprets and clarifies an order which already exists in the facts. But is there an order in the birth, multiplication, combination, dissolution and re-synthesis of images? Mannerism had discredited or demystified form with its pretense of reproducing an order which does not exist in reality. But is the world of existence, like the world of images, chaos or cosmos?

Erwin Panofsky's[1] great merit consists in having understood that, in spite of its confused appearance, the world of images is an ordered world and that it is possible to do the history of art as the history of images. In order to do this, he had to begin, as indeed he did, with the demonstration that classical art, in spite of the deep-rooted theoretical certitude, is also an art of the image; its forms are nothing if not images to which one tries to attribute the consistency of concepts, with the sole result of demonstrating that even concepts are images and that the intellect is still another sector or segment of the image.

Warburg and his circle in Hamburg, in which Panofsky first began to develop his ideas, had already demonstrated with patient philological research that the artistic culture of the Renaissance lives by the legacy of images received from classical antiquity. It lives, in other words, by his-

1. See, e.g., Erwin Panofsky, *Meaning in the Visual Arts: Papers in and on Art History* (Garden City, N.Y., 1957; Harmondsworth, 1970); *Studies in Iconology: Humanistic Themes in the Art of the Renaissance* (New York, 1939, 1962, 1967); *Problems in Titian, Mostly Iconographic* (New York, 1969); *Idea: Ein Beitrag zur Begriffsgeschichte der älteren Kunsttheorie* (Leipzig and Berlin, 1924) [*Idea: a concept in art theory*, trans. Joseph J. S. Peake (Columbia, S.C., 1968)].

Reprinted from *Critical Inquiry* 2 (Winter 1975): 297–305

torical images. Before Christian revelation, when the essence of the true was still hidden under the veil of appearances, all knowledge was made up of images; the wisdom of the ancients in interpreting the universal allegory of nature was the sign of the divine and the proof of its eternity. The divine in things is myth; classical art is the representation of a mythological universe, a necessary type of representation since myth does not exist except through representation. Myth is tied to form, and art is the expression of a mythic conception of the world. The return to the ancient or, more precisely, the palingenesis of the ancient is the very meaning of the history of art as cyclical and non-evolutive history. Ancient images reach the new humanistic culture through the obscurity, indistinctness, and irrationality of the Middle Ages, a fact which once again demonstrates their survival in the depths and their transmission along with the very flux of existence.

Panofsky's iconological method has nothing to do with that subsidiary science of art history known as iconography, a science which can be reduced finally to the formation of classes of objects having certain common countersigns. It is instead an historical method because it forms series, not classes; that is, it reconstructs the development and the continuation of traditions of images. We must not forget that Panofsky built on the systematic study of canons and on the principles of authority in Renaissance classicism: perspective, proportion, *idea*. But his conclusion, which must be reached by anyone who, like Panofsky, has seriously studied Cassirer's theory of symbolic forms, was this: in spite of mathematical or philosophical foundations, perspective and proportional systems are still iconologies of space and of the human body. They do not indicate a higher level of consciousness but, rather, point to the substantial analogy between those forms retained as conscious and those retained as images of the unconscious.

The process of traditions of images as Panofsky reconstructed it is tortuous, fortuitous, full of uncertainty, past echoes, and unexpected turns. It absolutely does not possess a logic; it has no constant direction,

Giulio Carlo Argan is professor of modern (post-medieval) art at the University of Rome. His works include three volumes of critical essays on modern art and studies of Fra Angelico, Botticelli, Borromini, Brunelleschi, and Gropius. "Ideology and Iconology" originally appeared in Italian in the journal *Storia dell'arte,* which he edits, and in *Psicon.* **Rebecca West** is an assistant professor of Romance languages and literatures at the University of Chicago.

no goal. But we are not saying that it does not have its own order. The artist is one who creates and has a technique, who surely has an order because he presupposes a project and a determined succession of acts. It is the practical exigency of making that recalls past, often remote, even at times obliterated, experiences to the present moment, to the immediacy of the thing to be made. It is the order of making that gives order to mnemonic recoveries and to the movement of the imagination. Obviously it is not a question of elaborated materials, since the mnemonic datum is often partial and imprecise and will assume a meaning only later. The iconologist knows that he cannot allow himself the luxury of working with selected materials of certified artistic worth. In order to study the genesis of art he must start with something which is not yet (or no longer) artistic. He gathers together the greatest number possible of those documents directly or indirectly related to the imagistic theme which he has decided to consider. He is like a geographer who studies a water course: he must isolate its origin, calculate its path, keep in mind all of its branches, and then describe its behavior which depends upon its tendency to overflow, rush, or stagnate.

It can of course happen that an iconological theme is presented in some famous masterpiece which magnifies it, but more often its presence or its passage is signalled by artistically impoverished figurations—by second- or third-hand documents such as illustrations, popular publications, plaques, monies, playing cards, and such. In some cases it can be a question of vicarious or provisory documents such as copies or derivations based on lost works of art. But it is certainly symptomatic that the storiographer of the iconological method prefers this copious and "worthless" imagery. The image which is worn out, consumed, recited for the thousandth time, or deformed by the careless habit by which it has been adapted to the most varied occasions is often much more eloquent for the historian of the image than the scholarly, purified, controlled version which is established by the lucid structure of a formal system. The image which is discredited or sometimes contaminated by ingenuous associations, combinations, or even by banal confusions (through assonance) with other latent images in the memory is the document of a culture of the diffused image; it is a *signifiant* to which may be attributed, as to the words of a spoken language, many *signifiés*. For this reason iconologism, much more than Wölfflinian formalism, confronts the problematic of art as that of linguistic structures. Panofsky, not Wölfflin, was the Saussure of art history. Needless to say, therefore, that by going back to the original seeds of the image and following their growth in the fecund ground of the collective unconscious, one can thereby deduce the common motivation of the artistic fact's production and fruition, thus re-establishing the unity of the aesthetic act and the continuity between the genetic and the fruitive history of the work of art.

Panofsky often declared himself to be an historian of art, even a philologist in the humanistic sense of the term, and not a gatherer of iconological documents. His objective remained, in spite of all else, the value judgment which, however, he preferred to call "re-creative synthesis." "It is not true," he said, "that the art historian first constitutes his object through a re-creative synthesis and then begins his archaeological research, as one first buys a ticket and then boards the train. Actually, the two processes do not occur successively, but rather proceeed in an interwoven manner; not only does the re-creative synthesis serve as a basis for the archaeological research, but the latter in its turn serves as a basis for the process of re-creation. Both qualify and correct each other in a reciprocal relationship." The work of the iconologist is completely different from that of the iconographer; the latter describes the connotations of the figure as an entomologist describes the characteristics of an insect; the former synthesizes, not analyzes, because he reconstructs the previous existence of the image and demonstrates the necessity of its rebirth in that present absolute which is the work of art.

The iconological method is often criticized by many, as is the history of criticism, for having a purely subsidiary utility. Granting, for the sake of argument, it is said, that it can be interesting to explain the meaning of a work whose subject escapes us (for example, an allegorical composition), it is a fact that most of the time it does *not* escape us, and from the first glance we know if the painting before us represents the crucifixion or Saint Jerome Penitent, a portrait, a landscape, or a still life. Is it worth the trouble to undertake laborious research in order to reconstruct, at best, the history of allegory, of myth, of figurations, or of genres? One could answer that the iconological method has produced excellent results even when the work of art is not figurative, as Wittkower's[2] and Krautheimer's[3] illuminating contributions to the history of architecture have demonstrated. Or one could ask the objector to indicate one figurative work which is not in some way allegorical, since allegorization is a constant, constitutive, and structuring process of representation. Moreover, the "disreputable" subject is never missing, and the critic who wishes to study the artistic phenomenon in its integrity cannot help but deal with it. In order to find a work of art without a subject we would have to come to our own times, to works that exclude a subject in a polemical manner, but then the very lack of a defined subject constitutes a theme, as in the case of those humorous vignettes under which is written "without words." If Raphael portrays the Madonna with Child in a way different from that of Duccio, there must be a reason, and we cannot guess it simply by attributing all the iconographical newness to

2. See, e.g., Rudolf Wittkower, *Architectural Principles in the Age of Humanism* (London, 1949; Baltimore, 1973).
3. See, e.g., Richard Krautheimer, *Studies in Early Christian, Medieval and Renaissance Arts*, trans. Alfred Frazer et al. (New York, 1969).

the brilliant inventiveness of the artist. From Raphael to Duccio, the image of Madonna with Child has made a long voyage whose stations certainly cannot be reduced to the interpretations which the theme has received from the great masters. Obviously, that which a superficial kind of criticism attributes to the imaginative will of Raphael is actually a process of the imagination which can be researched and reconstructed with the inevitable result of discovering that the materials elaborated in the course of that process are perfectly separate cultural experiences.

Iconological research can also be done into the portrait, the landscape, or the still life, but it certainly would not consist in ascertaining who the characters are, or what place, fruit, or flower we see represented. The iconology of a portrait is the pose, the dress, the social or psychological meaning which can be attributed to the figure; the iconology of a landscape or of a still life is the mode of perspective, the configurations, the rendering of places and things as significant. Titian's portrait of Charles V on horseback obviously partakes of the iconographic class of portraits of Charles V or even of the more extended class of warriors on horseback. But this is a classification which is of no use to history (if not perhaps occasionally as a method of dating), just as classification according to technique, such as "oil painting on canvas," is of no use. An iconological historian like Panofsky would place it instead in the series (not class) of portraits with historico-allegorical significance. He would then proceed to establish that significance and, bearing in mind the occasion for which the portrait was painted (the victory over the Protestants at Muhlberg), he would explain that the emperor, armed with a lance like any common soldier and in the act of emerging from a symbolic forest, is here portrayed as *miles christianus*. All this would still be nothing more than an historical curiosity if the choice of theme had not influenced the psychological interpretation of the character, as is easily seen when this painting is compared with others painted by Titian himself (for example, the one in Munich). We need only think then of Poussin, Claude Lorrain, or Corot in order to be persuaded that there is an iconology of landscape easily recuperable in the choice of perspective and in naturalistic components such as trees, rocks, water, and clouds, as well as in the choice of season and time of day. Nor does it help to invoke the instinctive emotion of the artist as he stands before the "real" (given that it is a question of real landscapes), since he has chosen that reality and pursued that emotion; of course the emotion is still a fact of the memory-imagination, even if brought about by some external stimulus. Even in the most "objective" of seventeenth-century Dutch still lifes, iconological research demonstrates how an intense activity of the imagination is joined to observation; diverse meanings, recondite symbologies determine the choice of objects (fruits, flowers, game, fish, crystals, musical instruments, etc.), and there is a profound sense of space and time in the grouping and in the objects themselves. If we did not already

know that a still life often has allegorical or allusive meanings (the five senses, *memento mori, vanitas rerum,* etc.), we would still have to deduce that a still life is also an allegory.

Not only those images that come from the inexhaustible mine of antiquity, but also those that depend on sensory experience can be found gathered together helter-skelter by the artist's imagination. There are also images which we could call "technical" and which are part of the baggage of notions that the artist carries with him along with the tools of his trade; all those representative habits or conventions which Gombrich[4] has studied, for example, and which constitute the catalyst of art. Without those conventions which form a sort of code common to artist and spectator, the work would be indecipherable, and art, not acting on a specific and accepted cultural terrain, would not collaborate, as it often does, to modify that terrain.

Panofsky was perhaps too modest when he said that iconology is concerned with the subject and not with the forms of works of art. If a Madonna with Child by Raphael is not simply a cult object but a work of art which visibly expresses the tie between natural and divine which can be seen in a determined historical moment, this meaning is not established solely by the fact that the madonna is a beautiful woman seated in a lovely landscape but also by the progression of the lines which is the same in figure and in landscape, by the relationship between the blue of her cloak and the blue of the sky, and by the subtleties of color which make one feel the diffused presence of the atmosphere. And with this we are already in that *hortus conclusus* known as style, in which the ideal-formalist critic gets up on tiptoe requesting silence with his finger to his lips so that the work might speak for itself. But the work is silent. It is always the scholar alone who speaks in the presence of the work of art, and his entire problem consists in deciding what kind of talking he should do.

But even when limiting itself to the subject, iconological research is still not partial or secondary. Even in architecture, in ornamentation, in the arts which are called minor because of an old classicistic prejudice, the morphology is saturated with iconological meanings. The research which has been done in the great typologies of the temple with a central plan or of the dome could easily be extended to the particulars of the cornices and the friezes, and as for ornament, processes of the styliza-tion and repetition of images could be studied. As for the applied arts, the innumerable and very subtle threads which link them to custom could be examined. If it is possible to do iconological history of perspec-

4. See, e.g., E. H. Gombrich, *Art and Illusion* (Princeton, N.J., 1960), and *Norm and Form: Studies in the Art of Renaissance* (London, 1966; London and New York, 1971).

tive, proportions, anatomy, representational conventions, symbolic references of color, and even of rituality and gesturality in technique, no one has said that it must stop there and that it is not possible to study historically, like so many other iconologies, line, chiaroscuro, tone, penstrokes, and so forth. It certainly would be possible and it would be a very useful kind of research, one to recommend to young art historians desirous of exploring new fields. The name would change, however, and this research would no longer be called iconology but, following modern terminology, semantics or, more exactly, semiotics.

Returning to that mass of documents gathered together by the iconologist as he follows the main thread of an image until it emerges in the end as a great work of art, as a true historical fact, it is immediately necessary to observe that not all the documents will turn out to be used or equally used; and of those that are used we cannot say that they were evoked or elaborated following some logical or chronological order. We are in the interior workshop of the artist and, just as in any workshop, we find a little of everything: works already completed, studies, sketches, drawings, notes. Furthermore we find casts, prints, reproductions of ancient and modern things which the interested artist has gathered for possible future works; moreover there are costumes, drapes, carpets, rags, tools, and junk of every sort which might serve to dress a model or improvise an ambience. Finally, there are canvases, boards, frames, jars of paints, brushes, and pencils. All that raw material is there because it might be of use, not necessarily to the work in progress or in mind but to all the works which are at the stage of pure possibility or intentionality. The raw materials are the instruments of the artist's poetics more than of his actual work, and often the artist himself will declare that to do the figure of a king, he prefers to use an old velvet drape rather than a real regal cloak. Gainsborough painted his landscapes in his studio, using as models some pebbles or bits of bark which he had picked up on a walk. Obviously they were not real models but stimuli for the working of his memory-imagination. When, in the course of the artist's work, a more or less remote memory is evoked and brought to the surface, you can be sure that the movement of his imagination is connected to that of his hand or at least to the interest in his work in progress.

All well and good, one might say, but if between the image which the artist creates and the remote iconic predecessor there is no possible historical correlation, why indicate a link which objectively does not exist? Because the fact that the correlation is neither conscious nor direct does not demonstrate that it does not exist at the unconscious level and that it does not function as a profound motivational force. As research goes deeper, the iconological themes tend to group themselves into a few thematics that are found in all ages and in all cultures. Beyond the historical limits of art it is possible to reduce all motivations of human

behavior to two basic impulses (as did Marcuse)[5]—*Eros* and *Thanatos*—just as it is also possible to reduce all languages to a few essential roots, as Thass-Thienemann demonstrated.

Only when all this is recognized will the entire phenomenic area of art appear as an immense net of interacting relationships, with or without historical awareness of the connections. And we do not mean by this that it is impossible to speak of Brunelleschi's or Michelangelo's dome without bringing to bear the Indian *stupa* or the constant link between centralized architectonic form and the idea of the cosmos, any more than it is impossible to speak of a Madonna with Child by Raphael without recalling the *mater matuta mediterranea*. We have already heard too much of this sort of chatter. We are all persuaded, and Panofsky himself always preached it, that historical research is more valid the more circumscribed and localized it is. The important thing is that research lead not to the isolation of a fact or a group of facts but to the individuation of a knot of relationships and that it be recognized that beyond the illuminated zone in which research moves these relationships extend and branch off infinitely into the immense area of artistic phenomena of no matter what period or culture. Thus the link which across long and obscure paths joins Michelangelo's *Last Judgment* to a Polynesian idol will not be seen as a metaphysical sameness of aesthetic worth but as an historical connection which can, if we desire it, be reconstructed and described.

In many aspects, then, the iconological method begun by Panofsky, although by design rigidly philological, can be qualified as the most modern and efficacious of historiographic methods, open moreover to great future developments which truthfully it has not as yet experienced, perhaps because Panofsky's own followers have reduced its range, making of it an almost esoteric science for a few initiates and providing thereby a case for the ideal-formalists who consider it a heterodox methodology.

Returning, as we conclude, to our point of departure, we must acknowledge before all else that the iconological method has the merit of having postulated all the premises for a transcendence of the europocentric limits of the history of art, demonstrating that form, so-called supreme worth of Western art and the basis for argument of its intellectual superiority, is nothing more than a variety of the image; more precisely, it is the method by which the image of the periods known as "classical" is qualified and legitimized. Bringing art from the "intellectual" plane to the plane of individual and collective psychology allows the way to be opened toward a confluence of psychoanalytic and sociological research, toward the dialectical encounter of the Freudian-Jungian line with the Marxist line, a meeting which is one of the essen-

5. See, e.g., Herbert Marcuse, *Eros and Civilization* (Boston, 1955; New York, 1962; London, 1970).

tial goals of today's culture. The level of possible connection is the phenomenological level; in this sense the iconological method owes much, in spite of the apparent discrepancy, to the method of pure visibility, since wherever an image is brought to perception through a technical procedure there is surely intentionality or desire of creating art. For this reason we would like to see iconological research extended far beyond the arts traditionally known as figurative, into the vast fields of urbanology and of architecture, into ornamentation and *Kunstindustrie*, all already indicated by Riegl[6] as the most propitious areas for research and discovery.

6. See, e.g., Alois Riegl, *Die Spätrömische Kunst-Industrie Nach den Funden in Österreich-Ungarn dargestellt von Alois Riegl* (Wien, 1901–23); Part I as *Spätrömische Kunst-Industrie*, ed. Otto Pächt (Wien, 1927; Darmstadt, 1964).

Two Visual Excursions

Joshua C. Taylor

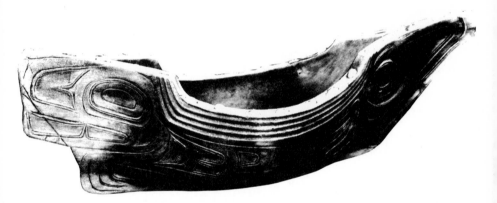

1. Art and the Ethnological Artifact

As some artists discovered early in the century, there is a particular pleasure and stimulation to be derived from works of art created by cultures untouched by our own traditions of form. In part this is probably a delight in exoticism, in being away from home, and in part it possibly is our sentiment for cultures we look on as traditional, in a Jungian sense, or primitive in their unquestioning allegiance to simple cultural necessity. But more significantly, without indulging in philosophical or anthropological speculation, we are forced, in looking at such objects as these elegantly designed boxes and bowls, to revise our visual thinking, our assumptions about unity and grace.

Of course, at this point in history, when we have trained ourselves to

Reprinted from *Critical Inquiry* 1 (September 1974): 91–102

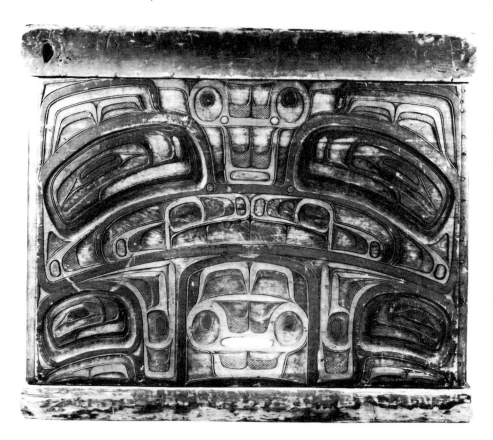

respond to, or at least accept, all manner of forms and harmonies, and even to search for nonform and harmonic chaos, there is always the danger of losing that sense of ritual upon which any formal harmony is based. For anyone so threatened, a study of such objects as the boxes and bowls from the Northwest Coast Indian cultures, with their deftly chiseled forms contrasting an inner life with an outward austerity, should serve as a helpful restorative.

How to talk about such objects, however, is a nice problem. For the last one hundred or so years they have been collected as artifacts, and al-

Joshua C. Taylor, director of the National Collection of Fine Arts of the Smithsonian Institution, is the author of *Learning to Look, William Page: The American Titian,* and, most recently, *The Fine Arts in America.* Part 1 of this paper has been published in somewhat different form in *Boxes and Bowls* (Smithsonian Institution Press, Washington, D.C., 1974).

though since the 1930s they have found their way into museum collections as objects of art, the language by which they have been expertly catalogued and described remains that of the ethnologist and anthropologist. Although the critical language of art has changed much over the years, keeping pace at its best with new concepts in art that have broken with nineteenth-century norms of imitation and formal composition, the new critical disciplines have made little inroad into archaeology or anthropology. If indeed we are dealing with works of art, there seems little reason for closing off those sensibilities that have proved fruitful in revealing meaning in other reaches of art from these objects simply because they were collected for another purpose. No matter how objective the archaeologist or anthropologist feels himself to be, he is making critical judgments in his descriptions and should have not only the courage to face up to the fact but the critical awareness to recognize the sources of his own tradition.

Most of Western design has been based on the interplay or opposition of two compositional principles: the proportional relationship of clearly defined forms of a relatively simple geometric sort, or a continuity of line or form in which one shape flows into the next with little concern for beginnings and endings. These have been characterized by theorists in many different ways over the years, sometimes on the basis of large cultural schemes (note, e.g., Worringer's *Abstraction and Empathy*), sometimes in terms of individual response. But we have learned to accept these modes as such, no matter what the rationale, as part of our visual stock in trade.

This handy distinction in formal order is little help in looking at these containers from the Northwest Coast. In the first place, they seem always to be made up both of distinct formal entities arranged in nice symmetry, and of continuities. Every line is polished in contour until it moves, even when it encloses what otherwise would be a discrete and static shape. As a result the eye confronts a continuously ambivalent situation, having to choose between simply looking at a form—and many forms have the unnerving habit of looking back—and joining a rhythm that leads to something else. Which does one choose? Both, of course. It is a bit like staying in one place and going somewhere else at the same time. In art, however, the awarenesses of being and becoming can live quite happily together, and these active though static compositions effectively demonstrate the fact.

The result of this somewhat wrenching experience, in which one is invited to join the lively movement and identify himself with the rhythm of the lines, only to be expelled from this empathetic union by the tightly integrated nature of the forms, is to recognize a kind of hypnotic power

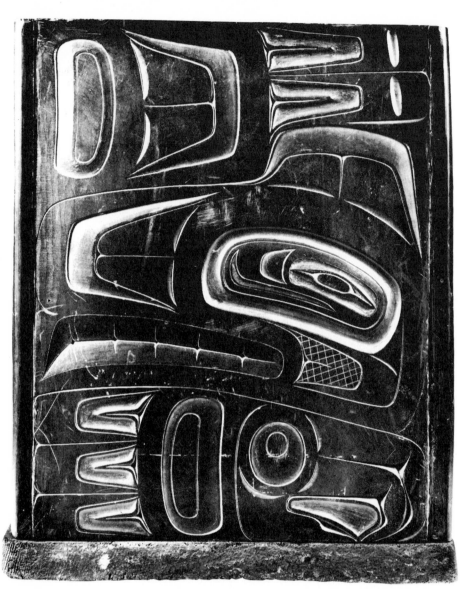

that surrounds these objects. And we need not be a believer in any particular mythological scheme to sense it. Worringer's distinction of cultures on the basis of abstraction or empathy would not work convincingly here because abstract distance and empathetic identity coexist, as if we were both participating in the work and looking on as observers. A universe is suggested that is part and parcel of ourselves, yet embodies an inner mystery that remains aloof.

Any insistence on distinguishing between the animate and the inani-

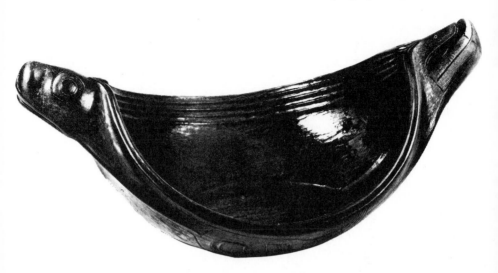

mate in these objects is bound to lead to frustration, chiefly because such a distinction is irrelevant. In a sense, every object or form that is kindled to life in the mind of the observer is animate and has to be dealt with as a separate personality. This is not an easy concept for one trained in the Western traditions in which to distinguish between animal, mineral, and humankind is a mark of sophistication. The idea that an identifiable, clearly dimensioned appearance is the only true reality dies hard, even though artists ceased trying to distinguish between objective and subjective a good many years ago. To attempt, in this case, to determine whether a bowl was made to look like an animal or the animal was distorted to become a bowl is a fruitless task. They grow together: the bowl became animate and its animation gave reason for its being a bird as well as a bowl. This is a very different situation from a Victorian soup tureen that looks like a sitting hen. The bowl does not have the form, the external appearance, but the spirit of a living thing, evoked not by likeness but by a compelling liveness of form. We tend to attribute organic life to a form if it eludes our imposition of geometrical order, or simple recognition as thing, but seems to proceed in accordance with an inner volition of its own. As in an early Chou bronze from China or a Zapotec design from Mexico, the flattened curves and elongated shapes of the Northwest Coast designs do just that. One can look in vain for circular arcs and spiral curves. For all their adherence to type, the lines of the carved designs are to be understood only in the act of following them, not by matching them to an established object or a geometrical concept.

All of this underscores the fact that these are not decorated objects in the usual Western sense. In sorting out their ideas about design in the

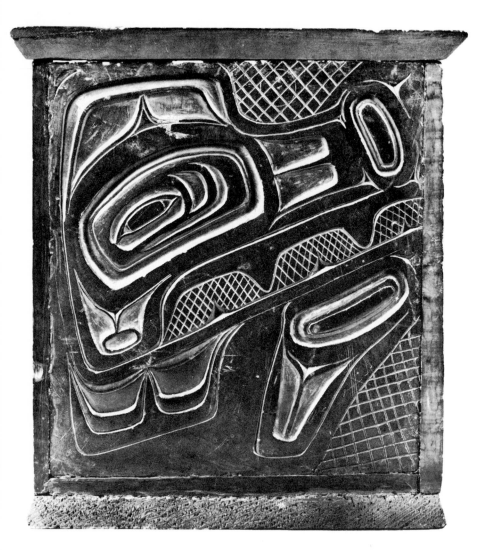

general scheme of things, theorists in the middle of the last century made clear that decoration of an object must be adornment beyond the dictates of use if it were to be of value. Its intricacy and costliness made clear that the owner was not bound, by taste or pocket, to the restrictions of utility. A countertendency took shape later in the century which insisted that decoration, if used at all, should be related to the structure itself. And finally came the moral dictum that there should be no decoration; structure was all and austerity was good.

None of these approaches to design is helpful in getting at the character of our boxes and bowls because all such concepts are based on a series

of isolated qualities such as utility, decoration, aesthetic structure, and a kind of symbolic morality. They all belong to a world of pragmatic values and are the product of deliberate analysis. To the Indian carver, decoration had meaning, not simply by virtue of its historical or sociological reference, although traditional mythological inferences were doubtless important, but because it effectively blurred precisely that difference between object and mind, the outer and inner, which has been so dear to the tradition of Western thought. Furthermore, the "inner" was not simply the expression of animal spirit, as sometimes seems to be the case in what we regard as primitive art, but that which maintained a quality of mystery, of an order beyond calculation or sense.

Quite possibly, then, the revision of our way of looking, dictated by such designs as these, goes rather further than simply adding another flavor to our repertory of aesthetic tastes. If we, too, even though uninformed of the mythological systems and cultural mores of the people who created these objects, can sense this combination of vitality and wonder that the carvings evoke, then our estrangement from the world is not so complete as some popular philosophies would have us believe. We rarely talk of magic as a function of our present art, but of course it is. Art serves to kindle into meaning aspects of our perception that would otherwise remain external to our minds. To be sure the Northwest Indians organized a culture far different from our own, but we can sense a bond of sympathy in their art that goes well beyond a respect for craftsmanship. Exotic distance drops away under the impact of a shared human awareness.

2. Literary Values in the Visual Arts

A major cry in defense of the modern arts since at least the beginning of the century has been against "literary" values in the visual arts, and a vast literature has been built up over the years explaining why. In fact, it would seem that the less obvious the subject of narrative has been in a painting the more extensive has been its literary support. The extent of the verbal complement for those tendencies critics like to list under geometrical abstraction is matched only by that which defended the total representation of natural appearance in the mid-nineteenth century.

If we look at the matter quite dispassionately, it is evident that twentieth-century painting has not in actuality separated itself from literature but has, rather, simply allied itself with different literary genres. There is nothing shameful about this—literature is constantly pilfering from painting; but the doctrine of "non-literary" painting has always been presented as so profoundly basic and moral a creed that to suggest

that it is not quite what it purports to be seems an affront to the sanctity of art itself.

Undeniably the relationship between writing and painting has changed enormously since the comte de Caylus published his exhaustive and exhausting list of subjects from Classical literature that a painter might follow, but the change has not been simply from dependence on literature to pictorial freedom. There were many steps along the way. Nor was the *ut pictura poesis* relationship always what it might seem. Lessing early pointed out the absurdity for art of Caylus's list of narrative subjects, maintaining that the visual arts were generally spatial in nature and therefore not adaptable to the temporal aspects of literature or music. The visual arts were thus most powerful in effect when least narrative in method. On the other hand, Francesco Milizia, equally suspicious of the narrative context, saw pictorial form and poetic form as operating for aesthetic satisfaction in the same way. Substituting the word "painting" for "poetry" in Marmontel's essay on invention, he maintained that the harmoniously operating "machine" that provided aesthetic delight was much the same whether disclosed in verse or visual form.

For the most part, however, literature has served to bolster the context surrounding a work in the visual arts, rather than to serve as a companion in form. Milizia lived in a period of form-conscious theorists. A generation later, painting, and sculpture too, were depending on a narrative context with an urgency greater than ever before. The German Nazarenes looked to the Bible or Dante, patriotic Italian painters drew upon Tasso and Italian history, Delacroix looked to Goethe, Byron, and Shakespeare for his artistic milieu, and Ingres filled his notebooks —though rarely his paintings—with useful passages from Homer and historians of the Greeks. Quite possibly in the early nineteenth century historical studies surpassed the novel or poetic narrative as a source for painting and sculpture, since the new study of history, no longer formulated as a march of heroes, provided not only a new repertoire of incident and detail but a nationalistic overtone that might galvanize the interest of a wide public. As one Italian critic put it, a great painting speaks to all by presenting a subject of deepest national significance with the utmost visual truth. Whether based on novels or nature and society, much art during the second quarter of the century took on the aspect of investigative reporting. Each work was the latest, certified dispatch from the realm of the real or the ideal.

Baudelaire, for one, pointed out the limitations of historical reporting and cast the researchers out of the temple of Romantic art. Hugo, with his footnotes and historical paraphernalia, was an example of what art

should not be. To suppose that Baudelaire was separating painting from the field of literature, however, would be quite wrong. He simply moved it into the sphere of poetry where he himself held sway.

The alliance of poetry and painting, rather than narrative and painting, was important for both. Poetry itself was changing, and there was little in it in the way of narrative for painters to mine. At least in France and eventually in England and throughout Europe, by mid-century the principle of evocation took precedence over description in poetry, and the means and extent of evocation preoccupied many serious writers. Structure, such as that described in Poe's much admired essay, "The Philosophy of Composition," was measured by intensity of impact, not shape. Flaubert's concentric circles of expanding association made the poem a source, not a record of experience.

Late works by Corot, once thought of as simply woolly were eventually seen as poetic in the new sense of that term, and even the female arabesques of the elder Ingres were seen by some, notably Gautier, as inhabitants of a new poetic world of sense and symbol. Of course the poets had to compete with the clinicians like Champfleury and later Zola in their formulations of values, but the poets won out, and by the end of the century even much critical writing on art was a form of poetizing. To describe a painting one had to be taken into its spell and write within its special poetic aura. Simple, dimensioned prose was not enough for such a taste. A new, expressive language had to be devised in order to talk convincingly about plastic values, whether with the concerns of Pater, Berenson, or Laforgue. Neither words nor forms alone proved quite enough for the new awareness, and sometimes the two were combined to reach beyond themselves. The way one learned to talk about painting had its effect on what painters were encouraged to do. The language helped to create a world of art, quite separate and often opposed to the humdrum activity that the larger population considered reality. It is a moot point as to whether the language came first or an awareness of those qualities the language was trying to describe. They were intertwined and depended upon each other. In fact, they were born together.

As if to marry the new poetry with the persistent clinical concern, a new strain in the literature of art appeared during the late nineteenth century, that of the psychologist-philosopher. People like Fechner or Lipps or Vernon Lee, who wished to find a physical basis for poetic values, attempted to make the freedom of the artist's choice seem physically inevitable. The link between sensory perception and psychic states was investigated with an intensity that made the efforts in a similar direction of a century earlier seem naively diagrammatic. The distinction between the beautiful and the sublime was relocated in Worringer's

opposition of abstraction and empathy, but the duality remained. A new subject matter was born, self-expression, and with it a whole new literature on the nature of self. Begun as a simple pursuit of Konrad Fiedler's *Kunstwollen,* the critical way led to the language and images of Freud. Something known as the psychology of art, which might better be called psychology through art, furnished not only new terms and schemes of discourse but a stock of established images no less restrictive than the subject lists of the comte de Caylus.

As seems inevitable with philosophical investigations, if not always with psychological preoccupations, the next step—actually in this case taken contemporaneously—was metaphysics and religion. The will to abstraction was rationalized in cosmic terms more often than in simple aesthetic principles. "Significant" form could remain an unexamined quality for only a limited time. From the Ecole de Beuron and new Thomistic thought to Steiner and the formulations of Kandinsky, Malevitch, and Mondrian, the work of art was both a visual demonstration and a winning plastic argument for a belief in an ordered universe. To be sure, one could respond to the work of art without reading the text, but few people needed to consult the sources because the fervor, if not always the meaning, of the essentially religious impulse had worked its way surreptitiously into general critical prose. We now think nothing of referring to "purity" in form and color, or the sanctity of the inviolate picture plane. Design is "good," and architecture is "honest."

Yet there was a further literary genre that could substitute its own meaning for the original impulses, finding its way back into art as a content of its own. That was the systematic and aesthetically inspired historical procedure developed initially to justify the modern arts themselves but finally serving as a prescription for change. Already before the First World War historical surveys appeared, demonstrating how one or another aspect of contemporary art was an inevitable product of that which was most worthwhile in the past and therefore completely justifiable. For the most part these treatises held up that variably defined quality known as abstraction as the only proper goal of visual, and possibly spiritual, progress, and rejected as peripheral any aspect of art that did not advance the cause. If such a direct line of development (a new cant word) was not subscribed to, one might accept a complex map depicting the relationship of one artistic movement to another, working a web of doctrine in which the past and present joined. This cartography was of interest to many artists after the First World War, Malevitch for one, and was beautifully presented on the dust cover of Alfred Barr's 1936 publication from the Museum of Modern Art on *Cubism and Abstract Art.* Every acceptable aspect of recent art was there someplace, connected with others by arrows and dotted lines, and the seeming wil-

derness of modern creativity was charted to expel the possibility of uncertainty or fear. A new work of art, then, could be talked about, not as a direct and personally isolated experience but as filling a place on the map of history. As matters progressed, the content of the work, in fact, might be just that: its place in a preordained network of critical thought.

In recent years, some critics and historians have come to realize that the popularity of the term "avant-garde," so long regarded as an element of content, is only a symptom of a widely held, but unnecessary, historical doctrine. Avant-garde is neither a simply descriptive phrase nor, in the long run, a useful term of aesthetic evaluation. Yet, even though the historical doctrine that provides for an avant-garde is no longer so highly regarded, the term remains essential because some works of art would have no meaning separated from the "historical" context for which they were created. The historical scheme provided the narrative that explained the significance of their particular event. The line between criticism and history has become blurred in a way quite different from what Croce had imagined.

The impact of this critical and historical verbalizing about the content of art might have been less had writings on art not gone through such an extraordinary expansion, beginning late in the past century. From the special audiences of the little magazines of the nineties, each with its *parti pris*, publications on all aspects of art have expanded to the vast market they command today. The historical web created out of the collections, exhibitions, and, no less in importance, the publications of the Museum of Modern Art in New York, to cite one—but possibly the most potent—example, furnished the vocabulary out of which a whole generation formulated the rationale for its art. The art magazines and exhibition catalogues, with their ever-mounting flood of self-perpetuating prose, have sustained a mythological world from which an artist could escape only with difficulty. It has furnished him the landscape in which he is free to create and a community with which he can share a language. The artist can assume that his viewers have read the book.

The degree to which a particular critical stance enters into the ultimate content of a work of art is variable, as was the case earlier with narrative or other verbally formulated contents. Form, color, and image can, of course, have a powerful impact quite without the assistance of a critical locale. Criticism has served in some instances chiefly to break down traditional barriers that would stand in the way of a direct impact. Then, too, in many instances a theoretical assumption, possibly even when little understood or misconstrued, has spurred an artist to create works that go well beyond in value and in kind what the assumption taken literally could be expected to provide.

Quite possibly a sliding scale would pertain, in which the greater the sensuous impact of the work of art, the less the critical setting tends to formulate the content. It is worth noting in this regard that in the seventeenth century when critical writing on art first began in earnest, there was a division of forces between the support of art with a strong senuous impact—usually exemplified by Rubens and the Venetians—and an art in which the premises according to which it was produced and the logic of its execution were more potent than the persuasions of sense as represented by the painting itself. The latter was known as more philosophical or intellectual, not because it drew on more philosophical subject matter but because it could more readily exist in the context of philosophical discourse. It felt intellectual. This sensing of intellectuality sounds quite compatible with the thinking of Gleizes, Malevitch, and the recent theorists of conceptual art.

But whatever the argument of degree or kind of interdependence between literary content and the visual arts, it is evident that any schism in the twentieth century occurred only as a strategy within critical theory itself, not between the arts of sight and the realm of words.

Redefining the Sister Arts:
Baudelaire's Response to the Art of Delacroix

Elizabeth Abel

Like other areas of criticism, theories about the relationships among the different arts undergo revision periodically. Reacting to the excesses of *Geistesgeschichte* studies that deliberately ignored the distinguishing features of different arts in order to reveal their manifestations of a common spirit, formalist critics, particularly René Wellek, insisted on the determinative role of each art's specific medium, an emphasis consistent with the growth of intrinsic criticism in the 1940s and '50s. Although general cultural studies in the *Geistesgeschichte* tradition, for example Wylie Sypher's *Rococo to Cubism in Art and Literature* and Mario Praz's *Mnemosyne: The Parallel between Literature and the Visual Arts,* continued to appear, they tended to provoke hostile reactions from the more established formalist camp. With the loosening grip of the intrinsic approach to literature, however, a new interest has developed in defining the relationship of poetry and painting in ways that are free of both the *Geistesgeschichte* abuses and the formalist restraints. This essay is intended as a contribution to the growing number of studies that incorporate a sense of each art's formal qualities into the definition of their broader similarities.

Recent studies of relationships among the arts can to a large extent be characterized by their deliberately modest claims and goals. Recognizing the difficulties of defining the arts and their relationships in universal terms, critics have turned to analyzing particular relationships within a given style or period and have called for an empirical, flexible approach responsive to the changing features of these relationships. Attempts to generalize about the nature of the arts or about their funda-

Reprinted from *Critical Inquiry* 6 (Spring 1980): 363–84

mental relationships are invariably problematic because each art form undergoes significant developments that alter its relation to the other arts. Thus, when Jacques Maritain asserts in *Creative Intuition in Art and Poetry* that poetry originates with the inner life of the poet and painting with the impact of the outer world on the artist, we might protest that poetry can be descriptive as well as expressive, that painting can be expressive as well as representational, and that Maritain's distinction does not apply to such modern developments as concrete poetry and abstract expressionism. Similarly, despite Lessing's famous distinction between the sequential, arbitrary signs of poetry and the simultaneous, natural signs of painting, we find that the words of poetry can be organized spatially or demand a simultaneous apprehension, while painting is sometimes ordered sequentially and invariably involves a temporal process of perception. And since Ernst Gombrich's analysis in *Art and Illusion* of the "language" of painting, we realize that the painter's signs may be just as conventional as the poet's. The relationship between two arts changes over time: the similarities between a painting by Picasso and a poem by Apollinaire differ from those between a painting by Claude and a poem by Thomson or a painting by Hogarth and a scene from Dickens.

Recent appraisals have met this problem in various ways. One collection, *Encounters: Essays on Literature and the Visual Arts,* deliberately juxtaposes studies of literature and painting in different historical periods to counter the assumption that their relationship is constant, while a recurrent call in the essays comprising the *New Literary History* issue devoted to "Literary and Art History" is for more limited studies of interart relationships within specified stylistic contexts. Alastair Fowler summarizes this sense of the field in claiming that "the notion of a universally valid systematic correspondence between the arts must be regarded as a chimera. Real correspondences exist and may be worth analyzing. But they change with time, and change so fundamentally as to make diachronic investigation a necessary preliminary to discussing them, if full rigor of method is to be achieved."[1] Just as the historical impulse of *Geistesgeschichte* overplayed the *Zeitgeist* as a transcendent force assimilating different forms of art into analogous expressions of a single spiritual state, the aesthetic orientation of formalist criticism can

1. "Periodization and Interart Analogies," *New Literary History* 3, no. 3 (Spring 1972): 486.

Elizabeth Abel is an assistant professor of English at the University of Chicago. A coeditor of *Critical Inquiry,* she is currently writing a book on literary and psychoanalytic representation of female identity.

underplay the role of history by positing a constant and determinative role for the aesthetic medium. Diachronic studies can avoid these two extremes by focusing on relationships between the differing expressions of related styles or subject matter in two forms of art.

The period of inquiry here is the Romantic era, particularly its development in mid-nineteenth-century France just prior to the transition into the symbolist movement. Because the interaction between poetry and painting underwent a fundamental change in the Romantic period, a change for which a method of analysis has not been clearly formulated, their relationship during this time is difficult to analyze. From the Renaissance through the eighteenth century, the "sister arts," poetry and painting, share a common subject matter; thus, fewer methodological problems are involved in studying their connections.[2] Panofsky's studies of iconography have demonstrated the use that Renaissance painters made of literary sources, and literary scholars such as Jean Hagstrum and Elizabeth Manwaring have pointed out the influence of painting on eighteenth-century poetry. The shift from a mimetic to an expressive theory of art, however, deprives these arts of a common ground in their objects of imitation and thrusts them into a less apparent, more problematic relationship. Indeed, the critical commonplace about the Romantic period—that music replaced painting as the analogue to literature—is itself an indication of the supremacy of expression over imitation. Yet the relationship between what were formerly sister arts persisted, even though it frequently took a different form from that of the preceding centuries. My purposes here are to define this new relationship, to discuss to some extent the theoretical model best equipped to handle it, and, finally, to analyze in some detail the ways it is exemplified in Baudelaire's response to the art of Delacroix.

The sister arts tradition began to dissolve in the middle of the eighteenth century under pressure from various sources. One important pressure was the reassertion of the neoclassical norm of purity of genre that had been violated by the vogue for allegorical painting and pictorial poetry inspired by the theory of the sister arts. Lessing's *Laokoön,* though

2. I do not mean to imply an invariant tradition from the sixteenth through the eighteenth century; the baroque period provides a partial exception to the use of visual content to relate the two art forms. The combination of a religious orientation which conceived of art as a vehicle of transcendent experience and an aesthetic orientation toward fusion and totality produced an art in which pictorialism was not the primary feature or the exclusive link between the arts. Nevertheless, despite the appearance of more generally aesthetic, less narrowly pictorial, similarities between the arts, the bond of subject matter continued to play a more important role than in relationships between the arts in the Romantic period. For a fuller discussion of the continuities and discrepancies between the baroque and the sister arts, see Jean Hagstrum's *The Sister Arts: The Tradition of Literary Pictorialism and English Poetry from Dryden to Gray* (Chicago and London, 1958), pp. 93–128.

influenced by the empiricist interest in perception, also called for a return to certain neoclassical ideals. Lessing's insistence on the importance of the aesthetic sign in determining the subject matter of a form of art finds a modern echo in Wellek and Warren's assertion that "the 'medium' of a work of art . . . is not merely a technical obstacle to be overcome by the artist in order to express his personality, but a factor preformed by tradition and having a powerful determining character which shapes and modifies the approach and expression of the individual artist."[3] Like Lessing, Wellek and Warren are reacting against the failure to appreciate the role of the aesthetic medium. Ultimately, this line of thought leads to a denial of relationships among the arts. Yet Lessing's critique of the sister arts tradition was in turn challenged from a perspective that points forward toward a Romantic conception of the arts rather than backward toward a neoclassical one. Johann Gottfried Herder's response to the *Laokoön* in the first of his *Kritische Wälder* takes issue with Lessing's conception of the external nature of aesthetic signs. Poetry may use successive signs, claimed Herder, but their sequentiality is less important than the energy (*Kraft*) which they contain, an energy which excites us to an emotional state that endures through the passage of words. In a later essay, *Plastik,* Herder expanded this view of energy into his concept of the basic source of art and the force relating all the arts to one another. The arts do not need to be related through their common subject matter nor sharply differentiated through their particular signs; instead, they could be recognized as different expressions of a common source, an idea which would be significant throughout the Romantic era. Herder also proclaimed the highest art to be the one that could express the greatest quantity of energy. For him this art was poetry, which involves both sight and sound, thereby fusing the qualities of painting and music into a composite art that alone is capable of fully expressing the unifying function of energy. This ideal of the composite art as the one best suited to expressing the synthesis performed by imaginative energy was also pervasive throughout the Romantic period.

Herder's belief that poetry and painting are related not through subject or through sign but as expressions of a unifying source that he called energy prefigured the theory that art is the expression of imagination and that the arts could be related through their efforts to portray the synthesizing power of imagination. The change from the empiricist conception of the passive, picturing mind to a belief in the imagination's active force affected the view of poetry and painting as nature's daughters, and fostered a new conception of these arts as the analogous but different products of an imagination that could combine aspects of both in its creation of unity. The ideal of *ut pictura poesis* is rarely voiced in the criticism of the Romantic period; on the contrary, the imitation of

3. René Wellek and Austin Warren, *Theory of Literature* (New York, 1949), p. 128.

painting in poetry serves often as an instance of what is to be avoided.[4] Coleridge and Hazlitt both insist that the poet must evoke an imaginative or emotional response rather than simply depict concrete visual imagery. This attitude reveals the influence of Burke's association of poetry with the emotional sources of the sublime and of painting with the descriptive clarity that creates the beautiful. The conception of painting, however, was also changing to emphasize its imaginative qualities, making possible new similarities between the former sister arts.[5] As the source of art was seen to change from an external to an internal one, the basis of the arts' relationship similarly shifted from the imitation of shared subject matter to the analogous expression of a common inner source whose subject matter changes but whose nature is the same.

Since an important aspect of the imaginative source of Romantic art was its unifying power, the capacity of poetry and painting to unify features of both arts emerged as an important bond between them. The ideal of aesthetic totality recurs in various ways throughout the Romantic period. Coleridge defined beauty as "in the abstract, the unity of the manifold, the coalescence of the diverse" and proclaimed "unity of mul- teity . . . as the principle of beauty."[6] Imagination, for Coleridge, was a "synthetic and magical power" which "reveals itself in the balance or reconciliation of opposite or discordant qualities: of sameness, with dif- ference; of the general, with the concrete; the idea, with the image; the individual, with the representative; the sense of novelty and freshness, with old and familiar objects; a more than usual state of emotion, with

4. Roy Park discusses this and other aspects of the relationship of poetry and painting in Romantic criticism in his valuable article " 'Ut Pictura Poesis': The Nineteenth-Century Aftermath," *The Journal of Aesthetics and Art Criticism* 28, no. 2 (Winter 1969): 155–64, in which he provides a particularly illuminating collection of quotations from the major Romantic critics.

5. A few indications of this change may be found in some of the critics who most influenced Baudelaire's approach to art. Diderot, for example, whose art criticism was undergoing a revival in the 1840s and whose tone and point of view are frequently re- flected in Baudelaire's Salon reviews during that decade, warned painters not to be bound by the external world: "Illuminate objects according to your sun, which is not that of nature; be the disciple of the rainbow, but do not be its slave," he commands in one of his "Pensées détachées," in *Essais sur la peinture*, ed. Roland Desné (Paris, n.d.), 5:139 (my translation). Stendhal, whose influence on Baudelaire was so great that the poet took some key passages of his review of the 1846 Salon directly from the *Histoire de la peinture en Italie*, insisted that art reflects the temperament of the artist and his culture rather than an absolute ideal of beauty. But the most important influence on Baudelaire, of course, was Delacroix's belief that the painter should use nature only as a source of imagery through which he could externalize his own internal states. As Baudelaire explains in his review of the 1846 Salon: "Now this is the principle from which Delacroix sets out—that a picture should first and foremost reproduce the intimate thought of the artist, who dominates the model as the creator dominates his creation" ("The Salon of 1846," in *Art in Paris 1845–1862*, trans. and ed. Jonathan Mayne [New York, 1965], p. 58).

6. Coleridge, "On Poesy or Art," *Biographia Literaria*, ed. J. Shawcross, 2 vols. (Lon- don, 1907), 2:257, 262.

more than usual order . . ."[7] or, one might add, of poetry with painting
(the general with the concrete, the idea with the image). A similar ideal
of totality recurs in Hegel's criterion for the highest art; for Hegel,
tragedy claimed this honor because it synthesized the objectivity of epic
with the subjectivity of lyric and the physicality of action with the ideality
of language. Hazlitt suggested an analogous ideal for painting both in
his praise of "gusto," the quality which arises "where the impression
made on one sense excites by affinity those of another,"[8] and in his
criticism of Claude—one of the most highly revered artists in the
eighteenth century—for emphasizing purely visual impressions and fail-
ing to evoke the other senses through his art. For his part, Baudelaire
insisted that fusing features of the different arts was an aesthetic
hallmark of his period: "It is, moreover, one of the characteristic
symptoms of the spiritual condition of our age that the arts aspire if not
to take one another's place, at least reciprocally to lend one another new
powers."[9] The culmination of this ideal of imaginative totality was at-
tained in Wagner's actual fusion of a number of different arts in his
version of the perfect art, the *Gesamtkunstwerk.* But the ideal of aesthetic
synthesis recurs in definitions of beauty throughout this period, as in
Delacroix's claim that "the beautiful implies the reunion of several qual-
ities . . . in a word, harmony would be the broadest expression of it."[10]
This desire for the integration of different qualities governed the re-
lationship of poetry and painting for Romantic artists and critics. Instead
of imitating one another, poetry and painting absorbed some of each
other's features into their own media to attain the harmony of dif-
ferences essential to beauty.[11]

Baudelaire's response to Delacroix's art and theories provides a par-
ticularly fruitful focus for a study of the new rapport between the
former sister arts. There is little similarity between Delacroix's action-
filled exotic subjects and Baudelaire's more intimate and private poetry;
their arts must therefore be related in some domain apart from content.
We are aided in deciphering this domain by Baudelaire's extensive

7. "Chapter 14," *Biographia Literaria,* 2:12.
8. "On Gusto," *The Complete Works of William Hazlitt,* ed. P. P. Howe, 21 vols. (London, 1930), 4:78.
9. "The Life and Work of Eugène Delacroix," *The Painter of Modern Life and Other Essays,* trans. and ed. Jonathan Mayne (New York, 1964), p. 43. Other references to this essay, to "Richard Wagner and *Tannhäuser* in Paris," and to "Philosophic Art," all included in this volume, will be noted by page numbers within the text.
10. *Journal de Eugène Delacroix,* ed. Jean-Louis Vaudoyer and André Joubin, 2 vols. (Paris, 1932), 2:142. Since this passage is not included in any of the English translations of the *Journal,* I have provided the translation.
11. I am not suggesting that there was a uniform relationship of poetry and painting in the Romantic period. Relationships of content did persist: the similar subjects of Con-stable and Wordsworth or of Baudelaire's prose poems and Constantin Guys' drawings are simply two examples that come to mind. Rather, I am focusing on what changed in this relationship and how this change reflects a new attitude toward art.

commentary on Delacroix. Moreover, perhaps because of its subtlety, the relationship between these arts has not received the attention it deserves.[12] Yet no sooner is the possibility for such a study recognized than the problems it entails become apparent. Without the focus of common subjects, where does one begin? The dangers of impressionistic comparisons of style are readily apparent in the tendency of *Geistesgeschichte* studies to transfer stylistic terms from one art form to another, creating such bizarre transpositions as "the visible chamber music of the bent furniture" or the "Titian style of the madrigal" in Spengler's *Decline of the West* or Wylie Sypher's suggestion that a Shakespearean play is like a Renaissance painting because it makes use of "perspective" to create a real and believable world.[13] And indeed it would be misleading to look for particular stylistic similarities between Delacroix and Baudelaire. Delacroix's dissolution of solid color masses into separate strokes of different colors, for example, would appear to be closer to Rimbaud's disjointed language than to Baudelaire's carefully interwoven sentences. Only by viewing the two art forms as interconnected systems can we determine their relationship. If the new affiliation of poetry and painting in the Romantic period derives from the expression of imaginative unity, a critical approach to their relationship must be attuned to different ways of expressing unity. The theoretical framework that accounts most completely for the kind of relationship existing between Delacroix and Baudelaire is provided by the structuralists, although, as we shall see, even this approach has limitations.

Structuralist claims that human creations are related as expressions of certain mental processes have affinities with the Romantic theory that the arts are related as expressions of imagination. According to Lévi-Strauss, for example, the products of the human mind are homologues,

12. There are several studies of Baudelaire's aesthetics and criticism, such as André Ferran's *L'Esthétique de Baudelaire* (Paris, 1968), Margaret Gilman's *Baudelaire the Critic* (New York, 1943), and Jean Prévost's *Baudelaire: essai sur l'inspiration et la création poétiques* (Paris, 1953), which contain sections on the influence of Delacroix but do not extend their analysis into Baudelaire's poetry as a whole. More specific works, such as Lucie Horner's *Baudelaire critique de Delacroix* (Geneva, 1956) and Pierre-George Castex's *Baudelaire critique d'art* (Paris, n.d.), also focus on Delacroix's influence on Baudelaire's criticism and on particular poems inspired by his paintings. The full-length book by Armand Moss, *Baudelaire et Delacroix* (Paris, 1973), provides a detailed study of their relationship based on their correspondence and references to one another, but no analysis of the relation between their two art forms. Some studies of Baudelaire's poetry, such as Lloyd James Austin's *L'Univers poétique de Baudelaire: symbolisme et symbolique* (Paris, 1956) and Martin Turnell's *Baudelaire: A Study of His Poetry* (London, 1953), point out aspects of Baudelaire's poems that appear relevant to the relationship with Delacroix, but they do not make these connections themselves. Most commentary on the relationship of Delacroix to Baudelaire's poetry is limited to those few poems that Baudelaire wrote on Delacroix's paintings.

13. Wellek and Warren quote the comments on Spengler in *Theory of Literature*, p. 131. Sypher's comments are in *Four Stages of Renaissance Style: Transformations in Art and Literature 1400–1700* (Garden City, N.Y., 1955), pp. 79–80.

related by their function rather than their content. For both structuralists and Romantics, the relationships between systems depend neither on content nor material but on the patterns of relationships within the different forms. Saussure's approach to language provides the model for the structuralist method: the linguistic sign consists of both a signifier and a signified whose conventional relationship can be dissolved to analyze the system of relationships among the signifiers. Any signifying system can be similarly analyzed regardless of the nature or meaning of its signs. The ways in which the constituent units are combined are important, not the units themselves. Saussure provides an alternative to Lessing's distinction by focusing attention on the structural rules that define a system instead of on our manner of perceiving different kinds of signs. This concern with structure allows a conception of homology to replace that of similarity and points the way toward formulating the relationship between arts affiliated by modes of functioning despite dissimilarities between their subjects and their signs.

There is a significant connection between structuralist analysis and Baudelaire's and Delacroix's conceptions of artistic activity. According to Roland Barthes: "The goal of all structuralist activity, whether reflexive or poetic, is to reconstruct an 'object' in such a way as to manifest thereby the rules of functioning (the 'functions') of this object. Structure is therefore actually a *simulacrum* of the object, but a directed, *interested* simulacrum, since the imitated object makes something appear which remained invisible or, if one prefers, unintelligible in the natural object. Structural man takes the real, decomposes it, then recomposes it. . . ."[14] As Barthes' definition suggests, "structuralist activity" can incorporate both critical and creative activity because the fundamental process of decomposing reality and recomposing it occurs in art as well as criticism. Baudelaire in particular invokes a similar model of artistic creation. Note how close his concept of imagination is to Barthes' definition of structuralist activity: "It [imagination] is both analysis and synthesis. . . . In the beginning of the world it created analogy and metaphor. It decomposes all creation, and with the raw materials accumulated and disposed in accordance with rules whose origins one cannot find save in the furthest depths of the soul, it creates a new world."[15] Baudelaire found a similar view of artistic creation in Delacroix. As Baudelaire puts it: "Nature, for Eugène Delacroix, is a vast dictionary whose leaves he turns and consults with a sure and searching eye" ("The Salon of 1846," pp. 58–59). Delacroix recomposes the images of this dictionary in his creation of a work of art. Barthes suggests that surrealism may have been the first "structural literature," but he seems to have overlooked the reconstructive nature of Romantic

14. "The Structuralist Activity," in *European Literary Theory and Practice,* ed. Vernon W. Gras (New York, 1973), p. 158.

15. Baudelaire, "The Salon of 1859," in *Art in Paris 1845–1862,* p. 156. Other references to Baudelaire's Salon reviews will be to this edition and will be noted by page numbers within the text.

art, expressed succinctly if not uniquely in Coleridge's description of the secondary (artistic) imagination as the power which "dissolves, diffuses, dissipates in order to re-create." The Romantic assertion of the primacy of imagination over the materials it orders, whether these are understood as the signs or their referents, finds an echo in the structuralist concern with the mind's ordering processes regardless of material. The change in aesthetic emphasis from content to structure is analogous to the change in critical interest from the meanings suggested by signs to the patterns of the signs themselves. As the study of iconography is appropriate to the relationship between two arts in which content is primary, and the emphasis on different signs is appropriate to arts in which the nature of the sign is considered to be primary, the study of relationships among the signs themselves is appropriate to arts in which the power of imagination is held the primary feature.

Though structuralism provides a theoretical model for discussing the relationship of Baudelaire and Delacroix, it unfortunately does not provide a precise methodology for this analysis. Structuralist analysis has in general been less successful in relation to poetry than to fiction, where the process of creating a world through signs is particularly amenable to the study of signifying systems. Moreover, the dichotomy between the interest in literature as a system, what Barthes calls the "science of literature," and the analysis of individual works, which Barthes designates by the traditional term "criticism," makes it difficult to translate general structuralist theory into practical criticism. The concern with the conventions of writing and reading that constitutes the science of literature involves a level of abstraction quite detached from specific texts, while structuralist criticism, unless it relies heavily on the linguistic model that tends to reduce poetry to bare grammatical and phonetic patterns, may be difficult to differentiate from more familiar analyses of individual texts.[16] Structuralist criticism has been most successful in studying re-

16. The most distinctive form of structuralist criticism of poetry makes use of linguistic categories to analyze the literary text. Some of the best-known examples of this method are Jakobson's analyses, including his analysis of poems by Baudelaire. Jakobson's method, however, fails to account for much of poetry's effect. He assumes that grammatical and phonetic patterns are the primary feature of any poem and he derives his interpretations exclusively from these patterns, disregarding the interplay of meaning with grammatical form. Jakobson's success is also his failure. By analyzing only patterns of linguistic signs divorced from what they signify, he demonstrates a pure form of structuralist analysis while indicating the emptiness of this pure form; he fails to tell us much that is significant about the poem. The limitations of this approach have been analyzed quite fully by Jonathan Culler in *Structuralist Poetics: Structuralism, Linguistics, and the Study of Literature* (Ithaca, N.Y., 1975). Michael Riffaterre also provides a cogent critique of Jakobson's and Lévi-Strauss' analysis of Baudelaire's poem "Les Chats" in "Describing Poetic Structures: Two Approaches to Baudelaire's 'Les Chats,' " in *Structuralism*, ed. Jacques Ehrmann (Garden City, N.Y., 1970), pp. 188–230. Structuralist criticism of poetry is thus in a strange dilemma: having defined a specific perspective on literary study, it appears to succeed in its efforts only when it compromises this perspective by allowing some of the outlawed significance back into consideration.

lationships within a writer's work, subordinating meaning to the process of defining the relationships that prevail beyond the meanings of the individual terms, an enterprise admittedly not fundamentally different from that of other criticism, yet still somewhat distinctive in its emphasis on the nature of relationships among the different parts instead of on the nature of the specific parts themselves. This orientation suggests an approach to defining the similarities between Delacroix's paintings and Baudelaire's poems: we can characterize the relationships that prevail within each artist's work and see what similarities exist between their governing patterns. Delacroix's writings on art and Baudelaire's writings on Delacroix provide a convenient link between the two art forms.

Delacroix's view of art is particularly congenial to a structuralist perspective. Delacroix himself conceived of painting as a unified network of signs that expresses a state of mind primarily through relationships rather than through the referential value of the signs. In his *Journal,* Delacroix comments repeatedly that painting is superior to poetry because it is more concrete and indirect, resisting the immediate translation of sign to meaning that occurs in verbal art. Good painting, Delacroix claims, is not reducible to statement; rather, it expresses and evokes a state of mind indirectly through the interplay of all its parts. Thus he asserts:

> I confess my predilection for the silent arts, for those mute things of which Poussin made profession, as he said. Words are indiscreet; they break in on your tranquillity, solicit your attention and arouse discussion. . . .
> The work of the painter and the sculptor is all of a piece like the works of nature. The author is not present in it, and is not in communication with you like the writer or the orator. He offers what might be called a tangible reality, which is, however, full of mystery. . . . This mute charm operates with the same force and seems to grow, every time that your eyes fall on the work.[17]

Rather than speaking through his signs as the writer does, the painter makes signs interact with each other in an interrelated whole that becomes an expressive object rather than a referential statement.

Delacroix's conception of painting is fundamentally different from the conception presented by Lessing. While Lessing assumes that the painter uses "natural" signs to represent discrete objects, Delacroix suggests that the painter creates a work of art whose signs respond to one another as much as they represent things. Delacroix even objects to the overt use of gestures to portray emotion in painting. At one point in his *Journal* he distinguishes between "poetic" painting, which communi-

17. "September 23, 1854," *The Journal of Eugène Delacroix,* trans. Walter Pach (New York, 1948), p. 437. All further references to the *Journal* will be noted by page numbers within the text.

cates through the interrelationships of all its parts, and "prosaic" painting, limited to the direct "statement" of a figure's gestures and lacking overall unity. In poetic painting, Delacroix's ideal, expression is spread throughout the total form, not isolated in any one portion in which it is set forth directly.

In his own paintings Delacroix attempted to achieve his ideal of indirect expressiveness through his methods of relating colors on the canvas. This was the aspect of his painting to which Baudelaire responded most enthusiastically. In his review of the Universal Exposition of 1855, Baudelaire points out that Delacroix achieves his expressive effect independently of the figures represented:

> First of all it is to be noted—and this is very important—that even at a distance too great for the spectator to be able to analyze or even to comprehend its subject-matter, a picture by Delacroix will already have produced a rich, joyful or melancholy impression upon the soul. It almost seems as though this kind of painting, like a magician or a hypnotist, can project its thought at a distance. This curious phenomenon results from the colourist's special power, from the perfect concord of his tones and from the harmony, which is pre-established in the painter's brain, between colour and subject-matter. . . . It seems to me that M. Delacroix's colour *thinks for itself*, independently of the objects which it clothes. Further, these wonderful *chords* of colour often give one ideas of melody and harmony, and the impression that one takes away from his pictures is often, as it were, a musical one. ["The Exposition Universelle 1855," p. 141]

According to Baudelaire, Delacroix's paintings work through evocation rather than representation and are analogous to music in their ability to be expressive independently of reference to the external world.

Baudelaire was the first art critic to appreciate and explain Delacroix's ideals and methods. Throughout his salon reviews, Baudelaire stresses Delacroix's unprecedented achievement in harmonizing color. Delacroix was such a successful colorist, Baudelaire explains, because he realized that color in the natural world consists not of isolated color blocks, but of the interaction of different shades and tones which affect one another such that "nature seems like a spinning-top which revolves so rapidly that it appears grey, although it embraces within itself the whole gamut of colours."

> The sap rises, and as the principles mix, there is a flowering of *mixed tones;* trees, rocks and granite boulders gaze at themselves in the water and cast their *reflections* upon them; each transparent object picks up light and colour as it passes from nearby or afar. . . . Some colours cast back their reflections upon one another, and by modifying their own qualities with a *glaze* of transparent, borrowed

qualities, they combine and recombine in an infinite series of melodious marriages which are thus made more easy for them. . . . This great symphony of today, which is an eternal variation of the symphony of yesterday, this succession of melodies whose variety ever issues from the infinite, this complex hymn is called *colour*. ["The Salon of 1846," pp. 48–49]

Delacroix managed to recreate this intensity and harmony, Baudelaire explains, not simply by using bright colors, which would only clash, but by breaking up masses of color into separate brush strokes of different tones which fuse in the spectator's eye, creating a more luminous impression than that of uniform color blocks. At the same time Delacroix realized that complementary colors, which cancel each other out when mixed upon the palette, both harmonize and intensify their impact when juxtaposed upon the canvas. Since a color's complement could be used for shadows in the place of black or gray, there are no holes caused by shadows or impure tones in Delacroix's paintings. Instead, the pure tones of the entire canvas fuse in a luminous whole rather than falling into separate areas with little relation to each other, thus creating an impression of harmonious overall color.

Delacroix's color relationships animate his paintings with a sense of life and motion as well as harmony. In his first salon review, Baudelaire explains that there are different types of drawing; that of Raphael and Ingres captures the form of details with precision, while that of a colorist like Delacroix or Rubens portrays the imperceptible movements of nature and emotion through the fluidity and lightness of their lines. Delacroix's three major preoccupations, Baudelaire claims, are movement, color, and atmosphere. He continues:

These three elements necessarily demand a somewhat undecided contour, light and floating lines, and boldness of touch. Delacroix is the only artist today whose originality has not been invaded by the tyrannical system of straight lines; his figures are always restless and his draperies fluttering. From Delacroix's point of view the line does not exist; for, however tenuous it may be, a teasing geometrician may always suppose it thick enough to contain a thousand others: and for colourists, who seek to imitate the eternal throbbings of nature, lines are never anything else but the intimate fusion of two colours, as in the rainbow. ["The Salon of 1846," p. 59]

Delacroix's use of color prevents lines from imprisoning forms in fixed or static patterns, dissolving boundaries into the pervasive harmony of colors.

Delacroix's paintings are dynamic; their curving, fluid lines and colors echo and pursue each other in perpetual interaction. They are not, however, formless. One of Delacroix's supreme virtues, in

Baudelaire's opinion, was that he could balance animated movement with order and form. Delacroix believed that control was essential to the artist, and Baudelaire admired the painter's emphasis on technique, describing Delacroix as "passionately in love with passion, and coldly determined to seek the means of expressing it in the most visible way" ("The Life and Work of Eugène Delacroix," p. 45). The controlled expression of passion, the containment of movement within form, became the aesthetic ideal that Delacroix's paintings represented. Because painting is inherently a spatial, nonprogressive art, Delacroix's emphasis on movement counteracted what is static in the nature of the art itself. A number of his *Journal* entries suggest that Delacroix associated movement with the temporal art of literature: "I believe that the difference between the arts of design and the others derives from the fact that the latter develop the idea only by offering impressions *one after the other,*" he claimed in his *Journal* entry of 4 April 1854 (p. 372), and on 11 December 1855, he asserted that the perfection of the visual arts "resides in producing a simultaneous effect" and disparaged literature as "merely a sequence of successive pictures" (p. 501). By infusing movement into the static form of painting, Delacroix assimilated some of literature's temporal development into what he felt was painting's superior simultaneity.

This at least was how Baudelaire saw it. In his frequent comparisons of Delacroix and Ingres, Baudelaire criticizes Ingres' attempt to represent an ideal timeless moment abstracted from life and frozen into perfect form. Delacroix, he explains, incorporates life's movement into the timeless form and thus achieves a synthesis of poetry and painting. Although Baudelaire uses the terms "poetry" and "painting" somewhat loosely in his writings, he consistently associates poetry's sequential sounds with the world of time, process, and emotion, and painting's simultaneous forms with a timeless, completed vision. In his review of the 1846 Salon, Baudelaire asserts that Victor Hugo has become a "painter in poetry," portraying a completed image of the forms of things, whereas Delacroix is a "poet in painting" who "throws open immense vistas to the most adventurous imaginations" (pp. 56–57). There is no doubt that for Baudelaire the ideal in either art was to externalize the movements of emotion associated with poetry in the timeless and fully realized images characteristic of painting; Hugo's subordination of feeling to description was to Baudelaire a serious aesthetic error. Delacroix was the true poet-painter because he could give form to emotion and "translate the *word* by means of plastic images more vivid and more appropriate than those of any other creative artist of the same profession" ("The Life and Work of Eugène Delacroix," p. 42).

In his art criticism, Baudelaire articulates the aesthetic ideal of the indirectly expressive whole realized through the harmonious relationship of parts and synthesizing qualities of poetry and painting. This ideal, to which he grants his full allegiance, he finds embodied in

the art of Delacroix. The question then becomes to what extent Baudelaire's own poetry expresses this ideal and what transformations are incurred by the change in media. This is a complicated question because Baudelaire insisted on the special characteristics of each art form's medium and denounced attempts to imitate one art form in another. In his essay on "Philosophic Art" he asks: "Is it by some fatal consequence of decadence that today each art should evince a desire to trespass on the next, so that we have the spectacle of musical scales being introduced into painting, colour into sculpture, plastic devices into literature?" (p. 204), and in his review of the 1846 Salon he asserts that "experiment with contradictory means, the encroachment of one art upon another" are "modern miseries" (p. 97). To avoid these miseries, the artist must not imitate the signs of other arts but must find some analogy within the form of his own art. Poetry and painting are separate media and must use their own techniques. Baudelaire knew, for example, that words that refer to colors are not the same as pigments on a canvas. Unlike the overall harmony of color attained by Delacroix's brushstrokes, color words like red, yellow, and green remain much more distinct and localized; they designate precise areas bounded by the nouns they modify. To analyze the relationship between Baudelaire's poetry and his perception of Delacroix's paintings, then, we must remember that Baudelaire would never imitate the painter's art directly. The relationship between his poems and Delacroix's paintings derives neither from their subjects nor the actual patterns of their signs, but from their common emphasis on establishing interrelationships achieved in the different ways dictated by their different signs.

To come to an understanding of Baudelaire's methods of creating harmony, we must look both at techniques that recur throughout the poetry and at an example of these techniques within a particular poem. In *Les Fleurs du Mal,* Baudelaire uses recurrent images to suggest a harmonious atmosphere similar to that which he admired in Delacroix. Various critics have pointed out that Baudelaire uses color words rarely, and one critic concludes that his poetry is thus closer to the etcher's than the painter's art, but this position assumes that one art must replicate another's techniques in order to achieve analogous effects. Rather than literally adapting painterly techniques, Baudelaire chooses images that evoke a harmonious atmosphere. One striking aspect of Baudelaire's poetry is the frequency with which he uses imagery of sunshine (one critic has calculated that Baudelaire uses the word "soleil" sixty-three times in *Les Fleurs du Mal,* making it fifth in order of frequency),[18] especially of sunshine diffused at sunset or through mist in such a way that it dissolves a scene into a flow of refracted light. In "La Vie an-

18. Marc Eigeldinger, "La Symbolique solaire dans la poésie de Baudelaire," *Revue d'histoire littéraire de la France* 67, no. 2 (avril–juin 1967): 358.

térieure," for example, the poet's vision of his past is bathed in the swirling colors of the sunset. The "mille feux" of the "soleils marins," diffused by the mingling of water and fire and by the plural suns, are seen only indirectly as they paint the pillars of the porch and as they are reflected in the rolling waves which blend their music with the colors. Without a single color word except "azur," Baudelaire creates a sense of color which expands beyond specific things to fuse in a luminous harmony embodying his mood. Similarly, "Harmonie du soir" takes place in "les temps" between the clarity of day and "le néant vaste et noir," a twilight time in which things lose concreteness and evaporate like the flowers or dissolve like the setting sun into a dance of color, sound, and perfume. With no detailed description and no color words (except "noir"—the color which Delacroix became known for deliberately avoiding), Baudelaire creates the crepuscular effect he so admired in Delacroix. A similar atmosphere dominates "Le Balcon," in which the setting sun suffuses the evening with the "vapeurs roses" which veil the scene on the balcony. Sometimes, particularly in his addresses to Marie Daubrun, Baudelaire uses mist instead of sunset to diffuse the light of the sun: "Comme tu resplendis, paysage mouillé / Qu'enflamment les rayons tombant d'un ciel brouillé!" Direct light can also be diffused by reflections. The summer sun the poet craves in "Chant d'automne" is no isolated globe of fire but a shimmering light upon the sea. The vision of "La Chevelure" is full of bright sunlight, but here again it glistens on the water's gold and silk. Whatever its nature, light is absorbed by the scene to become part of its life, distributed throughout, merging even with darkness, as in the "Noir et pourtant lumineuse" spectre of "Un Fantôme." The only type of light imagery that Baudelaire avoids, or uses only to suggest the fixity of despair, is the direct sunshine that clarifies objects and defines their boundaries.

The dissimilarities between Baudelaire's use of light and Delacroix's use of color are a function of the differences between words and paint. Yet what is striking about these two art forms is that while the actual patterns of relations within each art differ, the effect they achieve is similar: both manage to create a harmonious atmosphere. Other aspects of Baudelaire's language contribute to a harmonious relationship of parts comparable in various respects to the effect of Delacroix's art. Baudelaire uses his syntax to counteract the temporal flow of language and to reinforce our sense of a composite image. Martin Turnell points out that Baudelaire's long sentences that wind through whole stanzas and at times entire poems help bind the different elements together in what T. S. Eliot calls "a whole of tangled feelings."[19] Moreover, Turnell suggests, Baudelaire's technique of separating subject and object by subordinate clauses encourages the impression of a unified image.

19. Turnell, *Baudelaire: A Study of His Poetry*, p. 260.

Baudelaire also frequently uses periodic syntax, which prevents the reader from forming a sequential image and creates instead a feeling of suspension until the picture takes form as a whole. It would appear at first that Baudelaire's attempts to counteract the temporal unwinding of his poetry is contrary to Delacroix's concern with movement in his paintings, yet here again the differences in media explain the different emphases. Both artists are attempting to synthesize movement with form, but this synthesis must be achieved in poetry by working to subsume sequential language to a single vision and in painting by enlivening the spatial form with movement. The two arts are alike as wholes and not in their individual features. Despite the stylistic differences between Baudelaire's deliberately constructed sentence patterns and Delacroix's deliberately fragmented color blocks, the functions of these different methods are the same in both the arts: to balance form and movement in an interrelated whole.

The famed sonorities of Baudelaire's poetry are the most direct analogy to Delacroix's color harmonies, which Baudelaire frequently describes in terms of sound. As Delacroix fuses colors to create a unified atmosphere, Baudelaire repeats certain sounds to sustain a particular tone. In addition to his emphasis on alliteration, Baudelaire's adherence to regular and intricate rhyme schemes reinforces the insistence on particular sounds. The aural harmony created by the intricate end rhymes is also intensified frequently by internal rhymes. Like his construction of syntax, Baudelaire's emphasis on aural harmony works against the linear progression of his verse by establishing a constant pattern of repeated sounds. To assert an analogy between this pattern of sound and Delacroix's color harmony is consistent with Baudelaire's own belief in correspondences among the different senses. Baudelaire argues in his essay on "Richard Wagner and *Tannhäuser* in Paris" that "what would be truly surprising would be to find that sound *could not* suggest colour, that colours *could not* evoke the idea of a melody, and that sound and colour were *unsuitable* for the translation of ideas, seeing that things have always found their expression through a system of reciprocal analogy ever since the day when God uttered the world like a complex and indivisible statement" (p. 116). Baudelaire's assertions in this passage account not only for the ability of one sense to evoke another but also for the nature of relationships among the arts. If the world is like a "complex and indivisible statement" ("une complexe et indivisible totalité") which finds new expression through interconnected systems, the relationship among the different systems of expression derives not from isolated similarities but from analogous organizing principles.

A look at Baudelaire's procedures in a particular poem demonstrates more concretely how these relationships work. Since Baudelaire's poems about actual paintings by Delacroix are among neither his best nor his most characteristic works, I have chosen instead to analyze "L'In-

vitation au voyage." Although this poem, as we shall see, makes deliberate use of painting, it has no direct relationship to any works of Delacroix. It does, however, reveal characteristic aspects of Baudelaire's style which here transform the imagery suggestive of Dutch painting into a vision more like Delacroix's than Vermeer's:

> Mon enfant, ma soeur,
> Songe à la douceur
> D'aller là-bas vivre ensemble!
> Aimer à loisir,
> Aimer et mourir
> Au pays qui te ressemble!
> Les soleils mouillés
> De ces ciels brouillés
> Pour mon esprit ont les charmes
> Si mystérieux
> De tes traîtres yeux,
> Brillant à travers leurs larmes.
>
> Là, tout n'est qu'ordre et beauté,
> Luxe, calme et volupté.
>
> Des meubles luisants,
> Polis par les ans,
> Décoreraient notre chambre;
> Les plus rares fleurs
> Mêlant leurs odeurs
> Aux vagues senteurs de l'ambre,
> Les riches plafonds,
> Les miroirs profonds,
> La splendeur orientale,
> Tout y parlerait
> A l'âme en secret
> Sa douce langue natale.
>
> Là, tout n'est qu'ordre et beauté,
> Luxe, calme et volupté.
>
> Vois sur ces canaux
> Dormir ces vaisseaux
> Dont l'humeur est vagabonde;
> C'est pour assouvir
> Ton moindre désir
> Qu'ils viennent du bout du monde.
> —Les soleils couchants
> Revêtent les champs,
> Les canaux, la ville entière,
> D'hyacinthe et d'or;
> Le monde s'endort
> Dans une chaude lumière.

Là, tout n'est qu'ordre et beauté,
Luxe, calme et volupté.[20]

Jean-Bertrand Barrère suggests that possible sources for the vision
of Holland in the poem include Gautier's *Albertus* and interiors by
seventeenth-century Dutch painters.[21] A glance at these sources, how-
ever, reveals the extent to which Baudelaire has transformed them if he
has used them at all. Whereas Gautier describes a Flemish town in some
detail in *Albertus*, Baudelaire suggests only the vaguest visual details and
floods them with emotional significance. Instead of the minute specificity
of a Dutch interior, Baudelaire creates a general sense of richness and
harmony. Despite its subject matter, the poem is consistent with Cole-
ridge's request that contemporary poets avoid the detailed copying of
objects that he believed was characteristic of Dutch painting. Baudelaire
uses the imagery of seventeenth-century Dutch painting as a vehicle for
evoking a world of harmony and light analogous in all but subject to the
world of Delacroix's painting.

In "L'Invitation au voyage" the speaker invites a woman to imag-
ine living with him in a dreamland of harmony and luxury which is the
embodiment of her spirit. The poem is structured as three consecutive
pictures which embody with increasing fullness the qualities presented
more abstractly in the refrain. By constructing a vision through succes-
sive realizations of the essence of that vision, Baudelaire complies with
his own theory of the ideal method of painting. In his review of the 1859
Salon he explains:

> A good picture, which is a faithful equivalent of the dream
> which has begotten it, should be brought into being like a world.
> Just as the creation, as we see it, is the result of several creations in
> which the preceding ones are always completed by the following, so
> a harmoniously-conducted picture consists of a series of pictures
> superimposed on one another, each new layer conferring greater

20. "My child, my sister, think of the rapture of going over there and living together!
Of loving at leisure, of loving and dying in the country which resembles you! The moist
suns of these murky skies have, for my spirit, the charms so mysterious of your treacherous
eyes, shining through their tears. There, all is order and beauty, luxury, calm and voluptu-
ousness. Gleaming furniture, polished by the years, would ornament our bedroom; the
rarest flowers mingling their fragrance with the faint scent of amber, the ornate ceilings,
the deep mirrors, the oriental splendor, all there would speak secretly to the soul its soft,
native language. There, all is order and beauty, luxury, calm and voluptuousness. See on
the canals those vessels sleeping; their mood is adventurous; it is to satisfy your slightest
desire that they come from the other end of the earth. The setting suns adorn the fields,
the canals, the entire city, with hyacinth and gold; the world falls asleep in a warm glowing
light. There, all is order and beauty, calm and voluptuousness" (prose translation in
French Poetry from Baudelaire to the Present, ed. Elaine Marks [New York, 1962], pp. 50–51).
21. Jean-Bertrand Barrère, "Chemins, échoes et images dans 'L'Invitation au voyage'
de Baudelaire," *Revue de littérature comparée* 31, no. 4 (décembre 1957): 481–90.

reality upon the dream, and raising it by one degree towards perfection. On the other hand I remember having seen in the studios of Paul Delaroche and Horace Vernet huge pictures, not sketched but actually begun—that is to say, with certain passages completely finished, while others were only indicated with a black or a white outline. You might compare this kind of work to a piece of purely manual labour—so much space to be covered in a given time—or to a long road divided into a great number of stages. As soon as each stage is reached, it is finished with, and when the whole road has been run, the artist is delivered of his picture. [P. 161]

Delacroix of course provides Baudelaire with his example of an artist who conceives of the creation of a painting as the creation of a complete world, unified at every stage of development, and Delacroix's *Journal* entry of 25 January 1857 suggests a similar idea: "The first outlines through which an able master indicates his thought contain the germ of everything significant that the work will offer. . . . For intelligent eyes, the life of the work is already to be seen everywhere . . . it has scarcely opened to the light, and already it is complete" (p. 551). Most important to both artists is the relationship among the parts at each stage of creation, a relationship essential to the unity of the final work. In "L'Invitation au voyage" Baudelaire brings his vision into being "like a world," unified at each stage of its gradual realization. Each of the poem's three stanzas, separated by the refrain that serves almost as a constant picture frame within which the scenes change, presents a unified image of the poet's dreamworld as it comes slowly into focus. Unlike the sketches of a painting, these scenes do not portray identical content, yet they all possess qualities of richness, harmony, and light, expressed more completely in each successive stanza.

The scene of the first stanza remains quite vague, sketching in primarily the quality of misty light that fills the woman's eyes and permeates the dreamland that expresses her being. This world remains a dream here, brought into being by the command of the poet: "Songe." The quality of indefiniteness is suggested from the beginning by the poet's opening address to "Mon enfant, ma soeur." The woman is not important here as a definite character but as a mélange of qualities that evoke the poet's tenderness and become the substance of his revery. The imprecise language of the next two lines—"Songe à la douceur / D'aller là-bas vivre ensemble"—suggests that the emotional quality of this dreamworld is more important than its actual appearance. Time in this world is also undefined, characterized by the infinitive form of the life-encompassing verbs: "Aimer et mourir." These basic rhythms of life will take place in a nameless country defined only by its resemblance to the woman that is loved. This resemblance is manifested not in precise description but in the diffuse quality of light, made yet more pervasive by the use of the plural in "Les soleils mouillés / De ces ciels brouillés," which

permeates the landscape and glistens like the woman's tear-filled eyes. By evoking a vision of a world whose only concrete quality is that of misty sunshine, Baudelaire suggests an atmosphere that permeates and harmonizes the entire vision, achieving the same effect that Delacroix attains by using strokes of different colors that fuse in the spectator's eye.

The fluidity of the poet's vision remains an important quality in the second stanza, yet this stanza defines the vision more concretely through the image of a richly furnished room and the change in mood from the impersonal infinitive to the conditional. The furniture in this room, however, is used to suggest pervasive qualities rather than to focus our perception on specific things. The stanza begins with the indefinite and plural pronoun "Des," which introduces the undefined pieces of furniture that are described only in terms of their glow. All the objects in this room are presented in the plural, a technique which Baudelaire frequently uses to drain objects of their particularity and diffuse their outlines. The plural ceilings in particular diffuse the image of the room while maintaining its suggestion of a basic principle of order. Baudelaire uses another of his common techniques—the combination of a general adjective with a concrete noun or a concrete adjective with a general noun—to emphasize the atmosphere that pervades this imagined room. He describes the flowers as simply "Les plus rares"; the superlative adjective, given extra weight by its position before the noun, suggests not specific attributes but a general exotic beauty. The adjective "riches" in "Les riches plafonds" suggests an image of deeply glowing wood without defining its specific size or shape. The use of "profonds" in "Les miroirs profonds" describes not the mirrors but the added dimension they give the room by expanding its limits in their receding reflections while maintaining its order. The outlines of particular things dissolve into an atmosphere pervaded by their richness and their glow. Specific details are subordinated to other senses and more pervasive qualities that blend in a general harmony. The smells of the flowers mingle with the glow of amber perceived synesthetically as "vagues senteurs." The presence of the mirrors tends to dissolve things into a pattern of reflections. In a subtle transition from concrete nouns and general adjectives to a general noun and more specific adjective, Baudelaire summarizes the room's atmosphere as "La splendeur orientale," making this splendor tangible as the harmony of rich colors associated with an Oriental rug yet more diffuse than any object. Finally, the physical room disappears into the "langue natale" that it speaks, the sweet native language of the soul. In addition to dissolving the concrete objects into a spiritual communication, this concluding reference to language mingles sound with sight and smell and makes the harmony of sound created by the rhyme scheme an explicit aspect of the poem's relationships. These relationships of lights, smells, and sounds that expand beyond specific things to blend in a

general harmony suggest the analogy to Delacroix's use of color to evade the boundaries of objects and create a harmony evocative of music.

In the third stanza the dream image is fully realized: the conditional mood gives way to the present, the command "Songe" becomes "Vois," the indefinite "Des" is replaced by the precise "ces." The diffuse light suggested in the first stanza now permeates the fields, canals, and whole city of this final scene; the confines of the room in stanza two have been dissolved into the image of a world. Despite the change in setting the sense of harmony remains and is in fact intensified by the imagery of light. The boats sleeping on the canals suggest an animate repose that contains the potential of movement ("Dont l'humeur est vagabonde") and keeps the scene from becoming static. At the same time the setting suns clothe the whole world in the warm blue and golden light which becomes the substance of the scene. The fields and canals, unmodified and plural, become faint outlines sketched against a luminous background which suffuses all of them and holds them together. The hyacinth and golden colors are general, pervasive, and not attached to specific things. At last the whole world sleeps within this warm and harmonizing atmosphere, exchanging its materiality for the radiance of light. Although the setting resembles that of seventeenth-century Dutch painting, the light that suffuses and transforms the scene endows it with the harmony that Baudelaire admired in the art of Delacroix.

The effects for which Baudelaire strives in "L'Invitation au voyage" in no way entail the deliberate intention to imitate Delacroix; they merely suggest that Baudelaire uses language to achieve a kind of harmony analogous to that which he admired in Delacroix. Another similarity between Baudelaire's poem and Delacroix's art lies in their synthesis of movement with form, the synthesis the poet felt made Delacroix a "poet-painter" and the most complete artist of his time. For Delacroix this synthesis entailed an emphasis on movement to animate the inherently static nature of his art. For a poet, however, an analogous synthesis demands the suggestion of a form that incorporates the movement of the poem. In "L'Invitation au voyage" Baudelaire suggests this form through his use of visual imagery to construct scenes which evoke paintings and which relate to one another as the different versions of one vision whose final expression subsumes them all as aspects of itself. At the same time, however, Baudelaire stresses movement through his alternation of two lines of five syllables with a line of seven syllables, suggesting the unstable rocking motion of a voyage. "L'Invitation au voyage" evokes both the voyage and the voyage's goal, whose qualities are summarized in the refrain as well as given visual form in the three stanzas. The use of the refrain reinforces the importance of order in the poem by providing a constant and repeated element whose internal emphasis is on the word "ordre," which begins the list of qualities to be

found at the journey's end and provides a formal principle to shape their sensual appeal. Baudelaire succeeds in "L'Invitation au voyage" in fusing movement with order both within the separate stanzas and in the poem as a whole. Although he achieves this fusion differently from Delacroix, the resolution of these qualities is attained in both their arts and implies that Baudelaire, as much as Delacroix, deserves the name of "poet-painter." The arts of these two poet-painters are related as the syntheses of attributes of both the arts.

It is of course impossible to generalize from one brief example of a certain kind of relationship of poetry and painting to the nature of this relationship throughout the Romantic period. The kind of relationship revealed in this example, however, does conform to the Romantic critics' notion of the synthesizing nature of the imagination and the consequent harmony of differences contained within each form of art. Other studies are needed to determine how typical the relationship of Baudelaire and Delacroix actually is. This study, however, may provide an initial definition of one kind of relationship that has been little analyzed and suggest some approaches to investigating it. The structuralist conception of a signifying system, although it fails to provide an adequate method for analyzing individual poems, helps us formulate appropriate questions about the relation of two arts not linked by subject matter. It enables us to see that though the patterns of relationships in Baudelaire's poems and Delacroix's paintings are determined by the nature of their different media and thus have different characters, the two arts are homologous because they share the common function of expressing harmony and synthesizing qualities associated with both arts. But defining the questions is only a beginning; it is a step toward understanding a particular relationship that developed during the nineteenth century. The case of Baudelaire and Delacroix suggests a fundamental change in the possible relationships between two forms of art, a change whose implications should be probed for their significance for art from the Romantic era through the present.

Word and Image in Quarles' *Emblemes*

Ernest B. Gilman

Given its current reputation, we might be surprised to learn that Francis Quarles' *Emblemes* (1635) came out in three editions during the author's life and long remained among the staple works of piety on seventeenth-century English bookshelves from London and Little Gidding to the sugar plantations in Jamaica. According to Horace Walpole, even Milton "had to wait until the world had done admiring Quarles." Yet modern critics have been willing to grant Quarles and his fellow emblem writers only the distinction of the second-rate. Rosemary Freeman, for example, concludes that in the mechanical "imposition of meaning upon a predetermined image lies the essential weakness of the emblem writer's method," while Mario Praz believes that "Quarles's *Emblemes* supplied the wider public with a cheap substitute for that metaphysical wit which authors like George Chapman and John Donne provided for a more refined audience."[1]

As Praz's comment suggests, in English studies we are likely to read Henry Hawkins or George Wither or Quarles, if at all, as a duty. We come to them for the raw material of the emblematic imagination so conspicuous in their work, but only to equip ourselves to recognize that material in a more finished or subtle form in the major dramatists and lyric poets. Indeed, George Herbert's achievement is measured by his ability to go beyond the merely emblematic, while the stuff of emblems may even be seen to clog the work of other writers. Alan B. Howard has

1. Rosemary Freeman, *English Emblem Books* (London, 1948), p. 28; Mario Praz, *Studies in Seventeenth-Century Imagery*, 2d Eng. ed. (Rome, 1964), p. 163.

Reprinted from *Critical Inquiry* 6 (Spring 1980): 385–410

claimed, for example, that the work of the American poet Edward Taylor is unfortunately trapped inside the emblem tradition:

> The emblem tradition—both as a body of conventional analogies and as a habit of mind—allowed [Taylor] to use metaphors drawn from the book of the scriptures and the book of nature without, he thought, leading the reader to delight sinfully in the beauties of his language or in the world of "mere appearances" which it reflected. It allowed him to use those metaphors as transparent counters, valueless in themselves, through which he might see the wonders of God's truth as revealed in Puritan doctrine.[2]

Such "counters" permitted Taylor to pile his verse richly with emblematic images and to manipulate them with the most fervent ingenuity, all the while blinding himself, Howard argues, to the fresh vision of William Bradford or Anne Bradstreet, whose "contemplation of the natural world, perceived in its complexity, richness, and beauty, leads gracefully and inevitably to a consideration of God; then, just as naturally, it leads back into this world and a heightened appreciation of its significance."[3] Taylor attempted instead to strain the sinfulness of the visible world through a filter of emblematic imagery; the result was a failure of vision. Taylor's bookish verse confirms Walter Benjamin's remark that "the Renaissance explores the universe; the Baroque explores libraries." Benjamin's meditation on the ruined, grieving world of the seventeenth-century German *Trauerspiel* reveals its similarity to the mood of Taylor's verse: in each the clutter of emblematic fragments becomes the appropriate furniture of the artist's imagination.[4]

I would like to propose here that we reexamine that perception of failure—the dissatisfaction with the emblem, finally, as mechanical, inadequate, brittle—not in order to argue that we have made a mistake all along in regarding Milton as a better poet than Quarles, but to look closely at our assumptions about success. How well, and under what circumstances, does the emblem "work"? The interest of Quarles' *Emblemes,* as I will argue, lies, at crucial moments, precisely in a certain kind of failure—their failure to accommodate the illustrations to the texts. The energy of the book flows less from the plates or the poems

2. Alan B. Howard, "The World as Emblem: Language and Vision in the Poetry of Edward Taylor," *American Literature* 44 (1972): 384.

3. Ibid.

4. Walter Benjamin, *The Origins of German Tragic Drama* (London, 1977), pp. 140, 175–85.

Ernest B. Gilman, assistant professor of English at the University of Virginia, is the author of *The Curious Perspective.*

taken separately, or from the harmony of their cooperation, than from the discord of the confrontation between them. That confrontation displays their ultimate success in reconceiving the emblem to enact a new relationship between the word and the image.

1

Traditional descriptions of emblematic art assume that the image and the word—the "body" and "soul" of the emblem—join to create a total effect richer than that of either component alone, that the two parts are commensurate and reinforcing. Thus a sequence of plates and their appended texts generate two complementary codes running on parallel tracks, each holding the key to deciphering the other. Thomas Blount, translating Estienne's *L'Art de faire les devises* in 1646, is typical of the emblem writers in his belief that the two should "be so strictly united together, that being considered apart, they cannot explicate themselves distinctly the one without the other,"[5] and the many strands of tradition behind the emblem book support this assumption. According to the precepts of the *ars memorativa,* the combination of picture and text, mirroring each other, worked to make the idea of the emblem especially memorable.[6] Many collections call this to the reader's attention and also emphasize the importance of the emblem in terms of the sister arts: "If you eye well and marke these silent Poesies, give ear to these speaking pictures."[7] Ever since Alberti advised artists to associate with poets and orators, who might be helpful in composing the invention for a painting, the visual arts had appropriated the categories of literary theory in ways that served to draw the pictorial and the verbal all the closer. As a form of allegorical image that needed to be interpreted, that is, spoken rather than merely seen, the emblem was understood to embody a language *in rebus* mutually interchangeable with the language *in verbis* of the accompanying text.

This essentially linguistic conception of the image finds support in the hieroglyphic tradition from the discovery of the Horapollo manuscript in 1419 through the speculations of Alberti, Ficino, Fasanini, Valeriano, Ripa, and Athanasius Kircher. According to Renaissance belief, the Egyptian priests had preserved their arcane wisdom in ideograms, which they had perhaps first discovered on an obelisk outside the gates of Eden. Here was a "mute and symbolic language of ideas" (Valeriano) that had the advantage of being at once universal and esoteric, more

5. Thomas Blount, *Art of Making Devices* (London, 1646), p. 10.
6. See Freeman, *English Emblem Books,* p. 203.
7. Henry Hawkins, *The Devout Heart* (Rouen, 1634), pp. 4–5. Such tags as *poesia tacens, pictura loquens* are common in the titles of emblem books: see Robert J. Clements, *Picta Poesis* (Rome, 1960), p. 175.

indelible than other tongues, and more directly expressive of divine wisdom than written language. For, as Ficino notes in his commentary on Plotinus, the Egyptians "did not use individual letters to signify mysteries, but whole images of plants, trees, and animals; because God has knowledge of things not through a multiplicity of thought processes but rather as a simple and firm form of the whole thing." Thus they "presented the whole of the discursive argument as it were in one complete image."[8] Some emblem writers, like Geoffrey Whitney, incorporated hieroglyphic inscriptions whether authentic or confected on what were understood to be Egyptian principles.[9] Others, like Quarles, invoked the aura of hieroglyphic mysteries more than the substance. Quarles' smaller collection of emblems, published in 1638, is entitled *Hieroglyphicks of the Life of Man*, while the foreword to the *Emblemes* of 1635 (anticipating Tesauro) instructs the reader that "An *Embleme* is but a silent Parable. . . . Before the Knowledge of letters God was known by *Hieroglyphicks:* And, indeed, what are the Heavens, the Earth, nay every Creature, but *Hieroglyphicks* and *Emblemes* of his Glory?"[10] As a "hieroglyphick" and a pictorial "poesie," the device served as a *praetextum*, a "text-before" the adjoining text of the motto or epigram, so that the whole series was intertranslatable. Many emblems, the Jesuit productions especially, were polyglot editions like the *Typus Mundi* with its verses in Latin, French, and German. In such a sequence, the engraving stood as yet another version of the conceit, only in a pictorial tongue.

On the other side of the *ut pictura poesis* equation, language might be conceived as intrinsically pictorial, distinguished at its best by the *enargeia* and colors of the liveliest painter. In the Augustinian tradition the *verbum* of scripture, although accommodated to the halting human intellect, shadows the nontemporal, luminous *res* of divine truth. The goal of interpretation—formed in part by the neo-Platonists' sense of our intuitive, unmediated perception of the intelligible as a mode of visionary experience—was to see through language "to the realities themselves,

8. Cited in Rudolf Wittkower's "Hieroglyphics in the Early Renaissance" (1972); rpt. in his *Allegory and the Migration of Symbols* (London, 1977), p. 116. The chief studies in the hieroglyphic tradition by George Boas, E. H. Gombrich, Erik Iverson, and Lieselotte Dieckmann all continue the pioneering work by Karl Giehlow, "Die Hieroglyphenkunde der Humanismus," *Jahrbuch der Kunsthistorischen Sammlungen der allerhochsten Kaiserhauses* 32 (1915).

9. Whitney's *A Choice of Emblemes* (London, 1586), borrowing from the *Symbolicae Quaestiones* (1555) by Bocchi, illustrates the motto, *Victoria ex Labore Honesta et Utilis* by a laurel wreath (Victory), above a bucranium (Labor), adorned with hoes and palm leaves (Useful and Honorable). Herman Hugo, Quarles' source, published a treatise *De Prima Scribendi Origine et Universa Rei Literariae Antiquitate* (Antwerp, 1617).

10. *The Complete Works of Francis Quarles*, ed. A. B. Grosart, 3 vols. (1880–81; rpt, ed., New York, 1967), 3:45. All citations to Quarles refer to this edition. Grosart replaces Quarles' images with new illustrations by Charles Bennett and W. Harry Rogers, a dubious improvement. The images included in this essay (figs. 1–8) are photographed from the first edition of the *Emblemes* in the Folger Shakespeare Library.

from the temporal realities to the eternal realities, from talk to silence, and from discourse to vision."[11] Indeed, the technical language of biblical exegesis *(typos, schema, figura, paradeigma)* is insistently visual.

The bond between the two parts of the emblem thus gains its strength from a number of related traditions. In Jakobson's terms the relationship between word and image is, potentially, at once metonymic and metaphoric: metonymic in that the two complete each other sequentially and as parts of a whole; metaphoric in that each translates into the other's medium. Ideally, image melts into speech, speech crystallizes the immediacy of the image.

While that ideal bond was forged principally in Italy, Quarles' work shows the strain placed on it in an English Protestant culture formed on the primacy of the Word. That culture was not only peripheral to the great achievements in painting and sculpture on the continent (the illustrated book was still something of a novelty in the early seventeenth century), but in its recent history actively iconoclastic. The confrontation between the visual and verbal elements in the *Emblemes* was far more urgent than the *paragone* between the arts that had always been a feature of the *ut pictura* tradition. Whereas a Leonardo might base a defense of painting on the Platonic and Christian ground, endorsed by Augustine, that the sense of sight is the highest of the faculties, a Protestant reader of Augustine would also find ample reason for distrusting the visual arts: the divine medium is the creating Word, and the Christian must beware of the enticements of the eye and the delusions of the visual imagination. That suspicion is all the more deeply rooted in the seventeenth century, whose logocentric bias prefers notations of the dramatic voice and the mind in motion to composed ecphrastic structures.

This logocentric bias is clear in the religious verses of the English poets. Vasari's idea of God as the primordial painter and architect is alien to Herbert's conception of writing as the challenge to copy the "fair, though bloudie hand" of a divine author ("The Thanksgiving"). Like Donne in the "Anniversary" poems ("I am The Trumpet, at whose voice the people came"), Herbert associates himself as a poet with music and preaching. Where the analogy is with painting ("Jordan II") or with architecture ("Sinnes Round"), Herbert's point is always that his art has been tainted by "lewd intentions." When reassurance comes, it makes itself heard, not seen, in whispers and echoes. Henry Vaughan's obsession with recovering special moments of visual illumination propels him inward on a pilgrimage along the track of memory. The brilliant flashes of regeneration all too seldom granted his "restless Eye" are etched against a foggy, shrouded external world eclipsed in sin. The surprisingly pervasive influence of Ignation and Salesian meditative procedures

11. Joseph A. Mazzeo, "St. Augustine's Rhetoric of Silence," *Renaissance and Seventeenth-Century Studies* (New York, 1964), p. 19.

in English sacred poetry may be understood in this context: as the start-
ing point for meditation, the Catholic manuals encouraged the "compo-
sition" of an inward "place"—a mental picture which Protestants could
safely substitute for the painted devotional images condemned by Calvin
and Luther. The example of Milton's Samson may remind us that where
blindness is a special gift and insight supercedes sight, the visual arts are
not in a propitious climate.

Even the English Catholic poets Ben Jonson and Richard Crashaw
share this antivisual temperament. In "The Flaming Heart" Crashaw
mocks the "cold Pencil" of the inferior painter who has tried to capture
the ecstatic flame of Saint Teresa. He devotes his most extravagant hymn
to the "Name of Jesus," that "one Rich Word" whose "each Syllable"
contains "A Thousand Blest Arabias." Jonson's criticism of great houses
"built to envious Show" ("To Penshurst") is of a piece with his smolder-
ing contempt for Inigo Jones, the scenic designer of court masques for
which Jonson supplied the texts. As D. J. Gordon has shown, the issue
between Jonson and Jones runs far deeper than personal rivalry to Jon-
son's faith in the unique power of language to embody the truth of
things.[12] As a kind of verbal legislator, Jonson exercises this power
magisterially in his *Epigrammes,* where the highest praise for the virtuous
is to honor their names ("On Lucy Countesse of Bedford"), while the
severest punishment for the vicious is either to rechristen them with
their true names ("On Sir Voluptuous Beast") or else to withhold the
dignity of a name altogether ("On Something, that Walkes Somewhere"),
as if some people who present a great figure to the eye are too morally
insubstantial to deserve the attention of language. Although Jonson
translated Horace's *Ars poetica* and transcribed for his use all the com-
monplaces of *ut pictura poesis,* he also added the note that "of the two, the
Pen is more noble then the Pencill. For that can speake to the Under-
standing; the other, but to the Sense."[13] Thus Jonson imagines the Sid-
ney family at Penshurst not as portraits but as moral texts to be "read,"
and understandably complains that his own lady has misjudged him by
looking at his "Picture Left in Scotland" rather than hearing the weight
and authority of his language.

Quarles' project was to domesticate the imported Jesuit engravings
of his sources for a potentially inhospitable English Protestant poetic
sensibility that lacked the Jesuits' confidence, sanctioned by the edicts of
Trent, in the efficacy of the visual image to embody and teach sacred
truths. In some respects the Jesuit emblems were pliable enough to
withstand the change of context. One aspect of their wide appeal had

12. D. J. Gordon, "Poet and Architect: The Intellectual Setting of the Quarrel be-
tween Ben Jonson and Inigo Jones," *Journal of the Warburg and Courtauld Institutes* 12
(1949): 152–78.

13. *Ben Jonson,* ed. C. H. Herford and Percy and Evelyn Simpson, 11 vols. (Oxford,
1925–52), 8:610.

always been the latitude of interpretation that they would permit. Many
of their motifs had already been adapted by the Jesuits from Dutch
secular love emblems, and the Alexandrian Eros was transformed into
Divine Love by the substitution of biblical for Ovidian and Petrarchan
texts.[14] Still, the peril involved in Quarles' further adapting these sacred
figures to a Protestant setting is reflected in Luther's *Theses:*

> (19) The one who beholds what is invisible of God, through the
> perception of what is made, is not rightly called a theologian.
> (20) But rather the one who perceives what is visible of God, God's
> "backside," by beholding the sufferings of the cross.[15]

In his other writings, Quarles suggests the difficulty of this task. He
distinguishes between the "soul's two Eyes," the eye of faith being more
clear sighted than the eye of reason, and so objects to the attempt of
Raymond Sebond to understand divine mysteries "By Nature's feeble
light."[16] But both these inner sources of vision are surer guides than the
eye of sense fixed on the objects on which it feeds: "Gaze not on Beauty
too much, lest it blast thee; nor too long lest it blind thee. . . . If thou like
it, it deceives thee."[17] God's image in us before the Fall was the one
perfect picture, "a dainty Piece! In every part, Drawne to the Life, and
full of curious Art." Its restoration must await not the smudged hand of
the human artist but Christ, the

> . . . great Apelles that can lim
> With thy owne Pencill; we have sought to Him:
> His skilfull hand will wash off all the Soyle
> And clense thy Picture with his sacred Oyle.[18]

We cannot emulate the "skilfull hand" that painted our redemption by
the sufferings of the cross. When he asks, "Why not the Picture of our
dying Lord, As of a Friend," Quarles takes up the issue of sacred im-
agery explicitly: "does not th' eternall Law command, that thou Shalt
ev'n as well forbeare to make, as bow?" And he concludes: "No, no; the
beauty of his Picture lies Within; 'Tis th' object of our Faith, not Eyes."[19]

14. The chief sources for the Jesuit emblems include Daniel Heinsius, *Emblemata
Amatoria* (Antwerp, 1604), Otto van Veen (Vaenius), *Amorum Emblemata* (Antwerp, 1608),
and Pieter Hooft, *Emblemata Amatoria* (Amsterdam, 1611). Vaenius had shown the way by
spiritualizing his own earlier emblems in the *Amoris Divina Emblemata* (Antwerp, 1615). See
Praz, *Studies in Seventeenth-Century Imagery,* pp. 143–49.
15. *Martin Luther: Selections from His Writings,* ed. John Dillenberger (Garden City,
N.Y., 1961), p. 502.
16. Quarles, *Divine Fancies* (London, 1632), bk. 3, p. 54, also in *Complete Works,* 2:237;
Divine Fancies, bk. 2, p. 66, in *Complete Works,* 2:226.
17. *Enchyridion* (London, 1641), bk. 3, p. 9, in *Complete Works,* 1:31.
18. *Divine Fancies,* bk. 3, p. 70, in *Complete Works,* 2:238–39.
19. *Divine Fancies,* bk. 3, p. 49, in *Complete Works,* 2:236.

And with this attitude Quarles precariously inserted the engravings into his *Emblemes.*

2

Quarles takes all but ten of his plates from two Jesuit emblem books published in Antwerp in the 1620s, the *Pia Desideria* (1624), by Herman Hugo, and the *Typus Mundi* (1628), put out by the College of Rhetoric of the Society of Jesus and dedicated to Saint Ignatius. With only a few departures, Quarles' engravers William Marshall and William Simpson have carefully reproduced the Jesuit plates (designed, in Hugo's case, by the great baroque engraver Boethius a Bolswert), although the debt is not acknowledged.[20] But like Christopher Harvey and John Hall, who also produced Protestant emblem books around the illustrations in Catholic sources, Quarles largely ignores the texts in the *Typus Mundi* and the *Pia Desideria* except for an occasional paraphrase or for a general similarity in theme dictated by the content of the device. His poems simplify the sensual texture and mythological decoration, which in the Jesuit verses had echoed the rapturous feeling of the plates, and concentrate instead on a more austere psychological and moral drama of the soul.[21] In the process of adaptation, furthermore, Quarles subtly modifies his sources to give the larger design of the work a distinctively Protestant cast.

The *Emblemes* is divided into five books of fifteen emblems each.[22] The last three books reproduce in order the forty-five engravings of the *Pia Desideria,* itself falling into three books. But Quarles omits the subtitles of the Jesuit work. These subtitles corresponded to the three-part movement—much in the fashion of a sequential meditation—from the soul's grief-stricken search for penitence *(Gemitus Animae Poenitentis),* through the expression of its desire *(Desideria Animae Sanctae),* to the more fervent sighs of the soul yearning for and at moments touching the sweetness of divine love *(Suspiria Animae Amantis).* The pattern implicit here is repeated in other Catholic emblem books such as Henry Hawkins' *Parthenia Sacra* (1633), in which the twenty-four plants in the garden of the sacred Parthenes correspond to twenty-four acts of devotion

20. See Gordon S. Haight, "The Sources of Quarles's Emblems," *Library* 16 (1936): 188–209. Quarles used the second edition of Hugo (1629).

21. On this point see Freeman, *English Emblem Books,* pp. 139–40.

22. All further references to Quarles' *Emblemes* as found in *The Complete Works,* vol. 3, pp. 43–101, are henceforth cited in the text by parenthetical reference to the book and the emblem number. Quarles' alterations in other plates seem similarly intended to heighten the emphasis on temptation and death. For example, 1:7 adds a tiny figure of death, menacing Cupid with an arrow, in the background of the engraving borrowed from the *Typus Mundi;* 1:9 adds the figure of time toppling the world with his scythe; 1:10 adds the figure of Mammon as a bowling companion for Cupid.

and provide the mnemonic framework for a whole meditative scheme. With no such framework, each of Quarles' poems stands independent, as an individual moment in a Christian life rather than as a step in a sequence which presupposes the smooth cooperation of text and image to guide the reader along a steady course.

In books 1 and 2 (evidently written last) Quarles follows the *Typus Mundi*'s presentation of the rivalry between human and divine love against the background of a fallen world. But taking even more liberty with this source than he had with Hugo, Quarles changes the original order of the emblems he selects (twenty-two of the thirty-two in the *Typus Mundi*) and adds others not found in the *Typus* at all. Those he adds—for example, the concluding five emblems in book 1—portray the delusions of a world suffering under the reign of the Devil, who rides off with the world despite the efforts of *Amor Divinis* to restrain his chariot with a rope (1:11) or who presides over the scene of Fraud scourging Justice and Sense clipping the wings of Faith (1:15). The last five emblems in book 2 restructure the conclusion of the *Typus Mundi* into a darker, more precariously Protestant ending. The Jesuit work ends by revealing the monstrous nature of the earthly Cupid (plate 27), contrasting the blind Cupid to Divine love reveling in a vision of heaven (plate 28), and finally banishing him altogether as Divine Love emerges triumphant with his foot on the world (plate 30). When in the final emblem (plate 32) Cupid reappears holding the orb of the world, he is countered by Divine Love displaying the purified heart which streams upward toward heaven. Quarles retains that emblem of the heart "restor'd and purg'd" from the "drossie nature" of the world (2:15) but makes it the last element in an antithetical series:

2:11 (emblem 23 in the *Typus*): Divine Love, playing billards with Cupid, admonishes his earthly opponent that the heavenly shot is the more difficult: "My way is hard and strait."

2:12 (emblem 22 in the *Typus*): Divine Love stands secure on the cross above the world, unmoved by adverse winds or fortune's wheel.

2:13 (newly added): Cupid is wounded into repentance by a shaft from the bow of Divine Love, but the Devil pours his own poison into the wound, and the soul's desire for this "most delicious world" revives. The motto, from 26 Proverbs, warns: "As a dog returneth to his vomit, so a fool returneth to his folly."

2:14 (newly added): Although in a wrestling match with Cupid, Divine Love is thrown down, the victory is only temporary because "A just man falleth seven times and riseth up again" (24 Proverbs).

This ending reflects what an emblem later in the volume (4:1), its motto drawn from Saint Paul, will call the "unresolv'd resolves" of the will: "O how my will is hurried to and fro, And how my unresolv'd

resolves do vary!" The poet's "rambling thought" (4:12) carries him along a pilgrimage of self-scrutiny whose emblem (4:2) is the labyrinth: "The world's a lab'rinth whose anfractuous ways Are all compos'd of rubs and crook'd meanders: No resting here." At the center of the plate (fig. 1) the soul takes a direct sighting of Divine Love on a distant watch-tower, but the poem is spoken by a smaller figure haltingly negotiating the maze with his dog and staff. In an Augustinian mood of spiritual restlessness, the epigram offers the pilgrim only the encouragement of an unresolved resolve:

> Pilgrime, trudge on; What makes thy soul complain
> Crownes thy complaint. The way to rest is pain:
> The road to resolution lies by doubt.

Far less sure than the meditative steps of the Jesuits, these "trembling paces" between pain and comfort, doubt and resolution, mark the larger rhythm of Quarles' book. Like Donne's Holy Sonnets ("Oh, to vex me, contraryes are met in one"), Herbert's *Temple,* and Bunyan's *Grace Abounding,* this poem is an inner spiritual autobiography rather than a public manual of pious instruction.

Oh that my wayes were Directed
to keepe thy Statutes . Ps-119-5.
W. Simpson Sculp:

Fig. 1.

The rhythm of self-scrutiny apparent in the overall movement of the *Emblemes* is central in every respect to Quarles' project—to the materials of his art, and to the bond between the pictorial device and the adjoining text. Just as the pilgrim's staff probes his path, the poet probes the crooked meanders of composing sacred emblems. At poignant moments the probing extends to the authority of language (4:1):

> The curious Penman, having trimm'd his page
> With the dead language of his dabbled quill;
> Lets fall a heedlesse drop, then in a rage
> Cashiers the fruits of his unlucky skill;
> Ev'n so my pregnant soul in th' infant bud
> Of her best thoughts, showrs down a cole-black flood
> Of unadvised ills, and cancels all her good.

The plate shows the soul trying to fend off the enticements of Amor while fixing her gaze on the tablets of the law held by Divine Love; the implicit contrast between that indelible writing and the poet's "dead language" sharpens the rueful tone. As the spiritual and verbal fertility of a "pregnant soul" is canceled by its own heedlessness and rage, the Pauline drama of the motto to this emblem—"I see another Law in my members warring against the Law of my mind"—plays itself out in the very process of writing. In another emblem (5:9), the soul, her flight prevented because her foot is chained to the ball of the globe, complains, "I cannot speak a word which earth profanes not." In yet another (4:12), her "unregarded language" only vents the "sad tautologies of lavish passion," "feeding Upon the rad'cal humour of her thought," until comfort appears suddenly to resolve the labyrinthine circling of language: "Ev'n whilst mine eyes were blind, and heart was bleeding, He that was sought, unfound, was found unsought." The verbal play here deepens the irony of a language that achieves its end despite itself through its own failure and exhaustion. "Unregarded" language is heedless language, like the penman's spilled ink. Its plea is apparently not heeded, yet love comes unexpectedly, and unseen—that is, "unregarded"—before the blinded eye of the poet. Divine Love reverses the order and logic of the poet's language ("sought, unfound . . . found, unsought"), saves it from the sad tautologies of unresolved repetition, and so subtly cancels the penman's original error: his words are "regarded" after all.[23]

In this passage about language, the latent visual meaning of *un-regarded* as *unseen* is one instance of Quarles' nearly obsessive concern with the act of seeing. If for Quarles language is at times ink spotted, it is nonetheless the more stable medium, while sight and its objects are presented again and again as infected, dark, and treacherous. In the

23. Cf. the similar treatment of sinful language resolved despite the poet in Marvell's "The Coronet" and Herbert's "The Collar."

"Invocation" to the *Emblemes,* the poet rouses his soul so that the "sacred influences" of heaven may "hallow" his "high-bred strains" and the music of his words may "reach th' Olympick ear." As the "consort" grows more perfect, however, the eye is dimmed: it too rises above the "dark fog Of dungeon-earth" but to a vantage point from which "this base world" will "appear A thin blew Lanskip." The eye is to be enlightened by withdrawing its gaze from a world now seen in its correct anagogical perspective—a mere painted image, diminished and hazy despite the artist's skill, offering only the false "lanskip joyes" (4:12) of human love, and smudged by a "poore mortall blaze . . . whose flames are dark And dangerous, a dull blew-burning light" (1:14). This long perspective secures a view removed from the world's contamination but nearer the clarity of true vision.

The embodiment of this mode of perception appears in engraving 3:14 (fig. 2). There Spirit looks through an "Optick glass" at the distant prospect of death and the fires of the last judgment—the "latter end" that the motto from 32 Deuteronomy exhorts us to consider. In the Jesuit version of this plate (*Pia Desideria* 1:14), Spirit sits alone, her

Oh that they were wise, then they would Underſtand this; they would conſider♀, their latter end.Deeteron: 32 · I Payne ſcul.

FIG. 2.

telescopic view sufficient and unchallenged. She is accompanied only by a marigold leaning, as she leans, toward the distant object of her sight to suggest both how faithful and how effortless the act of vision is: eyes and plants alike are drawn heliotropically toward the light. But Quarles replaces the marigold with the naked figure of Flesh, who now attempts to distract her companion with a triangular prism displaying a distorted "world in colours" to "ravish eyes." Spirit, echoed by the appended quotation from Bonaventura's *De Contemptu Seculi* ("O that men would be wise, understand, and foresee"), replies that "Foresight of future torments is the way. . . . Break that fond glasse, and let's be wise together." Quarles thus crystallizes the problem of vision: in order to focus therapeutically on "future torments," the eye must resist the present torment of taking pleasure in what it sees close at hand. Here, as in other emblems where the state of the soul is at issue between two contestants (Eve and the serpent, Divine Love and Justice), Quarles recasts the poetic commentary of his sources into dramatic dialogue which charges the moment more fully with the energy of competition. The condition of sight has become a kind of agon between Flesh and Spirit for the eye of the viewer, who is made to feel the pull on him from two directions.

As we are thus led self-consciously to reflect on our own perception, we appreciate how precariously the engravings that meet the eye in the *Emblemes* must balance between these two poles of Flesh and Spirit, prismatic sight and telescopic foresight. More radically than other visual allegories, these bizarre, colorless configurations are drained of the usual contents of our visual experience and jumbled with devils, souls, cupids, globes, wheels of fortune, candles, and bowling balls. From a spiritual point of view, that is their great advantage: by engaging what the *Everyman* poet had called our "ghostly sight," they intend to refocus our sight telescopically from the image before us—now become "thin" and "indistinct" and not to be mistaken for a representation of Flesh's world—to the "latter end" of spiritual insight, an object of thought and meditation beyond the pictorial surface. Their vanishing point is not in the depths of the image but in the soul of the viewer. Emblematic images might thus be regarded as partially immune to strictures against sacred imagery, since they do not claim to be objects of devotion in themselves but, as for Edward Taylor, signs pointing away from the image and so, in the tradition of *via negativa*, extinguishing themselves.[24] Engravings as "types" are to be understood not in the literal sense as palpable incarnations signifying "through the perceptions of what is made" but rather in the allegorical sense as figures of "the sufferings of the cross": here we may see, as Quarles himself instructs us, "the allusion to our blessed Savior figured in these Types" ("To the Reader"). Seen—or rather, exegetically read—

24. See E. H. Gombrich, "Icones Symbolicae" (1948); rpt. in an expanded form in *Symbolic Images* (Oxford, 1972), pp. 150–52, 157–60.

in a way that virtually deprives them of their pictorial content, emblematic images are thus textualized. As the mere outward simulacra of interior states of mind, they may be safe from any suspicion of idolatry.

Yet by their very nature as pictorial images—the "body" of the emblem—they can hardly escape some implication in the world of flesh. We see and dwell on their intricacies in a way strikingly similar to the pleasure that Flesh takes in her prism: "Here mayst thou tire thy fancy, and advise With shows more apt to please more curious eyes." Indeed the insistent reminders of our "benighted eyes" (1:14), our "faithless Opticks" (1:7), our "Owl-eyed lust" (2:9), our "deluded eye" (3:2), our "Leprous eyes" (3:13)—all cast doubt on the very faculty we must exercise in a collection of emblems. In 2:6 we look at Cupid looking at his own image mirrored in the globe of the world. The text's warning on the theme of vanity reflects outward to our own act of perceiving the emblem as well as inward to Cupid admiring himself:

> Believe her not: Her glasse diffuses
> False portraitures: thou canst espie
> No true reflection: She abuses
> Her mis-inform'd beholder's eye.

No longer a glass channeling the eye to a world beyond the flesh, the engraving as a mirror of the flesh distorts the gaze and returns it upon the viewer as an indictment of his cupidity: he is "mis-inform'd" because of his own deformity. The tension between the need to see and the perils of sight complicates our passage through the labyrinth at every step and asserts itself as the true subject of Quarles' book.

3

I would like to explore this tension in detail in four particular emblems, 1:1–2, 1:14, 1:15, and 3:2 and 10, and then consider the broader significance of Quarles' work. The examples I have chosen are of special interest because they confront the problematic nature of the image directly, unlike others which find strategies for avoiding it. Elsewhere Quarles may either draw out the allegorical interpretation of a complicated image point for point (e.g., 1:10 or 3:9) or, at the other extreme, use some feature of the image as the inspiration for a poem that develops along a tangent tenuously connected to the given engraving (e.g., 3:8). The first method relegates the text to a gloss on the picture and so collapses the bond between the two; the second ignores the engraving to establish the independence of the text and so severs the bond entirely. In 1:1 and 1:2, however, the strength of that bond is put to the test.

The first emblem (1:1) shows the temptation in the garden, the serpent coiled around the trunk of the tree and Eve listening to his blandishments (fig. 3). In the second (1:2), Adam, holding the fruit, stands before a background depicting the four elements whose fury (in contrast to the harmony of the animals in the background of the first plate) is now unleashed by the act of disobedience: "Fire, Water, Earth and Aire, that first were made To be subdu'd, see how they now invade" (fig. 4). At Adam's feet is the image of the world—literally the *Typus Mundi* of Quarles' source. As the principal motif of books 1 and 2, this globe will reappear some twenty times ingeniously transformed into a wasp's nest (1:3), a top (1:5), a breast (1:12), or a mirror (2:6). Here, like some enormous, wormy fruit (the plate suggests the visual parallel between the globe and the fruit in Adam's hand), the world spawns the seven heads of the deadly sins. Quarles emphasizes the theme of malignant fertility, both by the motto from 1 James ("when lust hath conceived it bringeth forth sinne") and by the main text:

> See how the world (whose chast and pregnant womb
> Of late conceiv'd, and brought forth nothing ill)
> Is now degenerated, and become
> A base Adultresse, whose false births do fill
> The earth with Monsters.

These passages also draw out the visual implication that the globe we see before us in 1:2 is the monstrous version of Eve's naked and globular womb pictured in 1:1, deceptively planted by "lust" with the seeds of sin and death, and now grown "thriving, rank and proud" into the horrid fruit. This fruit will recur later in the volume as "earth's false pleasure . . . Whose fruit is fair and pleasing to the sight, But soure in tast, false at the putrid core" (1:7). It appears again near the end, fulfilled typologically in 4:14, where the soul raises its "humble eye" to gaze at Divine Love hanging in the branches of a tree; the motto reminds us not only of the crucifixion but of the final harvest of Eve's seed at the heavenly banquet: "I sat under his shadow with great delight, and his fruit was sweet to my tast."

The energy of each of these moments—Eve entranced by the serpent, Adam regarding the globe, the soul enjoying the sight of Love—flows through an act of vision. At the same time the texts engage the reader in the drama by channeling his sight to the scene. In 4:14 the reader is implored to "permit [his] eyes to climbe this fruitfull tree," in 1:2 he is forced repeatedly to rivet his gaze on the consequences of the Fall from which he would rather turn away: "Poor man! Are not thy joynts grown sore with shaking. To view th' effect of thy bold undertaking?" The poet's command, "Lament, lament; look, look what thou hast done," indicts us as fully as it does Adam. It would appear to assume that

Totus mundus in maligno (mali ligno) positus est.

Will Marshall sculp:

FIG. 3.

Sic malum crevit vnicum in omne malum.

FIG. 4.

regarding an image of the fallen world will humiliate the eye and so raise it for its climb to Divine Love. As a form of lamentation, vision prepares for penitence, and penitence for spiritual sight. The scene of emblem 1:2, "degenerated" as it is to the sight, is still invested with an exemplary moral value by the text.

But for the reader who has passed to that scene from 1:1, the poet's emphatic pleas to "look," to "see," to "behold" curiously echo the voice of the serpent:

> Not eat? Not tast? Not touch? Not *cast an eye*
> Upon the fruit of this fair Tree? and why?
>
> *See* how the laden boughs make silent suit
> To be enjoy'd; *Look* how their bending fruit
> Meet thee half-way; *Observe* but how they crouch
> To kisse thy hand; Coy woman, Do but touch:
> *Mark* what a pure Vermillion blush has dy'd
> Their swelling cheeks, and how for shame they hide
> Their palsie heads, to *see* themselves stand by
> Neglected: Woman, Do but *cast an eye*. [Emphasis added]

The ironic parallel between the two emblems could not be clearer, or more troubling. The serpent's insidious and successful method had been less to befuddle Eve's reason or stimulate her taste than to awaken her visual lust—to tempt her as Flesh tempts Spirit in 3:14. He had done so by presenting the image of the fruit emblematically as a blushing lover making "silent suit" to her eye. Eve had in effect become a "base Adultresse" by being tempted to engage in illicit visual intercourse with an image already forming itself, as the serpent offers it to her, into the cupid figure of Amor.[25] Worse yet, the serpent's visual art challenges the verbal art of God's "strict commands" to Eve to avoid the fruit. This enticement to lust forms a contrast to, but also a reflection of, the poet's enticement to remorse in 1:2. The poet establishes the authority of the engraving by using its harsh theme to cleanse the viewer's eye with tears; the serpent in effect undermines the authority of *all* engravings by making us realize both their covertly lustful appearance and our complicity in that lust. Adam's ability before the Fall to name the animals with what Milton calls "sudden apprehension"—to see through their "body" to their linguistic "soul" and thereby to perceive the essential connection between *res* and *verbum*—made him the ideal viewer of the emblem. But ever since Eve set the pattern for art appreciation, our motives for viewing are compromised whenever we open our eyes. Thus the irony of the

25. According to one of the several competing contemporary theories of vision, the eye sees by projecting its "visual spirits" outward in a kind of coupling with the object of sight. Cf. the lovers' "eye-beames twisted" in Donne's "The Extasie": "And pictures in our eyes to get / Was all our propagation."

poet's remark to Adam, and to us, "thou lamentst too late," is directed at more than our tardy regret over an unforeseen catastrophe in Eden; it tells us at the beginning of the *Emblemes* that the innocent vision that alone would purify lamentation is debased by the very sin we would lament. Our "freedome gone"—and this will be Milton's point as well—we are no longer free as we once were not to sin with the eye. Which is to say that the perfect penitential emblem could only have existed in Eden, where it would not have been needed.

The need to grapple with this paradox in perception runs throughout the rest of Quarles' book, beneath the various moral lessons developed in the individual emblems. Quarles' solutions reflect more sharply than do purely literary forms a Protestant strategy for accommodating—or rather, for enacting the failure to accommodate—the visual image: destruction of the image (1:14), mortification of the viewer (1:15), and lifting the burden of sight (3:2 and 10).

Plate 1:14 presents the soul praying for morning while seated before a looming black globe (fig. 5). The scene is lit by a single candle—"this poore mortall blaze, a dying spark." The soul's anguish increases as she realizes that even though the candle may burn with the intensity of "all

Prosper redde diem.

Will.^m Marshall Sculpsit.

FIG. 5.

the Sunnes that glister in the Sphere Of earth" its power is insufficient to
bring into view the "promised light" for which she longs. Indeed its dull
flame conceals that greater light and must be dispelled before "the day"
can be revealed: "Haste, haste away Heav'n's loytring lamp." For the
viewer this implies that the image before him is not a transparent sign
pointing toward a spiritual meaning but an impediment to what he
would truly wish to see. Like the faithful soul in the illustration, he must
correct his vision by refusing to look—by turning his back on the image
of the globe and repudiating spectatorship for prayerful expectation. As
it thus defeats our penetration, the image is reconceived as an emblem of
its own opacity. The natural—that is, sinful—desire to see better by
having the image more brilliantly lit only further darkens the vision. The
soul therefore calls upon Ignorance to complete the image by destroying
it: "Blow Ignorance . . . blow, blow thy spite; Since thou has pufft our
greater Tapour, do Puffe on, and out the lesser too." The epigram
finishes the thought:

> My soul, if Ignorance puffe out this light,
> Shee'll do a favour that intends a spight:
> 'T seems dark abroad; but take this light away,
> Thy windows will discover break a day.

By such creative iconoclasm, the image is made significant by being
obliterated.

Ignorance is here the victim of the traditional irony associated with
the fortunate fall. As Herbert's "The Sacrifice" shows in its dramatiza-
tion of the liturgy of the Reproaches for Good Friday, even those who
spitefully crucified "our greater Tapour" furthered the divine plan de-
spite themselves. The soul's ignorance allies it with the prismatic Israel-
ites who were dark to the light of Christ shining behind His incarnate
flesh. The crucifixion was the result of their failure to perceive Christ
truly as a kind of divine emblem, and yet their violence wonderously
"opened" him, as the hidden meaning of an enigmatic device is laid bare.
As an alternative to our prismatic delight in the image for itself, this
passage justifies "spight" as a mode of pictorial exegesis and carries the
reassurance that the spiteful act will be a "favour" in effect. This re-
sponse to the image proposes an uneasy compromise between the corro-
sive and the therapeutic nature of vision. It acknowledges the sinfulness
of the viewer and the inadequacy of the image but redeems both
through their very susceptibility to violence.

This emblem directs the destructive force of perception against the
image. The one following (1:15) directs this force inward against the
viewer (fig. 6). The engraving shows Astraea driven off with a scourge by
Fraud, and Faith, holding the cross, threatened by Sense wielding a pair
of shears: "Her wings are clipt, and eyes put out by sense." Again, as in

Debilitata fides : Terbras Astræa reliquit.

w : M : ſcul :

FIG. 6.

1:2, the text repeatedly enjoins us to look at the scene ("See how the bold
Usurper . . . ; See how she flutters . . . ; Behold how double Fraud . . . ; See
how she stands"), and again, as in 1:14, it implies that our vision is im-
paired, for "Quick-seeing Faith" is "now blind" and imprisoned and the
slow eye of sense usurps her place. This brutal scene is conceived as a re-
venge tragedy in which the soul and God are both apparently helpless
spectators. Although with the foresight of 12 Revelations the motto as-
sures us that the Devil "hath but a short time" to rule, the poet addresses
the rightful king impatiently:

> Lord! canst thou see and suffer? is thy hand
> Still bound to th' peace? Shall earth's black Monarch take
> A full possession of thy wasted land?
> O, will thy slumb'ring vengeance never wake?
> . . . revenge, revenge thy own.

But at the end the poet turns the rebuke upon himself:

> My soul, sit thou a patient looker on;
> Judge not the Play before the Play is done:
> Her Plot has many changes: Every day
> Speaks a new Scene; the last act crowns the Play.

The role of the spectator here grows out of an awareness, implied in the full meaning of "patience," that vision is a form of suffering. Like Christ, the viewer will "see and suffer" not only because he can foresee the "last act" and so suffer patiently the presence of evil but also because—as for Christ—the sight of that evil is itself a suffering to be endured. In this sense, "see" and "suffer" are synonymous. The viewer's patient inspection of every detail of the image reveals nothing that he does not already know about its contents. Vision is not a form of knowledge but a form of pain, and thus every "see" and "behold" in the text inflicts another lash in a process of visual scourging. In moving from the impatient opening of the poem to the wish for patience at the close, the reader moves toward a bitterly unresolved resolve, for these opposite terms both mean suffering.

In each of these two modes of perception—destruction and mortification—the verbal "soul" of the emblem locks us into a struggle with the pictorial "body" which reenacts the Pauline struggle within the self. Between the viewer and the image flows a charge of lust, compulsion, and violence which cannot find release so long as the eye in its "blind dungeon" (1:15) is sealed off from the satisfaction of an unmediated, untainted vision. The relation between the eye and the image darkly parodies our perfect vision at the "last act," when we have Saint Paul's assurance of seeing God "face to face" in a reflection bound by love.

Until then the only relief from the burden of sight can come from shifting it onto the one viewer willing to bear its weight; for what matters ultimately in the *Emblemes* is not how we see but how we are seen. When Divine Love conceals himself behind a "fleshly curtain" (5:12), the soul's desire to see "the full beams of thy Meridien eye" remains unfulfilled; and when Divine Love holds an "eclipsing hand" before his eye, the soul cannot remove it (3:7). But when Justice brings the "prisner" soul before Jesus (3:10), the soul makes the proper defense even though she stands condemned of sin by her own confession (fig. 7):

> Vile as I am, and of myself abhorr'd
> I am thy handy-work, thy creature, Lord,
> Stampt with thy glorious Image, and at first
> Most like to thee, though now a poore accurst
> Convicted catiff, and degen'rous creature,
> Here trembling at thy bar.

And Jesus must reply:

> Stay, Justice, hold;
> My bowels yearn, my fainting bloud growes cold,
> To view the trembling wretch; me thinks I spy
> My Father's image in the prisner's eye.

Enter not into iudgment with thy
servant for no man liuing shall be
iustified in thy sight Will: jmpson

Fig. 7.

In the context of an emblem book, the words "handy-work" and
"stampt" take on a special suggestiveness that suddenly revises the di-
lemma of sight. The crucial emblem is not the one the viewer sees but the
one stamped in his eyes, the crucial perception is of the divine emblema-
tist's visual repossession of his handiwork—and his yearning to absorb the
pain of looking.

Thus in plate 3:2 the soul appears in a fool's cap and bells as the
emblem of its own love for "antick pleasure," and the text places us into
the image (fig. 8): "Such very fools are thou and I." Divine Love holds his
hand before his face to shield his eye from this vision of human folly but
sees it nonetheless—through the *stigmatum* in his palm. The dot signify-
ing the hole in Christ's hand is the tiniest and yet the most telling of
Quarles' emendations. Without it, the identical image in the *Pia Desideria*
conveys a very different feeling. In Hugo's work Love indulgently plays
a childlike game of forgiveness with his childish companion; peeking
between his fingers, he sees but pretends not to, hiding his eye from our
sins by regarding them as follies:

But by Heav'n's piercing Eye we are descry'd,
Which does our Sins with Follies Mantle hide.

FIG. 8.

He's pleased to wink at Errors too in me,
And seeing seems as tho' he did not see.[26]

In the *Emblemes,* divine sight passes through an "open wound," the very
medium of its vision and inseparable from pain:

O canst thou choose but see,
That mad'st the eye? can ought be hid from thee?
Thou seest our persons, Lord, and not our guilt;
Thou seest not what thou maist but what thou wilt:
The Hand that form'd us, is enforced to be
A Screen set up betwixt thy work and thee:
Look, look upon that Hand, and thou shalt spy
An open wound, a through-fare for thine eye.

26. *Pia Desideria,* 1:2, trans. Edmund Arwaker (1686; 3d ed., London, 1702),
p. 14. Hugo's Latin (1624), p. 9:

Sed videt haec, magnus qui temperat arbiter orbem,
Nostraque, stultitia nomine, multa tegit.
Et mea propitius deliria plurima transit,
Multaque scit caeca dissimulanda manu.

"Open" in pain, Christ's wound opens a clear channel for the healing power of his "gracious eyes" to see through the flesh—through a hand raised to "screen" the guilt of his handiwork rather than to "confound" it. Having once willingly joined himself to a body of flesh, he cannot now avoid the compulsion and suffering of mortal sight—he cannot "choose but see" his creation. But for that very reason, divine sight is free to transform the object of its vision from our "guilt" to our "persons" within or beyond the obstruction of sin: "Thou seest not what thou maist but what thou wilt." The "through-fare" of the wound uniquely joins the two perspectives of Flesh and Spirit in a way that resolves the tension between the two and measures the distance between our sight and God's.

Playing on the "empty fulnesse" of our "vain desire," the text guides our vision of this image of our folly: the soul is full of "empty dreams," yet feeding on emptiness this "fulsome Ideot" must be "insatiate" in its desires. Driven by the insatiate need to "please The fond aspect" of our "deluded eye," we could find no deliverance from the labyrinth of perception were it not possible to transfer the unresolved paradox of full yet empty vision to Christ as he regards his "handy-work." We empty the images that fill our eyes by feeding on them, and so diminish ourselves by the emptiness of our diet; but Christ's eye sees by replenishing the object of his sight in us. He is willing to suffer an emptiness in his own flesh to fill the emptiness of ours. Thus the drama of perception includes, at moments, the "new Scene" of regeneration: the mutual destructiveness of the viewer's engagement with the emblem is repaired by the flow of grace from the divine eye to *its* emblem within the viewer. The image embodied by the engraver's hand fills the page of an emblem book. It releases, but cannot satisfy, our desire to see: we cannot see through the guilt, as Christ can, because our eye is itself guilty, and so our act of perception empties the image. In this sense, the images before us may be regarded as open wounds in the text—the visual "body" of the emblem pierced by our attempt to see through it. These empty spaces can be filled only at points where the labyrinth of our perception intersects the "through-fare" of grace. Our unaided vision either defaces the image or suffers the pain the image inflicts on us. In Quarles' *Emblemes,* only by our faith in Christ-as-viewer looking at us through the body of the book can the integrity and significance of the image be sustained.

4

The *Emblemes* enacts the difficult attempt to insert a pictorial element into what I have called a potentially inhospitable literary culture. In the Catholic emblems from which Quarles departs, the connection between the visual and the verbal remains untroubled; for Quarles, as we have seen, it is intensely problematic. Catholic emblematists assume that what we see is congruent with the inner life, with what we feel and think.

There is no better contemporary example of this in the visual arts than the relationship between the sculpture of Saint Teresa in ecstasy in Bernini's Cornaro Chapel and the figure of Federigo Cornaro in the right perspective frame of that same chapel. The ecstasy we see presented in the Saint Teresa is represented, we sense, inside the vast, bulbous head of Federigo—who is, in fact, looking away from the saint, intently focused on his own thought. Teresa is for him, as she is to become for us, an object of meditation, just as immediate to his mind and spirit as the sculpture of the saint and the seraph is to our eye. Indeed the chapel itself is the direct translation of a private experience into a public spectacle—just as it is a translation of a written text, Saint Teresa's *Vida*, into a visual form. But when the pictorial presses too closely on the prior claims of language in a Protestant setting, when the visual intrudes upon a culture that values introspection over spectatorship, the strain on Quarles' *Emblemes* reveals the failure of accommodation between the two.

But the strain also reveals an extraordinarily intense way of being in the world—or of being split off from it. Insofar as the experience of reading answers to the experience of everyday life—and the book's popularity argues an intimate response for seventeenth-century readers—the *Emblemes* dramatizes a radical estrangement of the authentic *linguistic* self from its visual bond to the world. We can no longer verbalize the world by a process of direct translation. We no longer walk through a world whose divine hieroglyphic imprint speaks to us at every turn—such a fully signifying world appears in Vaughan's poetry only as a memory. Instead we stumble among blinding images that continually tempt us to repeat the fall in the garden. Spiritual advisors like Richard Sibbes warn us at great length how *"imagination* hurteth us" by "false representations."[27] The visual world falls silent and recedes from our immediate comprehension, yet beckons dangerously. It becomes less a "readable text" and more an "unreadable rebus"—like a dream, dissociated, compressed, and deceptive in ways that jeopardize discursive interpretation. The implicit analogy—that dreams are to their interpretations as emblematic images are to their texts—suggests that the visible world, as it is pictured in Quarles, becomes a realm of concealment that both resists and fascinates us.[28] No longer a mirror of the divine, it reflects the anxieties of our own attempts to decipher it.

27. Richard Sibbes, *The Soules Conflict with It Selfe* (London, 1651), p. 163.

28. The phrases "readable text" and "unreadable rebus" and the analogy between dream interpretation and emblematics are suggested by Paul Ricoeur, "Image and Language in Psychoanalysis," in *Psychoanalysis and Language*, ed. Joseph A. Smith (New Haven, Conn., and London, 1978), pp. 293–324. Commenting on a passage in the *Interpretation of Dreams*, Ricoeur notes that the "kinship" in Freud "between the task of interpreting a dream and that of interpreting a text is confirmed by the fact that analysis takes place between the story of the dream and another story which is to the first what a readable text is to an unreadable rebus, or what a text in our maternal language is to a text in a foreign language" (p. 300).

The power of Quarles' *Emblemes* stems from that dynamic. In the Catholic sacred emblem, language and image are duplicative: their redundant relationship assumes a world in which words are essentially connected to the objects they name. This relationship gives way in Quarles to a new form of the emblem whose inner tension is its coherence. Despite his invocation of a hieroglyphic cosmos, his work assumes and enacts a drama of perception in which names have become conventional, detached from their objects. Like Hobbes and Descartes, Quarles is wary of the ephemeral nature of sense experience: the mind must reconstitute itself in the isolation of its own language; it can no longer take for granted a network of correspondences between its speech and the language of imagery. The task for philosophy will henceforth be to construct new languages, like the language of mathematics, independent of the evidence of the eye.

In Quarles' world the emblem as traditionally conceived must strain across a widening gap between the verbal and the visual. Rosemary Freeman's criticism of Quarles, that in a mechanical "imposition of meaning" the text of the emblem applies an interpretation to, rather than discovers a significance within, the image, is more apt than Freeman realized. With the semantic congruence between word and image no longer guaranteed, artists attempting to yoke the two would have to reconceive the relationship between them. Seen as a response to this need, Blake's illuminated books complicate the emblem tradition in an art of dazzling improvisatory juxtapositions. Indeed, his revaluation of the ties between "body" and "soul" may be taken in one sense as a revision of the emblematist's traditional distinction. Words, once the soul of the emblem, now become truly animate for Blake—flowing, sprouting, multicolored—while their quirky energy, no longer restrained by standardized print, is embodied in sensual, quasi-pictorial shapes; images speak in a new and private vocabulary of emblematic birds, curling tendrils, and other forms that gesture allusively from plate to plate. These frame, underscore, celebrate, intrude upon, parody, or oppose themselves by "contraries" to the meaning of the adjoining text. If Quarles' work signals the failure of the emblem in England, its success in probing the problems of combining language and imagery points toward the renewal of the form in Blake.

The Line of Fate in Michelangelo's Painting

Leo Steinberg

There are several reasons why an art historian of fastidious taste might want to look at bad art—at poor early copies, for instance, of a great painting, even when the latter survives in near perfect condition. I will need the reader's goodwill on this point since the present essay continually pairs copies of little intrinsic merit with their awesome originals.

That early copies may furnish evidence of damage accrued to the original, and of subsequent overpainting, is obvious and requires no argument. But copies have subtler uses. Where they depart from their models—provided these departures are patently willful and not due to incompetence—they constitute a body of criticism more telling than anything dreamt of in contemporaneous writing. The man who copies a painting looks harder, observes by the inch, and where he refuses to follow his model, follows an alternative, usually critical impulse. Few writers on art have the patience or the vocabulary to match the involvement of a recalcitrant copyist. His alterations reveal how a closely engaged contemporary regarded his model, what he admired or censured, or chose to omit. But while we welcome contemporary comments recorded in writing as evidence of critical attitudes, the more pointed critiques embodied in the copyists' alterations are commonly brushed aside as inaccuracies without positive content.[1]

One more consideration: in a strong design the detail is so integrated that it is hard to unthink. But a deviant rendering in the copy restores to the corresponding feature of the original the character of a decision. One comes to see it as a thing done—and if done, presumably for a reason. Where a copy is manifestly at odds with its model, it not

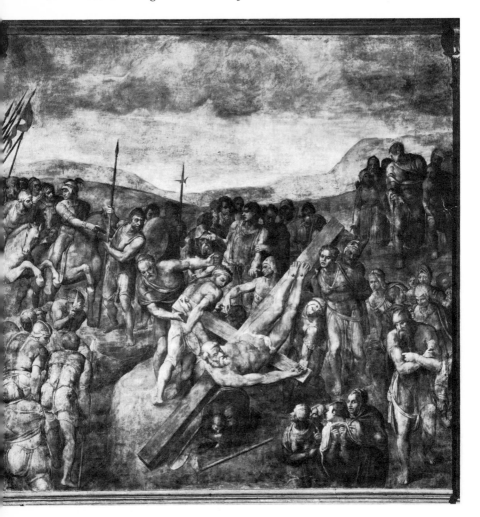

Fig. 1.—Michelangelo, *The Crucifixion of Peter*, fresco. Vatican, Cappella Paolina.

only leads me to see what the copyist missed but what I too hadn't noticed. Ours is by nature a pejorative eye, better adapted to registering a mismatch than agreement. The discrepancies that leap to the eye in comparing replicas with their ostensible models are jolts to one's visual sloth.

Of Michelangelo's last painting—the *Crucifixion of Peter,* completed in 1549 at age seventy-four—three sixteenth-century copies are known: an engraving by Giovanni Battista de Cavalieri, an etching by Michele Lucchese, and an unattributed panel painting (figs. 1-4). The engraving reverses the composition and cuts off the sky; the etching converts the

square format of the fresco into an upright; and the painted panel, though clearly based on the engraving, substitutes a luminous panorama for the bleak background of the original.[2] These massive changes do not affect the dramatic presentation of the event; the copyists, at least, do not seem to have thought so. In transcribing the narrative as conveyed by the fresco's fifty-odd figures, they aspired to accuracy (to the point even of omitting the nails and the loincloth, as the master had done).

FIG. 2.—Michele Lucchese after Michelangelo, *The Crucifixion of Peter,* etching.

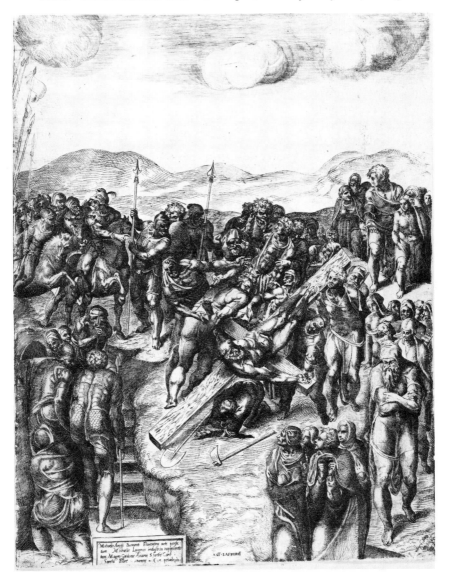

Nevertheless, numerous adjustments and alterations were made—but these, on the face of it, are so inconsequential that the very recital of them suggests a pedantic insensitivity to large issues.

Larger the issues could hardly be. Michelangelo's wall-size fresco was created for the Cappella Paolina, newly built to adjoin the Vatican's stateroom—a chapel designed for the staging of future papal elections. Its decoration had to address the effective meaning of the proceedings, Christ's grant of authority to the Church. But instead of representing Saint Peter in the act of receiving the keys, the fresco, contrary to expectation, depicted a martyrdom: the Prince of Apostles, impaled for his upside-down crucifixion, wrenches his body around and inflicts an all-seeing glance on the voters, of whom one will be summoned to follow him in the Apostolic Succession. A forbidding work, overwhelming in scale, chilling in color, oppressive in its troubled calm and inhibited motion. Whoever has seen it *in situ* without a shudder has not seen well. But my present purpose is not so much to praise the original as to focus on certain minutiae in the copies.

1. Concerning the Ancient in the Phrygian cap, descending at lower right: in the fresco, he strides down almost to very bottom; not a hand's breadth separates his forward foot from the margin, leaving no slack in which to consummate the next step. The copies elevate his position and provide space underfoot to give him somewhere to go. This accommodation must have struck the copyists as a gain. The loss, if there is one, appears only in the context of that thoroughgoing diagonal which dips from the upper left of the fresco toward the lower right corner. By elevating the Ancient's figure, the weight of the downtrend is eased and dispersed.

2. All three copies curtail the transverse beam of the cross. In the fresco (fig. 5), its bright upper end projects past the haunch of the young executioner (three-quarter back view, regardant). In the replicas, the raised end of the crossbeam is both dimmed and cut back. The copyists evidently thought it a pity to see the sweep of the young henchman's hip interrupted by an overrun of mere timber. The fact that this "interruption" helped to promote the continuity of the aforementioned diagonal was no deterrent.

3. In the fresco, the bare-shouldered soldier with pointing index (right of center behind the stem of the cross, wearing a yellow-green leather casque) has no body. Hardly more than a head, arm, and right side of bust constitute his physique; the rest never materialized, though the space to receive it is vacant. Now the artist may have been simply negligent, in which case Michelangelo's commentators, disregarding the lapse, will have matched the original oversight with complementary inattention. Only the copyists saw what had happened and balked, and supplied the deficiency by means of a fluted skirt touching down beneath Peter's arm. But what could have caused Michelangelo to deny this bare moiety of a man his full allotment of body? It takes more than negligence

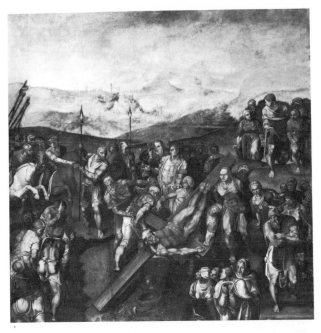

Fig. 3.—Anonymous sixteenth-century painter after Michelangelo, *The Crucifixion of Peter*, panel. Private collection.

Fig. 4.—Giovanni Battista de Cavalieri after Michelangelo, *The Crucifixion of Peter*, engraving (reversed).

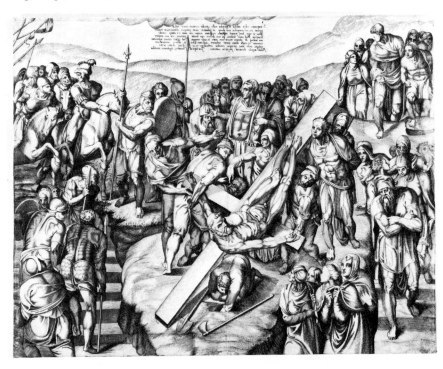

to forget that a soldier has legs; and more than indifference to leave such radical deprivation unremedied through three years of labor. We discover a likely motive when we observe how the omission works and how its work is undone in the copies. For the effect of the unfilled void at the crux is once more to keep that insistent diagonal uninterrupted, gliding over a blank; whereas the columnar extension of Michelangelo's fragment figure stabilizes the center and hampers the downward flow.

One last detail. At upper left, between the profile of the mounted captain and the turbaned head of the rider behind, Michelangelo inserts

Fig. 5.—Michelangelo, *The Crucifixion of Peter*, detail.

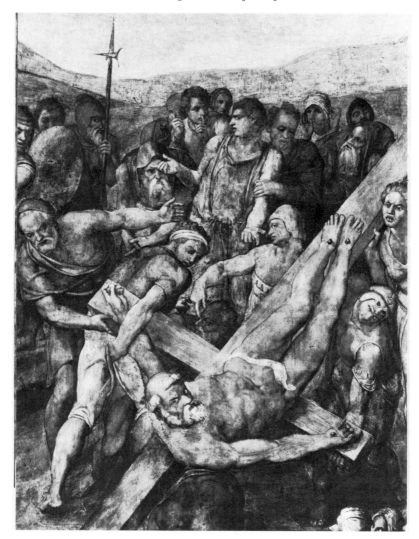

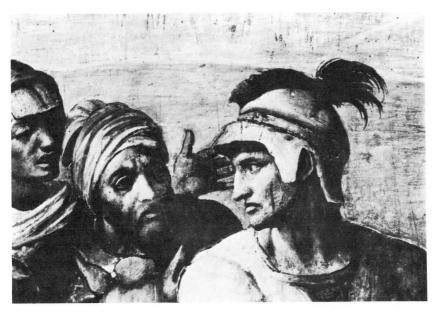

Fig. 6.—Michelangelo, *The Crucifixion of Peter*, detail.

the flat palm of the third in the cavalcade—thumbs up, fingers unfurled (fig. 6). Since this left hand performs no telling gesture, the copies either divert or delete it. The hand's role as hyphen between the captain and his first follower is ignored.

Now the reader may feel that none of the changes described is *significant*, that Michelangelo's narrative content has not been disturbed. If so, he sides with the copyists who must also have felt that their venial trespasses were too slight to affect the work's meaning. I believe they were wrong.

Some years ago I concluded a monograph on the two Cappella Paolina frescoes by hypothesizing a latent, confessional content in the scene of the *Crucifixion*.[3] My interpretation enlisted the very features spurned by the copyists; which explains why that diagonal has been so much on my mind. Following is what I wrote, more or less.

The *Crucifixion* fresco contains no certain self-portraits. Yet two among the fifty-odd faces depicted have been claimed as likenesses of Michelangelo; not perfect resemblances, but facial types into which a self-conscious artist would inevitably project a symbolic self-image. One of these is the ancient solitary at lower right, approaching his exit. He recalls the doleful self-portrait Michelangelo carved upon the face of the mourner in the Florence Duomo *Pietà*. Since this is the work that occupied Michelangelo's nights at home while he was painting the Vatican

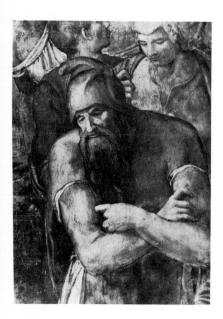

Fig. 7.—Michelangelo, *The Crucifixion of Peter*, detail.

Fig. 8.—Michelangelo, *Pietà*, marble, detail of mourner. Duomo, Florence.

fresco, the psychic resemblance between the carved and the painted figure cannot have escaped him (figs. 7 and 8).

The other "Michelangelo" head—subtly emphasized by the cresting horizon at upper left—belongs to the middle-aged horseman hard behind the equestrian captain.[4] His likeness, dressed in the artist's characteristic turban, comes too close to authentic Michelangelo portraits to be discounted (figs. 9 and 10).

But this gives us two Michelangelos. And as no man can be in two places at once, scholars have allowed only one or the other to represent Michelangelo's self; or else have dismissed both, since the case for either head as a self-portrait seems compromised by the existence of another pretender. But such arguments proceed from misplaced rationality. Suppose we consider the "irrational" alternative that both identifications are right, and that we are seeing the artist portrayed in the full span of his moral history. The turbaned rider then stands for a younger Michelangelo, and we shall find it significant that his place is under the Roman captain's command.

This Roman is not anonymous. In the Acts of Peter he is named the Prefect Agrippa and appears in a fairly good light: the emperor Nero complained that he had not put Peter to death with greater torment.[5] And his face too—like a profile incised on a gem—seems familiar. It is kindred to the face which Michelangelo in his youth bestowed on the *David*, the biblical hero to whom he gave all he knew of alluring mas-

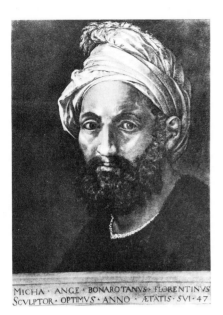

MICHA · ANGE · BONAROTANVS · FLORENTINVS
SCVLPTOR · OPTIMVS · ANNO · ÆTATIS · SVI · 47

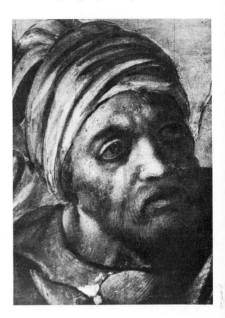

FIG. 9.—Copy after Bugiardini's *Portrait of Michelangelo.* Louvre, Paris.

FIG. 10.—Michelangelo, *The Crucifixion of Peter,* detail.

culine beauty. The square-jawed Agrippa, painted almost half a century later, bears the same sovereign pagan features, matured and hardened, but still the face of Michelangelo's early idealism.

The Prefect now assumes a twofold role. On the narrative level, and in relation to Peter, he is the cool man of action, the officer overseeing the execution. But for the anxious rider behind him, whom we identify with Michelangelo, he embodies the graces of pagan antiquity. And the painter has taken care to ensure that the two heads, crested and turbaned, are seen as a pair; for the interval between them is closed by the hand of another, serving as copula. The Prefect, then, not only commands Michelangelo but intervenes between him and Saint Peter.

Our musing is worth pursuing a while longer because it deepens the sense of at least one other action within the picture, that of the youth leading the chorus of witnesses at upper center. Again, at a literal level of interpretation, he is protesting the Apostle's ignominious execution to the Prefect; hence his pointing both ways. But for whose benefit is he pointing? To the Captain in charge of the operation, the victim protagonist hardly needs to be pointed out. The artist has even averted the Captain's head, clear signal that not he is being addressed. Aimed at the Prefect, the gesturing of the chorus leader would remain functionless and inadequate to the occasion. Yet the glare of his eye and his fingers outthrust at right angles bespeak fierce intensity. They suggest a more terrible possibility—that the chorus leader directs his expostulation not to the

Prefect alone, but to him and his turbaned follower. For he points both to Saint Peter and to where Michelangelo is spending his manhood, as if to say, "They are crucifying the Apostle of Christ, and you keep their company?" The old convert's regret over a misspent life—his poems bemoaning the "fantasy" that had led him to make art his "idol and sovereign"[6]—this internal indictment raking Michelangelo's conscience would then be personified in the chorus leader.

If this reading is true—though beyond proof or disproof—then the whole fresco turns into a chart of the artist's personal trial. It is the descending graph of Michelangelo's destiny that runs, from his early idolization of pagan beauty and art, from the vigorous upper left corner, down the imperious diagonal of the Prefect's commanding arm and on through the transverse beam of the cross, down to his own self again— himself in deepest old age. Arrived at the lower right, he meditates on the death of the Apostle who had denied Christ and repented. And the arms of Saint Peter's cross reach to connect the poles of Michelangelo's life—from his own early denial to his present contrition. The work's ultimate meaning flows in the geometry of its structure.

So much for the reading proposed five years ago—hardly a model of safe methodology; shot through with escalating assumptions. The identification, for instance, of the Ancient as a spiritual self-image is arguable—his beard is longer than Michelangelo's ever grew. The same goes for the turbaned rider, whose beard in the fresco is a villainous red—not Michelangelo's natural color. And a skeptic could claim that the chorus leader's reproach (if reproach was intended) cannot be addressed to the man in the turban since the Prefect gets in the way.[7] As for the connecting diagonal by which my hypothesis links two phases of the artist's divided self, we have seen our sixteenth-century copyists give it short shrift, and they, if anyone, being participants in Michelangelo's culture, would have grasped its semantic potential. Yet they seem to have thought the diagonal insufficiently meaningful to need stressing, too obvious as a compositional bond, and, in its sinking seesaw effect, undesirable.

Critics of my book voiced more fundamental objections. Sir Ernst Gombrich, reviewing *Michelangelo's Last Paintings* as "a dangerous model to follow," reminded readers of the *New York Review of Books* that I had presented my reading as beyond proof or disproof.[8] "But," he added, "it is not proof one would like to be offered but documented analogies." And he went on to ask why Vasari, who "to be sure . . . missed certain things and was altogether not a very profound man, but [who] knew Michelangelo quite well and admired him unconditionally," why this same Vasari never referred to "any such painted autobiography as the descent from an earlier to a later self."

I take this rhetorical question to mean that there are limits to the

inventiveness we may safely impute to Michelangelo. If what I credit him with is not duplicated elsewhere (no analogous instance being reported), then my interpretation can only be a misguided attempt to "approximate Michelangelo to artists of our own time whose creations may indeed resemble dreams where personal and public meanings interpenetrate. But history is about the past, not the present," says Gombrich.

Let me for a moment assume that I erred—this would not be a matter of general interest. But what becomes of the observations on which the hypothesis rested? Consider an archaeological parallel: an excavator digs up certain potsherds and assembles them as best he can in a hypothetical structure; and suppose his construction is questioned. What's to be done with those sherds? Shall they be built into a stronger vessel or be plowed back underground? Now the sherds I applied to my *vas interpretationis* are certain data: that Michelangelo's picture lays down a pervasive diagonal, keeps it running through stress and sacrifice, tips its extremities with two self-like figures contrasted as young and old, and so on. These observations have not been invalidated; they remain pieces of Michelangelo. Shall they be barred from consideration and revert to randomness as before? For the implicit result of Gombrich's caution is this: since my perceptions led to a culpable misconstrual, let them be driven from consciousness; one is safer without them. Indeed, Gombrich's article reproduces not Michelangelo's fresco, but the reversed Cavalieri engraving—a substitution whereby the latter's divergences from the original are pronounced inconsequential. And if Cavalieri's dismantling of Michelangelo's rigid diagonal is not felt as a loss, then clearly any interpretation resting on its alleged potency rests on nothing. It then becomes proper to ask by what right a modern heaps meaning on a compositional feature which even contemporary copyists thought expendable.

Yet I persist: for though that diagonal may not have interested a soul since Michelangelo laid it down, I perceive it as an unalterable necessity. Nor would I placate my critics by tapping Vasari; one consults him, of course, but not for permission to see.

And suppose that a symbolic structure resembling a dream "where personal and public meanings interpenetrate" had once been attempted in sixteenth-century art. That attempt will not be so recognized unless someone salutes. Because, as the physicist J. A. Wheeler has put it, "no . . . phenomenon is a phenomenon until it is an observed phenomenon."[9] And once observed, other Michelangelo paintings may unexpectedly bring confirmation. With this prospect in view, I turn to the work immediately antecedent to the decoration of the Cappella Paolina—the *Last Judgment* fresco on the altar wall of the Sistine Chapel, executed during the years 1536 to 1541 (fig. 11).

The literature on the *Last Judgment* is very large. What shocks one in

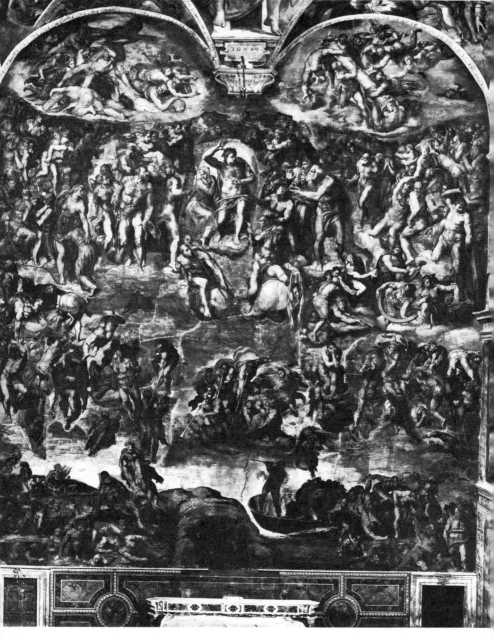

Fig. 11.—Michelangelo, *Last Judgment,* fresco. Sistine Chapel, Vatican.

the perusal of it is the prevailing carelessness of observation. There are valiant exceptions, of course, but their rarity proves how much easier it is to read and rehearse one's reading than to use one's eyes and trust what one sees.[10] The fresco's critical history is a classic instance of how an interpretative tradition feeds on itself, and how rarely the object interpreted is permitted to interfere. Through four centuries of continuous exposure, the *Last Judgment* ranked with the world's best-known monuments, incessantly reproduced and described, praised and denounced,

scanned and scrutinized daily by thousands, with detail photographs available for the past hundred years. Yet it was not until 1925 that the face in the flayed skin held by Saint Bartholomew (to the right below Christ) was identified as the artist's self-portrait (figs. 12 and 13).[11] Why this delayed recognition? What inhibited the perception, which now seems so overwhelmingly obvious, that the Apostle martyred by excoriation appeared in the fresco as a bald white-bearded figure, holding the skin of another, whose short hair and beard were, like Michelangelo's, black and curly? Was the visual evidence eclipsed by Vasari's silence? Did Vasari as our primary source set the professional norm for what was to be overlooked? And is this why the discovery of the self-portrait had to await an outsider, Francesco La Cava, a physician unconcerned about art-historical rules?[12]

With La Cava's discovery, the flayed skin in the fresco became once again controversial, as it had been when first unveiled. Traditionally, Saint Bartholomew had been represented as a venerable Apostle, content to display a knife in sufficient token of martyrdom. The conceit of doubling his attributes by making him flaunt his own peeled-off hide seems to have struck some of Michelangelo's critics as outlandish and unnecessarily savage.[13] Yet the motif was not, in fact, new, and the offense to good taste does not seem appreciably greater than that of depicting Saint Lucy with her eyes on a platter. But I suspect—though no one said so outright—that Michelangelo's Catholic critics reacted to something more sinister than a breach of decorum: a faint reek of heresy. For it was the Protestant North that had produced the outstanding precedents for the motif of Saint Bartholomew with the flayed skin in his hands. In drawings, woodcuts, and book illustrations (figs. 14 and 15), Lucas Cranach, Hans Baldung, and others associated with the *luterani* had celebrated the cult of Saint Bartholomew's skin, because that skin was preserved as a principal treasure in the collection of relics assembled in Wittenberg by Luther's protector, the Elector of Saxony, Frederick the Wise.[14] In 1509, the collection had been published with exquisite woodcuts by Cranach, including the skin of Saint Bartholomew's face (fig. 16). And though Frederick never broke with the Catholic Church, and though Luther himself condemned the veneration of relics, yet the link between Saint Bartholomew's skin and the city of Wittenberg, hotbed of heresy, could not be thought away. Since Saint Bartholomew was also a patron of Rome (where his bones had been revered since their last translation in 983 to the Church of S. Bartolomeo all'Isola), what justification was there for Michelangelo's touting of the famous Wittenberg relic? His emphasis on this Northern motif must have struck informed Catholics as a provocation. And his ridiculous fancy in identifying himself with that skin—assuming that the likeness was recognized—would not have blunted its provocative character. Hence, perhaps, the intrusion of the word "Lutheran" in an anonymous blast directed at Michelangelo in 1549.[15]

But did anyone in Michelangelo's day recognize the man in the skin? Here the record is inconclusive. Condivi's text makes the skin no more than the token of the saint's own ordeal. But an engraved copy of the *Last Judgment* (by Beatrizet, 1562) has the legend "Michael Angelus Inventor" issue from the skinned portrait as from an alternative signature, alluding apparently to an open secret (fig. 17). More problematic is the painted copy by Marcello Venusti (fig. 18), Michelangelo's close collaborator during the 1540s. The copy (commissioned in 1549 by Cardinal Alessandro Farnese and now in Naples) has been cited as proof that the skinned face was not recognized even by Michelangelo's friends, since Venusti's work introduces an authentic Michelangelo portrait among the resurrected at lower left.[16] This, it is argued, Venusti would not have done, had he known the artist to be already present in effigy. But the evidence can go either way, for Venusti may have contrived an elaborate cover-up. Observing the physiognomic discrepancies between the Apostle and his flayed visage, he reconciled them by blackening Saint Bartholomew's pate and beard, while lengthening the skinned nose and whiskers. In other words, he dissembled Michelangelo's features and mutually approximated the two faces involved. And he may have done this either because the given dissimilarity made no sense, or because he understood that the sense it made were better played down. Meanwhile, the insertion of a conventional author portrait in a decently marginal place might divert attention from Michelangelo's self-display in Christ's entourage.

When the fresco was recent enough to be newsworthy, and while altercation about its libertinism troubled the Vatican, the disparity between the saint and his supposed skin was commented on in writing by at least one observer. He was Vasari's friend and diligent correspondent, Don Miniato Pitti, Prior of the Florentine Olivetans, a learned man with a light touch. In a jovial letter sent on 1 May 1545 to Vasari in Naples, Don Miniato, fresh from a trip to Rome, refers to a visit he paid to the Sistine Chapel. After stating that he preferred the Ceiling to the *Last Judgment,* he adds, as if to mock the accusations hurled at the latter: "Because there are a thousand heresies here, and above all in the beardless skin of Saint Bartholomew, while the skinned one has a long beard; which shows that the skin is not his, etc [*sic*]."[17]

No evidence here that the writer failed in his grasp of this recondite "heresy." His irony seems rather to hint at a matter known to his addressee, but best left unspoken, since the fresco was already overexposed to attacks on the artist's licentiousness. Who knows what lurks in the "etc" at the end of the passage? We are left, at any rate, with these two possibilities: either Vasari failed to recognize the master's self-portrait— which would make him more obtuse than we think he was; or, being cognizant how such egocentricity amidst universal doom confounded "personal and public meanings," he thought it prudent, when writing his

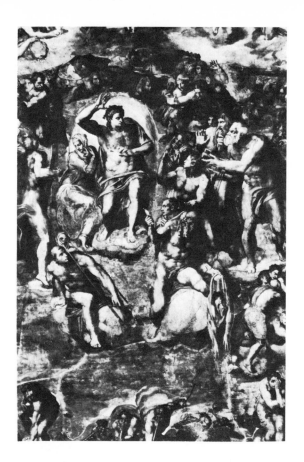

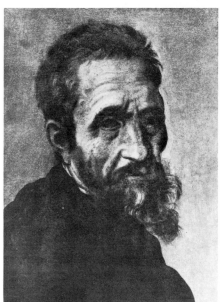

FIG. 12.—Michelangelo, *Last Judgment,* detail.

FIG. 13.—Jacopino del Conte, *Portrait of Michelangelo.* Uffizi, Florence.

Michelangelo *Vita,* to divulge less than he knew. As he referred to no "painted autobiography" in the *Crucifixion of Peter,* so he kept silent about the self-portrait in the *Last Judgment;* and nearly four centuries of occultation ensued.

During this period, Michelangelo's features were emblematic—like those of a Socrates, Dante, or Charles V. Yet his presence in the Sistine *Last Judgment* ceased to be visible because it lacked written certification, and because the visual datum alone was too unexpected: no known analogies prepared one for the paradox of a painter's self investing Saint Bartholomew's skin; or, more important, for his presumptuous claim on Christ's full regard, just when the divine Judge must be having all humankind on his mind. Even those numerous writers on the *Last Judgment* who focused on the Apostle missed Michelangelo's conspicuous likeness—overlooked even the incongruity between the saint and his skin—expounding instead what it was logical to expect.[18] L. L. Chapon's little book on the *Last Judgment* (1892) pretended to identify some eighty of the characters represented—from Esau to Cesare Borgia, managing one direct hit in the identification of Savonarola; but Michelangelo's likeness escaped him.[19] And Michelangelo specialists—Steinmann's Saint Bartholomew holds "die eigene Haut"—scored no better.[20]

FIG. 15.—Hans Baldung Grien, *Saint Bartholomew,* drawing. Kupferstichkabinett, Basel.

FIG. 14.—Lucas Cranach, *Saint Bartholomew,* woodcut. Geisberg 573.

Der Sechst gang
Nam vñ zwentzig andre partickel des gebeins sant Bartholome
Die gantze hawt des angesichts sant Bartholomej
Summa .xlv.partickel

FIG. 16.—Lucas Cranach, *Reliquary of Saint Bartholomew*. Woodcut from the *Wittenberger Heiligtumsbuch* (1509).

It is disconcerting, in retrospect, to see so great a Michelangelo scholar as Karl Frey wrestle the problem only to go down in defeat. Frey was the first to publish Miniato Pitti's letter to Vasari and to comment on it at length. Pitti's "thousand heresies" he understands to be meant tongue in cheek, "scherzosamente," and he praises the Prior's astuteness in catching the disparity between the bearded Apostle and his beardless skin. But Frey attributes the observation to that "monkish bantering superficiality which in those times held sway in matters religious"—and promptly misunderstands it. Don Miniato had offered both an observation and a conclusion: he had noticed that the bearded Apostle held a skin with a beardless face; he had concluded that the skin must be another's. But though it was clearly the conclusion that mattered, Frey pretends that Don Miniato had faulted the Saint Bartholomew figure solely for retaining its beard after excoriation. This deflection enables him to exonerate Michelangelo on the grounds that the face in the skin does show a bit of a beard; and that, anyway, the skinning was thought of symbolically, not realistically. Finally, in a desperate appeal to

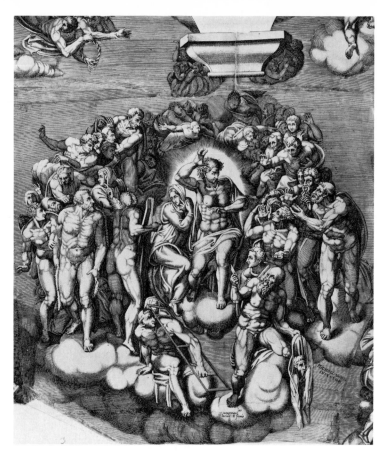

Fig. 17.—Nicolas Beatrizet after Michelangelo, *Last Judgment,* engraving, detail.

eschatological pogonotrophy, Frey suggests how Michelangelo might have silenced his critics by pointing out that the saint's protracted sojourn in Paradise would have allowed him to grow a fresh beard along with new skin in time for Doomsday.[21] Since Frey saw no purpose in Michelangelo's differentiation between the saint and his skin, he must either minimize it or explain it away. The one unavailable recourse was the acknowledgment of Don Miniato's conclusion: that the flayed skin pertained to a different person. Two years later (1925), La Cava published his paper, *Il Volto di Michelangelo scoperto nel Giudizio Finale.*

The response to La Cava's "sensational discovery" was instantaneous. Outstanding scholars, notably Wittkower, welcomed it with enthusiasm and congratulated the finder.[22] And the art-historical world by and large has accepted that rumpled ragface as Michelangelo's only certain self-portrait. A few voices rose in vain opposition, and skeptics demurred as late as 1942, when Angeleri argued without success that, since Michelangelo's contemporaries had not recognized the self-portrait, those who would so identify it four centuries later must be hallucinating.[23]

The self-portrait was no sooner identified than Corrado Ricci built it into a small private drama.[24] If the skin represented the artist, then, he proposed, the man holding it could be none other than Aretino, whose features, as portrayed in Titian's painting at the Pitti Palace, have much in common with Michelangelo's Saint Bartholomew. And since Aretino did chide the artist in one famous diatribe, Michelangelo may well have thought himself "flayed" by the unscrupulous publicist. The hypothesis had some flaws: Aretino's attack did not come until 1545—about seven years after the Bartholomew would have been painted. And it is hard to accept an identity glide that invests Aretino with the dignity of an Apostle. Furthermore, as pointed out to me by Dr. Sheila Schwartz, the instrument of the saint's martyrdom cannot also be the tool by which he

FIG. 18.—Marcello Venusti after Michelangelo, *Last Judgment*, painting. Museo di Capodimonte, Naples.

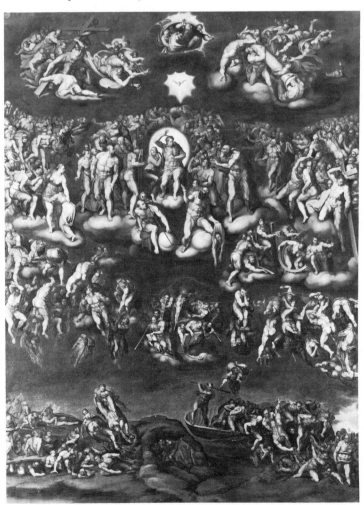

himself administers torture; an interpretation, however attractive, should not contradict the literal sense of an image. Nevertheless, the hypothesis was widely accepted,[25] even by Tolnay, who wrote: "The brutal figure of Saint Bartholomew, bearing the knife with which he has skinned Michelangelo, shows a strange resemblance, as has already been observed, to Pietro Aretino, who was a real castigator of the artist. . . . The [written] correspondence between Michelangelo and Aretino would explain sufficiently the role which the artist reserved for the latter in his fresco."[26] Incredible that these lines appeared as late as 1960 in a standard five-volume Michelangelo monograph. The writer is willing to cast an Apostle of Christ in the role of Michelangelo's executioner; willing to make the divine Judge—whom he sees dispatching Michelangelo into hell—join forces with Aretino. In Tolnay's reading, the affliction which Michelangelo would here claim to have undergone is consummated by Christ. What are we to think Christ is doing? Cursing Michelangelo for allowing Aretino to flay him?

The Saint Bartholomew-Aretino equation (unworkable if only because Aretino enjoyed a full head of hair until his hilarious death) has quietly dropped out of recent discussions. But it left behind a habit of explaining the flayed skin in the fresco as a reference to hardships endured, a habit instilled originally by the wishful secularism of the past century. Modern scholia continue to gloss the flayed portrait as a grim joke or, if in dead earnest, as a protestation of personal martyrdom in the cause of art.[27] Such interpretations isolate the shed skin from the rest of the fresco and from the general proceedings of Resurrection and Judgment. Overlooking the context, they assimilate the self-portrait to the Romantic mythology of the suffering artist, *le peintre maudit.*

Now it is undeniable that Michelangelo was a habitual complainer. But by the mid-1530s, his Christianity and his anxiety to be saved for the Vision of God were authentic and urgent. Reading his poetry and the facts of his life, we are left in no doubt that he believed in the reality of the Last Things. And what does such a believer say to the wound-flashing Christ of the Second Coming? Our secularizing interpreters would have Michelangelo say, "You're telling me, look how *I* suffered!" This is not the Michelangelo of the sonnets, nor that of the fresco.[28]

But if all these interpretations went wrong, where does one turn for right guidance? Where but to the work itself? Let us agree, to begin with, that we are not shown, as *Life Magazine* long ago phrased it, a Saint Bartholomew who "holds his own mortal skin, in which Michelangelo whimsically painted a distorted portrait of himself."[29] The face was sloughed with the rest of the skin and goes with it. What we see is a Saint Bartholomew with another's integument in his hand. We next consider an aspect of the self-portrait which even La Cava left out of account—its relative siting. This has to matter since the portrait lies in the path of

Christ's imminent action. More than that, it lies on a diagonal that traverses the fresco like a heraldic bend chief to base—from left top to right bottom (fig. 19). The twofold competence thus assumed by the self-portrait—in its concrete location and in the range of its influence—is something to marvel at. A hangdog face flops to one side, helpless and limp. But the tilt of its axis projected upward across the field strikes the apex of the left-hand lunette, the uppermost point of the fresco. And if, departing once again from the skin's facial axis, we project its course netherward, we discover the line produced to aim straight at the fresco's lower right corner. Such results do not come by chance. To put it literally, letting metaphor fall where it may: it is the extension of the self's axis that strings the continuum of heaven and hell.

There is more. Upward from the face in the skin, the passage of the diagonal seeks, like a mystic's itinerary, the most intimate contact with Christ. Inevitably, the line crosses some forms, such as Saint Bartholomew's torso, without marking significant stops. But can it be unintended that the line runs unerringly to the wound in Christ's side—the source of the saving Sacraments?[30] Higher still, the line traces the diameter of the Crown of Thorns, displayed by an angel naiant in the left-hand lunette. (We suddenly understand why this Crown is held forth ostensively at full circle, whereas copyists such as Venusti, Della Casa, and Bonasone thought it more interesting to tilt it into a perspectival ellipse.) Finally—after intersecting that point on the triumphant Cross where the head of Christ rested at the Crucifixion—the line touches the vault of heaven at its visible peak, that is to say, the topmost reach of the fresco. In other words, the deceptively feeble sway of the face in the skin generates a diagonal axis that climbs to the summit point of the vision.

Hellward bound, this same trajectory links three foci of deepening degradation. Down one step from the abject self-image, it pinpoints the stricken shameface of the first of the reprobate, Michaelangelo's gruesomest image of man rejected. He may be one anonymous sinner, but he looms in the fresco like an emblem of guilt, his thighs clutched by demons, snake-gnawed, impacted by shame. And verging forth from this castaway, the deadset, hellbent itinerary—solidifying near bottom in a figure falling from Charon's barque—plunges to the ultimate abomination, the engaged groin of the Prince of Hell, so-called Minos, his penis berthed in a serpent's mouth (figs. 20 and 21).

In the original fresco this unseemly detail has been long covered up by overpainting, and we would lack knowledge of it were it not for the early copies and for one scurrilous sonnet *dell'epoca,* still unpublished.[31] The art-historical literature observes silent censorship on the subject, endorsing the spirit of the Council of Trent which ordered the cover-up of the fresco's obscenities. You would think Michelangelo had defaced the altar wall of the papal chapel with a lewd provocation—like schoolboy smut on a public wall, which one punishes by inattention till they get

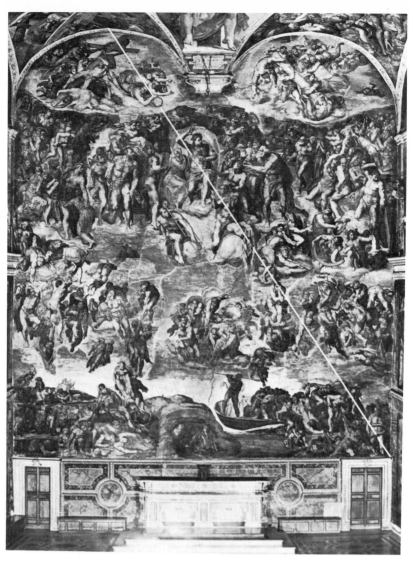

FIG. 19.—Michelangelo, *Last Judgment* (with Line of Fate).

around to cleaning it up. As for the rare published references to this feature, they prove that it has not been frankly observed, let alone pondered: for the authors agree in declaring Minos' genitals to be bitten, thinking, no doubt, of the painful reptiles in Dante's *Inferno*. But those are instruments of the Devil who would not maltreat their own lord—a Prince of Hell, incorporeal in substance, does not undergo the physical pains he bestows. And Michelangelo's so-called Minos does not, in fact, show the least sign of unease. He stands snugly wrapped in his snake, which his right hand sustains in position, and entrusts his private parts to its mouthing. Between them, no enmity; for it is a befriending serpent

that hugs him, female to his own sex, the lodgement of the phallus received defining the spouse. In a satanic inversion of sacred marriage, the consort's caress betrays a connubial tryst, unholy nuptials perpetually consummated. Michelangelo's Antichrist, mounted over the Sacristy door in odious prominence and proximity, is an icon of naked evil, of corruption wed to the serpent's mouth, fount of poison.

But what chiefly concerns us here is the alignment, the topical definition of the motif. Is it not strange to see this bestial fellation trued with Christ's wound and crown, and again with the artist's self-image, bobbing the line that plummets from peak to base?[32]

At this point, some of my cautious colleagues are tossing their heads, protesting that one can always crisscross a picture with lines that are bound, sooner or later, to strike points of interest. To still their qualms, I propose the following operation: apply an inch rule to our diagonal on a good-sized reproduction (mine, purchased some years ago at the Vatican, hangs five feet tall). You discover—I am still awed at the sight of it—that the midpoint of the face in the skin marks the centerpoint of the bend, exactly halfway between the highest and lowest points of the traversing diagonal. Again, such precise ratios do not materialize accidentally, and no one who has ever constructed a picture will doubt that these metric relations were planned. In fact, the centrality of the shed

FIG. 20.—Cherubino Alberti after Michelangelo, figure from *Last Judgment*, engraving.

FIG. 21.—Michelangelo, *Last Judgment*, detail.

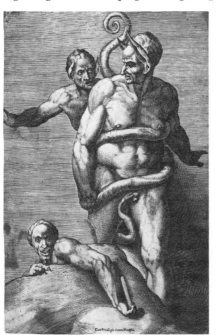

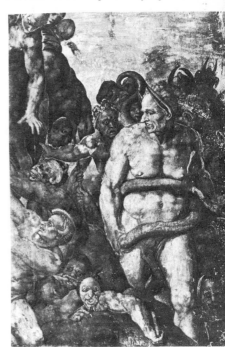

skin on that two-way track must have been envisioned by Michelangelo before the painting began. No late afterthought could have made his mournful visage bisect as well as engender the universal diagonal in prolongation of its own axis. Within the overall composition—which we normally read as a system of stratified symmetry—the included self was to constitute a secret, alternative center.

But why as a flayed skin? The fresco contains intimations that Michelangelo shared Juan de Valdes' belief in the "Resurrection of the Just," a heterodox doctrine widely held in the 1530s in that circle of evangelical Catholics to whom Michelangelo was attached. The doctrine reserved resurrection for the righteous alone, while the wicked, denied the friendship of God, were extinguished.[33] Where, in this scheme of things, would Michelangelo place himself? His vision of the Last Judgment arrests an uncertain instant when, among those repossessed of their flesh, one man alone remains unrestored, a dejected sheath lacking body; for whom Saint Bartholomew pleads as his intercessor: "Do not cast him away; let him too resurrect into eternal life." The image evokes words from the Book of Job which Michelangelo, in his youth, would have read beneath an abbreviated *Last Judgment* on Bertoldo di Giovanni's medal for a bishop of the Medici family (fig. 22). On the medal, too, the Last Judgment was referred to one individual's hope. Its legend—ET IN CARNE MEA VIDEBO DEUM SALVATOREM MEUM—derived from those verses in Job which Aquinas cites as proof of bodily resurrection: "I know that my Redeemer liveth, and in the last day I shall rise out of the earth. And I shall be clothed again with my skin, and in my flesh I shall see my God. This hope is laid up in my bosom."[34]

FIG. 22.—Bertoldo di Giovanni, *The Last Judgment,* reverse of medal of Filippo de' Medici. National Gallery of Art, Washington, D.C.

Christ's glance and gesture direct themselves pointblank at the wretched likeness of Michelangelo's self—the whole cosmic drama collapses upon his destiny. Not because the artist thinks himself foremost amongst mankind, but because the Last Judgment conceived as more than a fable, and more than a warning to others, is real only to the extent that the man who tells of it knows himself to be the first on trial. This is why the detritus of the artist's life usurps Christ's attention. It *had* to be Michelangelo who was first in line, because the narration was his. Or put it this way: the Last Judgment—as I believe Michelangelo pondered it—is not staged for generic mankind but for each self within mankind. And how shall this eachness be tested but on this only-known body in its own dear corruptible hide?

Thus the question whether the flayed skin represents the artist in fact, and whether Michelangelo's friends had so identified it, fades into relative insignificance. Saint Bartholomew holds a skin which is not his but another's. And more important than that other's identity is the consequence of its location. The issue at the instant of falling judgment is whether one rotted vesture is to be fleshed or not, salvaged or dropped. Nothing in the character of this worthless rag recommends it for grace; gravity, which would pull it down, is all it contributes. But the uncertainty of the outcome is implied by the indeterminacy of Christ's gesture, by the intercession of the Apostle, and by the skin's centered position on one beam of destiny discharged from its axis two ways. The predicament is that of every believer. And if Michelangelo, by dint of a physiognomic resemblance, projected himself into it (as the poet Crashaw would do a hundred years later[35]), the universality of the symbol remains undiminished.

Inevitably, this coincidence of private and public meaning—and of meaning engendered by collocation—surpassed the comprehension of the artist's contemporaries, Vasari included. The numerous sixteenth-century copyists of the *Last Judgment* paid little heed to the pervading bend as a compositional feature, and none to the significant linkage of stations charted upon it. Entirely unsuspected was the centrality of the portrait on the diagonal. The copies see the design governed by only two general principles: axiality and stratification. That is to say, they acknowledge a bilateral symmetry about a perpendicular dropped from corbel to altar, and they preserve the terracing in four superposed tiers: above a thin stratum of earth and an aerial zone of transition comes the realm of the blessed, topped by a heaven of angels—each zone preserving a perceptible correspondence of left and right.[36] Apart from respecting this layered symmetry, the copyists treat Michelangelo's composition as elastic and episodic—nothing lost if some units are moved about. Say that the copyists of the *Last Judgment*—in common with literary detractors and panegyrists—responded only to a middle range of phenomena: they saw the *dramatis personae,* their groupings and clusters, their motions and famous foreshortenings, and so forth. But they missed

the artist's intent at its extremes: in its calculated refinement and in its largesse. The minute adjustments that enabled Michelangelo to maintain, for example, a precise ambiguity in the posture of Christ—this lay demonstrably outside their ken.[37] And they missed as surely the larger connections—the far-flung ligatures crossing the field, the changes of scale that cause space to fold in and out, or the fresco's bold interaction at every juncture with the given architectural set.[38] Nowhere in the sixteenth century (nor since, for that matter) do we find an awareness that location in Michelangelo's compositions is stringent, not loose or approximate; that a unit emplaced derives operative power from its position, like a chesspiece in play.

The placement of the face in the skin has far-reaching consequences. First: it removes lingering doubts about the correctness of an identification resting on likeness alone; for it would be contrary to Michelangelo's essentially anatomical sense of stress to articulate a median or major junction with a nonentity. Second: the integration of the motif with the vision in its entirety assures us that the self-portrait is no mere "signature," or grim joke, or autobiographic aside recalling illusage by Aretino, or more general plaint about life's tribulations. Any interpretation that fails to locate the portrait at the nub of the compositional-ideological structure misses the point. Third: it appears that Michelangelo injects a self-image into a public work where he feels fatally implicated. The degree of actual likeness is variable.[39]

Fourth: the very positioning of the self in the *Last Judgment* fresco is metaphoric and produces something like a continuous emission of meaning. Without straying from the visual evidence, we may say, for instance, that the zoning of the wall surface keeps heaven far distant from earth and hell, but that the self, by virtue of its linear potential, draws them together. And there is more. Christ and the soul on trial emerge as correlative centers. And the respective natures of the systems they centralize differ significantly: Christ at the hinge of a coordinate cruciform structure, the labile self centering an unstable obliquity, and so on. The dispositions in space convert gladly into theological propositions because they are framed in that same ground whence religious thought too takes its rise.

Fifth: since the fresco pins Michelangelo's self between the remote poles of a diagonal, it becomes less improbable that the work of the next decade, his last fresco in the Cappella Paolina, should find him at the termini of a diagonal that reads once more as a line of fate. And the persistence of such structural thinking in Michelangelo's work is confirmed by the one fresco cycle we have yet to consider—the Sistine Ceiling (1508–12), begun a quarter century before the *Last Judgment,* when the artist was thirty-three.

The Ceiling's long central rectangle, a simulated stone cornice

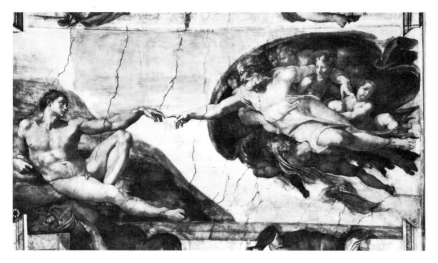

Fig. 23.—Michelangelo, *The Creation of Adam,* fresco. Sistine Chapel, Vatican.

crossed by nine rectangular bays, contains scenes from the Old Testament, wide and contracted frames alternating. Thematically, the series falls into three triptychs. The chronological sequence begins over the altar with the creation of nature. It ends toward the Chapel entrance in three scenes from the story of Noah. The middle triad tells the story of Adam and Eve, and a word must be said about each of its parts.

The *Creation of Adam* is the best known (fig. 23). It has lately become as banal as any image whatever, if only because, like Leonardo's *Last Supper,* it is continually being adapted to political satires, lampoons, advertisements, and the like. These travesties (which I collect with grim relish) deserve careful study for what they reveal about the psychology of perception—not one of them recognizes that Michelangelo's figure of the Creator is ambidexterous. Since the fresco is famous for God's right-handed reach toward Adam, no more than His right hand is noticed—as if the left were idly thrown over the back of a chair. But Michelangelo's bimane figures need watching at both extremities, and we should be missing the better half if we ignored God's alternate arm, which, without lassitude or diminution of power, embraces a winsome girl.

Unfortunately, the identity of the embraced is still in dispute because Vasari failed to single her out. His description acknowledges only "a group of nude angels of tender age"; the young female under God's reserved arm is consigned as one of "alcuni putti" to a nondescript status, there to abide incognito from Vasari's day until about 1900.[40]

But see what she does. Crouched in the posture of the familiar *Vénus accroupi,* she eyes God's latest invention with the keenest interest and reacts with a left-handed gesture, gripping the heavy paternal arm that weighs on her shoulder. Is she holding on to it in the shock of her vision,

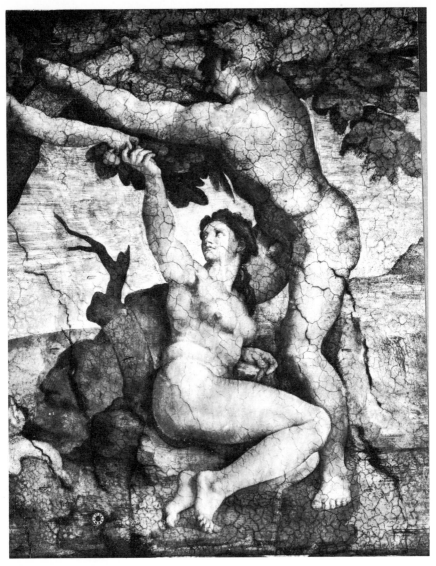

FIG. 24.—Michelangelo, *The Temptation and Expulsion from Paradise,* detail of the *Temptation,* fresco. Sistine Chapel, Vatican.

or wanting to shake it off? The ambivalence of the gesture implies woman's relation to the father as she assumes her relation to man.

And there is more, for being all-woman, she relates as well to the child. God's far-reaching arm, yoking her huddled form, comes to rest on a powerful putto reclined in Adamic pose, a child overscaled for his infant years and gravely serious—the only person within these biblical histories in eye contact with the beholder. Michelangelo surely meant him to represent the Second Adam, so that the span of God's arms becomes coextensive with the redemptive history of the race.[41] And the

Child's intimate nesting near to the woman's limbs makes him the son of Eve, son of the First Eve as of the Second. For the First is the type of the other: as theologians used to point out, the "Ave" by which Mary is hailed is but "Eva" reversed. Accordingly, we do better by Michelangelo if we distinguish the young female under God's arm from Vasari's "alcuni putti" to recognize Eve in her—Eve as yet uncreated, whom Adam aborning foresees, as we read in Saint Augustine.

The middle panel, which is also the midpoint of the whole Ceiling, depicts the *Creation of Eve,* the woman marking its center. At the bidding of God she steps forth from the body of sleeping Adam, her childlike trust strangely at odds with her ripeness. There follows the last of the three central panels, representing sequentially the *Temptation* and *Expulsion from Paradise* (fig. 24).

The Eve in the *Temptation* scene, resting at ease between Adam's thighs, has grown remarkably debonaire. Without discommoding herself, she turns centerward and humors the serpent with a complaisant hand by taking the proffered fruit, rendered here as a pair of figs. Nothing better confirms her insouciance than the way she has of leaning on her right arm, of which only the hand, seemingly idle, is visible. But if one studies this hand—a detail almost too small to discern from the Chapel floor—one discovers it to be strained in a manner incompatible with relaxation: a stiff middle finger, stretched straight between thumb

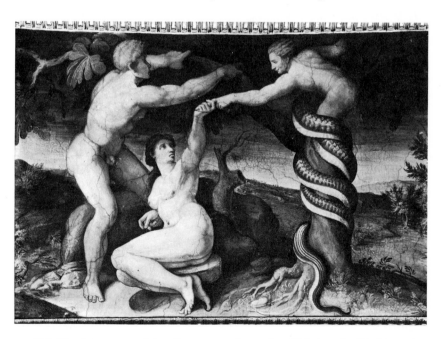

FIG. 25.—Anonymous sixteenth-century painter after Michelangelo, *The Temptation,* fresco. Palazzo Sacchetti, Rome.

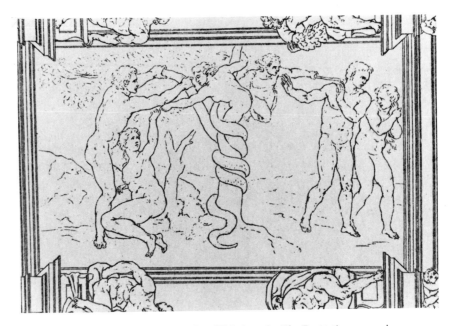

FIG. 26.—Domenico Cunego after Michelangelo, *The Temptation*, engraving.

and flexed index, points back to herself. If Michelangelo was not being thoughtless, then this rigid finger is a phallic allusion. At the instant of Original Sin, as if by unconscious reflex or premonition, Eve designates her receptive womb.[42]

Before we speculate further on this fateful gesture, it is well to cast a glance at the copies, which turn out to be surprisingly few. The left half of the fresco was included in no engraving until the late eighteenth century. And only one painted copy—part of a decorative frieze in the Palazzo Sacchetti, Rome—comes down from the Cinquecento (fig. 25). The frieze is hackwork, a potpourri of crude adaptations from various Michelangelo frescoes. But in the *Temptation* scene the painter has been at pains to clear our first parents of any suspicion of impropriety in thought or deed. His Eve is taught to keep a more decorous distance; her serpent's gift takes the form of apples, not figs; and her relaxed middle finger stops pointing. The anonymous copyist may well have been the first to decide that Eve's unemployed hand needed correction.

It received harsher punishment in the large documentary engraving of the Sistine Ceiling executed by Domenico Cunego in 1795 (fig. 26). Here Eve's shriveled hand recoils like a guilty thing, as if someone had slapped it. Alternative bowdlerizations occur in a nineteenth-century print and in a recently advertized commercial pastiche (figs. 27 and 28); these four being all the copies I know. Thus from the sixteenth century

FIG. 27.—Anonymous nineteenth-century artist after Michelangelo, *The Temptation,* engraving.

FIG. 28.—Advertisement with figure of Eve from Michelangelo's *Temptation.*

until the present, no copyist was willing to give offense by translating Michelangelo's text unmitigated. And I have found no evidence of any writer noticing this detail or, if he did, thinking it fit to mention. It was not cited in print until the winter of 1975–76, when I published fifteen responses from a class of graduate students on the assigned topic of "Eve's Idle Hand."[43]

The students' findings, taken in aggregate, proposed that Eve's ominous gesture could be read on three levels of meaning. At the first level, her focused finger denotes the concupiscence into which Adam and Eve will lapse through the withdrawal of grace attending Original Sin. At the second level, the gesture foretells Eve's motherhood and the travail about to be laid on her by an offended God. At the third, this first woman, in whom is prefigured the Second Eve, presages the role of her woman's womb in the plan of salvation. The finger addresses that port of sin which, by grace of that other Eve, becomes the gate of redemption. Nor do these three levels of signification exclude one another. What is excluded, and I believe once and for all, is *in*significance.

It was at this point that Francis Naumann submitted an observation under the title "The Three Faces of Eve." I quote from his exposition: "Following the direction of Eve's middle finger across the three central frames of the Ceiling, we find that it points directly to the other two figures of Eve as yet untouched by sin. Only the fallen, outcast Eve is

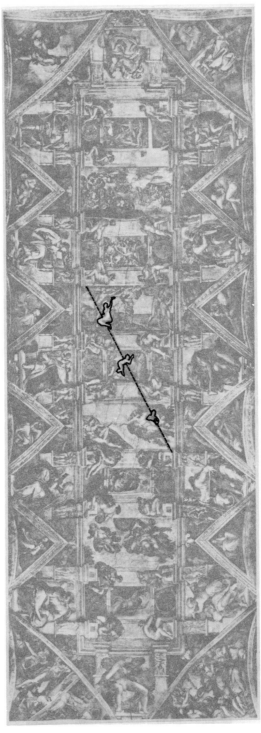

FIG. 29.—Michelangelo, the Sistine Ceiling (with overlay by Francis Naumann).

excluded; whereas the chosen three are linked by a single straight line" (fig. 29).

A straight running bond even here? Naumann's "straight line" differs from the two diagonals already discussed in that it traverses three contiguous frames rather than one composed unity. But perhaps the very existence of this unsuspected connective reveals something of Michelangelo's approach to the special problem posed by the Ceiling—its rigid framework and serial narrative structure. He had ordered the ground to be frescoed as a system of transverse and longitudinal axes, allocating one bay to each picture within the chain. To this extent, the system was additive, geometric and inorganic. But then a latent diagonal, a train of thought, as it were, glides across the three central panels: a movement, a countervailing principle of animation by which the staccato of rectangular frames attains an inward inflection akin to organic motion, like anatomical contrapposto. The Ceiling's midriff is crossed by a trajectory that confirms the emergent Eve at the omphalic center. For the rest, Naumann's diagonal linking of the three Eves anticipates that fateful bend which, three and four decades later, reappears in Michelangelo's work, laden with tragic personal meaning.

Lastly, a picture in London known since 1857 as the *Manchester Madonna*—a work whose attribution has been contested for over a century (fig. 30). The painting was never finished: the angelic pair at left exist only in outline; the Virgin's mantle, only as underpainting; and the medium is tempera, unlike the oils used in Michelangelo's subsequent panel paintings (the London *Entombment* and the *Doni Tondo* in Florence). But though Michelangelo's oeuvre contains nothing quite like it, no alternative attribution has proved convincing, and the attempt to postulate a hypothetical "Master of the Manchester Madonna" has long since foundered. The work combines passages of haunting beauty and delicacy with certain marks of naiveté that would be fully appropriate to a genius still in his teens. After decades of deepening admiration, I am convinced that the picture is Michelangelo's.[44]

Characteristic of his imagination is the fusion of the seven-figure group in a solid, relief-like slab, almost perfectly square. And it is characteristic again that this "slab" yields, on a second glance, to ambiguity: the angelic pairs at the sides are so staggered in depth as to suggest a semicircular grouping about the sacred figures at center. The latter are surrounded by the seraphic presences as the altar is by its apse.

Also characteristic of Michelangelo is the rendering of the scene as a nascent event. At right, two wistful angels study a scroll, presumably the scroll soon to be taken up by the little Saint John, bearing his message *Ecce Agnus Dei*. Thus is stated the foreboding of sacrificial death. The Virgin—assuming that the painter followed the traditional account of her reading habits—has been meditating Isaiah's prophecy of the In-

carnation. The Child's action, which reads superficially as a reaching up for the book, is doubly charged. Is the boy climbing up or stepping down, backward? Reaching up, his hand would be missing its aim as it passes between two pages. More probable that the hand lay on the page, expounding what is to come—and is now sliding down. The first part of the prophecy is about to be realized: let the page turn. Observe that the boy's left hand does not clutch at the Mother's dress to facilitate climbing, but is ingeniously disengaged by grasping a fistful of his own garment. And the hanging fold of the Virgin's mantle, which supports his left foot, is not a rung so much as a symbol of manifest filiation—as the hanging fold is again in Michelangelo's *Bruges Madonna,* where the Child, issuing from the Mother, prepares to set foot on earth. The boy's motion, then, appears programmed both ways. What we initially read as an upward tread tending inward becomes a step down, away from shared center. The Mother-Son group, conceived in monolithic integrity, foreshadows a separation, a departure to which the Virgin, her upper body gently withdrawing to left, gives melancholy consent.[45] It is as though, in their somber foreknowledge, the Passion were present already. And as the motion of the Christ Child indicates whence he came, so the action of the little Saint John, bending his knee to step forth, portends the next phase. For all its relief-slab stability, the work is astir, inly troubled, a history more than a still.

Most remarkable is the activating diagonal within the close-knit symmetrical schema of uprights and horizontals.[46] Launched from the upper left by an angel's hand laid about a friend's shoulder, the diagonal slides down the precipitous tilt of the open book, then flows through the arm and trunk of the Christ Child toward Saint John's bending knee, the imminent stride of the forerunner gazing at us.[47] Once again, a line of destiny descending from left to right, the diagonal of a square; geometric design and divine counsel coincident.

The *Manchester Madonna* was created by a very young Michelangelo. Setting a lifelong pattern for the interpenetration of personal and public meanings, he bestowed on the facing angel and on the Virgin herself his own broken nose. But the pervading diagonal, though it enters here as the form of necessity, bears as yet no personal connotation. And in one other respect the line of fate in this youthful work differs from its later manifestations: it results from volitional gestures—a collaboration of bodies united in common cause generates the descending diagonal. In the frescoes of the artist's maturity, the diagonal grows incorporeal, no longer constituted by bodies but prefixed and determinant of their positions. On the Sistine Ceiling, created some twenty years after the London picture, the disembodied diagonal is an indicator, a tie between three prelapsarian phases, the sign of an identity strung through sequential moments. A quarter century later, in the *Last Judgment,* the diagonal lifeline is more intimately appropriated. Along with its vital formative

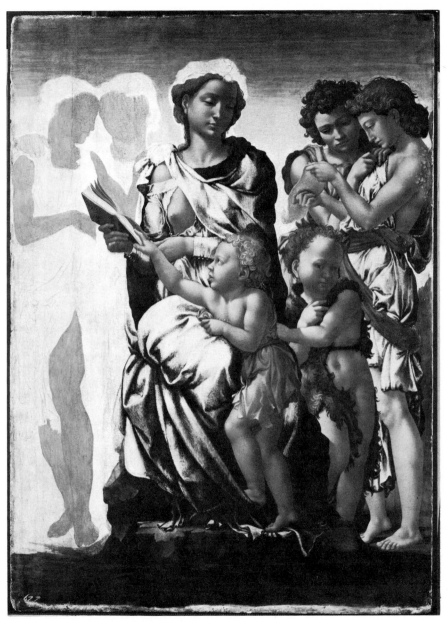

Fig. 30.—Michelangelo, *The Manchester Madonna,* painting. National Gallery, London.

function, it operates as a moral-theological vector—its descent charting the artist's consciousness of demerit, its ascent, his Christian hope.

In these three instances, the diagonal moves on the flat plane of the picture, like the connecting stroke of a capital N, traced bendwise across the field. In the final fresco of the *Crucifixion of Peter*, the line becomes multidimensional, issuing from a point upper left, deep in receding space, deep in time past.[48] The diagonal arrives as an oncoming movement, seeking the immanent foreground at lower right, the tense present. Spatial advance doubles as temporal metaphor, and the dissipated self-portrait—phased and disjoined, sometime mounted, now footsore and weary—defines the polarity of a life. Without disturbing the order of things, without interfering in the narration, without violence of displacement, the artist becomes omnipresent.

1. So far as I know, it was Wölfflin who first cited a deviant replica as an expression of explicit criticism. In his *Kunsthistorische Grundbegriffe* (1915), he reproduces a baroque relief copy of Raphael's *Disputa* fresco to show how the axial symmetry of the original was modified into an excentric design by a copyist who thought Raphael's system too static. This example, which I came across more than three decades ago, has been, I suspect, my unacknowledged methodological model. Copies as a form of articulate criticism are used in my discussion of Michelangelo's *Roman Pietà* in "The Metaphors of Love and Birth in Michelangelo's Pietàs," in *Studies in Erotic Art*, ed. Theodore Bowie (New York, 1970), pp. 231–33. The method was more fully developed in my essay on "Leonardo's *Last Supper*," *Art Quarterly* 36 (1973); and again in an article entitled "Michelangelo's *Last Judgment* as Merciful Heresy," *Art in America* 63 (November–December 1975): 49–63. Even where copies are comparatively few, I have in two recent cases found them revealing. See my *Borromini's San Carlo alle Quattro Fontane: A Study in Multiple Form and Architectural Symbolism* (New York, 1977), p. 438; and "Guercino's *Saint Petronilla*," in *Studies in Italian Art and Architecture*, ed. Henry A. Millon (Cambridge, Mass., 1980), p. 225.

2. The painted copy, 34 by 34 inches, is cited in Charles de Tolnay's *Michelangelo: The Final Period* (Princeton, N.J., 1960), p. 145, as in a private collection, New York. It was purchased by a New York art dealer, Sidney Orefice, in Madrid in 1955 and has been repeatedly published in the daily press (*New York Times*, 20 June 1963, p. 35, and *New York World-Telegram*, 6 December 1964) with partial claims to authenticity. The late Ludwig Goldscheider published it as the master's modello for the fresco (*Michelangelo's Last Painting* [London, 1968]). Disregarding questions of quality, it is demonstrable on at least five separate counts that the panel depends on the Cavalieri engraving, fig. 4. (1) Like the engraving, the panel shows six lances at upper left, not Michelangelo's eight. (2) The transverse beam is curtailed, as in the engraving (cf. p. 414, above). (3) The floated half-figure behind the cross is brought down to the ground by means of a fluted skirt (cf. p. 414, above). (4) The Ancient at lower right has room for an extra step underfoot (cf. p. 414, above). (5) The "hyphen hand" between the helmeted and the turbaned head at upper left is eliminated, as in the engraving. Some, though not all, of the colors follow the original, or an earlier painted replica now lost. The copyist may have seen the fresco and taken some color notes before working the picture up from the print.

3. L. Steinberg, *Michelangelo's Last Paintings* (New York and London, 1975), pp. 53–55.

4. A horizon cresting behind a significant foreground figure is a traditional means of emphasis in Italian narrative art.

5. Acts of Peter, chap. 39, in Edgar Heenecke's *New Testatment Apocrypha*, ed. Wilhelm Schneemelcher, 2 vols. (Philadelphia, 1965), 2:320.

6. Michelangelo sonnet, 1554: "Onde l'affettuosa fantasia, / Che l'arte mi fece idolo e monarca, / Conosco or ben com'era d'error carca, / E quel ch'a mal suo grado ogni uom desia."

7. Barry Weller's review of *Michelangelo's Last Paintings* in "Images of the Renaissance" (*Modern Language Notes* 92 [1977]: 1079) refers to this "specific detail" as the "least persuasive."

8. E. H. Gombrich, "Talking of Michelangelo," *The New York Review of Books*, 20 January 1977, p. 19.

9. J. A. Wheeler, quoted in *The New York Review of Books*, 17 May 1979, p. 40.

10. Literary commonplaces regarding the *Last Judgment*, which are not borne out by the visual evidence, include the anger of Christ, the timorous shrinking of the Virgin, the vindictive mood of the martyr saints, and the pessimistic, purely punitive character of the event. These and other entrenched errors are discussed in "Michelangelo's *Last Judgment* as Merciful Heresy," cited above, n. 1. A typical instance, not hitherto noted, concerns the angels in the lunettes with the instruments of the Passion. Once described as straining under the ponderous weight of the cross and the whipping post, a literary tradition of citing their puffing and heaving takes hold until, by the late seventeenth century, Michelangelo is faulted for not understanding that angels ought to perform such tasks without effort. Meanwhile, in the fresco, not one of the angels does anything useful in the way of functional work. Cross and column are buoyant and self-sustained—the angels sport with them in an ecstatic dance.

11. Francesco La Cava, *Il Volto di Michelangelo scoperto nel Giudizio Finale* (Bologna, 1925).

12. The suggestion that his medical training gave Dr. La Cava an edge over mere art historians was made by Achille Bertini Calosso ("Ritratti nel 'Giudizio Universale' di Michelangiolo," in *Michelangiolo Buonarroti nel IV Centenario del "Giudizio Universale"* [Florence, 1942], p. 51): "Grandissimo è stato il merito del La Cava di avere ritrovato ciò che molti cercavano indarno e di avere riconosciuto ciò che pochi forse avrebbero saputo ravvisare, guidato da uno spirito di osservazione e da un senso delle forme, fatti più acuti dalla sua professione di medico." Cf. Richard Hoffman (*Michelangelo: Das Jüngste Gericht* [Augsburg, 1929], p. 20): "Millionen von Menschen haben . . . das unsterbliche Werk bis ins kleinste nach allen Einzelheiten hin betrachtet und studiert, da machte der italienische Anatom La Cava diese wichtige Entdeckung." On the other hand, Tolnay (*The Final Period*, pp. 118–19) claims to have "made the same identification independently in the winter of 1924–25, communicating his discovery to his friends."

13. Thus Johannes Molanus (*De Picturis et Imaginibus Sacris* [Louvain, 1570]) quoted in David Freedberg, "Johannes Molanus on Provocative Paintings," *Journal of the Warburg and Courtauld Institutes* 34 (1971): 231 n.13: "It is excessively crude and wanton to depict St. Bartholomew totally flayed like a monster of old, . . . [as in] the picture which Michelangelo painted in Rome in the pope's private chapel showing Bartholomew at the Last Judgment holding his own skin." Cf. also Gilio da Fabriano, *Degli Errori de'Pittori* (1564), ed. Paola Barocchi, *Trattati d'Arte del Cinquecento*, 3 vols. (Bari, 1961), 2:81.

14. Cf. Lucas Cranach's engraving of Frederick the Wise venerating Saint Bartholomew, 1508–9, Hollstein 4 and F. Lippmann, *Lucas Cranach* (Berlin, 1895), pl. 57; the saint's flayed skin is here held by an angel. Images of Saint Bartholomew holding his skin with face displayed include the Hans Baldung Grien drawing of 1504 in Basel (fig. 15), presumably a preparatory study for the woodcut published in the *Hortulus animae* (Strassburg, 1511), fol. 1 8v; reprod. in Staatliche Kunsthalle Karlsruhe, *Hans Baldung Grien* (Karlsruhe, 1959), p. 325; see cat. no. 101 for the Hamburg drawing. Another example is a Dürer School woodcut of 1518, Geisberg 794. In the Cranach type, the head in the skin is shown from the back, but unmistakably with the same curls that cover the head of the saint. Thus in Cranach's woodcut dated ca. 1510–15, Geisberg 573 (fig. 14) and a

copy thereafter by Hans Weiditz, Geisberg 1549. See also an unusual early example—the mid-fourteenth-century oak relief on the choir stall in St. Bartholomew, Frankfurt; reprod. in Schnütgen-Museum, *Die Parler und der Schöne Stil*, 3 vols. (Cologne, 1978), 3:241, 243. For the Wittenberg relic and Cranach's woodcuts for the 1509 *Wittenberger Heiligtumsbuch* (fig. 16), see Dieter Koepplin and Tilman Falk, *Lukas Cranach*, 2 vols. (Basel, 1974), 1: nos. 95–97, and 2:489. A few isolated and excentric examples of earlier Saint Bartholomews with the skin are cited in Louis Réau, *Iconographie de l'Art Chrétien: Iconographie des Saints*, 3 vols. (Paris, 1958), 1:182; and L. Price Amerson, Jr., "Marco d'Agrate's San Bartolomeo: an introduction to some problems," in *Il Duomo di Milano*, ed. Maria L. Gatti, 2 vols. (Milan, 1969), 1:189–93. The first Italian Renaissance painting to follow the Northern mode—the saint holding a skin with a face replicating his own—is Garofalo's *Adoration of the Magi with St. Bartholomew*, dated 1549, in the Ferrara Pinacoteca; reprod. in A. Neppi's *Il Garofalo* (Milan, 1959), pl. 45.

15. The anonymous diatribe of 1549 denounces a copy of Michelangelo's Saint Peter's *Pietà* which had just been placed in the Florentine church of Sto. Spirito: "They say that it derives from that inventor of obscenities, Michelangelo Buonarroti, who is concerned only with art, not with piety. All the modern painters and sculptors, pursuing Lutheran whims, now paint and carve nothing for our holy churches but figures that undermine faith and devotion"; first published in Giovanni Gaye, *Carteggio inedito d'Artisti*, 3 vols. (Florence, 1840), 2:500. The "Lutheran" element in Michelangelo's work was less a matter of indecency or faulty content than the presumption to interpret doctrine according to private caprice. The equation of artistic license with theological heresy survives into the mid-seventeenth century. To a prelate who deplored Borromini's flouting of the rules of design, Bernini assented with the remark, "It is better to be a bad Catholic than a good heretic" (Filippo Baldinucci, *Notizie dei Professori del disegno* [1681], 5 vols. [Florence, 1847], 5:666).

16. The Michelangelo portrait in the lower left of Venusti's copy (fig. 18) is too small to register in the reproduction. The author referred to in the sentence following is Carlo Angeleri, "L'Autoritratto di Michelangiolo nel 'Giudizio Universale': lo videro i contemporanei?" in *IV Centenario del "Giudizio Universale,"* pp. 241–42.

17. "Perche vi è mille heresie, massime della pelle di San Bartholomeo senza barba; e lo scorticato ha il barbone; il che monstra, che quella pelle non sia la sua etc." The letter, one of several to Vasari from Miniato Pitti, was first published in Karl Frey's *Il Carteggio di Giorgio Vasari* (Munich, 1923), pp. 148–49. Pitti's letter provides the basis for Angeleri's inconclusive polemic in the article cited above, n. 16; which includes further biographical data on this interesting character (pp. 233, 236 n.3, 235 n.3, and 237).

18. After the mid-sixteenth century, observers cease to register the disparity between the martyr and his flayed skin. Molanus in 1570 finds the motif as such objectionable, never doubting that the saint was represented "cutem suam manu gestantem" (see n. 13, above). According to John Addington Symonds, "S. Bartholomew flourishes his flaying-knife and dripping skin with a glare of menace" (*The Life of Michelangelo Buonarroti*, 2 vols. [London, 1893], 2:61), while Mrs. Jameson sees the Apostle with "his own skin hanging over his arm" (*Sacred and Legendary Art* [1848], 2 vols. [Boston, n.d.], 1:252). Similarly, Ludwig Pastor has the saint "holding the implement of his martyrdom, the knife, in his right hand and in the left his skin as it had been flayed" (*The History of the Popes from the Close of the Middle Ages*, 3d ed., 38 vols. [London, 1950], 12:622). Nineteenth-century visitors fresh from America followed suit. To one, the saint appears to be "holding . . . in his left hand the skin of which he was bereft" (William Torrey Harris, " 'The Last Judgment' as Painted by Michel Angelo," *Journal of Speculative Philosophy* 3 [1869]: 81). Another writes: "By a strange *grotesquerie* which appears again and again in the picture, Angelo has put the figure of St. Bartholomew in the foreground, holding forth his empty skin to the view of the world. Such audacity of imagination is without parallel in the history of art" (Mary Wakeman Botsford, "Michael Angelo and the Sistine Chapel," *The Manhattan* 1 [1883]: 172).

19. See Chapon's exceedingly rare and perfectly insignificant *Le Jugement dernier de Michel-Ange* (Paris, 1892).

20. Ernst Steinmann, *Die Sixtinische Kapelle*, 2 vols. (Munich, 1901, 1905), 2:537.

21. Frey, *Carteggio*, p. 149. Note that the proposed regrowth of beard in the interval between death and Last Judgment not only leaves the saint's baldness uncured (a point raised in Gilio's *Errori*, ed. Barocchi, p. 80), but that it imputes a faulty theology to the artist. Before the general Resurrection, the saints in heaven are not as yet rejoined with their bodies—the bodily assumptions of certain chosen, such as Enoch, Elijah, and the Madonna being exceptions.

22. See Rudolf Wittkower, "Ein Selbstporträt Michelangelos im Jüngsten Gericht," *Kunstchronik und Kunstmarkt* 35 (1925–26): 366–67. The phrase "sensational discovery"—a surprising lapse into strong emotion—occurs in the La Cava entry in Steinmann and Wittkower's *Michelangelo Bibliographie 1510–1926* (Leipzig, 1927), no. 1109; with further literature.

23. See Angeleri, "L'Autoritratto de Michelangiolo," p. 232 n.2. A further argument adduced by Angeleri is even more infelicitous (p. 245). He argues that since contemporaries had no trouble recognizing the papal Master of Ceremonies, Biagio da Cesena, in the figure of Minos in the fresco's lower right corner, it seems improbable that they would have missed the artist's self-portrait. My article, "A Corner of the *Last Judgment*" (*Daedalus* [Spring 1980]), demonstrates that Vasari's identification of Biagio with Minos was an egregious blunder.

24. Corrado Ricci in *Il Giornale d'Italia*, 2 June 1925.

25. Cf. Calosso, "Ritratti nel 'Giudizio Universale,'" pp. 49–50: "Corrado Ricci ha avuto a sua volta un'intuizione felicissima, trovando nel S. Bartolomeo una stretta somiglianza con Pietro Aretino"; and Diego Angeli, "Il volto di Michelangelo scoperto nel 'Giudizio' insieme con quello del suo avversario Aretino nel supplizio di S. Bartolomeo," in *Il Giornale d'Italia*, 28 May 1925.

26. Tolnay, *The Final Period*, p. 45. Tolnay was anticipated by Romain Rolland, *Michel-Ange* (Paris, 1905), who imagined Saint Bartholomew raising his knife "avec une telle férocité, qu'il semble l'écorcheur plutôt que l'écorché." The passage was quoted approvingly ("come ha detto bene Romain Rolland") by Carlo Grigioni, "La nudità del 'Giudizio Universale' di Michelangelo," *Il Trebbo*, Mensile della Romagna, Forlì, 2 (1942): 77. This provincial monthly is near *introvabile* even in Rome, and I am grateful to my former student and present friend, Jack Freiberg, for his tenacity in tracking it down.

27. Hoffmann (*Das Jüngste Gericht*, p. 20) reads "die unverkennbar symbolische Bedeutung des Selbstbildnisses" in these words from Curt Bauer: "Er wollte sich der Nachwelt als den von diesen Zeitgenossen lebendig Geschundenen darstellen; eine ungeheure Anklage, mit der sich der grösste Genius der Renaissance, Gerechtigkeit heischend, an die späteren Geschlechter wandte." So also Calosso ("Ritratti nel 'Giudizio Universale,'" p. 50): "L'autoritratto di Michelangiolo e il ritratto dell'Aretino così riconosciuti giovano, nel loro insieme di tormentatore e di tormentato, a gettar luce sopra un doloroso capitolo della biografia dell'artista, e, per riflesso, sui caratteri della sua espressione." Similarly, a recent American author: "Michelangelo expressed his feelings about the ordeal of art by painting a distorted self-portrait on the flayed skin held by St. Bartholomew. . . . Made miserable by the difficulty—both physical and emotional—of painting the Sistine ceiling, Michelangelo considered himself martyred by art" (Barbara Rose, "Self-Portraiture: Theme with a Thousand Faces," *Art in America* 63 [January–February 1975]: 71).

28. Still un-Christian, but of deeper intuition, is Edgar Wind's interpretation of the flayed skin, *Pagan Mysteries in the Renaissance*, rev. ed. (New York, 1968), pp. 187–88. Though Wind recognizes in Michelangelo's later years "the growth of a more narrow and contracted piety," he derives the symbol of the self-portrait from the Dionysian ritual of flaying which, he believes, appears eroticized in Michelangelo's love poems. The mortal skin is "to be shed by the lover and offered to the beloved as a trophy of passion, sacrifice, and transformation, a token of renewal through death." Wind rediscovers this symbolism—in "an ostensibly Christian form"—in the *Last Judgment*, where "the Marsyas-like portrait is a prayer for redemption, that through the agony of death the ugliness of the

outward man might be thrown off and the inward man resurrected pure, having shed the *morta spoglia.*" Finally, Wind, like Eugenio Battisti ("Michelangelo o dell'ambiguità iconografica,"*Festschrift Luitpold Dussler,* ed. J. A. Schmoll gen. Eisenwerth et al. [Berlin, 1972], p. 220) senses a possible relevance in Dante's invocation of Apollo in the first canto of the *Paradiso,* 13–21: "Enter my breast, I pray you, and there breathe as high a strain as conquered Marsyas that time you drew his body from its sheath" (John Ciardi's translation of the lines: "O buono Apollo . . . Entra nel petto mio, e spira tue / si come quando Marsia traesti / della vagina delle membra sue").

29. *Life Magazine,* 6 December 1949, p. 45. So also Redig de Campos speaks of the Apostle's own skin, "dove il Buonarroti ha nascosto un singolare autoritratto . . . in caricatura tragica della sua 'infinita miseria' " (*Il Giudizio Universale di Michelangelo* [Rome, 1964], p. 39). Tolnay sees the matter correctly: "It is the artist's empty skin which the saint holds in his hand" (*The Final Period,* p. 44).

30. Cf. Saint Augustine, *The City of God,* bk. 12, chap. 17: "[Christ's] side, as he hung lifeless upon the Cross, was pierced with a spear, and there flowed from it blood and water, and these we know to be the Sacraments by which the Church is built up."

31. The sonnet is published in Steinberg, "A Corner of the *Last Judgment*" (see n. 23, above).

32. A portion of the pervading diagonal, from the Christ down to the figure falling from the bow of Charon's barque, was described by Tolnay (*The Final Period,* p. 44). But Tolnay's observation was marred by an intolerable misreading. Though he saw clearly that the thrust of Christ's action targets the artist's self-portrait, he did not question the received notion which would have the divine Judge deliver a malediction. He therefore concluded that Christ was depicted in the act of cursing the artist, whose further abasements, Tolnay thought, should be plotted sequentially in the figures of "Shameface" and the man falling hellward out of the barque. The fresco's central incident, then, would be the artist's damnation. Tolnay cannot have asked himself what it means to impute certainty of damnation to a believing Christian of the sixteenth century. For the effects of such certainty, we have the well-documented case of Francesco Spiera, a lawyer of Cittadella, who in 1547 became a *cause célèbre* because he believed himself to be rejected by Christ. As "Christ's enemy," he could not bring himself to pray, fell into a wasting condition, which the divines and physicians of Padua diagnosed as Judas Iscariot's sin of despair, refused food and sleep, and told his ineffectual consolers shortly before his death: "I have been swept away. I feel within myself the sentence of eternal damnation. I am cursed forever among the reprobate . . ." (quoted in Anne Jacobson Schutte's *Pier Paolo Vergerio* [Geneva, 1977], pp. 239–40). Spiera, whose mind remained lucid until the end, declared that he felt like a man in chains, unable to move. In such a condition, a man cannot tie his shoelaces, let alone paint a fresco. Or did Tolnay imagine that Michelangelo was not wholly in earnest?—like an eighteenth-century wag protesting, "Well, I'll be damned!" (Tolnay's earlier publication of his hypothesis was rightly rejected with irony by Angeleri, "L'Autoritratto di Michelangiolo," p. 233 n.3. Unfortunately, Angeleri tossed out the observed diagonal along with its faulty interpretation.) The diagonal in its purely formal capacity had been previously noted by Wölfflin, who saw it as one in a complementary pair. For the counter-diagonal in the *Last Judgment,* see Steinberg, "A Corner of the *Last Judgment,*" cited above, n. 23.

33. See Steinberg, "Merciful Heresy," p. 61 n.13. Cf. José C. Nieto (*Juan de Valdes and the Origins of the Spanish and Italian Reformation* [Geneva, 1970], p. 299 n.26): "The movement of [Valdes'] thought is toward the annihilation of those who do not belong to Christ"; and: "Only they who are incorporated into Christ are certain of their resurrection, grounding it upon the resurrection of Christ" (p. 300 n.30). Of Valdes' last years, Celio Secondo Curione writes (1550) that "he was, to the best of his ability, assiduously intent upon real mortification; in which, when death found him, he was perfectly mortified, to be afterwards perfectly vivified at the resurrection of the just" (quoted in Philip McNair's *Peter Martyr in Italy* [Oxford, 1967], p. 25, from Curione's preface to the first ed. of Valdes' *Hundred and Ten Considerations*).

34. Job 19:25–26. The relevance of the text was independently recognized by Thom

Grizzard, then a graduate student at the University of Pennsylvania. The enormous difficulties presented by the (probably corrupt) Hebrew text are not relevant here. I have quoted the wording of the Douay Bible which follows the Vulgate. An alternative text was adduced in a recent article by Marcia B. Hall, "Michelangelo's *Last Judgment:* Resurrection of the Body and Predestination," *Art Bulletin* 58 (1976): 87 n.5. The author quotes from Tertullian's argument for bodily resurrection: "And lest you should think the apostle [Paul] had anything else in mind, taking forethought for himself and toiling for you to understand that the statement referred to the flesh: when he says 'this perishable nature' and 'this mortal nature' he holds his own skin as he speaks" ("cutem ipsam tenens dicit"; *De resurrectione carnis*, 51, 9 ff., Evans translation [London, 1960]). "This verbal image," writes Hall, "seems strikingly like Michelangelo's visual one. . . ." But, in fact, Tertullian's is not an "image" at all. He is saying that Saint Paul, to emphasize that he had his very body in mind when he spoke of "this perishable" and "this mortal," must have been touching, pointing to, or holding onto, his own skin. That he would be holding a *flayed* skin is not indicated, nor by any stretch can Michelangelo's image be made to illustrate the Tertullian passage. Following is the translation of the Tertullian passage as given in *The Ante-Nicene Fathers*, ed. Alexander Roberts and James Donaldson (New York, 1918), 3:584–85: "Moreover, that you may not suppose the apostle to have any other meaning, in his care to teach you, and that you may understand him seriously to apply his statement to the flesh, when he says '*this* corruptible' and '*this* mortal' [italics original], he utters the words while touching the surface of his own body." The editors add: "Rufinus says that in the church of Aquileia they touched their bodies when they recited the clause of the creed which they rendered 'the resurrection of *this* body.' "

35. Crashaw's English translation of the *Dies Irae* begins with a self-apostrophe, "Hears't thou, my soul, . . ." an interpolation censured by a modern editor: "Crashaw by introducing himself in the first line has robbed the opening of its universality and much of its dignity and so set a tone of intimacy out of keeping with the intent of the Latin" (*The Complete Poetry of Richard Crashaw*, ed. George Walton Williams [New York, 1970], p. 186).

36. When we apply the rule of axial symmetry to Michelangelo's group compositions, we bear in mind that it obeys the same principle of animation which also modifies the axiality of his individual figures. Michelangelo's symmetries, whether simple or multiple, are disturbed, as though momentarily stirred by internal movement. In the *Last Judgment*, the centralized elements in the upper half shift to the left, in the lower half, to the right. For a detailed description of such modified symmetry in the *Conversion of Saint Paul* in the Cappella Paolina, cf. Steinberg, *Michelangelo's Last Paintings*, p. 34.

37. It would be worth making a study of Vasari's way with ambiguity, especially in confrontation with Michelangelo. The study would show that ambiguity is vitally present in Michelangelo's work; and that Vasari resists it wherever found. He evades the issue even where it cries out for acknowledgement, as in the case of Michelangelo's (lost) bronze statue of Julius II (for the portal of S. Petronio, Bologna, commissioned by the pope in 1507), whose vigorous action was so equivocal that the pope, inspecting the statue, "asked if the raised right hand was giving a blessing or a curse." Wherever Michelangelo's works exhibit an ambiguity, Vasari comes down with assurance on one side or the other. Of the Christ in the Saint Peter's *Pietà* he declares that "no better corpse was ever made," even though this corpse displays engorged surface veins and hands engaged in gesture, being both dead and alive in accordance with Christ's dual nature. The Virgin in the *Doni Tondo*, Vasari writes, is "offering the Child to Joseph." Yet Michelangelo has defined the offering of the Child in a functional ambiguity—a parental gesture precisely suspended in reciprocal giving (see L. Steinberg, "Michelangelo's Doni Tondo," *Vogue* [December 1974]: 139). Just so, describing the Christ of the *Last Judgment*, Vasari writes that "Christ is seated," whereas the figure has been seen—with good reason—as seated, or standing, or springing up, or as striding forward. "Such differences of opinion proceed less from carelessness in the viewer than from a given ambiguity which the viewer resists. . . . Michelangelo cast the Christ of the Second Coming in a posture which cannot be matched in our vocabulary or analogized to normal physical habits" (Steinberg, "Merciful Heresy," p. 50). Vasari understands allegory

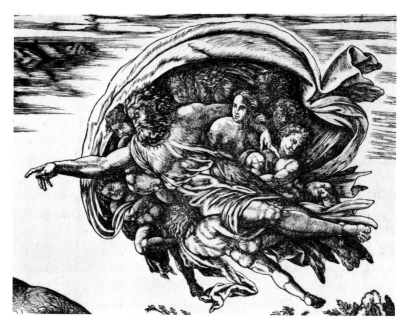

FIG. 31.—Gaspare Ruina after Michelangelo, *The Creation of Adam,* woodcut, detail.

of the kind that is susceptible to direct verbal translation. But he is programmatically silent about Michelangelo's irreducible ambiguities—lacking the conceptual equipment and the will to articulate this special dimension of Michelangelo's power.

38. The interaction of the *Last Judgment* fresco with the physical space of the Sistine Chapel will be discussed in a separate study now in progress.

39. Among Michelangelo's spiritual self-portraits I would include the drowned son in the *Deluge* on the Sistine Ceiling; the vanquished dotard in the *Victory* at the Palazzo Vecchio in Florence; the hooded mourner in the Florence *Pietà* (fig. 8). Charles Seymour has found that even the *David* represents a personal "search for identity," the subtitle of his monograph, *Michelangelo's David* (Pittsburgh, 1967).

40. Vasari writes of the *Creation of Adam:* "dove ha figurato Dio portato da un gruppo di angioli ignudi e di tenera età, i quali par che sostenghino non solo una figura ma tutto il peso del mondo, apparente tale mediante la venerabilissima maiestà di quello, e la maniera del moto, nel quale con un braccio cigne alcuni putti quasi che egli si sostenga. . . ." It was J. P. Richter who, in 1875, first corrected Vasari's misreading: ". . . keineswegs ein jugendlicher Knabe, . . . sondern unverkennbar—ein Weib. . . . Und dies Weib is Niemand anders, als Eva" ("Die Schöpfung des Menschen von Michelangelo in der sixtinischen Kapelle," *Zeitschrift für bildende Kunst* 10 [1875]: 171). The alternating acceptance and rejection of Richter's insight during the past hundred years cannot be detailed here. But it is instructive to compare two artists' copies. In the first, an early sixteenth-century woodcut by Gaspare Ruina (fig. 31), the femininity of the figure under God's arm is emphasized by the breasts, as if to clarify what the artist takes to be Michelangelo's meaning. In the other, a drawing by Watteau (fig. 32), the corresponding figure—raised knee omitted—becomes one of a group of rococo putti. Insofar as these copies are divergent interpretations of the original, only one of them can be correct.

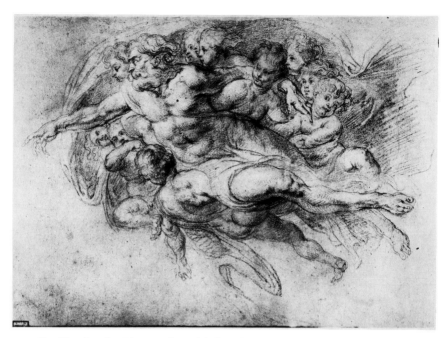

Fig. 32.—Antoine Watteau after Michelangelo, detail of *The Creation of Adam,* drawing. Collection Julius Held.

41. The identification of the great putto as the Second Adam again goes back to Richter, ibid. A typical expression of the opposition is found in Steinmann, *Die Sixtinische Kapelle,* 2:330. He reads the child as a putto about to burst into tears because he has not found a good viewing position: "Und nichts anderes ist auch das kräftige Putto, dessen Schulter Jehovahs Linke berührt und das man sogar als den Sohn der Maria bezeichnet hat. Es unterscheidet sich von seinen Brüdern nur dadurch, dass es nicht auf den Menschen blickt und höchst unzufrieden und dem Weinen nahe ist, wahrscheinlich weil es noch keinen bequemen Aussichtspunkt finden konnte."

42. To skeptics, whose fear of over-interpretation is such that they would rather leave things unnoticed than see them explained, I propose the exercise of performing Eve's manual gesture. Only he who has tried to repeat it, and felt the impossible strain the gesture imposes on one's resistant joints, is in a position to judge whether the interpretation here offered is compelling or arbitrary.

43. L. Steinberg, "Eve's Idle Hand," *Art Journal* 35 (1975–76): 130–35.

44. For a summary of the critical fortunes of the *Manchester Madonna* and a bibliography, see Cecil Gould, *National Gallery Catalogues: The Sixteenth-Century Italian Schools* (London, 1962), pp. 95–97. See also the excellent technical analysis by the restorer of the London National Gallery, Helmut Ruhemann, with results of a microchemical examination appended by Joyce Plesters: "The Technique of Painting in a 'Madonna' attributed to Michelangelo," *Burlington Magazine* 106 (1964): 546–54. Ruhemann dates the work to the early 1490s and finds it "exceptionally significant in that it was painted at a turning-point in the history of painting technique when tempera was being given up in favour of oil." With all his caution, Ruhemann clearly favors the Michelangelo attribution. Cecil Gould is in agreement, dissociating the work from the group of pictures assembled around the "Master of the Manchester Madonna" because the former seems superior in "the quality of

design and execution." It is superior also in quality of thought, but this is a criterion which many will regard as unprofessional, not objective enough for the science of connoisseurship.

45. Inspired ambiguity governs the Virgin's posture in the *Manchester Madonna.* At first sight, she appears erect, as becomes her regal and iconic character. Her withdrawal to left grows apparent only in the relation of the upright torso to the trailing left foot in its red leather slipper. But if she were pulling away from the boy's upward climb, the impulses of Mother and Child would be in conflict, which is, iconographically speaking, improbable. On the other hand, if the Virgin withdraws as the Child steps down, their respective motions express mutual consent.

46. The verticals, given in the uprightness of the six serried figures, are crossed by a weft of subtle persistence. Notice, at two-thirds the height of the picture, moving from left to right, a shelf traced from one angelic elbow to the sash of the scroll-reading angel on the opposite side.

47. Michelangelo's use of the forthright glance is sparing and, I suspect, always significant. In the *Manchester Madonna,* only the "messenger" engages us by eye contact. In the early *Battle of Cascina* cartoon, the herald glancing forth from the picture is exhorting a patriotic Florentine citizenry. In the histories of the Sistine Ceiling, the visual contact with the beholder is reserved for the promised Christ in the *Creation of Adam;* in the *Last Judgment,* for the figure of Death; in the Pauline Chapel, for the stern summons of Saint Peter. Among the allegorical Times of Day in the Medici Chapel, *Il Giorno* gazes at us. The single exception, if it is an exception, is the Sistine Ceiling *ignudo,* left above Daniel.

48. Cf. Leonardo: "the point may be compared with an instant in time and the line may be likened to the length of a certain quantity of time. And just as points are the beginning and end of the line, so instants are the end and the beginning of any given space of time" (Cod. Arundel, fol. 190v; J. P. Richter, *The Notebooks of Leonardo da Vinci* [New York, 1970], no. 916).

Leo Steinberg is Benjamin Franklin Professor and University Professor of the History of Art at the University of Pennsylvania. His publications include *Other Criteria: Confrontations with Twentieth-Century Art, Michelangelo's Last Paintings, Borromini's San Carlo alle Quattro Fontane,* as well as studies of Leonardo, Pontormo, Velázquez, and Picasso.

Kracauer's Two Tendencies and the Early History of Film Narrative

Gerald Mast

One of Siegfried Kracauer's least controversial and most borrowed claims is that the motion picture announced its two potential directions in its infancy. In the beginning, there was Lumière and there was Méliès. The films of Lumière allowed us to witness the world itself—at rest, at play, at work. Life went about its busy or nonbusy business while the camera unassertively and unobtrusively observed. On the other hand, Méliès sought to create his own private world, a universe of paint and impossibility in which nothing was solid and matter itself jumped, popped, or poofed into thin but usually smoky air.[1] Of course, careful study of the Lumière films reveals their conscious awareness of painting—both of Renaissance perspective and of the contemporary impressionists' concern with the play of light itself. And the Méliès fantasies could neither surprise nor delight if they did not somehow invoke our materialist convictions about the stability of space and the solidity of matter. But let that pass.

Kracauer then views the remaining history of film as the stirringly legitimate victory of Lumière's "realist tendency" over Méliès' "formative" one. Film respected its photographic basis by recording and thereby redeeming the objects of our physical world; such classics as *Potemkin, Open City,* and even *Swing Time* (according to Kracauer) reveal the richness of the realist tendency, while such films as *The Cabinet of*

1. See the Kracauer excerpt in *Film Theory and Criticism: Introductory Readings,* ed. Mast and Marshall Cohen, 2d ed. (New York, 1979), pp. 10–19.

Reprinted from *Critical Inquiry* 6 (Spring 1980): 455–76.

Doctor Caligari, Metropolis, and even *Berlin: The Symphony of a Great City* were aesthetically (and, not coincidentally, politically) dreadful aberrations. The almost twenty years of films that have followed the publication of Kracauer's *Theory of Film* could certainly be seen as an epilogue confirming the victory of the realist tendency. Faster film stocks, faster lenses, the wide screen, the conversion to color, and higher fidelity sound have steadily permitted each film to admit (this might be André Bazin's term) and thereby redeem more physical reality than its less seeing and hearing ancestors.

Unfortunately for this scenario, one element of these realist films seems closer to Méliès' magic than to Lumière's commitment to physical reality. Although these films may resemble Lumière's natural universe far more than Méliès' universe of cardboard and cloth, the one element that almost all of Kracauer's classics share with Méliès is that they depict a fictional sequence of staged human events that took place in physical reality only so that they could be recorded by the motion picture camera. They are Aristotelian "imitations of human actions," not recordings of actual human events. They are fictions. Indeed, the very semantic problem of describing these narrative films—they are "real" recordings of "real" physical actions that have been organized according to fictional narrative patterns—contains the very paradox that Kracauer's pure concern with physical reality overlooks.

If films really wanted to redeem physical reality for us, they would have no reason to use that reality as a mere backdrop, a context, for spinning tales about characters who never were, doing things they never did. We might point to the nobility of film's simply recording the surfaces and essences of everyday life—as it perhaps does in so-called documentary or nonfiction films. Or we might point to the nobility of film's examining its own illusions of motion, depth, color, or continuity as it does in some so-called experimental, avant-garde, or independent films. But in point of fact, for most of us (including Kracauer) film is synonymous with storytelling, and the telling of stories is a very ancient practice that has frequently had little or nothing to do with the surfaces of physical reality.

Little wonder that film theorists frequently probe the crevices of film history to expose the origins of their favorite essential tendencies. Since we have no other art whose origins are so clear and whose original texts are so—more or less—extant, and since the child is the father to the

Gerald Mast is the author of, among other works, *A Short History of the Movies, The Comic Mind: Comedy and the Movies,* and *Film/Cinema/Movie: A Theory of Experience.*

man, what can film history tell us?[2] It told Kracauer about Lumière and
Méliès. It told Bazin about our urge to get nature into our power by
remaking it in its own image. Bazin saw these early films as primitive
gropings to attain the "myth of total cinema," the godlike aspiration to
reproduce nature in its own image, uncorrupted by the transience and
decay of mortal time. And film history informed Erwin Panofsky of two
fundamental facts: (1) things move; and (2) film is a genuine popular art
that sprung from the folk below rather than descended from the literati
above.[3]

Of all this historical support for theoretical conviction, however, I
am currently most intrigued by Christian Metz's strangely defensive de-
fense of his exclusive critical commitment to film narrative.[4] This de-
fense seems strange because Metz finds himself forced to juggle two
competing positions. Because he wishes to approach the theoretical
problems of film with the objectivity of the scientist, Metz knows that he
cannot simply and silently equate all film with narrative film, as
Kracauer, Bazin, Panofsky, and almost everyone else who writes and
thinks about film automatically and tacitly does. Metz knows that there
are kinds of film other than those that tell fictional stories. And if such
different ends, such differing final causes of film exist, it must be sus-
pected that the theo etical issues generated by these different kinds also
differ. But because Metz, like so many others, is only interested in film as
a narrative medium, he argues historically that film only developed a
unique and comprehensible signifying system in its early attempts to tell
stories. This tension in Metz's position (that the problems of film both
are and are not to be equated with the problems of film narrative) seems
yet another variation on the essential paradox that narrative films are
physical, visual recordings of fictional, nonexistent human events. After
addressing and, in his view, relieving this tension, Metz raises his essen-
tial question about the signifying systems of film: "How does the cinema

2. Given the change in the United States copyright law in 1909, we have far more film
texts from the primitive pre-1909 era than from the period that followed it. Because the
method of protecting films from piracy was unclear to the early film companies until a
1909 copyright amendment granted protection to whole films, they submitted individual
still photographs of every frame to the Library of Congress (still photographs were pro-
tected by the 1898 Copyright Act). These still photographs have since been rerecorded on
motion-picture film and provide a valuable record of these early films for film scholars.

3. These two fundamental facts have nothing to do with one another, a problem that
gives Panofsky's essay a rather seesawing structure of moving back and forth between the
two of them. Some of Panofsky's points—his famous "dynamization of space" and "spatiali-
zation of time"—can be traced to the fact that things move, while other points—such as his
discussions of film plots and film acting—can be traced to this view of film as a genuine folk
art. See Panofsky's "Style and Medium in the Motion Pictures," in *Film Theory and Criticism*,
pp. 243–63.

4. See Metz's "Some Points in the Semiotics of the Cinema," in *Film Theory and Criti-
cism*, pp. 170–72.

indicate successivity, precession, temporal breaks, causality, adversative relationships, consequence, spatial proximity, or distance, etc.?"[5] How indeed? And does this how have anything to do with cinema's "realist tendency"?

Before examining this how and its implications in more detail, let me spend some time with the why. Why did film from its infancy adopt fictional narrative as its essential organizing principle and, in effect, final cause (since Méliès and Edison were as infantile as Lumière and both were groping toward a fictional narrative structure)? The earliest films could just as easily have been animated films (since the earliest persistence of vision toys on which the cinema illusion was based, such as the stroboscope and zoetrope, used drawn figures), or nonfiction films (since audiences enjoyed seeing the ephemeral world captured permanently), or abstract films (since the beginnings of modernist experiments in painting were contemporaneous with the early films). Why did films become movies?

One familiar (and patronizing) answer to this question treats film narrative as a calculated debasement of film art. To build and sustain their film empires, the nascent film moguls seized upon melodrama and farce to catch the feeble imaginations of the base and banal multitudes. Unfortunately for such a view, it is a bit difficult to determine precisely when film suffered this Fall from potential puristic grace. Annette Michelson specifically refers to the coming of synchronized sound as the Fall,[6] but her claim ignores the fact that Adolph Zukor, Marcus Loew, Thomas Ince, and Louis B. Mayer had been doing big business with film since almost the turn of the century. There has never been a more spectacularly lucrative commercial period in American film history than its very first one, the childhood years between 1905 and 1910, when an estimated 80 million Americans (out of a total population of 100 million) went to the nickelodeons each week and when William Fox's 1905 investment of $1600 in each storefront theater came to be worth over $150,000 each by the end of the decade.

Need these awesome commercial statistics be seen as evidence of a necessary aesthetic debasement or a pure historical accident—that film narrative had everything to do with vulgar finance and nothing to do with film art? Or should the coming of fictional narrative to film be seen as an inevitability, the predictable outgrowth of a century that had converted the populations of both America and Europe to enjoying fictionalized narratives and to taking them seriously? Further, every single audience entertainment that could be considered a genuine predecessor of the motion picture—the magic lantern show, the phantasmagoria, the panorama, the diorama, the tableau vivant, and the lantern slide

5. Ibid., p. 174.
6. See Annette Michelson's "Film and the Radical Aspiration," in *Film Theory and Criticism*, p. 621.

photoplay—had all organized their light shows and visual imagery according to fictional narrative patterns.

If narrating—the telling of stories, fictional or otherwise—is an inherent possibility of motion pictures (in fact, the first possibility to be realized in the history of film), then Kracauer's distinction between the realist and formative tendencies must be questioned and, in effect, the two must be synthesized. Wasn't the practical problem for the earliest films how to construct a formative sequence of events within an absolutely real-looking visual context? Wasn't the paradox of film narrative the combination of an obviously unreal sequence of events with an obviously real visual and social setting? And isn't that paradox the most intriguing and complex problem of narrative film today, when the visual and social setting have become increasingly real-seeming? And doesn't this paradox have something to do with the fact that narrative film today seems richer and more important than it did a decade ago, at a time when various admirers of both *cinéma vérité* and *cinéma pur* had announced the death of fictional filmed narrative?

Kracauer's realist aesthetic, concentrating exclusively on the photographic surfaces of things in the material world (as neither Bazin's nor Cavell's aesthetic does), overlooks this paradox altogether. It overlooks the fact—extremely relevant to cinema—that the term "realist" means one thing in its common application to a painting or photograph and quite another thing in its equally common application to a novel or play. A realistic visual image is one that is said to "look like," "resemble," "reproduce," "iconically represent" the surfaces of the visual world. We see—or think we see, or have learned how to see, or are fooled into thinking we see—in a painting what we see—or think we see—in the real world.[7] But a realistic story is one that is said to chronicle "credibly," "probably," and "believably" the way we think people feel, think, or act, the way things happen, and the reasons they happen, all of which are consistent with the reader-audience-society's beliefs about psychology, motivation, and probability. The standard of one sense of realism is primarily visual while the standard of the other is primarily psychological. One might see the early films groping, then, toward a synthesis of the visual realism of late-nineteenth-century painting/photography with the psychological realism of late-nineteenth-century novel/drama.

The initial problems that films encountered in making that synthesis were, predictably, both visual and psychological—and included precisely those questions of denotative sequentiality that Metz raised and upon which narrative coherence (in any medium) depends: before and after, near and far, at the same time as, as a result of, five years later, mean-

7. This equivocation deliberately avoids the question of whether there is anything actually real about what one sees in a painting or photograph. The fact is that a very large number of viewers operate on this assumption because *they* think there is something real about what they see, despite the theoretical imprecision of their holding such a belief.

while in another place, and so on. Although these narrative transitions have nothing in themselves to do with the surfaces of physical reality, discovering the means to convey this information successfully in the early films relied completely on producing some kind of mental connection in the viewer that linked what he saw in the filmed image with what he might see if he were looking at the world. Understanding the narrative connections in the early films required the viewer to connect objects and events with which he was familiar in the natural world—fields, trees, houses, rivers, deep spaces, the movement of bodies in those spaces— with the spatial and temporal linkages upon which chronological narrative depends—before, after, at the same time as, and so on. In effect, understanding a film narrative required the early viewer to make some connection between natural signs (in the sense that one can understand the meaning of seeing "these three specific people in front of that specific tree" because one has seen—or can imagine—and therefore can recognize people juxtaposed with trees in the world) and conventional signs (in the sense that if one then sees those same three specific people in front of a different tree one understands them to be not only in another place but, necessarily, at some other time).

In order to explore this connection, I will examine two early films in some detail: *Rescued by Rover* (shot by Cecil Hepworth in England in 1904, distributed in America in 1905) and *Her First Adventure* (directed by Wallace McCutcheon and photographed by Billy Bitzer for the Biograph Company in March 1908, just three months before D. W. Griffith would shoot his first film for that company). Both films vaguely display the same narrative pattern: a little girl, stolen away from her loving parents by gypsies, is tracked by the family canine and thereby reunited with her rightful parents. Despite the fact that *Rover* was made a full four years earlier than *Adventure* (a significant figure, since it represents roughly one-third of the entire history of narrative film to that point), it is a far more effective and accomplished film not because of its realist texture (Bitzer's photography makes the later film far more lovely in that respect) but because of its greater narrative coherence.[8]

Two minor narrative differences between the two films can be treated quite briefly before I examine the major narrative difference between them. First, there is the differing motivation for the gypsy's theft. In *Rescued by Rover,* the begging gypsy is insulted in the film's second shot (the maid walking the baby buggy turns up her nose and refuses to give the old woman money) and steals the child almost im-

8. *Rescued by Rover* is available for purchase or rental from any number of companies as an inexpensive, single-reel item. *Her First Adventure* can be rented or purchased from Pyramid Films as part of its series, *The First Twenty Years,* Program 12. These little primitive films make excellent subjects for study since their problems are, unlike later narrative feature films, so simple and single.

mediately thereafter in the third. This shot, one of the most interestingly planned in any film I have seen of this period, is a lengthy take combined with a camera pan that cleverly links the theft of the child from the buggy with an intimate detail—the maid's flirtatious chat with a soldier-suitor—which makes the theft both probable and initially undetected (fig. 1). But in *Her First Adventure* the child apparently strolls after the gypsies (they are street musicians) of her own accord, probably attracted by the music (as a Biograph Bulletin, rather than any information in the film itself, tells us). Only late in the film do the gypsies become active kidnappers rather than the passive beguilers of a wandering child.

Fig. 1.

This crucial shift of motivation, however, is never shown but takes place off-frame. The child, for some reason or other, begins to drift away from the gypsies, moving to her left, and the camera pans with her. After at least fifteen seconds, during which the crucial psychological decision must have been made by the gypsy, he suddenly rushes into the frame, picks the child up, and carries her back to the road. Of course the suppression of crucial narrative information by keeping it off-frame can

be an effective film device—as Hitchcock, Lubitsch, and any number of clever directors prove.[9] But in *Her First Adventure* this narrative transition seems too important to be thrown away, resulting in our puzzlement about the entire narrative itself (that is, how much were the gypsies to blame from the beginning?). No principle of Kracauer's visual realism has been violated in producing this narrative confusion. Instead, we are facing the familiar problem of "showing and telling," what to depict fully and what to summarize, which determines the effectiveness of any narrative work in any medium. If the transition seems "unrealistic" in *Her First Adventure*, it has nothing to do with the visual meaning of the term (the film's remarkable photographic "realness" is its most striking virtue) and has everything to do with its psychological sense: the film fails to satisfy our assumptions about motivated human behavior based on clear and credible preparation.

A second narrative flaw in the film, however, takes us closer to a connection with the real, material universe. In *Her First Adventure*, the father motivates the dog to begin his quest in a way that is quite consistent with our notion of canine behavior and potentiality in the natural universe. He pushes a piece of the little girl's clothing in Rover's nose (the dog's name, by the way, is also Rover, according to the Biograph Bulletin, revealing the influence of the earlier film), an act which instigates his pursuit (fig. 2). In the earlier *Rescued by Rover*, we see that Rover is emotionally attached to the baby in the first shot of the film, a close-up of the two sleeping together (fig. 3). After the theft, Rover hears the maid's lament, somehow understands her information, and races off to the rescue of his own accord. Although it is probable that a dog can understand the moods of his master, it is not possible that he can digest such complex information. Rover's perceptivity seems close to the extraordinary Super-Dog behavior that has been typical of the great canine stars from Rin-Tin-Tin to Lassie. If Rover's intelligence is narratively acceptable in *Rescued by Rover* (and in the other super-canine films as well), it is for two reasons: first, this is one of those probable impossibilities that Aristotle found acceptable; second, this probable impossibility occurs early in the film, at the beginning of the narrative process, where it becomes a *given* element of narrative premise.

After establishing the more possible, if not more probable, naturalistic motivation as part of its narrative premise, *Her First Adventure*, unfortunately, then commits the unpardonable narrative sin of later violating its own premise. The racing Rover refuses to respond nasally to an important clue, a little doll which the struggling girl drops on the road, a doll which certainly must have been as saturated with her scent as was the initial piece of clothing. Rover runs right over the doll without

9. This off-frame device never really suppresses information. It deliberately urges the viewer to savor the difference between what he knows and what he has seen.

Fig. 2.

Fig. 3.

even a pause, a pure pawn of the exigencies of the chase. In a sense, this Rover turns in a bad acting performance as a dog. He is simply not responding to a stimulus the way we know that a real dog would respond to a natural stimulus in that behavioral context.[10] In comparison, Rover in the earlier film is a completely doglike dog, despite his intelligence, since he is incapable of swimming a little stream without pausing to shake himself off afterward, regardless of the exigencies of the narrative and the chase. The greater narrative coherence and credibility of *Rescued by Rover* in its depiction of more believable canine behavior reveals a synthesis of both greater natural and narrative probabilities.

But the greatest narrative difference between the two films lies in their climactic chase-rescue sequences, one of which seems completely clear and, thereby, compelling, while that of the later film seems completely bewildering. Both of the films depend on the establishment of concrete and specific geographical locations to mark the spatial progress and proximity of the victim and rescuers. But *Rescued by Rover* uses the repetition of locations—what would be called the repetition of identical camera setups—much more clearly and coherently. Its general pattern of shots and locations might be diagrammed as: A – B – C – D – E, E – D – C implied – B – A, A implied – B – C implied – D – E (fig. 4).[11] The repeated locations from the identical camera angles—window of house (A), street (B), street corner (C), little stream (D), row of tenement doors (E)—establish precisely where the gypsy lives with the stolen baby, where the master's house is, and how Rover goes from one to the other—first alone to search for the baby, then returning home to summon the master, then returning to the rescue with him. By repeating each location from an identical camera position, by repeating them in precisely the same or opposite order (with the suggestive deletions), and by moving Rover across and through the frame in an identical direction in every shot of each sequence (toward the camera and to our left as Rover races toward the gypsy's dwelling, away from the camera and toward our right as he returns home), the film produces denotative narrative coherence as well as connotative narrative energy (especially when combined with the dynamic movement of Rover's motion across and through the frame and the tight cutting, which never leaves a frame empty or devoid of Rover's perpetual movement).

But the rescue-chase process of *Her First Adventure* seems very puz-

10. The fault, of course, is not Rover's but the filmmaker's, who never saturated the doll with any scent to attract Rover's attention in the first place. The dog's honesty reveals the director's narrative clumsiness. I am reminded of Francois Truffaut's *Day for Night,* in which a filmmaker must go to great, frustrating lengths to obtain a tiny, ironic touch. He wants to get a kitten to lap up the milk that has been left on the breakfast tray of the new lovers. The kitten has other ideas.

11. The rescue process is built of three sequences—five shots, then four, then three. The elimination of one shot each time is an effective way to preserve the clarity of the process but simultaneously decrease boredom and tighten its rhythms.

zling. Although the film uses the same principle of repeating five identical locations to follow the progress of both victim and rescuers, it does so without repeating the identical camera setups (in three of the five shots) and without separating the locations temporally. First, we see the little girl with the gypsies, walking down the street with a row of houses on our right. Then, immediately afterward and with a barely perceptible cut and shift of camera angle, we see Rover racing furiously in the same direction, followed by the throngs of people and police in equally furious pursuit. Next we cut to another street with fewer houses on it and witness a scene with the same editing pattern—gypsies and child, a cut so imperceptible as to seem more like a mistake than a cut, racing Rover, then the pursuing people. Then we cut to a more rural-looking setting—a road with trees, railroad tracks, patches of snow—and view a similar, but not identical, editing plan—walking child with gypsies, no perceptible cut at all, racing Rover, trailing people. The entire editing sequence would be diagrammed: A – A (barely perceptible cut) – A (no cut), B – B (barely perceptible cut) – B (no cut), C – C (barely perceptible cut) – C (no cut), D – D (no perceptible cut) – D (no cut), E – E (no perceptible cut) – E (no cut) (fig. 5). Although the entire sequence implies a movement from central city to distant country—city street (A), row of houses (B), road with tracks (C), sparser road with house (D), country road (E)—the process necessarily lacks the two geographic anchors of *Rescued by Rover*—home and hovel—which are firmly fixed in space and, thereby, in time, relative to one another.

First, what are we to make of the barely perceptible cuts that may or may not be intentional cuts? Since the cuts are almost undetectable when watching the film (they could only be verified as shifts of camera position with an analytic viewing machine), the shifts may signify nothing more than common mistakes of which the early films are full—mistaken stoppings and startings of the camera betrayed by slight shifts of its position midscene. I think not, however, since these mistakes are rarer by 1908, since Bitzer knew what he was doing, and since the shifts occur in precisely the same place in the three scenes which use them—after the child and gypsies have left the frame and before Rover enters it. Another explanation for the cuts—far more probable than the previous one—is that this American Rover was a very undependable canine performer who forced the filmmakers to cut around his unpredictable ability to race through the shot. Although this explanation would account for Rover's solo running performances, apparently unattached to the very humans he is supposed to be leading, it does not account for the slight shifts of camera position in A, B, and C. From film's earliest years the camera had been mounted on a tripod which could be locked into place so as to hide any perceptible change of camera position from shot to shot (if it were not, Méliès' films of magical tricks, which he had been making since 1896, could never have been made, for such convincing trickery de-

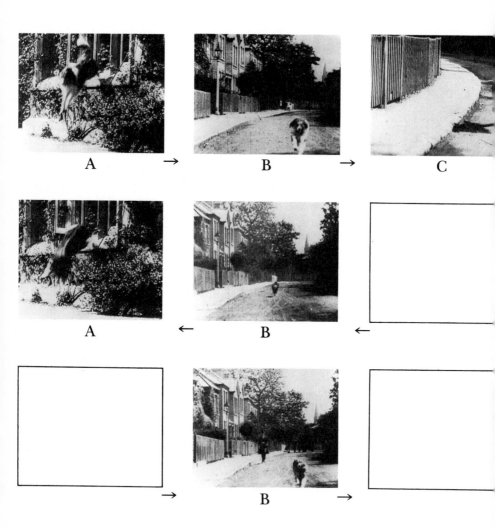

A → B → C

A ← B ←

→ B →

F

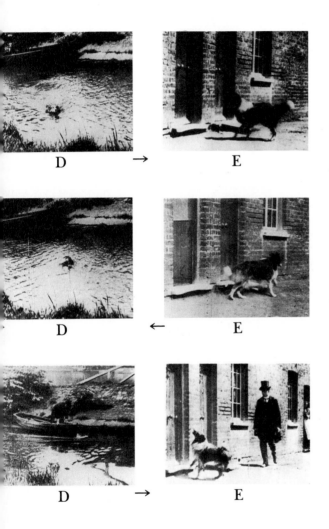

D → E

D ← E

D → E

FIG. 5.

143

pended on an absolutely fixed camera position). The filmmakers could easily have cut around a recalcitrant canine performer (as they probably did in D and E) without our perceiving any shift in viewing angle.

The problem we are confronting is whether a visual phenomenon in this early film is intentional, is significant—indeed, is a "signifier"—or not. *If* it is a sign, what might the sign signify? The only possible function of this device would be to imply significant narrative information—the passage of time. How else could a furiously racing dog not catch up with a slowly walking child if they both traverse the same space and if the one follows immediately after the other? The only answer is that a gap of time separates the fast dog and slow child, and the barely perceptible cut has been asked to signify that temporal gap. The fact that there is no perceptible camera shift in locations D and E would then signify that the spatial and temporal gap separating Rover and the child is much narrower than it was in locations A, B, and C.

Why do the barely perceptible cuts fail to make themselves clear? Why must we even wonder whether these cuts have any significance or signification whatever? The confusion results from a camera shift which is so slight that it fails to register a significant enough visual change and thereby fails to imply a significant gap of time; this confusion powerfully reveals the genesis for one of today's maxims of film narrative technique—shifts of the camera's position within the same scene or space must be significant enough to be clearly perceived as shifts. (The maxim has even been quantified: the shift of camera angle must be greater than thirty degrees!) Given our assumption that the stability of an uninterrupted visual space in a film implies, as does such a space in the world, a continuous space, our view of an identical space must be wrenched by a camera shift if we are to understand that the continuity of that space (and, therefore, of time) has been disrupted.[12] In *Her First Adventure,* the power of a natural sign (the stability of space and the continuity of time in the world) has come into conflict with the weakness of a conventional sign (an almost imperceptible shift in the way the camera views that space). The result is confusion—aggravated by the two scenes (D and E) in which there is no detectable cut (not even on an analytic viewing machine) but in which the racing dog is still no more successful at overtaking his slow-moving prey.

Then there is the problem of the A – A – A pattern itself that keeps us so resolutely within the same visually continuous space. Since Rover appears in the frame immediately after the child and gypsies have left it, and since he rapidly traverses the fifty feet or so of space so clearly defined by the shot, and since the cut is so imperceptible (and in two scenes nonexistent), we presume that Rover can be no more than a few

12. Once again, clever directors can play with the audience's assumptions of the relationships of cinema space and time. Godard and Ozu come immediately to mind. But both directors are aware that they are disrupting our expectations.

seconds from reaching his goal. Spatial proximity in such clearly defined locations implies temporal proximity (Panofsky's "spatialization of time"). But no, Rover is apparently not so hot on the gypsies' heels because in the very next shot the gypsies and little girl enter the frame alone, traverse it, and vacate it just as they did in the previous shot. This bewildering physical impossibility, magnified by the last two shots in which the action seems absolutely continuous and in which we see Rover enter the frame no more than fifty feet behind his quarry, climaxes in the film's final shot in which the pursuers finally rescue the child. Rover does not enter the frame first, leading the people to the gypsies, despite the fact that he has been as far ahead of his human helpers as the gypsies have been ahead of him. Somehow the humans enter the frame first to fall upon the gypsies (fig. 6), while a trotting Rover brings up the rear.[13]

FIG. 6.

One explanation for this confusing continuity might be based on a scholarly argument that has little to do with the specific narrative prob-

13. If the human pursuers have developed some strategy (for example, restraining Rover so as not to frighten away the gypsies), that human decision cannot be left off-frame (like the earlier decision of the gypsy to seize the girl).

lems of *Her First Adventure.* In copyrighting paper-print films, Biograph
sometimes sent them to the Library of Congress in the order in which
the scenes were shot, not in the order in which they were to be assembled
for public viewing. Without any question, the rescue sequence of *Rescued
by Rover* was shot according to individual locations and setups (that is, all
the A scenes first, then the B scenes, and so forth). There is no way to
repeat identical camera setups without shooting all the scenes for each
setup consecutively, before moving on to the next setup.[14] *Rescued by Rover*
was then reassembled after it was shot into its fluid narrative continuity.
Perhaps the same was intended for *Her First Adventure* and perhaps the
version of the film that survives for us today was not the version witnessed
by audiences of 1908.[15] One might be able to make the rescue sequence
coherent by reediting it into, say, a pattern of A – B – C, A – B – C (Rover
in the same locations), A – B – C (people chasing in the same locations),
and so on. This editing pattern would eliminate the problem of the im-
perceptible camera shifts in A, B, and C, implying that no inference was
intended by the shift and the camera merely moved a little between shots
that were conceived to be separate. Unfortunately, this explanation does
not explain why the camera moved at all and why it moved at exactly the
same point in the first three locations.

If the continuity of *Her First Adventure* today is exactly as it was
planned and intended in 1908, what might have been in its makers'
minds? The chase sequence in a theatrical production of *Uncle Tom's
Cabin* would be patterned exactly like that in the Biograph film—A – A –
A, B – B – B, C – C – C, and so forth. First, Eliza would move across the
stage, from our left to right, probably at a slow pace signifying the
difficulty of walking on ice. Then, five seconds after she disappears
beyond the proscenium arch, the pack of dogs would track across the
stage, moving from our left to right, at a much faster pace, followed by
Simon Legree and the human pursuers. After they disappear behind the
proscenium arch on our right, Eliza would appear again on the opposite
side of the stage. Perhaps to show the decreasing distance between pur-
sued and pursuers, Simon and the dogs would enter only one second
after Eliza leaves the stage on her second transit, then somewhat before
she leaves the stage on her third transit, even earlier on the fourth, until
they finally overtake her at stage center on the fifth transit.

The sequence is coherent in the theater because the width of the
stage, the distance that separates the two proscenium arches, in no way

14. One delightful detail makes it certain that the film was shot in this manner. The
second time Rover swims the canal (D₂), returning home to master, he shakes himself off
before plunging into the stream. This implies that he is still wet from his swimming it
immediately before in the opposite direction.

15. Despite its youth, film has been providing the scholars of future generations with
more filmographic problems than presently confront Shakespearean scholars trying to
determine an authoritative text.

corresponds to the specific distance between the pursuers and the pursued. How much space separates Eliza and Simon in their first transit across the stage? A certain, fairly significant amount, more than on their second transit, which is more than on their third. It is impossible to answer the question any more precisely because the distance between Eliza and Simon is not a natural one that can be quantified but a metaphoric, conventionalized one that must be imagined. Indeed, in this stage chase, the distance between Eliza and her pursuers is not spatial but temporal. As opposed to the cinema which spatializes time (temporal connections must be inferred from spatial ones), the stage chase in *Uncle Tom's Cabin* temporalizes space (spatial connections must be inferred from temporal ones). In *Her First Adventure,* the slight changes of camera position in A, B, and C, progressing to the unshifting camera in D and E, must have been conceived (if they were indeed conceived) as cinematic equivalents of the proscenium arch in the theater, as temporalizations of space. This particular application of conventions of the stage chase clearly failed to transfer the narrative coherence and excitement of such a chase to the screen.

Why? In *Her First Adventure* we are viewing that specific road, with those specific trees, and those specific patches of snow on the ground. Each shot depicts and defines that specific place in the world and no other. And each shot clearly defines the specific area which comprises that space. The film of *Her First Adventure* is subject to two natural, spatial laws: (1) a law of identity—a space in the world which appears identical to a previously depicted space is indeed that identical space (it is this powerful sense of identity that obliterates the potential signification of the shifted camera position); and (2) a law of velocity—a quickly moving body traverses the identical space much more rapidly than a slowly moving body (the violation of this law produces our perplexity about Rover's never catching the gypsies). The chase sequence in *Her First Adventure* is subject to natural laws in a way that the parallel sequence in *Uncle Tom's Cabin* is not; space cannot be temporalized by convention in the same way in a motion picture. This view would seem to agree with Kracauer's notion of realism as well as Bazin's dictum that the cinema can be emptied of every reality save one—the reality of space.[16]

Yet much of the conventional, rather than the purely natural, makes the rescue process coherent in *Rescued by Rover.* Although the earlier film respects the spatial integrity and natural identity of each place depicted in each shot, only a conventionalized relationship keeps the individual shots and places together so that our minds can link them into a single narrative process. To leap from window to street to stream to row of doors requires a mental leap to link them as parts of a continuous action. Our mind is aided in that process by several cues. First, there is the logic

16. "Theater and Cinema," in *Film Theory and Criticism,* pp. 378–93.

of the narrative process itself. We know Rover's general goal in each specific shot of the sequence, precisely what he is doing and why. This is precisely the kind of logic that allows us to make sense of the chase sequence in a stage production of *Uncle Tom's Cabin*. In *Her First Adventure*, however, our confusion resulted from the logic of the narrative process' coming into conflict with those natural laws of space and velocity.

Second, there is the direction of Rover's movement across and through the frame in each shot of the sequence. Direction of movement is also essential to our understanding the conventionalized chase in *Uncle Tom's Cabin*. Imagine our confusion if Legree and the dogs entered on the same side of the stage where they exited and moved across stage in an opposite direction from Eliza. In *Rescued by Rover* we know that Rover is returning home in the middle section of the rescue sequence, even before he arrives there, simply by his movement in the opposite direction through the frame.

Third, when Rover repeats the cycle for the final time with his master, both dog and man share the frame in every one of the previously established spaces. Further, Rover and master traverse those frames in precisely the same relative positions—Rover in the foreground, the master some twenty feet behind in the rear. Such consistent spatial relationships establish the narrative notions of *leading* and *following;* they also imply an intentionality—that the dog is leading his master to the place where the baby has been hidden, thereby solving the narrative problem established in the film's opening shots. But because in *Her First Adventure* Rover never shares the framed space—neither with the gypsies he is pursuing nor with the people he is preceding—it never becomes clear whether the dog is running toward any specific, purposeful goal or whether he is merely running miscellaneously.[17]

And fourth, there is the rhythm of switching locations—in effect, of editing—so that Rover's progress seems continuous despite the discontinuity of space. *Her First Adventure* confused us as much by its rhythms as anything else. Rover seemed to enter the frame as soon as the child and gypsies had vacated it, but a lengthy pause of empty frames separated Rover from the trailing humans. This sort of rhythmic variation is also essential to our understanding of the stage chase in *Uncle*

17. This feeling of random, miscellaneous movement in the film—rather than the feeling of intentionality about the motion in *Rescued by Rover*—reveals the closeness of *Her First Adventure* to the genre of "chase films" of the early 1900s, which depicted movement for the sake of movement rather than for the sake of solving a clearly established narrative problem. These films, which reached their peak of popularity in 1904 and 1905, simply delighted in running, running, running. Historically, then, *Her First Adventure* is an interesting hybrid—with one foot in the popular style of the past and the other in the popular style of the future. *Rescued by Rover,* though made three years earlier, is already a representative of the more narratively coherent, historically advanced type.

Tom's Cabin. The stage characters' miming of smooth movements as opposed to struggling ones, the rhythm of stage exits and entrances, the amount of time that the stage space remains completely empty all inform us about the progress of the chase and the distances that separate the chasers. My claim, then, is not that movie chases are natural and stage chases conventional—a rather familiar claim about the difference between stage and screen—but that, on the contrary, movie chases manipulate chase conventions that are parallel with or even identical to stage conventions but without violating the natural laws of time and space within each shot and without introducing conventions (the slight camera shift) that cannot successfully compete with those natural laws. Seen in this manner, *Rescued by Rover* is not more "realistic" than *Her First Adventure* but a more insightful application of stage conventions to the realist space of motion pictures.

Indeed, the same thing may be said of D. W. Griffith's discovering the so-called grammar and rhetoric of film in the years between 1908 and 1912. Although said to invoke Dickens as his mentor, Griffith served his real apprenticeship on the stage. It has become very unfashionable to link stage and film technique (the fashion has been to insist on the absolute differences between the two media), but almost every cinematic innovation in Griffith's Biograph films can be traced to the stage. His 1909 experiments with mood lighting (*The Drunkard's Reformation, Pippa Passes*) are stage lighting effects. His triangular blocking of scenes (rather than using the linear blocking of his predecessors) is stage blocking, of which the triangular configuration is a basic tool in creating pleasing visual patterns and signifying essential psychological information. His growing mastery of framing, particularly in using off-frame space (most brilliantly in the 1912 *Musketeers of Pig Alley*), is based on an analogy with the proscenium arch (and a much more valid and functional analogy than that in *Her First Adventure*). Even Griffith's famed cross-cutting can be found in Victorian melodrama and can be traced at least as far back as Shakespeare and his fellow Elizabethans.[18]

These early attempts to produce coherent film narratives convince me that the issue of cinema realism, certainly an important response to the prevailing formalist Arnheim-Eisenstein aesthetic of forty years ago, has now become a barrier itself to a deeper understanding of film form, art, meaning, and effects. A singular or single insistence on the realism of the filmed image is incapable of investigating film's complex power to tell stories. Unlike a Siegfried Kracauer, who maintains that film's essen-

18. All of the talk about the spatial stability of the stage is based on an erroneous linking of the Ibsenesque realist stage (which wanted to preserve spatial stability) with the physical fact that the stage itself does not move anywhere but is stuck exactly where it is. Shakespeare could, however, produce a "cross-cut" from the city to a forest by having a character come out and say, "Here I am in the forest."

tial power is solely to record and reveal the surfaces of physical reality, and unlike an Umberto Eco,[19] who maintains that there is nothing real or natural about the filmed image at all, I find that our understanding of a filmed image and our comprehension of a film narrative requires a combination of the conventional and the natural, of reading and re- sponding to both natural and arbitrary signs. I find the problem of making such a combination inherent in the medium from its beginnings, and I find attempts to effect such a combination in most of the little films of this early period. An awareness and investigation of this combination might lead to the consideration of a very demanding question: Exactly how and why has film become the dominant narrative medium of our century, the medium of all narrative "action," just as the novel was the dominant narrative medium of the previous two centuries and the drama of the two centuries before that? Although some of the answers to such a question are obviously cultural and commercial, others must have something to do with the artistic power of the medium itself to tell stories. Perhaps film must be seen as the logical extension and culmina- tion of the richly textured realist and naturalist novel of the late nineteenth century, extending the novel's inevitable progress in weaving complexly patterned fictions out of the apparent flow of life itself.

19. Eco's arguments that suggest such an opinion can be found in his "On the Contri- bution of Film to Semiotics," in *Film Theory and Criticism*, pp. 217–33; and in "Articulations of the Cinematic Code," in *Movies and Methods*, ed. Bill Nichols (Berkeley and Los Angeles, 1976), pp. 590–607.

Trucage and the Film

Christian Metz

Translated by Françoise Meltzer

1. The Concept of Image Track

The visual portion of a synchronized-sound film (or the totality of a silent film) corresponds to what is called the "image track." In spite of this term, the image track is not comprised of images alone but also includes two elements of a different nature. First, an entire collection of written statements and dialogues, such as the title of the film, production credits, the words "The End," the intertitles of silent movies, the subtitles of sound films shown abroad in the original version, scattered information like "Twenty Years Later," and the like. Second, that which is the object of this study: various optical effects obtained by the appropriate manipulations, the sum of which constitutes *visual,* but not *photographic,* material. A "wipe" or a "fade" are visible things, but they are not images or representations of a given object. A "blurred focus" or "accelerated motion" are not photographs in themselves, but modifications of photographs. The "visible material of transitions," to quote Etienne Souriau,[1] is always extradiegetic. Whereas the images of films have objects for referents, the optical effects have, in some fashion, the images themselves, or at least those to which they are contiguous in the succession, as referents.

The Marxist theorist Béla Balázs has remarked that these optical processes appear to signal a direct intervention of the film maker into

The word "*trucage*" usually translates as "trick photography" in the singular and "special effects" in the plural. But Metz places many terms, including these, under the rubric of *trucage,* and I am therefore retaining the French word. [Translator's note]

1. "Les Grands Caractères de l'univers filmique," in *L'Univers filmique* (Paris, 1953), p. 19.

Reprinted from *Critical Inquiry* 3 (Summer 1977): 657–75

151

the narrative,[2] whereas photographs (even when put into motion, as they are in film) express the author's point of view only through the development of a "story." The very manner in which the story unfolds reveals—and simultaneously conceals, *envelops,* in short—the author's stance with respect to the events presented. It is this effect of envelopment which was intimated in the concept of *mise en scène,** also including the structure of events, montage, camera movement, and the like. In short, this is a question of a certain kind of rapport between ideology and the manifest content of a filmic text. With a fade-out, on the other hand, that rapport is displaced, and the film maker (or, to some extent, the camera) seems to speak in his own name: "absolute filmic effects" and "expressive technique of the camera," concludes Béla Balázs.[3]

Nevertheless, it must be remembered that not all of these optical effects are obtained during the shooting; some are produced in the laboratory. The former are the result of *camera* manipulation, the latter of *celluloid* manipulation.[4] This is the first possible division inside "process effects."

2. Trucages *and Syntactic Signals*

It is not the only division. One can equally distinguish between those manipulations resulting in what are termed (and it is a term which I shall retain, for the sake of expediency) syntactic markings, the most promi-

**Mise en scène* is used in English because of its development by André Bazin, who defines it as a cinematic quality contrasted to montage. Although the term means "theatre staging," Bazin uses it to mean all of the plastic elements of image, both still (costumes, sets, lighting, etc.) and moving (blocking, composition). [Translator's note]

2. *Theory of the Film* (London, 1952), p. 144.
3. Ibid., p. 143.
4. In "Technique et idéologie," *Cahiers du Cinéma,* no. 239 (1971), pp. 7–8, Jean Louis Comolli correctly observes that the entirety of cinematographic technology should not be reduced to the camera alone.

Christian Metz, one of the foremost French theorists of the cinema, is the author of *Essais sur le signification au cinéma, Propositions méthodologiques pour l'analyse du film,* and *Langage et cinéma.* He is Sous-Directeur d'Etudes Suppléant à l'Ecole Pratique des Hautes Etudes, Paris. This is the first English translation of "Trucage et cinéma," from Metz's *Essais sur la signification au cinéma* tome 2 (© 1972 by Editions Klincksieck); translation printed by permission of the publisher. **Françoise Meltzer** is an assistant professor of Romance languages and literatures and of comparative literature at the University of Chicago and has translated a portion of Alain Robbe-Grillet's *Topologie d'une cité fantôme.*

nent of which are "punctuation marks," and those manipulations which constitute *trucages:* backwards motion, accelerated motion, slow motion, multiple exposures with matte and countermatte allowing for the display, on the same frame, of two "copies" of the same actor engaged in conversation with "himself."

The concept of *trucage* as presented here must not be confused with the "special effects" of which studio technicians speak. Preoccupied with the practical problems of their craft, technicians consider as special all those effects which they must create specially and which demand, in addition to the normal work of filming, a small, particular technique. There are, in fact, "special effects men" in studios—their names occasionally figure in the credits. Thus loosely defined, the rubric of special effects will obviously form, for the semiologist, a heteroclitical group.** Jean Louis Comolli is quite right in remarking[5] that the notions of technicians—who sometimes have a *professional,* and therefore corporate, personality—cannot automatically be considered as theoretical concepts. Each case must be examined separately.

3. Taxemes and Exponents

In the case which concerns us, the introduction of a third consideration will allow us to dissect the realm of optical effects differently. If the *position of the signifier* is considered with respect to the perceptible succession of the film (= distributional criterion), the fade-out will be in opposition to all other methods. In fact, it alone occupies a more or less lengthy segment of the image track. When a fade-out is followed by a fade-in, for a brief moment the only visual element offered to the spectator is the black rectangle. Here, the optical effect is in itself a filmic *taxeme,* in the sense of Louis Hjelmslev. An indivisible segment in the sequence, it monopolizes the screen for an instant.

What defines all process-effects, we have seen, is a kind of *divergence from "photographicity."* With the fade-out, that divergence rests in the very fact that the film, for an instant, offers no photograph for viewing. The situation is different with other optical effects. Indeed, superimpositions or dissolves consist in superimposing two units of perception, both photographic in nature. Certainly, their superimposition is not in itself a

**For an alternative view on this problem, see Gerald Mast's *Film/Cinema/Movie* (New York, 1977). Mast suggests that there is no single word capable of covering all the categories which Metz will include under the label *"trucage."* Some of the effects pertain to the differences between camera speed and projection speed, others to lenses and filters used during the shooting, still others to effects of film processing and printing. [Translator's note]

5. Ibid., no. 231, p. 47.

photograph, which is what defines the divergence here. But at no time will the spectator see the optical effect *only;* he will see images *affected* by a special effect, like a type of semiological exponent. The process is no longer a taxeme; it is the exponent of one or more taxemes, it is suprasegmental. It refers to an image with which it is simultaneous, whereas the fade-out refers to images coming immediately before or after it.

In contrast to the fade-out, a taxeme process, the processes of exponents are fairly numerous: the iris, the wipe, special lenses, blurred focus, backwards motion, accelerated or slow motion, the use of a freeze frame, dissolves, superimposition, overexposure, split screen (several photos at the same time, the screen being divided into a certain number of "scenes," but by juxtaposition and without superimposition)—as many effects as assume (and affect) one or more photographs.

Nevertheless, some of these allow for variables in which they become (so to speak) quasi taxemes. This is the case with the iris (irising in or out). If we consider that part of the image which remains visible to the end, it is an exponential process, the exponent here being the black halo which closes on that which we continue to see. But if we consider that invading black, in itself soliciting attention, the iris reveals itself to be related to the fade-out—which in fact replaced, in the history of the cinema, most of its functions. And it is, to a certain point, the iris as such which occupies the corresponding segment of the film (or at least of the image track, with which this study is concerned, leaving the sound element aside).

Similar remarks can be made about the wipe, in which one sees two images one of which seems to be pushing the other off the screen (at which point the effect produced is like the exponent of these two images). The very fact of this curious eviction can, by logical extension, become the essential viewed subject as long as it is not completed. This is especially the case in one of the variants of the wipe in which a large white strip of fairly great width sweeps across the screen, pushing the new image in and the previous one out. This effect was used, for example, in Tony Richardson's *Tom Jones* (England, 1963), and tends to make the transition itself an autonomous segment by virtue of the perceptual attack of the extradiegetic material used. This impression is strengthened when the white strip does not move parallel to the vertical sides of the screen but rather adopts some more imaginative itinerary across the textual fabric, such as a radius circularly sweeping the screen from a central point. (Again, in *Tom Jones,* such processes correspond to a deliberate distancing, and are the cinematographic equivalent of a certain jocular style peculiar to eighteenth-century novels.) On the other hand, in *The Seven Samurai* by Akira Kurosawa (Japan, 1954), and in many other films, there appears a variant of the wipe which is noticeably different: a sort of vague shadow passes over the screen laterally, separating (without being perceived) the image which is "departing"

from that which is "entering." Such a wipe is exponential to both images, and thus returns us to the general case.

If the optical effects are rarely taxemes, it is because the purpose of film is to produce images treated in one manner or another and not (as is implicit in the definition of a process-taxeme) to produce something other than images. I will try to show later that in classical cinema the method judged to be optimal for special effects is that which permits assigning them, through a division of belief and denial of perception, *both* to the diegesis and to the statement. The process-taxeme is from the start very noticeably outside the diegesis, and therefore partakes of speech in action. The fade-out fulfills the often imperious demands for clarity in the narrative (which it is capable of satisfying by the very fact of its particularity). There are times when the film maker wants to distinguish clearly one sequence from a succeeding one. Common in its usage, this process is exceptional in its rule: it can be compared only to certain production credits (those mounted on title cards and not imposed on the image), to certain titles indicating major sections, and to the words "The End" (with the same restrictions). There are as many filmic moments during which the image track offers us no image. Again, in the latter examples, it offers us a written text. In the fade-out, it offers us nothing: the black rectangle is viewed far less as such than as a brief instant of filmic void. Such a diminution creates its own strength. This singular void on the screen, in a filmic universe normally so full and so dense, by its very singularity leads us to assume a strong separation between before and after. The fade-out is perhaps the only true "punctuation" mark which the cinema possesses to date. This is because it is *irregular* (as one says of a conjugation) and efficacious. And because it is efficacious, it has become habitual. Rare in the system, it is common in the text.

4. Profilmic Trucages *and Cinematographic* Trucages

There is another important distinction, this time concerning *trucages* only and not "syntactic" signs. The word *"trucage"* itself normally designates two kinds of interventions not situated at the same point in the total process of film making. The first, which I shall call *profilmic trucages* in the exact meaning given to that adjective by filmology,[6] consists of a small machination which has been previously integrated into the action or into objects in front of which a camera has been placed. It is *before shooting* that something has been "tricked." These are ruses essentially analogous to those of conjurers. The specific codes of cinema play but a minor role here, even though films resort to them frequently. For tech-

6. Profilmic is everything placed in front of the camera (or in front of which it is placed) for the camera to "take."

nicians, these are *trucages* on the same order as others, since they must, like others, be specially prepared. Resorting to stunt men is a common example. The stunt man replaces the actor in certain scenes (difficult or dangerous acrobatics, for example). The film maker chooses a person of the same general appearance as the actor or actress; the wardrobe and makeup departments achieve the "resemblance"; the cameraman is careful to film him only at a certain distance and from certain angles.

Among the "tricks" of Geoge Méliès, many were not cinematographic but profilmic. Méliès did not make this distinction—conjurer of his craft, he considered even his cinematographic *trucages* to be merely temporary substitutes for his illusionist's ruses which various insufficiencies in the machinery of his theater had made impossible for a time.[7] In 1896, when Méliès inaugurated the "disappearing trick" in *L'Escamotage d'une dame*—a matter of simply interrupting the shooting while the lady in question left the set—he opted for it reluctantly. This procedure replaced, in his eyes, the theater trapdoor which he lacked that year. If after 1900 Méliès' cinematographic invention slackened and lost its impetus, it is because his new studio was comprised of a perfected collection of theater apparatus. Jean Cocteau, for his part, has declared that in several of his films, notably in *Orphée* (France, 1950), he preferred older machinations to the *trucages* of cinema.[8] Reflections in the mirror, for example, are "interpreted" by doubles.

In contrast to these profilmic *trucages* are those which belong specifically to cinema. They come into play at another point in the production of the film. They belong to the filming, not to the filmed. As I have said earlier, they are produced, according to the situation, during the shooting (= camera *trucages*) or after it (= track *trucages* produced in the laboratory). In any case, they are never shot beforehand. I have tried elsewhere to demonstrate that "cinematographic specificity" is a phenomenon which allows for degrees.[9] Certain figures are more specific than others, which nevertheless remain so. This presence, at the very heart of the wholly specific domain (which is, in turn, merely a part of the film), of several *degrees of specificity,* can also be determined, among other things, in the case of *cinematographic trucages* (= non-profilmic *trucages*). The "blurred focus," for example, belongs in the category of filming, and not in the action filmed. It is thus "specific." And yet, blurred focus is a photographic technique which the cinema has been content to adopt. This is not to say that it is void of all specificity, since one of the characteristics belonging to cinematographic codes is the ability to integrate photographic codes. Nevertheless, blurred focus belongs less specifically to the cinema—since cinema shares it with a

7. Georges Sadoul, "Georges Méliès et la première élaboration du langage cinématographique," *Revue internationale de Filmologie* 1 (July–August 1947): 23–30.
8. *Entretiens autour du cinématographe,* ed. André Fraigneau (Paris, 1951), pp. 126–38.
9. Chap. 10 in *Langage et cinéma* (Paris, 1971).

number of other "languages"—than does, for example, accelerated motion. The latter assumes the multiplicity of photograms,* does not belong to photography, and is possible only in the cinema. In short, what is significant in profilmic *trucages* is the complete scale of different *trucages,* more or less cinematographic.

As for the optical effects reputed to have "syntactic" value and to participate in no way in *trucage,* it will be shown that they are never profilmic. The totally black screen, the dissolve, irising, wipes, the swish pan, etc., are all, to varying degrees, cinematographic processes which entail camera work or treatment of the celluloid. This is only logical, since we are dealing with enunciation markings which the cinema, in the course of its history, has gradually accumulated, and whose conscious finality excluded their intervention into the heart of filmed action. They belong to the narrative, not to the story; to the telling process, and not to the told. And yet we shall see that, despite this principle, the real working of the film often brings them into play, at least in part, for the benefit of the diegesis.

5. *Imperceptible* Trucages, *Invisible* Trucages, *Visible* Trucages

By its very contents, the distinction between profilmic and cinematographic belonged to the making of film. The next distinction, on the other hand, has to do with film "reading." At first glance, it seems to apply only to *trucages,* and yet film "reading" is what leads, by natural extension, to a return to the very distinction of *trucages* and syntactic processes.

In classical cinema (diegetic cinema), a detailed and coded procedure which is part of the *cinematographic establishment* prescribes the different types of relationships which the spectator can have with *trucages.* Here we are touching upon a real regulation of perception, in itself connected, as I would like to demonstrate, to the historical development of cinematographic *genres.*

Some *trucages* are imperceptible, while others are on the contrary meant to be discernible (accelerated motion, slow motion, etc.). *Imperceptible trucages,* moreover, must not be confused with *invisible trucages.* Resorting to a stunt man is an imperceptible *trucage.* We have seen the precautions taken by the film maker: if they are successful, the spectator will not notice that there has been a *trucage.* He may *know* it by having read of it in a film journal, but it is of little import, if he has not noticed it, whether he knows it or not (it is even better if he does know, as will be shown later). Imperceptible *trucage* is in complete compatibility with the

*I am retaining Metz's term, *"photogrammes,"* by which he seems to mean "photographic recordings," that is, an individual frame blow up. [Translator's note]

convention, characteristic of the majority of present-day films, of a minimum degree of average realism—that is to say, within the limits of what is called the "realistic film." If the actor is shorter than the actress (= films with Charles Boyer and Ingrid Bergman), he wears special shoes or is photographed only at planned angles. The shooting for the film *Crin blanc (White Mane)* by Albert Lamorisse (France, 1952), was done with three or four different horses, although it tells us the realistic story of a horse (only one, of course).

Invisible *trucage* is another matter. The spectator could not explain how it was produced nor at exactly which point in the filmic text it intervenes. It is invisible because we do not know where it is, because we do not *see* it (whereas we see a blurred focus or a superimposition). But it is perceptible, because we perceive its presence, because we "sense" it, and because that feeling may even be indispensable, according to the codes, to an accurate appreciation of the film. The same is true of the *trucages* used in the most successful films on "the invisible man." These are very convincing *trucages,* impossible to localize, but the existence of which is beyond doubt and even creates one of the major interests of the film. They are *trucages* which everyone will agree are "well made" by virtue of their perfect quality (whereas a sequence with a stunt man is successful only if we do not suspect his intervention). The spectator who is accustomed to cinema, and who knows the rules of the game, has at his disposal three apprehensible systems which correspond respectively, in the film, to imperceptible *trucages,* visible *trucages,* and to perceptible but invisible *trucages.*

As to the punctuation marks, it will come as no surprise here to state that they all belong to the category of visible effects.

6. Trucage *as Avowed Machination*

Thus the indigenous theory of cinema reserves a special place for certain optical effects, turning them into rhetorical instruments, clauses of speech, thus escaping the universe of *"machination."* Conversely, it is this "machination" which defines the official status of *trucage* in the cinematographic establishment. The result is that *trucage,* curiously enough, is *always avowed.* It is avowed in the film even in the case of invisible but perceptible *trucage* (and a fortiori in visible *trucage*). And if it is an imperceptible *trucage,* it avows itself, so to speak, in the periphery of the film, in its publicity, in the awaited commentaries which will emphasize the technical skill to which the imperceptible *trucage* owes its imperceptibility. (We will not be fooled by particular instances in which the publicity, at least the immediate publicity, remains silent about certain imperceptible *trucages,* the divulgence of which would be injurious to another publicity—to that of the actor, for example, if he is short, and

the film has made him artificially "taller." This is a temporary and timely silence which does not prevent the cinema, in its publicity as more loosely defined, from voluntarily emphasizing its machination abilities.)

There is then a certain duplicity attached to the very notion of *trucages*. There is always something hidden inside it (since it remains *trucage* only to the extent to which the perception of the spectator is taken by surprise), and at the same time, something which flaunts itself, since it is important that the powers of cinema be credited for this astonishing of the senses. Visible *trucage,* invisible *trucage,* and imperceptible *trucage* represent three types of solutions, three levels of balance between these two fundamental requirements.

7. Trucage *as Diegetization Process*

Syntactic markings are thus distinct from *trucages* because they are not, in theory, machinations. Further, the term "special effects" (the meaning of which is, moreover, fairly vague) is generally reserved for *trucages* and more often than not excludes rhetorical signals. And yet, the latter *are* special effects according to the definition given at the beginning of this text: process-effects which are particular and localized, which do not merge with the normal movement of the photograms, and which are visual but not photographic effects.

It is no doubt because of this technological affinity that *trucages* and enunciation markings are less easily distinguishable in practice than the theoretical bipartition proposed by the *vulgate* of cinematographic commentary on this subject would have us believe. The vulgate will tell us, for example, that a given "ripple effect" has the value of a syntagmatic signal of separation between "before" and "after," whereas such a deceleration is a *trucage* aimed at creating a dreamlike atmosphere. And it is true that, in certain cases, the difference is indeed clear (even though slow motion, by gradual conventionality, can also be viewed as the rhetorical sign of a passage into dream, thus avoiding the entire problem). But even if we admit this, and concede that the contrast is often quite clear and distinct, the fact remains that this is not always the case, nor has it always been so.

What is experienced as a simple figure of speech today was quite frequently, for the first spectators of the cinematograph, a magic "trick," a small miracle both futile and astonishing. It is known that Méliès developed a good portion of the optical effects still in use today, but he considered them "little magic formulas," and "pure abracadabras" (to return to Georges Sadoul's remarks,[10] continued by Edgar Morin[11])

10. Sadoul, "Georges Méliès," p. 26.
11. *Le Cinéma ou l'homme imaginaire* (Paris, 1956), pp. 57–63.

rather than as figures of language, as Jean Mitry has pointed out.[12] It took the force of habit and the progressive stabilization of the codes for certain *trucages* to cease being *trucages* (this is particularly clear in the case of the dissolve). This uncertainty of the diachrony is in part projected onto the synchronic level, at the very heart of contemporary cinema. When a dissolve occurs between two sequences for the purpose of concomitantly emphasizing their separation and deep kinship—since this is, in short, the signified of that "punctuation"—it is already a mark of transition (but still an *evocative* mark). If that same dissolve, this time drawn out with more insistence, superimposes, for a fairly lengthy period of time, the face of the dreaming hero and the representation of the subject of his dream—then the rhetorical indicator, already perceptible as such, emerges only with difficulty from a *trucage* enterprise, and the sequence retains something miraculous as well as a bit of magic. One more step backwards, and it will become the prolonged superimposition; still a *trucage,* and yet already bearing the beginnings of a *deixis* of enunciation, as in the sequence from *The Ballad of a Soldier* by Grigori Chukhraï (USSR, 1959), in which the young hero carries with him, in the train crossing a sad winter landscape, the wonderful memory of a few brief moments of happiness.

It is understandable that quite often optical effects reveal themselves to be hovering between the status of *trucage* and *clause.* Since they are not photographs, they are never "realistic." They remain somewhat a divergence from the film (which is precisely why they are "special" processes). This divergence, more or less sensed, is interpreted (according to the context, the genre of the film: fantasy, burlesque, or on the contrary less marked by the fantastic, etc.) as either a leap into the unusual or as an indication of a metalinguistic order which helps to comprehend better the adjacent images.

In the sequence from *The Ballad of a Soldier,* the superimposition of the young girl's face on a frozen landscape over railroad images attempts in no way to fool the spectator: it is clear that in "reality" (= that of the diegesis), the soldier is traveling on a train and mentally evoking the features of the young girl encountered shortly before. The same could be said on the subject of the famous sequence in accelerated motion in Eisenstein's *The General Line* (USSR, 1929). The Kolkhozian girl and the worker have finally succeeded in shaking the bureaucracy out of its inertia and are on the verge of obtaining the signature necessary for buying their tractor. The governmental offices, which until then had been somnolent, nearly asleep, will suddenly become animated (thanks to the accelerated motion) by a feverish activity which results in the precious signature in the wink of an eye. But we are well aware that this is a caricature (as well as a convention characteristic of the burlesque

12. *Esthétique et psychologie du cinéma,* 2 vols. (Paris, 1963–65), 1:271–79.

genre), and that the governmental offices, even if appropriately solic-ited, as the film suggests they be, are not expected to work at such a pace in diegetic reality.

On the other hand, films on "the invisible man" (which often resort to another process effect, the black background with mattes) achieve their goal, when they do achieve it, by the extent to which the impression is conveyed that it is *in diegetic truth* the hero himself, albeit invisible, who is slowly turning the doorknob. The effect would fail if the idea of the optical process used were too clearly present in our minds, as is the case when the film is clumsy.

Trucage then exists only when there is *deceit.* We may agree to use this term when the spectator *ascribes to the diegesis the totality of the visual elements furnished him.* In films of the fantastic, the impression of unreal-ity is convincing only if the public has the feeling of partaking, not of some plausible illustration of a process obeying a nonhuman logic, but of a series of disquieting or "impossible" events which nevertheless unfold before him in the guise of eventlike appearances. In the opposite case, the spectator undertakes a type of spontaneous sorting out of the visible material of which the filmic text is composed and ascribes only a portion of it to the diegesis. The services of the department of agriculture have worked more quickly because they were approached in an appropriate manner: this amounts to the diegesis. The film makes light of this sud-den rapidity; ironically, it exaggerates it: here is the *intention,* which amounts to the enunciation. In the exact degree to which this percepti-ble bifurcation is maintained, the connotated will be unable to pass for denotated, and there is no *trucage.* The optical effect has not merged with the usual game of the photograms, the entire visual material has not been mistaken for the photographic, the diegetization has not been total.

8. Trucage *and Rhetorical Markings (Return): The Fluidity of Boundaries*

That is what explains, in many cases, why there has both been and not been *trucage.* The apprehensible segregation defined in an instant is neither rigorously maintained nor definitively abandoned. The spec-tator is not the victim of the machination to the point of being unaware that it exists, but he is not sufficiently conscious of it for it to lose its impact. The attitude of the spectator, whose credibility is divided, thus answers to that of the cinema, which I said presents its *trucages* as avowed machinations. It is a game at which the cinematographic establishment wins twofold: by the performance, in the extent to which the special effect, barely discernible as such, is credited to the diegesis (= weakening of the segregation, slippage into magic), and by the affirmation of its own power in the extent to which this process, fairly

distinct as process, is to the benefit of the discourse. Thus both the segregation and the rhetorical play are retained, and from this comes the love for cinema.

Now we can more readily understand why punctuations and other transitions are often hard to distinguish from *trucages*. It is not merely because they began as *trucages* in the history of cinema. Nor is it only because they have in common with *trucages*, from a technological point of view, the fact that they are special effects. It is also because the *trucages* themselves, on one of their facets (admission of enunciation), demonstrate an intrinsic kinship with the rhetorical markings and are only distinct from them, in synchrony, by the threshold which leads to the boundary. From avowed machination (*trucage*), we move to the purely syntactic figure when the avowal becomes sufficiently unambiguous for the machination to cease being one, and for the spectator, before this optical effect, to ascribe no part of it to the diegesis (this is the case in several dissolves which are conspicuous to mark the "chapter" boundaries). It remains then that it is the *absence of machination* which defines, in the face of *trucage*, the pure signal of transition. But it is rare for a signal of transition to be pure, without it involving a beginning (or an end) of *trucage*.

In the most successful films on "the invisible man," the most naive spectator—as long as he is accustomed to going to the movies—never loses sight of the fact—even in the midst of his passionate interest in the plot—that the images were of necessity obtained through some special technique. Conversely, in the sequence from *The General Line*, even the most critical and best-informed spectator will have the fleeting impression, in the midst of the thoughts which he sketches out concerning the film maker's writing, that the characters in the film are "really" moving as fast as he sees them move. The distancing, like the identification, is never total; it is one of the aspects of this "interfusion" of the real and the imaginary which has already been well analyzed by Edgar Morin in *Le Cinéma ou l'homme imaginaire*.

The "syntax" of film stays snared in the movements of the affectivity, and a miraculous *trucage* can become a convention at any moment in realistic cinema. The most captivating of fantasy films, the most amusing of burlesque films, offer us *trucages* which always remain more or less perceived as instruments of discourse, for that is in fact of what those genres are comprised. They can function as such only because they elicit a double and contradictory reaction in the public: a belief in the reality, wonderful or comical, of the events presented, and an interest in the tour de force of which the cinema demonstrates it is capable. These genres remain in fragile balance, one which can be destroyed at any time by tilting to either side. No doubt this explains in part why there are few good burlesque films, and even fewer good fantasy films.

In short, the rhetorical dimension is evident in *trucage* itself, which is

not *only* miraculous. On the other hand, the figure of speech is not only syntactic; it often encourages the process of diegetization. We noted earlier that the spectator of *The Ballad of a Soldier* is not expected to diegetisize the content of the superimposition. He knows that the young girl is not in the train, that the soldier is there "for real," and that the optical effect serves to introduce, in a conventional manner, mental images in the representation of the diegesis. It is nevertheless obvious that this manner of introducing them (without denying their conventional aspect) is in no way the equivalent of a linguistic statement such as "In the train, the soldier thought about the young girl." This would have set a *representation of words* into action, in the Freudian sense, while superimposition proffers itself as a "representation of things." Moreover, the two images, diegetic and mental, are superimposed with no formal mark of differentiation, and in an identical "context" (= both are photographic). What is supposed to separate them in the eyes of clear logic—the opposition of the "real" to mental evocation—finds itself, by virtue of cinematographic process, subtly denied and blurred at the very instant which convention expressly indicates. The narrative exponent of the "passage to the interiority" is necessarily mirrored by more confused and deeper suggestions. From the first, it presents itself as a condensation of two faces, in which the soldier achieves his desire. It carries with it centuries of legends and stories about the telepathy of lovers, presence in absence, and the eyes of the soul. In this very way, it loses its syntactic purity and functions to inflate the diegesis. To varying degrees, this is the case for all signs of enunciation. Their eventual "purity" is merely an extreme case.

The other extreme case, one which takes us to the polar opposite (on the side of *trucage,* therefore), is that of imperceptible effects, of which I spoke earlier (stunt men, for example). It is no doubt the only case in which we do not have to ask ourselves to what extent the special intervention has been viewed as diegetic. At such a point, the cinematographic establishment prefers to *ensure* its power rather than to *display* it. The machination is at a maximum; confession at a minimum.

9. The Denial of Perception at the Cinema

In intermediary cases (which comprise the majority of *trucages* and a good portion of "syntactic" markings), the double game is only possible, from the spectator's point of view, in a psychic process somewhat similar to denial (or "traverse," in legal terms), which was described by Freud in relation to castration anxiety and the birth of fetishism. What we call the "spectator" of the film—the person viewing the film—is, in fact, not only the conscious *I* (which is in any case, as we know, subject to "cleaving"), but the person in his entirety. Logical thought constantly "de-

diegetisizes" optical processes: it *knows* that the young girl in *The Ballad of a Soldier* (the object of desire) is not on the train. But at the same time another thought, more closely connected to primary processes and to the pleasure principle, is not informed of what the *I* knows, has not been notified (or refuses to be notified). It constantly diegetisizes that which the clear consciousness grammaticizes at the same time. It should be noted that it has much at stake in this (after a secondary identification with the soldier, which the film *displays*, specularly). It wants the young girl to be on the train, and the film allows for precisely this, by means of the mental crutch of the superimposition (which "condenses" so effectively). Thus this presence can be hallucinated or dreamed.

The powers of the cinematographic establishment thus anticipate wishes which, for the spectator, are neither superficial nor transitory. Cinema, in turn, is strengthened all the more for it. The very possibility of constantly dividing one's credibility goes far to explain the hold which cinema has on the spectator. For him it represents the formation of a compromise, greatly beneficial, between a certain degree of retention of one's defenses and thus the avoidance of anxiety.

Reasons such as this largely explain individual phenomena of attachment to the cinema. This may result from an evolution which is mostly opaque and subtle (in which the creation of the compromise manifests part of the symptom); or, conversely, from the lucid elaboration of an "economy" which is the least terrible possible, once the integration capabilities of the super-ego are made supple, and the subject matter has made possible a minimal capacity to tolerate oneself. The latter case corresponds to the least obscure form of *cinephilia*, and further explains the tenacity of classical cinema, such as genre films which regulate pleasure with a complexity difficult to replace.

10. From Cinema Trucage *to Cinema as* Trucage

It will perhaps come as somewhat of a surprise that considerations of a fairly general nature have little by little followed an analysis of *trucages* and of punctuation marks—that is, very particular phenomena which occupy but a small portion of the textual fabric of the film. But these cases are in fact particular only in the extent to which they draw particular attention to two facts which are not in themselves particular but which help to define cinema as a whole: the role of avowed machination in the cinematographic establishment and that of the denial of perception in the "spectatorial" economy.

It is in fact essential to know that cinema in its entirety is, in a sense, a vast *trucage,* and that the position of *trucage,* with respect to the whole of the text, is very different in cinema than it is in photography. It is a difference which, in the last analysis, insists that cinema be founded

upon *several* photographs, making the "shots" file by at the interior of the film and the photograms at the interior of the plot.

It is an abrupt undertaking to trick a photograph (a unique and, moreover, a permanent one), for the representation which it renders of its object is reputedly rigorously analogous and draws from this its specific system of social function. But we can already see what is lacking in a photograph: for the most part, the syntactic exponents of discourse, so numerous in cinema. Certainly, the angles, the distance of the camera, the lighting, etc., comprise a subjective interpretation of the object photographed, and society readily admits that other "treatments" would have been possible for the same objects. But this interpretation, as Roland Barthes has clearly shown,[13] is experienced culturally as distinct connotation and is unrelated to denotation—that is, to the object represented, equivalent to the diegesis in regular photography. Everything occurs as though the rules of the game invited the spectator of a photograph to effect a distinct, apprehensible dichotomy between the intentions of the photographer (always more or less recognizable as such, so that there can never be *trucage*), and the photographic representation itself, theoretically strictly faithful since it was obtained, so to speak, in one stroke. The spectator somewhat succeeds in rediscovering, *under* the coefficient of enunciation from which he makes the mental subtraction, this "brutal, frontal, clear (even utopic) photograph" of which Roland Barthes speaks. Common sentiment dictates that the denotation may not be *constructed,* and that everything which is constructed be connotation.

This is why it is difficult (not technically, but psychologically, deontologically) to trick a photograph. The photographer only has the choice between a "normal" shot—which, even if pushed to the limit, cannot be tricked because the ideal denoted will find a way of passing unharmed through all the effects which simply ornament it—and, if he really wants to fool his audience, the characteristic lie, the fraudulent practice, such as those in photographic "montages"—skillful collages from two different angles, used by dishonest politicians in order to discredit their adversaries surprised in some compromising situation by the "objective" eye. Photographic *trucage* must be a brazen *falsehood,* or not be at all. It is forced to intervene crudely into the very heart of photographed action, since the photograph is supposed to refer *as a whole* to a real spectacle which it reproduces in a unified fashion, thus leaving no flaw, no crack to allow for the chance of a fine *trucage,* for a half-*trucage.*

On the other hand, cinema manages a great number of such interstices, sowing them at every step. Each sequence from "shot" to "shot"—or from photogram to photogram, if we take into consideration accelerations or retardations of slight amplitude—offers the opportunity of sliding in between the compact but disjointed pavement produced by

13. "Rhétorique de l'image," *Communications* 4 (1964): 40–51.

analogous codings, the skills of a subtle and permanent *trucage,* which is here customary. It has no need to extend itself to the point of lying in order to achieve its efficacy, since it can play on the multiplicity of the photographs and the links between them, the existence of which is avowed and *moral.* The denotation is no longer a combined one; it proffers itself as a construct (here is one of the great semiological differences between cinema and the photo); there is no longer an assumed gap interposed between the denotated and the connotated, and we may progress with ease and without discontinuity from the simple discursive intention (which the spectator will nevertheless partially ascribe to the diegesis) to the beginnings of *trucage.* Here the spectator will be only partially duped.

Montage itself, at the base of all cinema, is already a perpetual *trucage,* without being reduced to the *false* in usual cases. If several successive images represent one place at different angles, the spectator, victim of "*trucage,*" will spontaneously perceive that place as unitary, since it is precisely his perception which will have reconstructed the unity. Here the *trucage* stems from a *projection,* another aspect of analogous construction, of the construction of the represented. It is a construction in the film as well as in the mind of the spectator. But at the same time, the latter will not be unaware that he has seen several photographs. He will not have been fooled. Today we are so accustomed to montage that it would occur to no one to add to the list of *trucages* (or "special" effects) such an ordinary and general manipulation. But montage—which remains the *trucage* prototype in photography, a significant point—was mentioned in 1912, in a book by Ducom on cinematic technique, as the most elementary of *trucages.* This explains why imperceptible *trucages* are the only pure *trucages.* Only with these can we be certain that the spectator has been fooled, since he has noticed nothing. As soon as we approach the vast domain of perceptible interventions, *trucage* and language become no more than two poles situated at the extremities of a common and continuous axis. They are distinct one from the other by their gravitational center, but not by their boundaries.

*
* *

The difference just discussed between cinema and photography has a paradoxical aspect. It would indeed seem that our culture grants to cinema a *reality quota* far superior to that granted the photograph. For is not cinema capable of "reproducing life" in a manner far more complete—far more "alive," as we say, not coincidentally—than photography? But it must be remembered that the social function of these two

languages stems, not only from their alleged relationship to "reality," but as much from their respective positions in terms of the historical tradition of representational art (epic, classical novel, subject painting, theatre of intrigue, etc.). Cinema—precisely because it abounds in signs of reality, and because these can work for the benefit of the fiction—integrated itself into the tradition with little effort. Too vulnerable, too "poor," photography has largely remained on the periphery. A significant part of its uses emerges in this respect as "nonartistic": identification photos, family photos, illustrations for technical books of all kinds, archive photos, etc. The social image of the photo is deeply affected by these and carries with it the odor of vital statistics, from which cinema is exempt.

Photography does not dispose of a power of reality sufficiently prestigious to be assigned the job, considered more elevated, of imaginative fiction. Nevertheless, it is granted (still mythically), in a movement which can be read as a need for a type of compensation, a sort of fierce *integrity* (even though one without sparkle) by the literal respect for this same reality. It is this reputation as untreatable which reduces the trickster to a counterfeiter. Cinema, on the other hand, enjoys in the public eye that type of half-fascinated indulgence which the misogynist feels for women, and which we bestow more generally upon all those from whom we do not expect total honesty, and who can afford a certain duplicity without falling into disrepute. Here we rediscover the avowed machination of which I spoke earlier. The cinema became a representational art; culture has legitimized—as occurred in the past with the novel or with painting—its games on the fiction of reality and the reality of fiction. Cinema thus has social "facilities" like those of heirs; facilities not enjoyed by photography.

*
* *

That is not all. Technologies also play a weighty role in this problem. The technologies of cinema and those of photography are frankly very close, since the second is in fact a part of the first and since, more fundamentally, they both produce analogous codings in which resemblance is developed, and consequently the impression of non-coding. The difference between them lies mainly in their degree of complexity. But it is an important difference. Photographic coding is relatively simple and compact: it is a strong mechanism, which can be subtly or poorly adjusted only with great difficulty, and which can be counterfeited only by an intervention of sufficient brutality to reveal a distortion of the natural course of events. The mechanism of cinema, though of an analogous model, possesses a far greater number of distinct coding pro-

cesses, interlinked by a complex tapestry of connections. Each photogram is a photograph, but succeeds the preceding one only through the intervention of a "blackness," the duration of which is material for decision (and today has changed from the silent film). These photograms are themselves grouped into bundles (the "shots"), whose concatenation creates a choice every time (straight cut, optical effect, etc.). It is a mechanism of great precision, whose power of resemblance continues to grow, but from which also grows, concomitantly, a vulnerability to slight distortion—merely the other face of numerous, necessary adjustments.

This point should be substantiated in more depth. But I will illustrate it here merely by noting the remarkable character of cinematographic *trucages:* none of them ever entirely "tricks" that which it tricks. A freeze frame, which alters normal movement, leaves the photographicity intact. The blurred focus, which destroys visual adaptation, does not modify the respective positions of objects in space. A backwards motion respects a type of specularity principle in the temporal order. Mattes and countermattes leave untricked photographic spaces. Slow motion, which cheats with the acceptable speed of the track, alters neither the form nor the direction of movement, and so on.

Here we are touching upon a problem which has recently been the subject of great controversy. Jean Patrick Lebel has written a book about it—a book whose argument is compelling, and which contains certain elaborations which seem to me both solid and convincing.[14] And yet I disagree with one of the central theses of the work: it seems to me that *le technique* [sic] does not outline a type of enclave sheltered from history. It is true that *le technique,* by its very function, proves the scientific truth (nonideological) of principles which are at its basis. But the *how* of its functioning (= adjustment of the machine), not to be confused with its *why,* is in no way controlled by science, and involves options which can only be sociocultural. *Le technique* is far from leaving culture aside. Certain technologies—by the very play of their technical nature—lend themselves to interventions whose historical determinations leave no room for doubt. It is not even necessary to be a Marxist in order to be convinced of this; one need but look around.

Conclusion: Cinema, in What History?

At the horizon of all of these problems, we are forced to wonder about the exact nature of the relationships, both real and little known, which the cinematographic establishment—and not only *commercial cinema*—has with ideology in general. To what extent is that establishment determined by its desire to lure the customer, by its search for

14. *Cinéma et idéologie* (Paris, 1971).

profit and thus by the economic system (or by its survival in other systems)? To what extent is it tied to the event, itself historic and yet displaced in the chronology of economic systems, which make possible the emergence of the representational arts, as well as the very existence of a diegesis? And finally, to what extent is the whole of cinema merely one of the inventions through which man tries to respond to the insistent goals proposed to him by his narcissism, vested in the playful form of a perceptual *aesthesia*—one which is nevertheless susceptible, as well, to being caught in the temporality of a story, but one which would then make for a third story?

A Plea for Visual Thinking

Rudolf Arnheim

Perception and thinking are treated by textbooks of psychology in separate chapters. The senses are said to gather information about the outer world; thinking is said to process that information. Thinking emerges from this approach as the "higher," more respectable function, to which consequently education assigns most of the school hours and most of the credit. The exercise of the senses is a mere recreation, relegated to spare time. It is left to the playful practice of the arts and music and is readily dispensed with when a tight budget calls for economy.

The habit of separating the *intuitive* from the *abstractive* functions, as they were called in the Middle Ages, goes far back in our tradition. Descartes, in the sixth *Meditation,* defined man as "a thing that thinks," to which reasoning came naturally; whereas imagining, the activity of the senses, required a special effort and was in no way necessary to the human nature or essence. The passive ability to receive images of sensory things, said Descartes, would be useless if there did not exist in the mind a further and higher active faculty capable of shaping these images and of correcting the errors that derive from sensory experience. A century later Leibniz spoke of two levels of clear cognition.[1] Reasoning was cognition of the higher degree: it was *distinct,* that is, it could analyze things into their components. Sensory experience, on the other hand, was cognition of the lower order: it also could be clear but it was *confused,* in the original Latin sense of the term; that is, all elements fused and mingled together in an indivisible whole. Thus artists, who rely on this

1. Leibniz, *Nouveaux Essais sur l'entendement humain* (Paris, 1966), bk. 2, chap. 29.

Reprinted from *Critical Inquiry* 6 (Spring 1980): 489–97

inferior faculty, are good judges of works of art but when asked what is wrong with a particular piece that displeases them can only reply that it lacks *nescio quid,* a certain "I don't know what."

In our own time, language has been designated as the place of refuge from the problems incurred in direct perceptual experience; this in spite of the fact that language, although a powerful help to our thinking, does not offer in and by itself an arena in which thinking can take place. Thus the very title of a recent collection of articles by Jerome S. Bruner suggests that in order to arrive at knowledge the human mind must go "beyond the information given" by direct sensory experience.[2] Bruner adopts the belief that the cognitive development of a child passes through three stages. The child explores the world first through action, then through imagery, and finally through language. The implication is, unfortunately, that with the arrival at a next level the earlier one falls by the wayside. Thus when the child learns to go beyond a particular constellation directly given to his eyes, the ability to restructure the situation in a more suitable way is not credited by Bruner to the maturing of perceptual capacity but to the switch toward a new processing medium, namely, language. Thus language is praised as the indispensable instrument for essential refinements of the mind of which in fact language is little more than a reflector.

Since experts insist that perception offers nothing better than the fairly mechanical recording of the stimuli arriving at the sensory receptors, it is useful to respond with a few examples which show that perception transcends constantly and routinely the mere mechanical recording of sensory raw material. (I am limiting myself in the following to visual perception.) At a fairly simple level, the psychologist Roger N. Shepard and his coworkers have shown that visual imagination can rotate the spatial position of a given object when a different view is needed to solve a problem, for example, in order to identify the object with, or distinguish it from, a similar one. This is worth knowing. But reports by artists and scientists indicate that visual imagination is capable of much more spectacular exploits. Indeed, the imagination of the average person demands our respect.

2. Jerome S. Bruner, "The Course of Cognitive Growth," in *Beyond the Information Given,* ed. Jeremy S. Anglin (New York, 1973), pp. 325–51.

Rudolf Arnheim is the author of *Art and Visual Perception: A Psychology of the Creative Eye, Toward a Psychology of Art, The Dynamics of Architectural Form,* and *Visual Thinking.*

Let me use an example cited in an article by Lewis E. Walkup.[3] The solution of the puzzle should be attempted without the help of an illustration. Imagine a large cube made up of twenty-seven smaller cubes, that is, three layers of nine cubes each. Imagine further that the entire outer surface of the large cube is painted red and ask yourself how many of the smaller cubes will be red on three sides, two sides, one side, or no side at all. As long as you stare at the imagined cube as though it were nothing better than a pile of inert building blocks and as long as you take only a diffident, haphazard nibble at this or that small cube, you will feel uncomfortably uncertain. But now change your visual conception of the cube into that of a centrically symmetrical structure, and in a flash the whole situation looks different! What happens first is that suddenly the imagined object looks "beautiful"—an expression that mathematicians and physicists like to use when they have attained a view that offers a surveyable, well-ordered image of a problem's solution.

Our new view shows one of the twenty-seven cubes surrounded by all the others, which cover it like a shell. Shielded from the outside, the one central cube obviously remains unpainted. All the others touch the outside. We now look at one of the six outer surfaces of the large cube and notice that it presents a two-dimensional version of the three-dimensional image from which we started: we see, on each of the six surfaces, one central square surrounded by eight others. That central square is obviously the one painted surface of a cube—which gives us six cubes with one surface painted. We now proceed to the linear dimension of the twelve edges that constitute the large cube and find that each edge has three cubes and that the one in the center rides on two surfaces, like a gable. The two surfaces it exposes to the outside make for a cube painted on two sides, and there are twelve of those cubes. We are left with the eight corners, which cover three surfaces each—eight cubes with three of their sides painted red. The task is done. We hardly need now to add one + six + twelve + eight, to make certain that we have accounted for all twenty-seven cubes—so sure are we of the completeness of our solution.

Did we go beyond the information given? In no way. We only went beyond the poorly structured pile of blocks a young child would be able to perceive. Far from abandoning our image, we discovered it to be a beautiful composition, in which each element was defined by its place in the whole. Did we need language to perform this operation? Not at all; although language could help us to codify our results. Did we need intelligence, inventiveness, creative discovery? Yes, some. In a modest way, the operation we performed is of the stuff good science and good art are made of.

3. Lewis E. Walkup, "Creativity in Science through Visualization," *Perceptual and Motor Skills* 21 (1965): 35–41.

Was it seeing or was it thinking that solved the problem? Obviously, the distinction is absurd. In order to see we had to think; and we had nothing to think about if we were not looking. But our claim goes farther. We assert not only that perceptual problems can be solved by perceptual operations but that productive thinking solves any kind of problem in the perceptual realm because there exists no other arena in which true thinking can take place. Therefore it is now necessary to show, at least sketchily, how one goes about solving a highly "abstract" problem.

For the sake of an example, let me ask the old question of whether free will is compatible with determinism. Instead of looking up the answer in Saint Augustine or Spinoza, I watch what happens when I begin to think. In what medium does the thinking take place? Images start to form. Motivational forces, in order to become manipulable, take the shape of arrows. These arrows line up in a sequence, each pushing the next—a deterministic chain that does not seem to leave room for any freedom (fig. 1a). Next I ask What is freedom? and I see a sheaf of vectors issuing from a base (fig. 1b). Each arrow is free, within the limits of the constellation, to move in any direction it pleases and to reach as far as it can and will. But there is something incomplete about this image of freedom. It operates in empty space, and there is no sense to freedom without the context of the world to which it applies. My next image adds an external system of a world minding its own business and thereby frustrating the arrows that issue from my freedom-seeking creature (fig. 1c). I must ask: Are the two systems incompatible in principle? In my

a b

c d

FIG. 1.

imagination I start restructuring the problem constellation by moving the two systems in relation to each other. I come across one pattern in which the arrows of my creature remain intact by being fitted to those of the environmental system (fig. 1d). The creature is no longer the prime mover of its motivational forces, each of which is fitted now into a sequence of determining factors of type 1a. But in no way does this determinism impair the freedom of the creature's vectors.

The thinking has barely started, but the description of these first steps will suffice to illustrate some remarkable properties of the thought model. It is an entirely concrete percept although it does not spell out the images of particular life situations in which freedom arises as a problem. While being concrete the model is entirely abstract. It draws from the phenomena under investigation only those structural features to which the problem refers, namely, certain dynamic aspects of motivational forces.

By no means is my imagery only a by-product of the "real" thinking going on in some other region of my mind. It is no epiphenomenon but the very arena in which the action takes place. All the needed features of the problem are sufficiently represented, and my mind will make forays into images of actual life situations only for the purpose of checking on whether those constellations of forces correspond to the ones represented in my model.

But, someone might say, I could investigate the problem also in an entirely nonvisual way, namely, by means of purely conceptual propositions. Could I? We have already excluded language as an arena of thought since words and sentences are only a set of references to facts that must be given and handled in some other medium. But yes, there is a nonvisual medium capable of solving a problem in an entirely automatic fashion as soon as all pertinent data are supplied. Computers function in this way, without any need to consult perceptual images. Human brains can produce approximations of such automatic processing if they are put under sufficient educational pressure or deprivation, even though a brain is not easily prevented from exercising its natural ability to approach a problem by structural organization.

But it can be done. The other day, my wife bought twenty envelopes at seven cents each at the local university store. The student at the cash register punched the key of seven twenty times and then, to make sure that she had done it often enough, proceeded to count the sevens on the sales slip. When my wife assured her that the sum of $1.40 was correct, she looked at her as though she were privy to superhuman inspiration. We supply children with pocket calculators; but we must consider that the saving in time and effort is made at the expense of precious elementary training of the brain. Genuine productive thinking starts at the simplest level, and the basic operations of arithmetic offer fine opportunities.

When I assert that thinking is impossible without recourse to perceptual images, I am referring only to the kind of process for which terms like "thinking" or "intelligence" ought to be reserved. A careless use of these terms will help to make us confuse purely mechanical, though immensely useful, machine operations with the human ability to structure and restructure situations. My analysis of the cube was an example of a problem solution at which a machine could arrive only mechanically. Another example comes from the performances of chess players.[4] It is well known that the ability of chess players to retain whole games in their memories does not rely on a mechanical copy of the arrangements of pieces on the board, preserved in eidetic imagination. Rather a game presents itself as a highly dynamic network of relations in which each piece comes with its potential moves—the queen with her long, straight outreach, the knight with his crooked hop—and with the endangerments and protections of its particular position. Each piece is meaningfully held in its place by its function in the total strategy. Therefore any particular piece does not have to be remembered piecemeal—which would be much more cumbersome.

Or think of the difference between a machine reading letters or digits—a purely mechanical procedure—and a young child figuring out how to draw a picture of a tree (fig. 2). Trees as seen in nature are intricate entanglements of branches and foliage. It takes truly creative structuring to discover in such a jumble the simple order of a vertical trunk from which the branches issue, one by one, at clear angles and serve in turn as bases for the leaves. Intelligent perceiving is the child's principal way of finding order in a bewildering world.

Visual structuring occurs in two ways which, for lack of more precise terms, I call the *intuitive* and the *intellectual* mode. What happens when someone tries to "take in" the pattern of figure 3, whose five shapes are vaguely reminiscent of a painting by Kasimir Malevich, *The Sensation of Flight?* One can take cognizance of the picture by simply looking at it. In that case, all the properties of the five elements—their size, shape, and color, their distances and directions in relation to one another and to the quadrate frame—will be projected, by means of the eyes, upon the brain field of the visual cortex, where they all blend into an indivisible but highly organized structure. The result is a true *cognitio confusa,* in which every component is dependent on every other. The structure of the whole controls the parts and vice versa.

This "intuitive" mode of cognition is available only through perception. The process of structuring, in which each element receives its character by taking its place in the whole, occurs to some extent below the level of consciousness. What the viewer "sees" in the picture is

4. Alfred Binet, "Mnemonic Virtuosity: A Study of Chess Players," *Genetic Psychological Monographs* 74 (1966): 127–62.

FIG. 2.—Courtesy Gertrude Schaefer-Simmern.

already the outcome of that organizational process. Only when someone struggles to discover the order of a complicated composition does he experience within himself something of the shaping process in search of the final image.

Intuitive perception conveys the experience of a structure but does not offer its "intellectual" analysis. For that purpose each element of the image must be defined independently. Its particular shape, size, and color are established in isolation, after which the various relations between the elements are explored one by one. The intellectual mode of cognition must sacrifice the full context of the image as a whole in order to obtain a self-contained description of each component. This is the scientific method, which contents itself with an approximation of the true phenomenon but gains analytical exactness. The method is as visual as direct perception but it must draw a fence around each of the elements and consider them in succession rather than in a synoptic overview.

Fig. 3.

In recent years the duality of human cognition has captured the popular imagination through the discovery that the two modes of functioning correspond to different locations in the crust of the cerebral hemispheres. Somehow these physiological findings seem to have put the stamp of authentic reality on mental distinctions that have been acknowledged since antiquity. Not only that, but the symmetrical location of the two functions in the two halves of the brain has come to symbolize the fact that these functions are of equal dignity and therefore should receive equal consideration, especially in education. Given the traditional view that perceiving is inferior to reasoning, this reevaluation is entirely welcome. At the same time, the popular symbolic image, gained from a superficial knowledge of the actually quite complex physiological facts, tends to reinforce the prejudice that the intuitive and the intellectual modes of cognition function in separation from each other and that, in fact, different individuals and different professions come under either the one or the other heading. This is a harmful misunder-

standing. Everything we are learning about the mental functioning of scientists and artists strengthens the conviction that the intimate interaction between intuitive and intellectual functioning accounts for the best results in both fields. And the same is true for the average schoolchild and student.

In conclusion I would like to cite a testimony coming from an unexpected source, a presidential address of the psychologist B. F. Skinner, to which, it seems to me, not enough attention has been paid although it was presented more than twenty years ago.[5] In opposition to the usual statistical treatment of experiments based on a large number of subjects, Skinner recommended the careful scrutiny of individual cases. Mass experiments are based on the rationale that by compounding the behavior of many subjects one causes accidental factors to cancel out, which lets the underlying lawful principle show up in its uncontaminated purity. "It is the function of learning theory," said Skinner, "to create an imaginary world of law and order and thus to console us for the disorder we observe in behavior itself." He became disenchanted with this procedure through his interest in the training of individual animals. For that purpose the lawfulness of average behavior offered little consolation. The performance of the particular dog or pigeon had to be flawless to be usable.

This led to attempts to clean the individual case of whatever was not pertinent to it. In addition to perfecting the practical performance of the animal, this method had two advantages. It induced a positive scrutiny of the modifying factors, which in the statistical procedure simply dropped out as so much "noise." In addition, however, the method reduced the scientific practice to "simple looking." Whereas the statistics divert the psychologist's attention from the actually observed cases to the manipulation of purely numerical data, that is, to the refuge "beyond the information given," the cleaned-up individual case makes a type of behavior directly perceivable. It displays for the observant eye the interaction of the relevant factors.

With this enjoyable spectacle of the behaviorist all but holding hands with the phenomenologist who endeavors to see the essential truth through the unhampered inspection of the perceptually given experience, I rest my case. Perhaps we are witnessing the beginning of the convergence of approaches which, under the impact of the evidence, will return to the intelligence of the senses its rightful privilege.

5. B. F. Skinner, "A Case History in Scientific Method," *American Psychologist* 11 (May 1956): 221–33.

Standards of Truth: The Arrested Image and the Moving Eye

E. H. Gombrich

Humourists have a way of summing up a problem in an amusing drawing which can save many words. The desperate artist in Smilby's picture from *Punch* (fig. 1) is shown wrestling with the need to produce what I have called in my title an "arrested image" of his view through the window during a thunder-storm. As he is trying to make a truthful record of the flashes of lightning which race across the sky, we can see his hand swishing from one position to another, for Smilby in his turn is presented with the task of representing movement in a "still."

Fig. 1.—Smilby, drawing from *Punch*,
1 February 1956, p. 177.

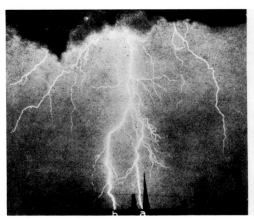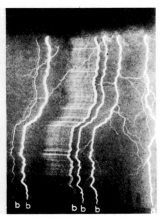

FIG. 2.—Photographs of lightning from *Der grosse Brockhaus,* 22 vols. (Leipzig, 1929), 3:25.

In contrast to what I may call the man-made image, the machine-made image can now be used with confidence to give us a truthful record of the path of lightning across the sky. The photographic camera can cut down the time it takes for the phenomenon to leave its trace on the emulsion. Some of the camera's resources are well illustrated in the two photographs below of the same flash of lightning (fig. 2). The one on the left was taken by a stationary camera, the one on the right by a moving one which shows several phases of the event—not unlike the humourous drawing. It is clear that branch "a" consisted of one single discharge and branch "b" of a sequence of partial discharges which were recorded on the plate while the camera was turned to the right. The whole duration of the discharges was 0.556 seconds.

Data of this kind are characteristic of the way the scientific image is used. We can only extract the required true information from it if we have all the specifications of the instrument and of the exposure. The information thus obtained is quite independent of what anyone might have seen when watching that flash of lightning. It is not a visual truth, it is an objective record, but one which has to be interpreted in the light of additional information.

E. H. Gombrich was director of the Warburg Institute and Professor of the History of the Classical Tradition at the University of London from 1959 to 1976. His many influential works include *The Story of Art, Art and Illusion, Meditations on a Hobby Horse, The Sense of Order,* and, most recently, *Ideals and Idols.* An early version of "Standards of Truth" was presented at Swarthmore College in October 1976 at a symposium to mark the retirement of Professor Hans Wallach.

Philosophers have sometimes questioned the use of the term "information" in relation to visual images.[1] Naturally, this like any other term has to be used with circumspection; I am convinced, however, that even the student of the hand-made picture can profit from an acquaintance with the methods science has used and is using in the extraction of information from visual records. In my book *Art and Illusion* I have paid tribute in this context to my late friend Gottfried Spiegler who started his career in the early days of X-ray technology and who taught me to look at the interpretation of images as a philosophical problem. I learned from him that both technological and psychological variables must be considered and that the standards of truth are anything but obvious in the evaluation of X-ray photographs.[2] What strikes the layman or even the inexperienced physician as an optimal picture because of its clarity and its easily legible contrasts may actually suppress rather than convey all the desired information (figs. 3a and b). Thus the "sharp" image on

Fig. 3a.—X-ray with high contrast, from Gottfried Spiegler's *Physikalische Grundlagen der Röntgendiagnostik* (Stuttgart, 1957), p. 58.

Fig. 3b.—X-ray with soft contrast, from Spiegler's *Physikalische Grundlagen der Röntgendiagnostik*, p. 58.

1. See Max Black's "How Do Pictures Represent?" in Gombrich, Julian Hochberg, and Black's *Art, Perception, and Reality* (Baltimore, 1972), esp. p. 105 f; Nelson Goodman, in *Languages of Art* (Indianapolis, 1968), merely warns against making information a standard of realism.

2. Gottfried Spiegler, *Physikalische Grundlagen der Röntgendiagnostik* (Stuttgart, 1957); see also my tribute to Spiegler, "Zur Psychologie des Bilderlesens," *Röntgenblätter,* 20 February 1967.

the left fails to show that the outlines of the bones in question are anything but sharp, and it is this pathological condition the X-ray should reveal.

Scientific images do not, of course, aim at recording what is visible, their purpose is to make visible. This applies to the ordinary enlargement as well as to the miracle of the electron-scanning microscope which has enabled scientists to answer so many questions—always presupposing that they know the specifications of the instrument, its magnification, power of resolution, and so on.

In no other field have we been made more poignantly aware of the wizardry of science in obtaining information far beyond the reach of the human eye than in the exploration of the universe. Pictures of the surface of Mars have been transmitted over the distance of some 212 million miles. It is worth recalling that the pictures shown in our newspapers were of course mediated through a most complex chain of processes. The picture taken by the landing craft on the surface of the planet (fig. 4) was transmitted in the form of weak electrical impulses to the "orbiter" where these impulses were so reinforced that they could reach our earth at any point turned at that moment toward Mars—for instance, Australia. From there they were bounced back to a satellite and thence picked up at the jet propulsion laboratory at Pasadena, the whole jour-

FIG. 4.—Photograph of the surface of Mars, *Time,* 2 August 1976.

ney taking some twenty minutes. At that point the information-carrying impulses had to be reconverted by computer into an arrested image, and this reconversion needed care. At the time, the story went through the newspapers that the sky on Mars looked blue, but it was subsequently found to be of a pinkish hue. It appears that it was not even very difficult to rectify this departure from visual truth in the final picture. The camera on Mars carried with it a colour calibration chart of which the values were of course known at Pasadena. Studying the appearance of that chart, they could work out the other colour values for which they had no independent evidence.[3]

To me, as a layman, this device of "calibration" illuminates the whole process of obtaining information from an arrested image, both by its power and its limitation. We can calibrate for colour but not for depth, for here we come up against what in *Art and Illusion* I have called the ambiguity of the third dimension. It is in the nature of things that the image, the permanent trace of the light which entered the lens, can give us no information of the distance the light travelled before it released the chemical process on the emulsion. Hence the picture must always be ambiguous or, to be linguistically more correct, multivalent, like any other projection of a solid on a plane. We really cannot tell the size of the boulders or ridges which are visible on the picture from Mars unless we know their distance, and vice versa, though for proximate objects there may be additional information through such clues as texture or "grain"—assuming again that we guess correctly at their composition. An arrested image might thus be compared to a single equation with two variables such as $n = x/y$. We can calculate the size of an object if we know the distance and the distance if we know its size, to know both we would have to have additional information.

For any professional who is engaged in extracting information from arrested images, this limitation is perfectly obvious, but psychologically, or, if one may use the word, experientially, it is less so. The reason is simple; we usually have a fair idea of the order of magnitude of the objects in our environment and hence of their size and distance in pictures, at least those which represent people or houses, animals, flowers or fruit. We thus normally approach any arrested image with the confidence of being able to solve its implicit equation at least approximately—and we are not frequently jolted out of our complacency.

A series of photographs (figs. 5a–d) of the monument of Stephenson, the inventor of the railway engine, which stands in front of Euston Station in London, was made at my request by Mr. Parker-Ross of the Warburg Institute to illustrate this point. In contrast to real men, men of bronze come in almost any size and so do buildings of uncertain charac-

3. I am indebted for this explanation to Thomas Gold of Cornell University.

Fig. 5a.—Monument of Stephenson in front of Euston Station, London.

Fig. 5b.—Monument of Stephenson with reading man.

ter, like the one that is seen behind the monument. In the first photograph that structure can be interpreted as a tall building some distance away. The second reveals that it is merely an air vent which is accordingly much closer to the monument. The size of the monument can be approximately inferred from the figure sitting beside it. The statue is about twice life-size. In the third photograph, taken with a wide-angle camera, the obliging assistant has placed himself next to the air vent which is about six times his height. According to my rough estimate on the spot (aided by the flagstones of the pavement), the distance between the statue and the background structure is some twenty-eight feet. The last of the photographs would seem to me to suggest these relationships without much strain, though this must always remain a subjective feeling. It may be derived from the habit of viewing a monument from a standard distance, close enough to see the features but not so close as to have to crane one's neck, and possibly also from a viewing point which allows us to read the inscription on the plinth.

The relevance of our viewing habits to the perception of pictures is easily demonstrated by considering the effect or effects produced by a tilted camera. One reads in older books on photography that the resulting distortions are intolerable, but we have become quite used to them and accept without demur a monument shown from below with the houses in the background foreshortened (fig. 6). Naturally a correct

FIG. 5c.—Monument of Stephenson, wide-angle.

FIG. 5d.—Monument of Stephenson, normal view.

reading of the situation rests on the assumption that the picture was not taken during an earthquake, while the facade swayed and telescoped, for only if we start from the conviction that the monument and houses are normal can we infer the tilt. It is still a trifle less easy to accept the downward view of a tall building like Rockefeller Center in New York (fig. 7); it is hard to believe that the building is not both bulging and expanding upward.

It is not surprising that we are reluctant to accept the visual truth of such pictures and that we deny that we ever see a building in this way. We are right in our protest, and yet we must proceed with caution. We have good reasons for our basic conviction that the objects in our environment are solid and real and that we see them as such rather than as flat, rubbery, enigmatic shapes. The traditional justification of this conviction took recourse to our experience of touch and to such knowledge as we have acquired in the course of our lives, knowledge that comes to our aid in making sense of our sense impressions. The ghost of this theory still haunts discussions of the art of painting not only in the nineteenth century but even today, even though today this ghost has been exorcized, largely by that great student of vision, J. J. Gibson.[4]

4. The most complete statement of J. J. Gibson's view is to be found in his last book, *The Ecological Approach to Visual Perception* (Boston, 1979).

Fig. 6.—Piazza di Torino with tilted camera.

It is interesting to note that Gibson arrived at his alternative view through his involvement in a technical rather than an artistic problem. He derived it from his wartime work when he investigated the visual information available to a pilot landing at high speed. It was this example which brought home to him how misleading it was to start any account of visual perception with an analysis of the image formed on the retina by a stationary eye. In Gibson's developed view the comparison between the eye and the *camera obscura,* though perfectly justified from the point of view of optics, is at best irrelevant and at worst misleading for the study of visual perception. It is not such a static image which gives the pilot the required estimate of the distance and position of the runway but the flow of information he receives, the sequence of transformations all around which show him across these rapid changes the invariants of the lay of the land, invariants he must pick up if he is to survive.

And what is true of the pilot is true of any organism, whatever may be the construction of the visual organs with which it is endowed—the multiple eyes of insects can perform this service no less than can the eyes of mammals. It is an awareness of their own movements which enables their central nervous systems to solve the problem of separating the invariant shape of rigid objects from the transformations of their momentary aspects. For that equation with two variables stating merely the inverse relationship of size and distance, which I instanced as a problem for the interpretation of the arrested image, offers no similar difficulties to the organism in movement. It has at its disposal not merely

Fɪɢ. 7.—Rockefeller Center from top of Time-Life Building,
from Andreas Feininger's *The Face of New York* (New York, 1954).

two equations with two variables but a whole sequence of transforma-
tions which enable it to separate out the invariants of shape and colour
from the changing aspects and colours which characterise the momen-
tary view. These changing aspects, indeed, serve no purpose in the busi-
ness of orientation, and thus they rarely obtrude on our awareness. To
start the investigation of visual perception from a study of such arrested
monocular vistas seems to Gibson little short of perverse.

Whether or not it will ultimately be found that Gibson somewhat
overstated his case against what he calls "snapshot vision,"[5] the historian
of art will always have to be grateful to him for having contributed to the

5. Ibid, p. 1. Some of my reservations to the wholesale application of Gibson's ap-
proach are discussed in my contribution "The Sky Is the Limit: The Vault of Heaven and
Pictorial Vision," in *Perception: Essays in Honor of James J. Gibson*, ed. R. B. MacLeod and
H. L. Pick, Jr. (Ithaca, N.Y., 1975).

solution of the puzzle that has plagued the history of painting for so long. For this history has been written by critics (ancient, Renaissance, and later) who accepted the snapshot vision as the norm and who could not but notice how rarely it was adopted in the past. The images of great civilizations such as those of Egypt or of China were never constructed on these principles, and so their essentially different approach was seen as a deviation from a natural norm. Special theories and notions were constructed to explain the prevalence of "conceptual" styles in all parts of the globe which had failed to adopt the Western standard of truth. When this degree of ethnocentricity began to worry historians, they escaped into a facile relativism, declaring that all standards are equally conventional and that the Western method—that of the camera—is no less arbitrary than any other.[6]

Such relativism can draw no comfort from Gibson's researches nor, of course, from a consideration of the use of images in science. For there is at least one perfectly rational standard of truth which can be applied to the arrested monocular image, and this standard was discovered and applied for the first time by the ancient Greeks. I have argued elsewhere that what prompted the Greeks to explore this standard was a new function of the visual image which demanded what I propose to call the "eye-witness principle." It is the principle which has usually been described in the light of ancient aesthetics as one of mimesis, the imitation of nature. But in my view, formulation diverts attention from the most important corollary of the eye-witness principle which is so often neglected; I refer to the negative rule that the artist must not include in his image anything the eye-witness could not have seen from a particular point at a particular moment. While complete mimesis will always be a will-o'-the-wisp—for where should it ever stop?—the negative rule will immediately lead to a study of aspects, of foreshortening, and of perspective.

Note that this standard is not affected by the ambiguity or multivalence of the third dimension in any image. The photograph of our monument may leave room for interpretation, but it is surely a correct record in not showing us the back of Stephenson's head, which is not visible from the station point, and indeed any other features of the bronze man which cannot be seen in that aspect. Trivial as this may sound, the art student learning to draw from a cast would have to attend very carefully to avoid including in his drawing the slightest feature he could not see without moving.

There was no reason for the Greeks to worry too much about the inability of the method to convey information of previously unknown

6. I have taken issue with this view in "Image and Code: The Scope and Limits of Conventionalism," a forthcoming essay which was delivered at the Symposium on the Semiotics of Art (Ann Arbor, Mich., 1978).

Fig. 8.—The Alexander Mosaic, from the Naples National Museum.

motifs or objects. The purpose for which they developed the eye-witness principle was, as I tried to argue, essentially dramatic.[7] Art concerned itself with human beings in action. It served to render mythological or actual events. The imaginary eye-witness of the battle of Issus, the victory of Alexander the Great over Darius, thus makes us vicarious participants of the melee (fig. 8); the resources of Hellenistic painting of the third century B.C. allow the artist to use foreshortening, overlap, light, shade, and reflection; we see the warriors falling and the horses rearing and take part in the moment when the tide of world history turned and the Persian king on his chariot tried in vain to escape the conqueror. Mark that in conveying this experience of the eye-witness the image serves a dual purpose—it shows us what happened out there but also by implication what happened or would have happened to us, both physically and emotionally. We understand, without much reflection, where we are supposed to stand in relation to the event depicted and what moment we are made to share vicariously with the eye-witness. There is no difference in principle between the image and the one shot in a million of which the photographic war reporter may dream.

It happens to suit my purpose that the Alexander Battle is a mosaic, an image composed of a granular medium. The medium does not permit smooth transitions and makes it impossible to show objects smaller than the smallest tessera at the disposal of the craftsman. Go too near and you will no longer see what you are meant to see but rather individual patches. Not that there is something unique in this granular medium. Photographs reproduced in newspapers are also granular; they have a

7. See my *Art and Illusion* (Princeton, N.J., 1960), chap. 4; and my *Means and Ends: Reflections on the History of Fresco Painting* (London, 1976).

"screen" which will again restrict the information which can be coded and incorporated in the pictures, whether scientific, artistic, mechanical, or hand-made.

In this respect the standard of truth under discussion is also related to the medium. The image cannot give us more information than the medium can carry. But this limitation does not lead to a denial of any standard. On the contrary, while the principle may suggest that the information of the visible world can rarely be completely matched in any medium, we also learn why it can still exclude false information. It was due to the eye-witness principle that standards of truthfulness or accuracy could be accepted by the artist irrespective of the medium.

We observe the continued striving for these standards at the end of the Middle Ages when artists struggled to recover and to improve on the achievement of ancient art. It is notorious how intensely the Florentine painter Uccello studied the newly discovered laws of perspective for this purpose, and if you were to compare one of his famous battle pieces[8] with the ancient mosaic, you would notice his somewhat self-conscious demonstration of his knowledge but also his failure to avoid certain inconsistencies in arriving at a completely convincing eye-witness account.

Leaping a generation or two we can study the finished achievement in a work by Raphael who was to set the standards of academically correct drawing for four centuries. There is no doubt in my mind that a work like his *Saint Paul Preaching at Athens* (fig. 9) can best be understood as an application of the eye-witness principle. Note once more how the artist turns us into participants of the momentous scene when the apostle of Christ addressed the elite of pagan philosophers. We must envisage ourselves sitting on the invisible steps outside the picture, but the image shows us nothing that would not be visible from one point at a given distance, a distance which could be worked out mathematically but which we feel instinctively. It is this consistency which art historians like to describe as "the rationalization of space." Every object in view is seen as it would be seen from the same point. This standard of correctness is a standard of draftsmanship. It has again nothing to do with the medium employed and applies whether you look at Raphael's cartoon in colour, at a black and white reproduction, or at the tapestry which was woven in Flanders after this design.

I have mentioned that this standard of consistency is based on the art of perspective, an art which has caused so much agony to students of drawing and such dissension among art historians. Debates about the question of how far perspective can claim to embody a particular standard of truth have tended to be somewhat abstruse and arid; like other

8. For an illustration and discussion, see my *The Story of Art* (London and New York, 1950).

Fɪɢ. 9.—Raphael, *Saint Paul Preaching at Athens,* cartoon. London, Victoria and Albert Museum.

participants in this debate, I happen to be convinced that I have at last hit on the magic formula which should close it forever, though I know that this hope is somewhat unrealistic. I should like to propose that what I have called the negative principle of the eye-witness record could lead to an agreement about the nature of perspective and its problematic features. According to my formula, perspective enables us to eliminate from our representation anything which could not be seen from one particular vantage point—which may still leave the question open as to what can be seen.[9]

The story of how Brunelleschi developed the method of central perspective in Florence around 1420 has been rehearsed by students of the subject for any number of times.[10] He is said to have demonstrated the principle by depicting the Baptistry as seen through the door of the

9. See my "The 'What' and the 'How': Perspective Representation and the Phenomenal World," in *Logic and Art: Essays in Honor of Nelson Goodman,* ed. Richard Rudner and Israel Scheffler (Indianapolis, 1972).

10. See the astringent article by Martin Kemp, "Science, Non-Science and Nonsense: The Interpretation of Brunelleschi's Perspective," *Art History* 1, no. 2 (June 1978), where many of these discussions are summarised. A recent interesting addition is John A Lynes' "Brunelleschi's Perspectives Reconsidered," *Perception* 9, no. 1 (1980).

Florentine cathedral, having extended a net or veil over the entrance. A photograph of another centralized building, Santa Maria della Salute in Venice, as seen through a wrought iron gate (fig. 10), makes it easy to visualize the method. All the draftsman has to do is to turn the grill into a corresponding grid on his drawing pad and enter into each of the openings what he can see of the church through any of the particular gaps, while closing one eye and keeping the other at one point. If he

Fig. 10.—*Venise*, by Vianello, from *Art et Style* 2 (1955).

moves, and incorporates in his drawing something he could not have seen before, the picture will become distorted.

All that is needed for the understanding of this method is the fact, already known to the ancients, that light travels along straight lines through a uniform medium and is stopped by opaque objects. This permits us to work out by means of projective geometry what can be seen from where, except in those freakish circumstances when light does not travel in straight lines and produces a mirage through refraction.

In the absence of such exceptional effects the method is quite foolproof. Brunelleschi was an architect, and architects have never, to my knowledge, questioned its rationale. An application of this method which proves this point is exemplified by a typical picture from the London *Times* (fig. 11). It is a photograph of King's College, Cambridge, on which has been superimposed a drawing of a projected addition to the Fitzwilliam Museum to test whether and how much this intrusion would spoil one of the most beautiful views of the city. I do not think anybody can doubt that such a drawing can conform to the standards of truth. In fact in building another museum, that at Cornell University, the method was used with the aid of a computer to work out the aspects of the projected building from given vantage points on the campus. The fact that we normally look with two eyes rather than one, that our eyes move, or that our retinas are curved—all these alleged flaws in the principles of central perspective do not affect the validity of the demonstration.

Why, then, has perspective so often been called a convention which does violence to the way we see the world? Clearly because the eyewitness principle demands the witness to stand still and only look in one direction—and that we must indeed close one eye if the object of interest is sufficiently close for binocular parallax to make a difference. What

A photograph taken from King's Meadow, Cambridge, on which has been superimposed a drawing of the tower proposed as part of the development of the New Museums site. It shows the effect the building would have on a famous view of King's College. The new tower, with its pinnacled top, has something in common with the silhouette of King's College chapel. It stands about 300 yards beyond the near face of the Fellows' Building shown in the centre of the photograph.

FIG. 11.—Photograph of King's College, Cambridge, with drawing superimposed, from London *Times*, 22 November 1962.

happens when we move, as we normally do? The composite photograph of a view through a window suggests an answer (fig. 12). Looking down, looking up, and looking sideways, different views will become visible, and these could only be fully rendered on the inside of a sphere rather than on a flat surface. The argument has convinced great students of perspective, notably since Erwin Panofsky made himself the champion of this interpretation,[11] but it happens not to be quite accurate. It is perfectly true that our field of vision is rather limited and that we automatically turn the head to make up for this restriction. As soon as we do so, of course, different vistas come into view. The panoramic camera shows the result of this movement in a photograph of the Remembrance Day service at the Cenotaph in Whitehall, London (fig. 13). Whitehall is a straight thoroughfare, but looking down the road first in one direction and then in the opposite, we have two vistas of converging

Fig. 12.—Composite photograph of a courtyard seen through a window, by Paul Green-Armitage, *Architectural Association Journal* (February 1965).

11. See Erwin Panofsky's "Die Perspektive als 'Symbolische Form,'" *Vorträge der Bibliothek Warburg* (1924–25), and his *Early Netherlandish Painting* (Cambridge, Mass., 1953).

F<small>IG</small>. 13.—Panoramic photograph of Remembrance Day Ceremony at Whitehall, London, from London *Times,* 14 November 1966.

roads, as if the monument stood at the apex of a curve; but then the photograph infringes on the eye-witness principle by showing us things we could not see from one point. When we move the head our eye or eyes are carried around a semicircle pivoted on the neck. We turn, and the information changes.

What happens if we merely move the eye but not the head? Students of optics have known for some time that in this case the information available for sampling remains the same.[12] To demonstrate this point which has an important bearing on the debate about perspective, though admittedly on little else, I had an artist construct a box which I showed in a lecture given to the Royal Society of London.[13] It contains a row of three schematic trees of various shapes and sizes so aligned that they occlude each other from one point, the peephole of the box (figs. 14a and b). The photograph shows the silhouette of the nearest tree but none of the other trees, which are only revealed by means of the shadows they cast on the wall of the box. In theory it makes no difference to that silhouette if we remove first the foremost and then the second tree because their projections are designed to be identical as the laws of perspective imply.

Now if you keep your eye at the peephole but roll it up, down, and sideways, you will find that the image loses definition. It will become indistinct because it will fall outside the foveal area, but none of the schematic trees which were occluded when we looked straight into the box will emerge during that exercise. Hence if you want to follow the programme of the eye-witness principle of not including in your picture anything that is not visible from a given point, you can and indeed you must stick to the method of central perspective which the camera has taken over from the painter.

So far, I would claim my box (if I may so call it) vindicates the

12. See Gezienus ten Doesschate's *Perspective, Fundamentals, Controversials, History* (Nieuwkoop, 1964), and M. H. Pirenne's *Optics, Painting and Photography* (Cambridge, 1970).

13. "Mirror and Map: Theories of Pictorial Representation," *Philosophical Transactions of the Royal Society of London,* B. Biological Sciences 270 (March 1975).

standard of truth I have outlined. The positive postulate, the question of how much visual information he should include in his painting, presents a very different problem and leads to very different standards of truth.

Consider two records made by Turner during his visits to Holland, one his famous and characteristic seascape *The Dort Packet-Boat from Rotterdam Becalmed* of 1818 (fig. 16), showing what is no doubt a faithful view of the harbour of Dordrecht as the painter saw it, another a rapid sketch he made on a different visit to the same harbour (fig. 17). We may assume that both these contrasting records conform to the negative eye-witness principle and both can be taken, for argument's sake, to be correct. The painter obviously did not show any part of the shore which was obscured by the sail or any part of the boat which was occluded from him. But this formulation only applies if it is meant to refer to the objects and aspects which were *potentially visible* from his station point. As soon as we ask how much of that scene he actually saw at the moment of painting or drawing we are confronted with a radically different set of questions.

An anecdote told by John Ruskin well illustrates this point. Always eager to exalt Turner's paintings for their absolute fidelity to visual truth, Ruskin mentions that someone had criticised one of the master's marine paintings because it did not show the portholes of a ship. However, much to Ruskin's pleasure, a sea captain came to the painter's defence. The vessel, he said, must be so-and-so many leagues distant, and at that distance you cannot see the portholes. He may well have been right, and so may Turner have been. And still there is an important difference between saying that I cannot see a person's eyes because he is too far away or because he turns his back to me. The first fact depends on the structure and quality of our visual equipment, the second on the physical behaviour of light.

Not that this makes the first of these statements less important to the painter in the classical tradition. The loss of definition through distance preoccupied Leonardo at least as much as did the laws of geometrical perspective.[14] He tellingly described the phenomenon as *"Prospettiva de' perdimenti,"* the perspective of disappearance, though he more usually spoke of "aerial perspective." It could be argued that this second term is doubly misleading, first, because it attributes the loss of detail solely to the "air," that is, the degree of its permeability to light, and neglects the limits of the acuity of the eye; second, because in classifying the indistinctness of distant objects with perspective (the diminution of distant objects), we lose an important difference between the two phenomena. Linear perspective, as I have been at pains to show, rests on rigidly objective standards, the perspective of disappearance does not.

14. See Jean Paul Richter, *The Literary Works of Leonardo da Vinci*, 2 vols. (Oxford, 1939), 1:209.

FIG. 16.—J. M. W. Turner, *The Dort Packet-Boat from Rotterdam Becalmed,* 1818. Collection Mr. and Mrs. Paul Mellon, Washington, D.C.

FIG. 17.—J. M. W. Turner, *Rapid Sketch of Approach to Dort,* 1841. British Museum, Turner Bequest, as illustrated in A. G. H. Bachrach's *Turner and Rotterdam* (fig. 101).

Eyesight, illumination, atmospheric conditions, the nature of the objects themselves, their colour, their texture, their contrast with their surroundings—these and other variables play a role here, even if we do not take a pair of spectacles or binoculars to upset the principle either by magnification or, if we turn the binoculars round, by reduction in scale but increase in relative luminosity. As we have seen, the scientist remains aware of these variables and introduces into records the specifications of the instruments which produced the image he wishes to evaluate. The painter cannot take recourse to similar methods, and thus the observation of "the perspective of disappearance" has led him inexorably onto the path of introspection, of the exploration of his subjective visual experience.

Not that this experience could not be communicated and, if I may so call it, authenticated. It is an undeniable fact that by the introduction of Leonardo's programme paintings gained in visual credibility. The method enhanced the vicarious experience of sharing a privileged view with an eye-witness. The progressive loss of information about objects of increasing distance produces a gain in the evocation of the experience of the imaginary eye-witness. Claude Lorrain's magnificent vision of *The Sermon on the Mount* in the Frick Collection (fig. 18) conveys a very different experience from that mediated by Raphael's cartoon of *Saint Paul Preaching at Athens,* but in both cases visual truth enhances our feeling of participation.

Small wonder that the principle eliminating all that the eye-witness could not see led to further heart-searching on the part of the artist. In the seventeenth century it was observed that it was absurd to paint the spokes of a rapidly revolving wheel because we cannot see them, and so Velázquez painted the spinning wheel in the *Hilanderas* as a mere shimmering area.[15] So much for the moving object, but what, once more, about the moving eye? The difference I have mentioned in connection with my experiment between foveal and peripheral vision played a part in the history of optics in the special role assigned to what was called the central ray, but as far as I know it was not before the early eighteenth century that the painter was asked to pay heed in his work to the difference between the focussed area and the rest of the scene in front of him.

In *The Sense of Order* I have sketched part of that story,[16] quoting and criticising Roger de Piles who erroneously equated the lateral loss of definition with the perspective of disappearance and who in his turn influenced Hogarth. Though de Piles' and Hogarth's descriptions of the visual experience still left something to be desired, the relevance of the

15. See *Art and Illusion,* chap. 7, sec. 6.
16. *The Sense of Order* (London and Ithaca, N.Y., 1979), chap. 4, secs. 3 and 4.

FIG. 18—Claude Lorrain, *The Sermon on the Mount*, Frick Collection, New York.

phenomenon to the problems of the painter is well illustrated by a passage from Hermann von Helmholtz where this greatest student of optics discusses what he calls "indirect vision":

> The eye represents an optical instrument of a very large field of vision, but only a small very narrowly confined part of that field of vision produces clear images. The whole field corresponds to a drawing in which the most important part of the whole is carefully rendered but the surrounding is merely sketched, and sketched the more roughly the further it is removed from the main object. Thanks to the mobility of the eye, however, it is possible to examine carefully every point of the visual field in succession. Since in any case we are only able to devote our attention at any time to one object only, the one point clearly seen suffices to occupy it fully whenever we wish to turn to details; on the other hand the large field of vision is suitable, despite its indistinctness, for us to grasp the whole environment with one rapid glance and immediately to notice any novel appearance on the margin of the field of vision.[17]

At the time when Helmholtz wrote, these facts of vision were frequently appealed to by critics of painting. Particularly during the battle for and against impressionism, the question of finish, of definition, came much to the fore, and such sketchy methods as those of the popular Swedish etcher Anders Zorn were explicitly defended on the grounds of truth to visual experience (fig. 19). Looking at the face of the lady, the eye-witness could not possibly also see her hands or the details of her dress with any accuracy. Of course there can be no doubt about the truth of the negative argument. The artist could indeed not see or at least examine these features without moving his eye, but does the sketch also record truthfully how these unfocussed elements looked to him at one particular moment in time? The question of what things may look like while we do not look at them is certainly abstruse. We have learned from Helmholtz that it need not bother us in real life because we always tend rapidly to focus on any feature to which we wish to devote attention. This fact alone suffices to make nonsense of that notorious ideal of the so-called innocent eye which I was at pains to criticise in *Art and Illusion*. Even the eye of the impressionist must be selective. It must focus on the significant rather than the insignificant in the field of vision. More than that. The impressionist technique of trying to capture the fleeting vision of a moment must rely doubly on what, in that book, I called "the beholder's share." He can be sketchy only where we can supplement. We know or guess that Zorn's lady had arms and hands and can take this as

17. Hermann von Helmholtz, *Handbuch der physiologischen Optik*, 2d ed. (Hamburg and Leipzig, 1896), par. 10, p. 86; my translation.

read. But where the artist cannot rely on the beholder's experience, he will be compelled to inspect and convey the motif in much greater detail, presumably by moving his eyes.

It may not be very artistic to scrutinize paintings by great masters for the amount of information embodied in their pictures, but indirectly we learn a good deal even from this perverse exercise. I have paid attention for some time to the way impressionists rendered decorative motifs, patterns on dresses, on wallpapers, and on china, and I found to my surprise that they went much further into detail than I had expected. You can afford to leave out a hand or an eye, but you cannot ask the beholder to guess the design of a table-cloth of which he had no knowledge.

Needless to say the camera can never achieve the tact and selectivity which the painter can display in this effort to evoke a subjectively truthful visual experience, but the photographer has no difficulty in record-

FIG. 19.—Anders Zorn, *Rosita Mauri,* 1889, etching.

ing the effect of differential focussing along the line of sight. I have asked the photographer of the Warburg Institute to focus his lens on the leaves in the foreground of the courtyard of its building, leaving the background blurred (fig. 20). It is not a picture he would have taken normally because by using a different opening and exposure time he could easily have increased the depth of his picture far beyond what the eye can record at any one moment. But what about the lateral decrease of definition discussed by Helmholtz? Here the normal camera is less adapted to follow the eye. Our photographer resorted to the expedient of covering part of his lens with vaseline to get partial blurring of the field, but the results only demonstrate the futility of this device (fig. 21). Things are not simply blurred outside the foveal area, they are indistinct in a much more elusive way.

What compounds this elusiveness is the intriguing fact that peripheral vision is extremely sketchy in the perception of shapes and colours but very responsive to movement. We are aware of any displacement in the medley of forms outside the foveal area and ever ready to focus on such an unexpected intrusion. Once we have done so we can track the moving object without letting it go out of focus, while the rest of the field of vision recedes from our awareness. There is no means of conveying this experience in a stationary display. The perception of movement is different in character from the inspection of a static scene. True, photography, as we have seen, can record the track of a moving flash, and the trail of forms left on the emulsion during a long exposure has suggested to painters a number of devices for rendering motion—one of them being the device adopted by Smilby for suggesting the rapidity of the painter's movement, that is, by showing many hands linked by a blur.[18] But though we have come to take this convention for granted, it is rather untrue to the experience we would have had in watching the painter at work. If we had tried to track his hand, we could not have attended to his head, let alone to the lightning flashes seen through the window.

While I was reflecting on these perplexities several years ago, my attention was caught by an advertisement which was at that time frequently displayed in London buses (fig. 22). As is so frequently the case with such products of the advertiser's skill, I subsequently had considerable difficulty in tracking it down and procuring a copy when I wished to use it as a demonstration piece. I fastened on it because to my mind it came reasonably close to what I had been looking for, an arrested image which recorded both the effects of blurring through movement with that of selective focus. In the original, the effect is enhanced by the vivid colours which certainly provided attraction for those passengers who

18. See n. 15 above and my "Moment and Movement in Art," *Journal of the Warburg and Courtauld Institutes* 27 (1964).

FIG. 20.—Photograph of courtyard of Warburg Institute, close focus on leaf, by photographer of Warburg Institute.

FIG. 21.—Photograph of courtyard of Warburg Institute with lateral blurring, by photographer of Warburg Institute.

FIG. 22.—van Brissen, poster for Guards cigarettes.

were not meditating on the standards of truth in visual representation. The theme is the daily ceremony of the changing of the guards in London, a reminder of past pomp and glory which remains a favourite tourist attraction. Innumerable visitors must have tried to snap this approach of the cavalry with their resplendent uniforms, helmets, and flags, but if they did not get more on their films than we see on the poster they probably discarded it as a bad shot. The German designer van Brissen did not. Whether or not he had pondered the implications of the eye-witness principle, he may have found that the picture conformed to its negative demand that no more should be shown than can be seen from one spot during one moment of time—however we may wish to define such a moment. We focus on the white horse in the van, though its rider is less clearly visible. The flag on the left and the brown horse on the right are also less easy to discern, and it is hard to tell whether the eight helmets we can make out are all there were. The eye-witness could not linger and count during the cavalry's rapid advance, for I presume he had to get out of the way in a hurry.

Here, then, we have an arrested image which tries to convey both the effect of the moving motif and of the limitations of the nonmoving eye, and however eccentric the result may be, it provides food for thought on what I have called the subjective standard of truth—truth to our visual experience. In a sense it may also be described as a *reductio ad absurdum* of this very standard which has played such a part in dis-

cussions of the hand-made image. In the first instance it confirms Gibson's view that we have no privileged access to our own visual sensations which were supposed to underlie our perceptions. We cannot really tell to what extent the experience the eye-witness had is correctly mediated by the picture, and he could not tell us either. As soon as he tried to do so he would have to make it more definite than it was—a problem all of us have had who have ever tried to tell a dream. It is here, moreover, that we come up against the second and fatal flaw of the eye-witness principle; taken to its limits it flounders on what Gibson has called the Greco-fallacy, the naive belief that Greco's figures are so elongated because his astigmatism made him see them so distorted, forgetting that in that case he would also have seen his paintings elongated and would have had to correct them till they matched his vision of the model.[19]

It was no other than John Ruskin who anticipated and applied Gibson's warning to the representation of peripheral indistinctness: "We indeed can see, at any one moment, little more than one point, the objects beside it being confused and indistinct; but we need pay no attention to this in art, because we can see just as little of the picture as we can of the landscape without turning the eye; and hence any slurring or confusing of one part of it, laterally, more than another, is not founded on any truth of nature, but is an expedient of the artist—and often an excellent and desirable one—to make the eye rest where he wishes it."[20]

In the case of our poster it is especially easy to know where the designer wishes the eye to come to rest—it is not the leading horse of the cavalcade which is most in focus but the package of cigarettes. In obediently focussing on this area, indeed in reading the captions, it is the whole photograph which moves outside the foveal area and becomes indistinct. We can prevent this no more than we can prevent focussing on the indistinct passages and thus contradicting the experience they are meant to convey.

Clearly, then, there are more limits to the functioning of the eye-witness standard than could be foreseen when the visual image was first used to turn the beholder into the vicarious participant of an event. The shift from the object out there to the experiencing subject has resulted in perplexities which make it understandable that the very subject of visual representation has become problematic to psychologists and philosophers alike. The objective and the subjective standards of truth became hopelessly muddled in many of their discussions.

It is perhaps easier to see from the point we have reached how this confusion also affected the debate on perspective. I have stressed here and elsewhere that perspective cannot and need not claim to represent the world "as we see it." The perceptual constancies which make us

19. P. B. Meaward, in his *Advice to a Young Scientist* (New York, 1979), suggests the exposure of this fallacy as an elementary intelligence test.
20. John Ruskin, *Modern Painters*, 5 vols. (London, 1843), 1: pt. 2, sec. 2, chap. 4, n. 1.

underrate the degree of objective diminutions with distance, it turns out, constitute only one of the factors refuting this claim. The selectivity of vision can now be seen to be another. There are many ways of "seeing the world," but obviously the claim would have to relate to the "snapshot vision" of the stationary single eye. To ask, as it has so often been asked, whether this eye sees the world in the form of a hollow sphere or of a projection plane makes little sense, for it sees neither. The one point in focus can hardly be said to be either curved or flat, and the remainder of the field of vision is too indistinct to permit a decision. True, we can shift the point of focus at will, but in doing so we lose the previous perception, and all that remains is its memory. Can we, and do we, compare the exact extension of these changing percepts in scanning a row of columns extended at right angles from the central line of vision—to mention the most recalcitrant of the posers of perspective theory?[21] I very much doubt it. The question refers to the convenient choice of projection planes, not to the experience of vision.

But as I have tried to show at the outset, the scientist is never troubled by questions of this kind. What matters to him is that he knows the behaviour of light and the specifications of his instrument. Even in the absence of such a complete record he would not disdain using a photograph like our poster. If no other document were available, he might surely try to find out from it as much as it might yield about the the changing of the guards. After all, military intelligence officers have frequently had to work with even more fragmentary evidence, extrapolating from what they could guess of its probable history; and in this work they certainly would not have to worry about anybody's visual experience.

But if this subjective experience is in fact as private and elusive as I have made it out to be, how could it ever have been elevated into a standard of truth? I have attempted to give an answer to this question in *Art and Illusion* and in several other of my writings, but I welcome the opportunity to test it here against another kind of image. The standards, I argued, are based not on a comparison of the motif with the image but on the potential capacity of the image to evoke the motif. In this reading of the history of image-making, the artist has no more privileged access to his visual experience than has anyone else.[22] But he has trained himself to watch his own response to the image as it grows under his hand. If his aim is a matching of the visual world, he will follow up any device that suggests it to him. If his work is successful, we may infer that it also suggests such an experience to other beholders. A feedback loop is set up which leads to an ever closer approximation to the desired effect.

21. I now prefer this formulation to my somewhat laboured discussion in *Art and Illusion*, chap. 8, sec. 4.

22. My most explicit formulation is in the opening paragraph of chap. 11 of *Art and Illusion*.

This, then, is the reason why I have selected this poster for analysis. However debatable it may be whether it matches a visual experience, we must presume that those who selected it found that it had become acceptable to their public. I find it useful in this concluding section to concentrate on this photographic device because photography yields more easily to the separation of the standards of truth than does the hand-made image.[23]

One thing is sure. At the time when photography was a new medium a shot like van Brissen's would not have been acceptable, even if it had been considered readable. In tracing the development which made it so, the historian would have to consider at least three different factors—the technical equipment, the general notion of social decorum, and, most important of all, the education of the public in the reading of images which are capable of evoking an experience even through the absence of information.

In contrasting information and evocation as two different functions of the image, I am merely reviving a distinction which was made by Sir Joshua Reynolds in his famous discussion of Gainsborough's portraits. As long as a portrait "in this undetermined manner" contains enough to remind the spectator of the sitter, "the imagination supplies the rest, and perhaps more satisfactorily . . . than the artist, with all his care, could possibly have done." True, as Reynolds continues, the effect presupposes a knowledge of the sitter; in the absence of such knowledge the imagination may "assume almost what character or form it pleases."[24] Evocation, in other words, relies even more on prior information than perspectival records.

No doubt this is true. But the formula does not yet tell us what type of information we do need to bring the incomplete image to life.[25] Perhaps it is less information than understanding that is involved. An intelligent woman who had her first baby relatively late in life observed that baby snapshots began to assume more vividness for her after she had experienced how babies move and react. It is this capacity to generalise, to move from the known to the less known, which must never be left out of account when discussing "the beholder's share." A photograph from that famous anthology *The Family of Man* may illustrate this point (fig. 23). To me, at any rate, it immediately evokes the situation of the hunting bushman—the aiming hand, the tense watchfulness, the presumed fate of the quarry—but I have never hunted antelopes with bushmen. It is not to the memory of information previously stored that the image appeals but to the very faculty Reynolds invokes, the imagina-

23. I had a welcome occasion of discussing photography as an art in the introduction to the catalogue of an exhibition of Henri Cartier-Bresson (Edinburgh, 1978), arranged by the Scottish Arts Council and the Victoria and Albert Museum.

24. Reynolds' Discourse 14, 1788, quoted in *Art and Illusion.*

25. See my "The Mask and the Face," in *Art, Perception, and Reality.*

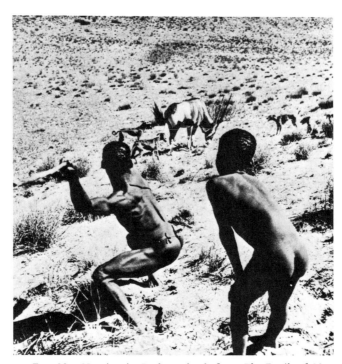

Fig. 23.—Hunting in Bechuanaland, from *The Family of Man*, Museum of Modern Art (1955), pl. 51.

tion. It is a term not frequently used in psychological debates today because it is insufficiently precise to be subject to measurements and tests, but I believe the student of the evocative potential of images cannot do without it. Whatever term he uses, he must account for the capacity of the human mind to respond not only to individual memories but to kinds or classes of events. Whatever we study, we are always likely to land ourselves right in the middle of the oldest and most persistent philosophical debate, the debate about the so-called problem of universals.

Without a prior disposition to respond to such generic classes as faces or bodies, we could not cope with novelty. Experience is always novel, it can never repeat itself exactly. I hold with those who believe that there are certain classes of experience to which we are programmed to respond from birth, while others are readily assimilated to this initial stock. I doubt whether we know enough about these mysteries to plot the course of this learning process and to tell in every case which of our reactions is learned and which is not. I believe that some degree of what used to be called empathy, the automatic reaction to another person's physical state, is built into our perceptions and that we see the tenseness of the throwing arm rather than infer it. Indeed I would venture to go further still and postulate that we have some empathy even with animals,

that the dramatic life-and-death fight between a cobra and a mongoose is intelligible to us, that it appeals to our imagination, because we instinctively understand the urgency of this confrontation (fig. 24). It is a configuration of which the meaning is easily learned because the pathways are laid.

But surely man is a strange creature. His ability to assimilate, to learn to respond to symbols and to novel situations, suggests a degree of plasticity of the moving mind which defies analysis and confounds prediction. A generation or two ago instantaneous snapshots were pronounced illegible because the public had not yet made the connection between the images and the process by which they came about. It is here rather than in the features recorded by the image that understanding presupposes a process of cultural habituation or training. Almost any recent collection of photographs of landscapes and people can serve to

Fig. 24.—Fight between cobra and mongoose after Ylla, *Animals in India* (Lausanne, 1958), p. 112.

remind us of this public habituation on which the photographer can rely. Four photographs from *Viaggio in Toscana,* the attractive book by Giovanni Berengo-Gardin, illustrate the range of this ready response. The first is traditional in style (fig. 25). It shows the unmistakable old-world scene of the road and allows us vicariously to experience its course as we automatically follow in our minds the movement of the cart and the donkey up the hill. We are left in no doubt where they came from and where they are going. But those of us who know the Italian scene may respond with equal vividness to the snapshot taken from an un-familiar angle, probably out of a window, showing a woman in a narrow road carrying loaves of bread on her head (fig. 26). A few decades ago such a picture would hardly have been selected for publication, even less, perhaps, the snapshot which records the reaction of the woman in the church to the photographer, the woman who turns round to stare at the intruder (fig. 27). If this picture relies on our understanding of how it came about, the fourth example from the collection presents the ex-treme of this expectation. It shows a famous palace facade in Montepul-ciano (Palazzo Buccelli) partly composed of Etruscan reliefs and tombstones (fig. 28). A documentary volume would have shown it neat and (incidentally) captioned it. Here the photographer included the blurred images of two passersby, a device which would have shocked earlier publishers and users but which serves eminently well to evoke the reality of an old building which still belongs to a living town. Next time when we travel we may also refuse to wait till the view is clear and hope for a similar result.

But whether or not we are used to taking snapshots ourselves, we have seen so many that we can classify them and understand them. We have adjusted to the peculiarities of the arrested image and accept it as "true" for its evocative rather than its informative qualities. Thus the photograph of a giraffe, which I take from a book by Federico Hecht published in 1971, no longer looks like a spoilt picture he should have discarded (fig. 29). Our tolerance is due to an understanding of the situation in which the picture was presumably taken; he probably saw these creatures in a fading light and risked a longer exposure time which resulted in a blur. But does not this ghostlike image permit us to imagine the appearance in the wild of these fabulous animals with a kind of vividness denied to the textbook illustration which gives us so much more information? In other words, has not the technical accident led to a psychological discovery?

We must not yield to the temptation to which the philosophy of art has given in far too often, of declaring that this picture is more truthful than the detailed photograph. This kind of aesthetic one-up-manship gets us nowhere. But it may be truthful in a different way, more evoca-tive of something which is not information but rather a peculiar kind of experience which we can understand whether or not we have ever been

Fig. 25.—Photograph from Giovanni Berengo-Gardin, *Viaggio in Toscana* (Lausanne, 1967), pl. 49; donkey riders.

Fig. 26.—Photograph from *Viaggio in Toscana*, pl. 59; woman carrying bread.

FIG. 27.—Photograph from *Viaggio in Toscana,* pl. 58 top; woman turning round.

FIG. 28.—Photograph from *Viaggio in Toscana,* pl. 88 top; two children walking past facade.

to Africa. We are back at what I have called the eye-witness principle, but from the other side, as it were. Not from that of the object, but from that of the subject. It was the shift from the one to the other which ultimately led to pictures like the poster of the guards which I analysed and criticised for its inherent contradictions. The contradictions are there, but they still illuminate the fascinating problem of the various standards of truth which we have learned to accept in our commerce with visual images.

Fig. 29.—Giraffe, from Federico Hecht's *Above and Beyond* (Munich, 1971).

Picturing Vision

Joel Snyder

1

In *The Dioptrics,* Descartes notes in discussing the mechanics of vision that "very perfect images" are produced in back of the eye "representing in natural perspective, all the objects outside."[1] This observation follows an apparently paradoxical remark about the relation of "perfect images" to the objects they represent:

> very often the perfection of an image depends on its not resem-
> bling the object as much as it might. For instance, engravings,
> which consist merely of a little ink spread over paper, represent to
> us forests, towns, men and even battles and tempests. And yet, out
> of an unlimited number of different qualities that they lead us to
> conceive the objects, there is not one in respect of which they actu-
> ally resemble [the objects] except shape. Even this is a very im-
> perfect resemblance: on a flat surface, they represent objects vari-
> ously convex or concave; and again, according to the rules of per-
> spective, they often represent circles by ovals rather than by other
> circles, and squares by diamonds rather than by other squares.
> Thus very often, in order to be more perfect *qua* images, and to
> represent object[s] better, it is necessary for the engravings not to
> resemble [them].[2]

1. René Descartes, Discourse 5 of *The Dioptrics,* in *Descartes: Philosophical Writings,* ed. and trans. E. Anscombe and P. T. Geach (Edinburgh, 1954), p. 245.
2. Discourse 4 of *The Dioptrics,* in *Descartes,* p. 244.

Reprinted from *Critical Inquiry* 6 (Spring 1980): 499–526

Descartes remarks are paradoxical only if we believe, as most of us are inclined to do, that the significance of a picture is based upon its resemblance to the objects of depiction or on other kinds of privileged or natural correspondences (such as impression or isomorphism) and that pictures are "more perfect" or "realistic" in proportion to the completeness of the relations.[3] Yet Descartes is surely correct in insisting that some pictures, at least, are more fully representative of objects or actions to the extent that they fail to resemble them.

Perhaps the most revealing way of measuring the success of picture makers in making "very perfect images" is to note the strength and tenacity of our belief that they do so by forging natural or privileged relations between picture and world. The belief in these relations accounts for the facile use by many art historians and critics of the visual arts of such weighty but indeterminate expressions as "reality" or "visual reality" in their explanations of key elements of realistic depiction. This ontological approach assumes a relation of resemblance between picture and referent as the condition of pictorial significance. The least complicated of these accounts, the so-called copy theories, maintain that pictures make sense to us because they "refer"—the referent being *the* (or, at least one) "meaning" of the picture. In the case of realistic pictures, the referent is "reality" or one of its ontological cohorts ("the facts of the moment," "the way things are," "the way things look," "the forms of things").

Ernst Gombrich has proposed a far more sophisticated and subtle analysis of realistic depiction in which he characterizes our response to such pictures as being "something akin to visual hallucination."[4] On

3. I have used the word "realistic" in preference to "realism" in order to avoid any possible confusion of my topic with the issues raised by Realism, the dominant movement in French painting roughly between 1840 and 1880. It will soon become clear that I regard "realistic" as an elastic category label that defies informative definition. *Webster's New Twentieth-Century Dictionary,* 2d ed., defines "realistic" as follows: "1. of, having to do with, or in the style of realism or realists" and defines "realism" as "2. in art and literature, the attempted picturing of people and things as they really are; effort at faithful reproduction of nature." Definition often proceeds by replacing general vagueness with a more specific kind of vagueness.

4. E. H. Gombrich, "Illusion and Art," in *Illusion in Nature and Art,* ed. R. L. Gregory and Gombrich (New York, 1973), p. 208. I have used this essay in preference to *Art and*

Joel Snyder, associate professor of humanities and of art and design at the University of Chicago, teaches theory and history of photography. A practicing photographer, he is the author of various articles on photography and vision.

Gombrich's account, perception itself is the product of habituation, although at "bottom" it is automatic and "programmed" to seek out certain natural features of the visual field (p. 204). For Gombrich, vision is essentially a process of making judgments about "meaning"— judgments about expectations that are elicited by certain clues in the environment. Artists invent rules or schemata for laying down clues on canvas. These clues substitute for the bits of information we seek when looking at nature. Thus, at least a certain portion of the recent history of art is a progressive history in which artists have sought to invent artificial "keys" that open the natural "locks of our senses" (p. 201). Gombrich's solution to the problem of realistic representation allows him to deny that pictures really look like nature. Realistic pictures achieve their purpose by "suggest[ing] a reading in terms of natural objects" (p. 202). Gombrich shifts the question of "looking like" away from the representation itself to the judgment of the viewer. The similarity of a picture to nature is not like the similarity of a facsimile to an original (which is the explanatory basis of copy theories), but "it is the similarity between the mental activities both can arouse, the search for meaning, the testing for consistency, expressed in the movement of the eye and, more important, in the movements of the mind" (p. 240).

While Gombrich's observations about realistic representation are interesting and suggestive, they only postpone the question of natural or privileged relations between picture and world. Judgments of similarity are based upon similar uses of visual skills, and ultimately these skills are "rooted" in automatic and natural mechanisms. For Gombrich, the standard for illusion ultimately resides outside of the reciprocal relation between skills of perception and skills of representation. Information that preexists perception and representation provides the standard for judgments of similarity.

According to Gombrich, any picture that provokes a response in the viewer "akin to visual hallucination" rates a position on the "ladder" of illusionistic representation. Now, it may very well be the case that we ordinarily do make hierarchical judgments about pictures being more or less realistic. But problems of discrimination become acute at the upper reaches of the "ladder," and recourse to "information" or to the power of induced "hallucination" does not help in assigning particular pictures to specific rungs.

I find it more than merely suggestive that we call many different kinds of pictures "realistic." As a category label, "realistic" is remarkably elastic. We cheerfully place into the category pictures that are made in strict accordance with the rules of linear perspective, pictures that are at

Illusion (Princeton, N.J., 1960) because it is a compact and updated version of Gombrich's original statement of his illusion theory. All further references to this work will be cited in the text.

slight variance with those rules but that nonetheless look perfectly "correct" (e.g., paintings that have been "fudged" so that certain "distortions" generated by strict adherence to the stipulated geometry have been "softened" or corrected), and pictures made in flagrant contravention of perspective geometry (e.g., pictures that *look like* they were made with one point perspective but that have two vanishing points). We accept as realistic pictures that are made in strict accordance with the rules of perspective construction that we could never judge as being similar to anything we might or could ever see (e.g., a picture done in three point perspective looking down at skyscrapers). We accept as realistic pictures that are in sharp disagreement with what we now take to be the facts of vision (e.g., an architectural view across a plaza in which all objects in every plane and across every plane are in focus; a brief look around the room he is sitting in will convince the reader that we cannot see that way).

The above list could be extended, but the point has been made. It explains little to note that in each case cited above the picture leads us to a judgment that is similar to the kind we would make if we were looking at the real thing; because now, "the real thing" fails to mean very much at all. Of course, it is always possible to suggest that pictures have had such an enormous impact upon our perceptual skills that our judgments of similarity are as much influenced by what we know of pictures as by what we know of nature. But this suggestion only underscores the futility of seeking a standard of correctness that resides outside of the reciprocal relationship between skills of representation and skills of perception.

There is something charming and yet nasty about the belief in the special relation of picture to world. It is charming because it allows us to "enter" with ease into pictures and allows them to "extend" into our world. It allows us to think of pictures as "true to life," to use Gombrich's beguiling term, to look at a picture and ask questions of it, as if we were looking at the world through a window. It allows us to treat pictures as substitutes for the objects they represent (I do not mean to imply that they represent only objects) and so, for example, to buy clothing from an illustrated catalogue, or to analyze architectural styles from pictures of buildings. In brief, it allows us to feel a proximity to what is depicted and urges us to conclude that in certain important respects looking at a picture is equivalent to looking at what is pictured.

But this belief in the special relation of picture to world has a pernicious aspect; it holds sway over us and mocks thought with a vengeance. I have no inherent objections to beliefs that are beyond reason, but this one defies it. It seems to me that the conclusive refutations of copy or illusion theories somehow fail to be convincing; we are left with a strong feeling, after all the refutations are advanced, that there must, nonetheless, be a natural or privileged or unreasoned relation between realistic picture and world.

Nelson Goodman has asserted that our "privileging" of realistic modes of depiction is a product of inculcation or habituation.[5] But to attribute this privileging to familiarity does not explain the habit, the ease with which we "pick it up," or its strength. We have all kinds of habits, some of which are easy to break and others which are like second nature. If we think about a comparable case in literature, the relation between familiarity and conviction seems to be weaker than Goodman requires. The suggestion that there are no privileged modes of writing that get us closer to "the facts" might horrify a reporter for the *New York Times,* but most of us find it easy to accept because we understand that rules of objective reportage in journalism or realism in literature may change as the habits of audiences and writers change. The arguments against privileged modes of written reportage are conclusive *and* convincing. But the arguments against privileged modes of depiction, while conclusive, do not carry the same power of conviction. To call the privileging of realistic depiction a product of inculcation grossly understates the case; it is more like an addiction. A belief of this kind that resists coherent formulation and that nonetheless defies conclusive and convincing refutation is obviously an important element in the structure of our thought. It is the source and nature of this belief that I shall examine.

I do not think it is possible to find features that are common and peculiar to all pictures that we classify as realistic. Realistic depiction is conceptually and historically based upon the adoption of a model that permits both picture maker and viewer to demand and, indeed, to find systematic relations between picture and object of depiction. But this "object" is not simply "the way the world is," "the way the world looks," nor even "the ways we use our vision"; it is rather a standardized, or characterized, or defined notion of vision itself.

In order to establish the "program" of realistic depiction, we must adopt a model of vision itself as pictorial. Once we characterize vision as pictorial, it is possible to devise means of "transforming," or "translat-

5. Nelson Goodman, *The Languages of Art* (Indianapolis, 1968), pp. 34–39. Goodman's discussion of copy and illusion theories is a model of analytic demolition. However, his suggestion that familiarity with the "standard" mode of depiction in a given culture defines "realistic" and accounts for the ease with which we use and understand such pictures is not satisfactory. I do not know what "the" standard mode of depiction is in our culture. By the time a child is three, he has "picked up" an astonishing number of "pictorial habits" and can use them intelligently, for example, in watching cartoons and detective shows on television and in looking at books. The habit of reading words is obviously much more difficult for a child to acquire as are habits of hygiene, speech, dress, and game playing. I am not suggesting that philosophers should build their accounts of depiction around observations like these, but a system that cannot be used to account for them except by invoking "familiarity" certainly begs some important questions.

ing," or "copying" the visual picture. In saying that the basic require-
ment of realistic representation is the "picturing" of vision, I do not
mean to imply that there is only one standardized model of vision as
picture that operates in all or even in most cases of realistic depiction.
While I shall show that the first text on linear perspective does, in fact,
characterize vision as being amenable to only one kind of pictorial defini-
tion, such picture making today assumes that vision may be charac-
terized by reference to many different kinds of pictures. The choice of
any particular pictorial model of vision depends upon numerous factors,
purpose of representation and expressive requirements being two of the
most important. Moreover, the relationship between characterizing what
we see as pictorial and making pictures becomes a reciprocal one. This
account of realistic depiction is the only way that we can understand our
powerful belief in the privileged relation between picture and object of
depiction. What we do in depicting is to establish a congruence between
a "natural" seen picture that we construct according to pictorial rules
and a re-presentation of that "natural" picture. The rules of construction
are the same for both pictures.

2

Before I present the account of vision as picture, it will be worth-
while to take a hard look at a picture that most of us would agree is un-
equivocally realistic—a photograph. This exercise has a dual purpose:
it will help us understand just what claims are made for realistic pictures,
and it will allow us to see if at least one kind of realistic picture, because
of special "genetic" factors introduced by the photographic process,
avoids the most obvious objections to privileged relations theories.
Photographs make a special claim upon our attention because they are
supposed not only to look realistic (although they do not all look realistic)
but also to derive from or be caused by the objects they represent. This
"natural connection" has been taken as a reinforcement and even as a
guarantee of realistic depiction.

Most modern accounts of photography place special emphasis on
the unique way that photographs come into being, a process essentially
different from the genesis of handmade pictures. Thus, while a painter
must resort to invented schemata—rules of representation that work
because they trigger projection responses in us (or because they aid
painters in delineating "the forms of things"), a photographer uses a
camera which "captures" a "trace" of the object itself. The photographer
does not intervene in the process of representation. The world delivers
itself to the film in the form of the image of nature, and the act of
exposure allows the world to trace or impress itself in a purely natural
way. This view, or views similar to it, allows critics to speak of photo-

graphs as "cosubstantial with the objects they represent," "perfect analogons," "stencils off the real," "traces," or as "records" of objects or of the images of objects. Photographs apparently do an "end run" around the conventions of representation; painters can, by genius or guile or conceit or simple human error, "mutilate" the given, but a photographer can only record it.

The accounts of photography that accord it a special status within the picture-making arts are often unclear about the specific claims being made for photographs. The camera is sometimes construed as a substitute for or an extension of the eye, so that what is depicted represents what we would have seen had we been at the camera at the instant of exposure. Some accounts emphasize the causal links between photographs and the objects of depiction. These links are supposed to explain why the picture looks the way it does, whether or not it looks like what we would have seen. Clearly, these two models for explaining the special status of photographs do not amount to the same thing, though it has often been held that they do.

Since photographs differ one from the next as much as other kinds of pictures, I will not provide an analysis of *the* photograph but of a particular photograph: Walker Evans' *Hotel Porch, Saratoga Springs, N.Y.*, made in 1930 (fig. 1). Evans' picture seems unmediated: the view looks neither upward nor downward but straight ahead and at eye level; the angle of view is neither unusually wide nor narrow. We see the subject as if looking through a window.

Now, the first and most obvious thing about the picture is that we could never see what is shown here in this way, if by "see" we mean how all the depicted objects would have appeared to a viewer standing at the side of the camera. To begin with, our vision is not formed within a rectangular boundary; it is, per Aristotle, unbounded. Second, even if we were to close one eye and place a rectangular frame of the same dimensions as the original negative at a distance from the eye equal to the focal length of the lens (the so-called distance point of perspective construction) and then look at the field represented in the picture, we would still not see what is shown in the picture. The photograph shows everything in sharp delineation from edge to edge, while our vision, because our eyes are foveate, is sharp only at its "center." The picture is monochromatic, while most of us see in "natural" color (and there are some critics who maintain that the picture would be less realistic if it were in color). Finally, the photograph shows objects in sharp focus in and across every plane, from the nearest to the farthest. We do not—because we cannot—see things this way.

No doubt some readers find these observations trivial and beside the point. In answer, I can only say that while they are indeed trivial, they precisely constitute the point. Recall that at least one theory maintains that photographs give us an image of nature that corresponds to what

FIG. 1.—Walker Evans, *Hotel Porch, Saratoga Springs, N.Y.* Courtesy of the Art Institute of Chicago.

anyone might see from the same vantage point as the camera. The picture is supposedly realistic because it gives us a substitute for vision, that is, a piece of visual experience. Evans' picture, however, clearly and unequivocally fails to do that; the picture is perfectly realistic even though it defies what we now know about the ways that things appear to us. One may object that the photograph need not look exactly like what we see in order to qualify as realistic. But this is not my point; my claim is not that the photograph has failed in some specific respects, but that our visual experience is not like the photograph. As far as I can tell, the objects depicted look just fine—but they look like objects in a picture. Whatever we might have seen from the side of the camera, it would not have looked like the picture.

But if the picture does not derive its realistic quality from its similarity to visual experience, how does it derive that quality? The second explanation for the realistic quality of the picture stresses the natural connections between photograph and photographed. Realistic depiction is allegedly guaranteed by the impression of the object upon the photo-sensitive material by natural means and in accordance with the laws of nature.

As a general explanation for resemblance, causal genesis is certainly lacking. Suppose that in a fit of anger I smash a wall with a large hammer. The wall may dent, but there is no reason to conclude that the dent *must* bear a resemblance to the head of the hammer. This is not to suggest that causal laws are inoperative in this case but simply that such laws do not guarantee even the suggestion of resemblance. In the case of devices *designed* to produce recognizable impressions, like signet rings and cylinder seals, the peculiar fact is that a well-produced impression does not stand to the impressing device as facsimile to original. Aside from possible differences in color and texture, what is raised on the device is depressed on the receiving medium and vice versa. And the final result of such an impression is critically dependent upon the careful choice of an appropriate medium and the *proper use* of the impressing device. If the device is moved laterally during the procedure, for example, or if too little or too much pressure is applied, an impression will result but not the desired one. It is, then, highly misleading to characterize the wax impression of a signet ring as a "natural" impression: such a view ignores the purpose for which the ring was made, the standards employed for the choice of medium, and the complicated rules governing the impression procedure. Finally, if I ink up my thumb and slide it across a sheet of paper, the resulting smear would certainly be an impression produced by the agency of my thumb, but it would nonetheless fail to look like my thumb. Even if I make what detectives consider to be a good thumbprint, it will work to identify me and only me but it will fail to be either a facsimile or a realistic representation of my thumb.

It is clearly dangerous to take the already problematic notion of

impression by means of physical contact between object and medium and extend it to photography. Much of the apparent explanatory power of impression derives from what appears to be the transfer of formal properties from the impressing object to the receiving medium. Even if impression by means of physical contact does work that way, there is no comparable contact in photography. Objects are not active in the photographic process, rather it is light that effects a change in the photosensitive medium. Thus, even if "impression" is the right term to characterize the changes effected on photographic film, what impresses the film is light. And light in nearly any form will have an effect upon film. Thus, the film will be impressed by light if it is exposed to focused light entering through the lens of the camera, or if it is exposed to unfocused light entering through the lens, or if it is simply taken out of the camera and placed in ambient light.

The notions of impression and natural law, invoked as a means of explaining why a photograph looks realistic, actually prove too much; such notions can account for *whatever* a photograph looks like. If Evans had exposed his negative to thirty-two times more light than he did, the resulting picture, although it would be a nearly white blank, would owe its appearance to the laws of nature (perhaps we should call such pictures "overactive impressions"). Similarly, a corresponding underexposure would result in a naturally caused black patch. Under these circumstances, it simply begs the question to argue that realistic depiction in a photograph is the result of natural connections between picture and world.

Let us return to the Evans photograph. I do not doubt that a catalogue listing of the objects in the picture might possibly accord with what an observer standing at the side of the camera might have listed as worthy of attention—though it might not. A skeptical viewer might have returned, picture in hand, to the place where the picture was made, to assure himself that Evans did not resort to photographic "distortion" or fabrication in order to obtain the final print. But this kind of matching game is not at issue; the game could be played with drawings, schematic diagrams that utilize some sort of arbitrary notation, or, for that matter, with plain English sentences. To return to the original question: it is simply false to say that we regard the picture as realistic because it comes close to recording a visual experience that we might have had; it simply does not do this. The picture does not provide a "copy of an appearance," nor does it attempt to duplicate vision or even to suggest how we might have seen what is shown. We accept the picture as realistic despite its failure to substitute for a visual experience. I am intrigued by the strong inclination many of us have to gloss over substantial and obvious discrepancies between picture and the experience of seeing what is pictured and still continue to maintain that the picture does indeed sub-

stitute for that experience. This conviction grows out of confusing *what* we might report having seen with *how* we would have seen what we report.

When we use our eyes with some definite purpose in mind, we anticipate, attend, discriminate, seek out. We do not find information in any simple sense of the term. Perhaps the most splendid feature of the concept of "information" is that it requires that form be actively imposed upon something. Only in the most equivocal sense is information "out there." We find, or fail to find, what we are trained to look for. Without the impetus of purpose, which gives definition to the activity, we identify what is easiest to locate, and by "easiest" I mean only what we are predisposed to find. It is unfortunately the case that what is easiest to find often gets characterized as what is "natural" to locate. And once we begin to speak of what we find in nature it is easy to believe that the information preexists in neat packages, out there, without regard to purposeful discrimination. We come to believe in privileged routes of access to pure information. But certainly there is a congruence between what we look for and what we find; purposeful looking is anticipatory. It is ludicrous to believe that a photograph captures images or records them, as if they managed to escape the reciprocal relations involved in purposeful attending.

The Evans photograph neither shows nor suggests the way we might have seen what is represented in it. The suggestion that this or any other photograph can stand in for vision is simply wrong if by "stand in" we mean somehow "replicate" vision. Vision cannot be formulated without reference to the enormously varied and complicated ways of attending, and the product of any such formulation will be relative to some purpose or to a set of operations incorporated in a purpose.

If we shift our terms, so that rather than characterizing the picture as the representation of a visual experience we discuss instead the depiction of objects we determine when looking at or attending to what is in front of us, a new possibility emerges. I suspect that if we just happened by Evans at the moment he made the exposure, we would have missed most of what is represented in the picture. If, on the other hand, we had been asked to attend to the field before the camera in a certain way, we might possibly have come up with a good or adequate laundry list of the items a photographer might choose to represent. If we had been provided with some information about the way Evans worked, the sorts of things that interested him and the kinds of photographs he made, chances are we could have provided a good list of objects he would represent, or a good description of the photograph he was engaged in making. But without some notion of what we were supposed to look for and list, without some rules of attending, it is far from clear that our catalogue would match the objects depicted in the photograph.

What Evans did in making this picture can best be characterized as an act of imagination. He gave expression to his rules of attending, and in so doing he taught his audience to attend in the same manner. Evans' achievement rests upon his power to make pictures that integrate all sorts of items represented in sharp focus, each of which competes with the rest and all of which nonetheless resolve into a unit. There is no referent for this unit; it does not exist outside of the picture. We could not see what is represented in this way, though we might hold it all together in an act of imagination.

None of this denies the possibility of using certain photographs to verify some statements about "the" way things were at the time of exposure. In many pictures like Evans', the viewer has a legitimate reason to say that such and such was in front of the camera at some past time. But in this regard, two points need to be kept in mind. Photographs are not self-warranting any more than, say, paintings are. More to the point, photographs do not owe their significance to the possibility of using them to establish facts about the world.

One strong motive for investing photographs with special powers—powers to represent what was "really there" or "the facts of the moment"—is that some photographs can serve a number of different uses—uses not intended by the photographer. Thus, in a quaint family snapshot of Aunt Maude, we also get a glimpse of a Model-T Ford and can use the photograph to establish something about old cars. But the ability to use certain photographs for a multiplicity of ends is a property shared with any kind of realistic picture. A painting of Delft by Vermeer can serve the ends of art historians, city planners, architects, stone masons, cultural historians, and so on.

The problems engendered by the analysis of photographs come about, in great part, because of a peculiar set of beliefs concerning the camera that have grown up during the past two centuries. The camera has taken on the status of natural machine—the giver of "the image of nature." Some critics believe the camera image is not only an independent and scientific corroboration of the schemata developed by realistic painters from, say, the time of Giotto onward but is a correction and fulfillment of those schemata. That we have failed to understand that this is quite simply false is as much an indication of our ignorance of the history of the camera, the purpose of its construction, and the source of its design as it is a mark of the ease with which we have come to accept certain tools as being products of nature. In our own age, surrounded as we are by consumer goods and gadgets built to average or indifferent standards, we have lost the sense of the tool as fit for its work and the extent to which the design and construction of a tool carries with it the standards of its intended use. To the extent that we believe cameras automatically give natural images, we have lost the sense of what these

tools are and have forgotten that they are instruments at all. And it is clear that most modern critics of photography have had no sense of the instrumentality of cameras. Cameras do not provide scientific *corroboration* of the schemata or rules invented by painters to make realistic pictures. On the contrary, cameras represent the *incorporation* of those schemata into a tool designed and built, with great difficulty and over a long period of time, to aid painters and draughtsmen in the production of certain kinds of pictures.

It is unfortunate that art historians have not provided us with a critical history of the camera. Aside from its inherent interest, such a history would do much to rid us of the tendency to think of photographs as *sui generis*—as standing outside of the "family" of handmade pictures. The following brief remarks on the history of the camera are intended to show that the construction of the camera did not flow out of the abrupt discovery of the "image of nature" but rather that it was developed as an aid for the production of realistic paintings and that such paintings provided the standard for the kind of image the camera was designed to produce.

The principle of what we now call "pinhole image" production[6] was known from antiquity and was used to observe solar eclipses. From the tenth century through the late fifteenth century, pinhole image formation was carefully studied by Arab and Latin natural philosophers, and this study was an important element of the theory of vision known as *perspectiva*.[7] I have been unable to find any evidence that during this

6. When light from a radiant source or light reflected from an object is allowed to pass through a small aperture into a darkened room or box, a reversed and inverted image of the source or object will form on a surface held in back of the aperture. This phenomenon is called "pinhole image formation." Even in its simplest form, numerous "design decisions" are built into a pinhole camera. For example, the size of the aperture will have a decided effect on the quality of the image. More important, the shape and position of the surface upon which the image is formed will have a great effect on the visual properties of the image. We favor a planar surface at right angles to the aperture: a planar projection surface at an acute or obtuse angle to the aperture will produce a "naturally distorted" image as will a concave or convex projection surface. Even at the simplest level, tools must be built to standards.

7. I will be discussing the relevance of *perspectiva* to Leon Battista Alberti's seminal work, *De Pictura,* in section 3 of this essay. This medieval theory of perception provided Alberti with a material and a formal account of vision. On the material explanation of vision, sight is initiated by the passive reception of light and color by the eye. This impression upon the eye can be mapped geometrically in terms of correspondences between points on the object and points on the lens of the eye. The impression, however, is in no way coextensive with what we see. The formal account of vision requires that what we see be understood as the product of a construction, initiated by the impression, but informed at the level of imagination. The rules of perspective construction are, for Alberti, the same rules employed by the imagination in attending to the visible world. These rules are given in depiction as rules of delineation and composition. Thus, visible objects and their struc-

period such imagery was thought of as having a possible use for the production of pictures. Not only was the phenomenon ignored for its potential pictorial applications, the natural philosophers who studied it were not at all concerned with the image produced by pinhole apertures but confined their interest rather to the shape of the outer boundary of the image. Indeed, they did not even refer to the image as an "image" at all; they spoke rather of the rays of light that passed through the aperture and were incident upon a surface in back of it.

The images produced by the kinds of cameras studied by medieval philosophers, flawed, reversed, and upside down as they are, do suggest a pictorial application to a modern eye—but they did not to the medievals. And they did not suggest a pictorial use until well into the sixteenth century, when the principles of linear perspective, "sharp" delineation of objects, and the coherent use of light and shade—in other words, the basic principles of realistic picture construction—had taken root in Italy. We have completely reversed the history of the camera in our popular accounts of photography. The problem for post-Renaissance painters was not how to make a picture that looked like the image produced by the camera, it was how to make a machine that produced an image like the ones they painted.

The first published account of the camera, or as it was known then, the *camera obscura* ("dark room"), appeared in 1521, nearly a century after the publication of Alberti's treatise on linear perspective, in Cesare Cesariano's annotations to Vitruvius' *Treatise on Architecture*.[8] Cesariano's *camera obscura* was a darkened room with an aperture fitted into a door or window. An image of illuminated objects outside the room was projected upon a sheet of paper inside. The *camera obscura* described by Cesariano is in all essentials the same kind of instrument used by the medieval *perspectiva* theorists. Cameras made in keeping with Cesariano's description produced reversed, inverted, and very dim images that were in focus no matter how close or far from the aperture the plane of projection was placed. The next step in the development of the camera was the introduction of a lens at the aperture that greatly increased the brightness of the projected image. This advance, most probably invented by Girolamo Cardano in 1550,[9] introduced the complication that with any particular lens the resulting image was in focus at a set distance from the aperture, and only those illuminated objects at a mathematically determined distance in front of the aperture were sharply delineated in the image.

tured relations are expressible only at the level of imagination. For Alberti, there was no problem of "the given," there was only the imaginatively "taken."

8. Vitruvius, *De Architectura Libri II, traducti de Latina in vulgare affigurati,* trans. Cesare Cesariano (Como, 1521), bk. 1.

9. See Girolamo Cardano, *De Subtilitate Libri XXI* (Nuremberg, 1550), bk. 4.

The first suggestion for a specifically pictorial use of the camera was published by Giovan Battista della Porta in 1558.[10] His brief remarks concerning the use of the camera for making pictures were aimed, however, at amateurs who did not know how to paint. The production of cameras that were useful aids for artists took nearly a century more to be produced. By the late seventeenth century, cameras were portable and were fitted with reflecting mirrors that projected the image upon a surface fitted to receive drawing paper. Two major problems remained to be worked out: lenses were still crude and did not produce particularly sharp images, and since objects at different distances from the lens could not be held in focus at the same time, artists had to learn how to draw on one plane at a time and to focus progressively from plane to plane. Artists had to instruct lens makers about the focal length of lenses. Since artistic practice demanded that painters stand at a set distance from portrait sitters in order to avoid exaggeration of features, specific lenses were required for portraiture. Likewise, special lenses for city- and landscapes had to be developed. Lenses for landscape depiction could not be used for portraiture without introducing "distortions" into the painting. Moreover, a portrait lens for a small camera could not be used as a portrait lens for a large one. By the middle of the eighteenth century, cameras and lenses had been specifically designed for the special uses of artists, and manuals of instruction for their correct use were produced by both lens manufacturers and artists. What I wish to emphasize is the relation of purpose to design: camera makers had to be told what the specific need of the artist was before they could work out a design for a camera that would satisfy that need. The mechanism of the camera was thoroughly standardized to meet specific pictorial requirements.

Despite these developments, as late as 1829 Charles Chevalier, the premier French optician who provided cameras to Joseph Niepce and Louis Daguerre, the two French inventors of photography, was able to write

the camera obscura bore many imperfections as it came from the hand of its inventor; the numerous modifications it had undergone [until recently] had only slightly improved its design; and painters, mindful of their reputations, had ceased to use it because it presented badly defined images, with confused outlines. Moreover, these images had a tonal crudeness which became a characteristic of the works of artists who used the instrument too frequently.[11]

10. Giovan Battista della Porta, *De i miracoli et maravigliosi effetti dalla natura prodotti libri IV* (Venice, 1560), bk. 4, pp. 139–45.

11. Intro. to Charles Chevalier's *Notice sur l'usage des chambres obscures et des chambres claires* (Paris, 1829), my translation. Heinrich Schwarz's "Vermeer and the Camera Obscura" (*Pantheon* 24 [May-June 1966]: 170–80) provides a useful, though brief, history of the *camera obscura* and its use as an aid to artists.

Photography did not sidestep the standards of picture production, it incorporated them.

3

Our willingness to accept photographs as natural and mechanical records of what we see underscores the power of our belief that certain kinds of pictures achieve significance because they are "natural"— meaning that such pictures are related to what they depict in exactly (or roughly) the same way that vision is related to what we see. In my brief remarks on the history of the *camera obscura,* I have shown that the significance of photographs cannot be accounted for by mechanical ex- planations of natural phenomena. The question that lies beneath the modern (and futile) discourse about the ontological status of photo- graphs is a far more interesting one than has yet been posed: How is it that we ever came to think of photographs as being natural phenomena at all? This question cannot be answered by reference to the mechanics of photography but must itself be referred to an examination of those pictorial standards that are the principles of camera design. These stan- dards grow out of a deliberate and thoroughly successful attempt on the part of Western artists, beginning in the early Renaissance, to construct a pictorial equivalent to vision. It is this pictorial equivalent to vision which is the source of our unshakable belief in the congruence of picture and world.

The history of Western painting during the past five hundred years has been characterized by an attempt to secure a scientific basis for picture construction that serves, in turn, to warrant the viewer's belief in the fidelity of the picture to what it represents. Broadly speaking, "the object" of representation is *what we see.* But this must be understood as a characterized or defined object that has been structured in accord with an account of how we see. The primary condition for this kind of picture making is the belief that vision is amenable to depiction because it is itself pictorial. New theories of vision breed new "facts" concerning what we "really see." The visual facts enshrined in a painting by Piero della Francesca not only differ from but are incompatible with the facts of vision represented in a work by, say, John Constable. And yet, we may call both pictures "realistic." The joining of artistic practice to a scientific theory of vision that generates facts about what we see grants the artist a new kind of freedom. Since the Renaissance, artists have had the ability to move ahead of the viewer, to make fresh discoveries about what we really see. This is not an unconditional freedom, but its very possibility implies a paradox. The artist can depict what we see because what we see is pictorial. And yet, in his paintings, the artist can achieve fidelity to his own vision based upon his knowledge of vision and depiction, and we

will accept the picture as credible and warranted even though we may insist at the same time that we never quite saw things that way before.

The aims of art are enormously varied, and I do not mean to imply that all artists at all times have been concerned with depicting what we see. As far as I can determine, abstract expressionists are not terribly concerned with accounts of the way the world looks. Nonetheless, the joining of artistic practice to scientific theory in the early Renaissance gave a new rationale and impetus to artists who wished to depict what they saw. And it provided rhetorical assurance to the audience that what they saw in paintings was related by the sure methods of science to what they saw when looking at the world.

The first text on linear perspective, *De Pictura*, written in Florence in 1435 by Leon Battista Alberti, also marks the first effort by a painter to establish the certainty of his method of picture construction by deriving it from a scientific account of vision.[12] The grounding of depiction in contemporary science has both an immediate and a long-lasting impact. Painters were quick to adapt linear perspective to their own needs. The system continues to be used today in its purest form, in many kinds of handmade illustrations and, of course, in nearly all applications of photography, including motion pictures and television. We remain strongly under Alberti's influence. On the level of theory and criticism, Alberti's system continues to engender lively and passionate debate in questions concerning its natural or conventional foundations.

Alberti sets out to derive depiction from an account of perception. *De Pictura* lays out procedures that permit an artist to paint what he sees by means of rules derived from a mechanical and psychological account of how he sees. For Alberti, a painter is able to represent what he sees because the elements of vision and the rules for their composition are themselves pictorial. Once this principle is established, Alberti identifies what he sees as a constructed picture, analyzes it, and uses the product of the analysis for the artificial and correct representation of the perceived image. The scientific examination of vision and its application to depiction provides the standard for pictorial correctness. This, in turn, requires a scientific and mathematically sanctioned method of picture construction. Linear perspective, by definition, requires the painter to "fix" his eye in a determined and unvarying relation to the picture surface in order to recreate within the picture the rational structure of perceptual judgments. It is precisely this notion of structured perception that is central to Alberti's text. The scientific account of vision adopted by him

12. Leon Battista Alberti, *On Painting and on Sculpture: The Latin Texts of "De Pictura" and "De Statua,"* ed. and trans. Cecil Grayson (London, 1972). All references to *De Pictura*, unless otherwise noted, are to this text. Alberti originally wrote the text in Latin in 1435 and rewrote it in Italian in 1436 under the title *Della pittura*. The Italian text, to quote from Grayson's preface, "has undeservedly enjoyed the greater fortune." I have used Grayson's text because it is more complete and precise than the Italian.

provides a basis for explaining how we are able to make "certified" judgments about the sensible things of the world. It is not an account of momentary glances or "impressions," nor is it, strictly speaking, an account of "appearances." A completed perceptual judgment, that is, a unified one in which we correctly identify objects, their attributes, and their interrelations, can be made only under specified observation conditions through time, by means of discrimination, comparison, and integration. What is fragmentary or unsure in perception cannot be certified, unified, or identified. Such fragments of perception have no place in depiction because they are irrational and incomplete; they fail to achieve the purpose of vision. The depiction of incomplete and shifting appearances would imply an inability to act rationally and harmoniously. A full perceptual judgment establishes objects as having existence apart from perception. Even a brief look at a painting produced in strict accordance with Alberti's method demonstrates how thoroughly unusual, by our standards, his notion of perception is. All visible things are delineated with exacting clarity, from one edge of the picture to the other and across planes from the foreground to the background. (The most distant objects cannot be clearly depicted because our perceptual capacities do not allow us to make certified judgments about things that are too far off.) Every object is rationally related to every other object in the picture, and distance and size relations can be given objective, that is, numerical, value by counting off the "tiles" of the "pavement" upon which the entire picture is structured. We still resort to this mode of depiction, or modes very closely related to it, when we wish to make "literal" pictures. But when we do so, we adopt a thoroughly medieval notion of vision and an early-Renaissance conception of depiction. That we can still respond to such pictures by saying "That is just the way it looked" is a demonstration of just how complex and capricious our behavior with pictures is—and a testimony to the power of Alberti's achievement.

With no hint of modesty, Alberti claims that his analysis has led him to the first true understanding of painting. He asserts that painters before him worked instinctively, without an understanding of what they were trying to do and therefore without a warranted mode of depiction. Unanchored by a correct and systematic approach to painting, painters had inevitably produced irrational pictures. According to Alberti, *De Pictura* does not outline *one* method of picture construction, it presents the *only* method. It is a manual for young painters and therapy for older ones. Yet the instincts of painters, while they have been insufficient to produce pictures that correctly represent vision, are essentially correct because painters have attempted, without knowing it, to depict what they see in accordance with how they see.

Alberti's criticism of previous artistic practice is a criticism of correction, not of demolition. His rhetorical problems therefore are consider-

able. He must provide a conservative analysis of vision and a revolutionary program for depiction. After all, people are in general agreement about what they see; the ease of navigation through the world is one clear indication of this. The problems arise in the practice of painting, in which there is scant agreement about how to make pictures. Like moral philosophers who claim to provide an analysis of ordinary moral judgments and not to correct them, Alberti must express principles of vision that explain ordinary perceptual judgments without doing violence to them. Unlike those philosophers, he must provide a corrective to irrational modes of behavior—the accepted manner of picture making. His solution is as simple as it is profound; the conservative is linked to the revolutionary by the instinctual. By nature, we all know how to see, though we do not know how we see. What painters have not recognized is that in painting they aim to re-present what they see. The ease and rapidity with which linear perspective was adopted by Alberti's contemporaries suggests, though it certainly does not demonstrate, that painters were prepared to accept his formulation of the true aim of painting.

Erwin Panofsky has argued that artistic practice in Italy during the two centuries prior to Alberti was, in fact, tending toward an equation of perception with depiction, and that this equation was one of two essential preconditions for the development of linear perspective.

> The *perspectiva pingendi* [painter's perspective] or *perspectiva artificialis* [artificial perspective] was thus quite literally the child of optical theory and artistic practice—optical theory providing, as it were, the idea of the *piramide visiva* [the visual pyramid], artistic practice, as it had developed from the end of the thirteenth century, providing the idea of *intersegazione* [a plane intersection of the visual pyramid].[13]

Panofsky's elegant, though not unchallenged, account of artistic practice in thirteenth- and fourteenth-century Italy suggests that the work of Duccio and Giotto established a new beginning in Western painting. He contends that Hellenistic and Roman painting had been "illusionistic" and had attempted to give the viewer a sense of looking through the picture surface at the objects behind it. While the ancient painters had not achieved an "exact perspective construction," they had produced something like a "prospect through a window." Panofsky further argues that the surface-as-window began to close during the early-Christian period and that while certain devices to suggest recession in depth continued to be used by Byzantine artists, "the Art of the

13. Erwin Panofsky, "*I primi lumi:* Italian Trecento Painting and Its Impact on the Rest of Europe," *Renaissance and Renascences in Western Art* (Stockholm, 1960), p. 139. All further references to this work will be cited in the text.

Western Middle Ages . . . came to abandon perspective ambitions altogether" (p. 130). Although they worked in quite different ways, Duccio and Giotto reachieved the sense of transparency of the picture surface that is an essential precondition for the development of linear perspective. This development allowed some painters to derive their work "from visual experience rather than from tradition" (p. 142), so that by the end of the fourteenth century, the "window pane feeling" had been well established. The sense of depth was greatly aided by a new treatment of "orthogonals" (lines parallel to one another and perpendicular to the picture plane) which came to be drawn as converging to a centrally defined area, or even to a point. By the beginning of the fifteenth century, the surface of the picture was intended to convey the impression of looking through a transparent surface into the space beyond as seen from a reasonably well-defined point of view. While such pictures invited the viewer to see the objects receding from the picture surface, odd inconsistencies remained; to use one of Alberti's examples, large men sat balled up in small houses, their heads touching the ceiling. The space constructed by painters did not "behave" in accordance with "visual experience." Panofsky sees the application of the medieval theory of vision, *perspectiva,* to this new kind of picture as a way of rationalizing it, of giving coherence and consistency to the objects of depiction in order to complete the analogy to window gazing. Panofsky's strategy, then, is to demonstrate how the reemergence of the picture surface as a transparent plane to be seen through provides the motivation to adapt the explicit geometric diagrams of visual rays as taught in *perspectiva* to specifically pictorial problems. The development of linear perspective is an outgrowth of the need to extend artistic practice. For my own part, I am comfortable with Panofsky's discussion of developmental tendencies within certain "schools" of Italian painting prior to the invention of linear perspective as well as with his demand that the system be seen as the joining of artistic practice to the theory of vision. Beyond this (and I say this with some trepidation), his argument is curiously ambiguous, at points misleading, and, in some places, to which I will return, simply false.

Throughout *De Pictura,* Alberti insists that the aim of the painter is to depict "visible things." This seems to be a straightforward indication of intention, but its usefulness obviously hinges upon a definition of "visible thing" as well as on a choice of representational mode. For example, an artist might draw a stick figure and reasonably claim that he has depicted a visible thing. The primary problem in the interpretation of Alberti's text is to provide an account of what Alberti takes a visible thing to be, for, as I will show, the definition of visible thing carries with it the manner and means of depiction. A number of commentators on the text have sought to clarify Alberti's program by drawing attention to the justly famous window analogy that is stated in the

first book of *De Pictura*. Alberti writes, "I describe a rectangle of whatever size I please, which I imagine to be an open window through which I view whatever is to be depicted there" (p. 120).[14] Panofsky finds in this statement a definition of what Alberti means by "picture": "Alberti's window simile defines the picture not only as the record of a direct visual experience but also, more specifically, as a 'perspective' representation" (p. 123). Elsewhere, Panofsky somewhat ambiguously states that the window analogy demands of the artist "a direct visual approach to reality" (p. 121). The expression "visual experience" is in itself problematic, and the addition of the qualifier "direct" further complicates it (are we to understand it in opposition to "indirect"?). Far more troubling is Panofsky's assumption that window gazing is a self-defining activity. The question of how we are to look through a window and what we are to look for is left unanswered. Of course, it is possible to find the rules for window gazing in the kinds of pictures that were produced prior to *De Pictura*, but then "a direct visual approach to reality" becomes a prescription for looking out of windows in the way that we look at these pictures. The window analogy does, indeed, state Alberti's entire case, but it does so only if we come to it equipped with a definition of visible things and with the rules for constructing such things. By itself, the analogy is far too equivocal to be of much use in understanding the relations between seeing and depicting.

Alberti defines visible things in terms of the physical and formal account of vision provided by *perspectiva*. The tendency to beg essential questions about the nature of "direct visual experience" comes, I would suggest, from the misunderstanding by art historians of the account of vision provided by *perspectiva*. Scholars who have dealt with the major role of medieval optical theory in *De Pictura* have treated it as a mechanical means of "cranking out" vision and have isolated the physical aspects of the theory from the faculty psychology that provides the formal principles of vision. This has the effect of distorting medieval optics by overlaying on it more modern theories of vision (some of which owe their genesis to Alberti's system of picture making), and, more to the immediate point, it thoroughly misrepresents Alberti's conception of visible things. Panofsky asserts that the exact geometric construction of linear perspective is

> founded on two premises accepted as axiomatic in classical as well as mediaeval optics: first, that the visual image is produced by straight lines ("visual rays") which connect the eye with the objects

14. I have used Panofsky's translation of the line from *Della pittura* since the upcoming quotation from Panofsky refers to this translation. Grayson gives this line as follows: "I draw a rectangle of whatever size I want, which I regard [*contueatur*] as an open window through which the subject to be painted is seen" (*De Pictura*, p. 55). *Contueatur* carries the sense of careful observation.

seen (no matter whether these rays were thought of as proceeding from the eye, the object or both), the whole configuration thus forming the . . . "visual pyramid" or the "visual cone"; second, that the size and shape of the objects as they appear in the visual image is determined by the relative position of the "visual rays". What was fundamentally new was the assumption . . . that all the points constituting this visual image are located on a plane rather than on a curved surface. [Pp. 123–26]

The crucial error in Panofsky's account of *perspectiva* is the reference to "the visual image." In medieval optics, on the level of rays and their geometry there is no image formation whatsoever. It is not "axiomatic" in classical or medieval optics that a (let alone *the*) image is produced in straight lines. There is no image formation by means of rays on the lens of the eye, on the retina, or even on the optic nerve. Panofsky's suggestion that there are points that constitute the visual image is not only false, it fails to understand Alberti's conceptual achievement. All perceptions, according to *perspectiva* and its allied faculty psychology, come about by means of image formation—there are images of hearing, sight, olfaction, and so on. Images are completed perceptual judgments about the objects of sense. They are made in the mind where one would expect to find them—in the imagination. What Alberti did was to conceive of this mental construct, the image, as a picture (this obviously will work only for vision—it will not do to have pictures of odors or tastes). This picture metaphor controls the text. But the genius of Alberti was not simply in conceiving of a visual image as a picture; he also provided a method by means of which that image could be projected and copied by art.

De Pictura begins with a catalogue of the elements of vision. Alberti states, ". . . things which are not visible do not concern the painter, for he strives to represent [copy, imitate] only the things that are seen."[15] He then gives a listing of "things that are seen." The least visible thing is a point that is a "sign" that exists on a surface. A line is a series of points joined together so that its length may be divided, but not its width. Many lines joined together "like threads in a cloth" produce a surface that possesses two kinds of properties: those that belong to the surface itself which are fixed and give the surface its name and those that are changeable owing to the relation of the surface to the eye that sees it. And finally, "A surface is the outer part of a body which is recognized not by depth, but by width and length, and also by its properties" (p. 37).[16] With

15. *De Pictura*, p. 37. *Imitari* is the verb for which I have given alternate translations. All further references to this work will be cited in the text.
16. Depth is constructed by the combination of surfaces; it is not a property of a surface. Alberti does not conceive of the problem of depicting what we see in terms of a "translation" of a three dimensional world into a two dimensional picture. His concern is to depict objects in relief. Issues of three dimensionality and binocular vision are foreign to *perspectiva*, although the question of why we do not see double, given the fact that each of

the addition of light and color, this listing exhausts the category of "things that are seen." All objects that are seen must be constructed out of these fundamental elements.

Alberti notes that while surfaces remain unchanged, they may appear to change. Such alterations are "related to the power of vision." These changes are judged by sight. Rays, which are the servants or "ministers" of vision, measure surfaces. There are three kinds of rays: extrinsic rays measure the periphery of a surface, they determine its outline; median rays are "tinged" with color and give the surface its color and light; the centric ray, the single most important, fixes the surface at a definite distance and direction from the eye. These rays taken together form a pyramid of vision with its apex at the eye and its base at the surface seen. In the first twelve paragraphs of *De Pictura,* Alberti lists the elements of vision together with the basic notion that rays measure quantities. A quantity is the distance between any two points on a surface. Mensuration is a fundamental power of vision, and measurement must find a precise expression in depiction. Exactly measurable quantity is one of Alberti's central concerns because it is by means of measurement that we are able to give certainty to the judgments of vision.

Thus far, Alberti has been concerned only with single surfaces. He then adds, "Since bodies are covered in surfaces, all the observed quantities of bodies will make up a single pyramid containing as many small pyramids as there are surfaces embraced by the rays from that point of vision" (p. 49). This establishes a congruence between the composition of natural bodies and the composition of vision. In vision we see surfaces. Bodies themselves are covered in surfaces. In the last book of *De Pictura,* Alberti is able to complete the statement of congruences, for, as it turns out, nature is an artist herself: "Look at Nature and observe long and carefully how she, the wonderful maker of things, has composed the surfaces" (p. 73).

Once the pictorial nature of vision is established, Alberti gives a remarkable statement of how a painter can match the process of vision by means of the process of depiction:

> We divide painting into three parts, and this division we learn from Nature herself. As painting aims to represent things seen, let us note how in fact things are seen. In the first place, when we look at a thing, we see it as an object which occupies a space. The painter will draw around this space, and he will call this process of sketch-

our eyes is active in vision, is answered. The reason for having two eyes is explained by John Pecham in the following way: "[Proposition] 32–{35}. *The duality of the eyes must be reduced to a unity.* The benevolence of the Creator has provided that there should be two eyes so that if injury befalls one, the other remains" (John Pecham, *Perspectiva Communis,* in *John Pecham and the Science of Optics,* ed. and trans. David C. Lindberg [Madison, Wisc., 1970], p. 117).

ing the outline, appropriately, circumscription. Then, as we look, we discern how the several surfaces of the object seen are fitted together; the artist, when drawing these combinations of surfaces in their correct relationship, will properly call this composition. Finally, in looking we observe more clearly the colours of surfaces; the representation in painting of this aspect, since it receives all its variations from light, will aptly here be termed the reception of light. [P. 67]

The visual process is structured and moves in moments, and therefore the process of depiction will also be structured and move in analogous moments. We first see a thing in space and we attend to its outlines; then we see constituent surfaces within the outlines and note how they are composed; and finally, we observe the colors of surfaces and their lights. The process of seeing has exact counterparts in depiction because seeing is the construction of a picture out of pictorial elements that proceeds systematically, in an ordered sequence.

Visible things, the particulars of picture construction, and the window analogy are brought together by the mechanics and the formal principles of *perspectiva*.[17] In practice, Alberti's system begins with the construction of a rational structure of composed surfaces—the pavement—that is, the picture space consisting of tiles that recede into the background in a precisely known and measured way. The pavement is itself a visible thing and serves as the principle of ordering and measurement for all objects that are depicted in that space. In order to depict "real objects," the picture space must be a rational structure because our perception itself has a rational structure. Alberti states, "no objects in a painting can appear like real objects, unless they stand to each other in a determined relationship" (p. 55). The pavement is the expression of the cross section through the visual pyramid. In other words, by standing at a fixed distance and position in relation to what we are viewing, an unvarying visual pyramid is established between the viewer and the world. The window, or the picture surface, "cuts" through the pyramid at a precise point exactly perpendicular to the eye.

None of this, however, gives final definition to the window analogy and the nature of the things to be represented in the picture. Why are all

17. The mechanics of *perspectiva*, given expression in ray diagrams and the pyramid of vision, explains the material basis of sight and the point-to-point correspondences between visible objects and the *anterior glacialis* (the anterior surface of the lens) of the eye. Alberti makes use of these principles in describing the elements of vision, the pyramid of vision, and its intersection which is the surface to be painted. But these principles cannot provide him with the formal properties of vision or depiction. This may best be understood by noting that we may look at, say, a friend and fail to see the color of his jacket. The eye was impressed with the color, but we failed to attend to the jacket. The formal principles of *perspectiva* provide Alberti with the formal properties of vision which entail self-conscious attention to the aspects of sensible things.

the objects depicted shown in sharp delineation? Why does the viewer have to look out the window straight ahead rather than upward or downward? The system seems to be so patently artificial and at odds with what we ordinarily take to be the "facts" of vision that Alberti's window analogy seems contrived in the extreme, or, perhaps, merely fanciful.[18]

Panofsky's explanation of the window analogy depends upon a formulation of "direct visual experience" that is at fundamental odds with Alberti's goals. For Panofsky, the notion of "visual experience" is an inherently subjective affair, one that defies rationalization without a corresponding distortion of the "facts" of experience. The definition of "visual experience" is posterior to the invention of the system of depiction. In other words, it is the goal of depicting what we see that leads Alberti to find a "symbolic form" for its depiction. Central to Panofsky's analysis is the principle that the depiction of what we see can follow only from a redefinition of experienced space—by hypostatizing space it becomes possible to find a rational pictorial expression for the inherently subjective experience of seeing. Panofsky states:

> It was not only that with [perspective] art was "elevated" to science (and for the Renaissance, that was an elevation); the subjective visual experience was rationalized to such an extent that it could form the foundation for the construction of a world of experience firmly grounded and yet in an entirely modern sense "infinite." . . . What was achieved was a translation of psychophysiological space into mathematical space: in other words an objectification of the subjective.[19]

By characterizing what we see in terms of visual experience and by disregarding the formal principles of *perspectiva*, Panofsky misrepresents Alberti's program. Alberti is not concerned with subjective experience, he is concerned with finding a means by which he can depict objects established by perception. For Alberti, there can be no issue that involves the "rationalization" of vision, because what we see is established by rational processes. The structure of perception is integral. If this were not so, we would be unable to act rationally and harmoniously in accordance with our perceptual judgments. Indeed, the very possibility of science itself is dependent upon the principle that perception has a ra-

18. Alberti's analogy is literally fanciful: perceptual judgments about things are made in the faculty known as *phantasia,* the seat of self-consciousness which produces *phantasmata* or complete images. The *phantasia,* which came to be called "fancy," consists of two organs of inner sense: the imagination and the *sensus communis.* "Since sight is the chief sense, the name φαντασια [phantasia] . . . is derived from φάος [phos] (light), because without light it is impossible to see" (Aristotle, *On the Soul,* trans. W. S. Hett [Cambridge, Mass., 1936], 429a, p. 163).

19. Erwin Panofsky, "Die Perspektive als 'Symbolische Form,'" *Vorträge der Bibliothek Warburg* (1924–25): 269.

tional basis. The use of the geometry of *perspectiva* is a clear indication of the measured and reasoned basis of vision.

Perspectiva is a system, based in part on Aristotle's *De Anima*,[20] that distinguishes between the passive and active components of vision. The purpose of vision is to make certified judgments about sensible things. The passive component of vision is initiated by rays that come from the sensible objects and make an impression upon the lens of the eye.[21] The eye "suffers" the impression. The impression initiates perceptual judgment, but the perceiver is not conscious of it. The impressed points on the eye correspond in a one-to-one fashion with points on the object. This system of points and rays can be charted geometrically and forms the material basis of sight. Forces set up by the impression are received by the *sensus communis* ("common sense"), an internal sense organ that discriminates among the many sensory "inputs" from each sense and from all of the senses. The *sensus communis* is active only when there are impressions flowing to it from the "proper" senses. The imagination, which can work in the absence of sensory stimulation, "takes" the discriminated bits and pieces from the *sensus communis* and integrates them into a judgment about the objects of sense. *Perspectiva* requires that the axial or centric ray of the eye be swept across an object in order to certify it. Each of these "sweeps" is momentary; only the imagination can grasp them in a unity, in the form of a constructed image with a rational

20. According to Aristotle, the senses allow us to identify correctly the attributes of natural things, and knowledge of attributes "contributes materially" to the knowledge of the thing's essence. "For when we are in a position to expound all or most of the attributes as presented to us [in the *phantasia* in the form of images or presentations], we shall also be best qualified to speak about the essence" (*On the Soul*, 402b, p. 13). This is the notion of perception that dominates *perspectiva*. All perception involves purposeful discrimination and the use of reason. Roger Bacon in his treatment of *perspectiva* gives an excellent example of how different his (and Alberti's) notion of perception is from our own. According to Bacon, if we place a square standing on end at an oblique angle to our eyes, we will note that the more distant edge of the square makes a much smaller angle at the eye than does the foreword edge (i.e., the more distant edge *looks* smaller than the leading edge), "and yet, the sides are equal, and the vision perceives that sides of this kind are equal" (*The Opus Majus of Roger Bacon*, trans. Roger Belle Burke, 2 vols. [Philadelphia, 1928], 2:531). Perception establishes the way things are. It is interesting to note that Bacon denies that Euclid's angle axiom is sufficient in itself to determine the size or distance of objects. Two other conditions are needed, both of which are "built into" Alberti's pavement. In addition to Bacon's *Opus Majus*, I have relied on the following texts in my treatment of *perspectiva*: *The Opus Majus of Roger Bacon*, ed. J. H. Bridges, 3 vols. (London, 1900), vol. 2, *De Multiplicatione Specierum; John Pecham and the Science of Optics*, pp. 62–239; Alhazen, *Opticae Thesaurus, Libri VII*, ed. Federico Risnero (Basel, 1572); and David C. Lindberg, *Theories of Vision from Al-Kindi To Kepler* (Chicago, 1976). Lindberg's book provides an excellent account of the mechanics of *perspectiva* and its history, but unfortunately he has little to say about the formal principles of vision that are crucial to an understanding of perception.

21. Strictly speaking, rays are fictions created for diagrammatic purposes. The cause of impression on the senses is properly termed "species" which is a "power" that all natural agents send off and which is received by sense organs.

structure, and make a completed judgment about the objects of sense. This activity is purposeful, and without purpose there can be no perceptual judgment.

The numerous authors of *perspectiva* were explicit about the conditions of observation that were required to make certified judgments. For example, distance and size relationships require ordered and measured distances between objects of known size. To certify judgments about distance and size, a standard of comparison, in the form of a human figure or part of a human figure, must be available to the perceiver. Such judgments do not take the form of qualified assertions. If I have certified an object, I say, for example, "It is a cube" and not, "From where I stand it appears to be a cube." The judgment that the object is a cube carries with it, by definition, the implication that as I move it will look different. It remains, nonetheless, a cube. Moreover, without moving, I can predict how the cube will look from another vantage point— this is assumed in a certified judgment.

Alberti's system gives a painter the ability to depict the rational structure of perceptual judgments. Perceptions are not mere appearances, they are established judgments about objects. The whole point of the pavement is to give the viewer a means of "checking out" what is depicted. Everything in the picture can be assigned a numerical value. The pavement itself is constructed out of tiles that are one-third the size of human figures standing on them within the picture. The standard of comparison for judgment is literally built into the pavement. For Alberti, the structure of depiction is the structure of perception.

Alberti's window is literally a frame of reference with the standard units of measurement incorporated into its periphery. By standing at a set distance and position relative to the frame and by stipulating that objects seen through the frame remain in a set position, Alberti provides viewing conditions that are essential for the certification of individual surfaces. We are to understand the window as a plane surface, placed at a right angle to a stationary viewer, through which many individual, certified, measured, and measurable surfaces are seen. In depiction, the artist scrutinizes each surface, delineates its outlines, and fills the surface with the appropriate color and light. By careful adherence to the viewing conditions, the artist is able to compose or bring many surfaces together in their correct relationship, the standard of correctness being the viewing conditions themselves which are built into the surface of depiction. Thus, the viewer is given a warrant to make his own certified judgments about visible things depicted on the surface of the window. Without precise delineation of outlines, without a standard of comparison and a means of measuring interrelated surfaces, no such warrant could be given.

If there is a paradigm inherent in the invention of linear perspective, as Panofsky urges us to believe there is, it is the model of vision as

picture. What Alberti accomplished was not the objectification of the subjective, but rather the externalization of the internal. In a sense this was nothing new; for all structured, harmonious, and rational behavior regarding the objects of sense had been conceived of as flowing from the images of sense. What was new was the belief, formed by the confluence of artistic practice and visual theory, that the visual images that give structure to our lives had a pictorial form and that they could therefore be given artistic expression. Alberti speaks of his demonstrations of linear perspective as affecting the audience like "miracles." To an early-Renaissance lover of paintings, the sight of these pictures must have been extraordinary—something akin to looking into the soul.

The grab bag category of realistic pictures will forever defy general analysis. If we can paint what we see because we define what we see as intrinsically pictorial, we can also change our artistic or scientific accounts of what we see without abandoning the notion of its "pictorialness." What is certain is that the depiction of what we see will always require a defined notion of the object of vision. And as it did for Alberti, that notion will begin with our habits of depiction. There are no end runs that get us out of language or depiction to the really real, to the inchoate traces of stuff that stand in back of things or our experience of things.

If there is a given in depiction, it is the traditions and assumptions of picture making. Making may or may not precede matching, but matching always proceeds by making.

Las Meninas and the Paradoxes of Pictorial Representation

John R. Searle

Why after over three centuries does *Las Meninas* continue to bother us? Its fascination clearly extends beyond the interests of art historians and admirers of Spanish painting. Picasso, for example, painted no less than forty-five studies modeled after it, and Foucault begins his analysis of the classical seventeenth-century system of thought, in *Les Mots et les choses*, with a discussion of the work, concluding that it is perhaps "the representation, as it were, of classical representation."[1] For the philosopher of language it poses a special challenge in the theory of representation. It produces in me the same feeling of puzzlement that I get in pondering the set theoretical paradoxes or the antinomy of the liar, and in this discussion I want to make quite explicit the nature of its paradoxes. That this picture even contains paradoxical aspects is in part concealed from us by the fact that we live in an era when far more blatantly paradoxical pictures have become quite common. In addition to our awareness of entire movements such as surrealism and cubism that are paradoxical from the standpoint of classical pictorial representation, we are all used to Steinberg's drawings of men drawing themselves being drawn, to Escher's staircases that rise to end in other ascending staircases that yet rise to other ascending staircases, until we are back at the bottom of the original staircase, and to impossible three-pronged objects with only two bases. Here I am going to set all these radically paradoxical and nonsensical forms of pictorial representation on one side and concentrate on *Las Meninas,* from within the canons of classical pictorial representation.

1. In English, *The Order of Things* (New York, 1970), p. 16.

Reprinted from *Critical Inquiry* 6 (Spring 1980): 477–88

At first sight *Las Meninas,* or *The Royal Family* as it was called until the nineteenth century, appears to be a conventional, if spectacular, representation of royal personages and their attendants (fig. 1). The center of attention (and the physical center of the bottom half of the canvas) is occupied by the figure of the Infanta Margarita, then aged five. She was born in 1651; the painting was made in 1656. She subsequently was married off to Leopold the First of Austria and died at an early age in Vienna. On her right kneeling to offer a red *búcaro* on a silver tray—presumably filled with the perfumed water then drunk in the Escorial—is María Augustina Sarmiento. On the Infanta's left leaning toward her is another maid of honor, Isabel de Velasco, daughter of the Count of Colmenares.[2] Both girls are good looking young aristocrats, expensively dressed, wearing elegant wigs. All of the standard authors say that Isabel is bowing or curtsying deferentially toward the Infanta, but closer scrutiny reveals that she is not paying the slightest attention to the Infanta; she is looking intently at—well, we will get to that in a minute. On her left is the squat ugly figure of a palace dwarf, Mari-Bárbola, who as Trapier writes "came into the palace service in 1651 and received various favours throughout the years, including a pound of snow on each summer's day in 1658."[3] Palomino describes her as having an "aspecto formidable." Beside her is another dwarf (some authors call him a midget as distinct from a dwarf), Nicolasito Pertusato, who has his foot on the back of a sleepy looking dog in the foreground. Behind María Augustina is the painter himself, Diego Velázquez, caught in the very act of painting; palette on his left forearm, brush in his right hand. He stands ready for action, but curiously he is several feet away from the huge canvas on which he is working, since doña María Augustina is plainly between him and the canvas. Furthermore the canvas on which he is working occupies almost the entire left hand edge of the picture: the blank back of the canvas, relieved only by the wooden framing and the leg of the easel, occupies more of the area of *Las Meninas* than do any of the figures. In most of the reproductions that one sees of *Las Meninas,* incidentally,

2. Some authors follow Palomino in identifying Isabel's father as the count of Fuensalida. See Antonio Palomino, *El museo pictórico,* 3 vols. (Madrid, 1796), 3:508–10. He apparently held both titles.

3. Elizabeth du Gué Trapier, *Velázquez,* Hispanic Society of America (New York, 1948), p. 341.

John R. Searle, professor of philosophy at the University of California at Berkeley, is the author of *Speech Acts, The Campus War,* and, most recently, *Expression and Meaning.*

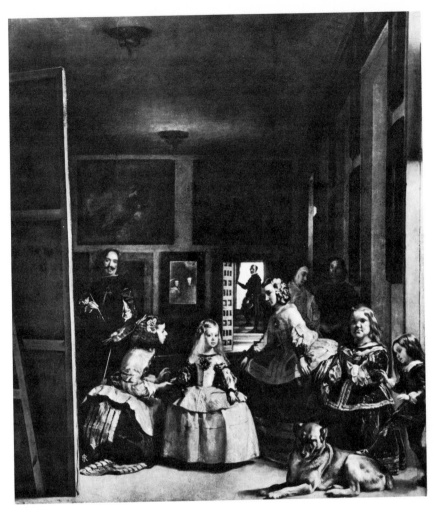

FIG. 1.—Diego Velázquez, *Las Meninas.* Alinari/Editorial Photocolor Archives.

the left hand edge of the picture is severely cropped, leaving out much of the canvas, no doubt because it seems to the croppers such a boring part of the picture. Behind Isabel is a woman dressed as a nun; she is in fact doña Marcela de Ulloa, *guardamujer de las damas de la reina,* and next to her is one of the *guardadamas,* or guards of the ladies. He alone of the human figures in the picture is anonymous. At the back of the room standing in a doorway is José Nieto Velázquez, *aposentador* or palace marshall to the queen, and among other things the keeper of the queen's tapestries. Although he has the same maternal last name as Velázquez,

there is no reason to suppose they are related. The faces are all as impassive as the faces of Cézanne; they simply look at us.

Just to complete our inventory, the two pictures high on the back wall are Minerva punishing Arachne after a composition by Rubens and a copy by Martínez del Mazo of the contest between Apollo and Pan by Jordaens. Most of these identifications come from F. J. Sánchez Cantón's *"Las Meninas" y sus personajes,*[4] but he in turn, like everyone else, apparently gets most of his information from Palomino.

I list the cast of characters to emphasize the excruciating realism with which this picture is painted. There is nothing fanciful or even fictional about it: one is left feeling that it is only an accident of the chroniclers that we do not know the names of the dog and the *guardadama* and that the contemporaries must surely have been able to recognize them both. Furthermore it is obvious that we are supposed to be able to tell who these people are. That is not just a young girl, that is the Infanta of Spain, and that is not just any artist, that is don Diego Velázquez, and so forth.

So much for the surface features of the picture. Now our problems begin. On the back wall, above the head of the Infanta, is a mirror of medium size, perhaps three feet high. In the mirror, exactly opposite us, the spectators, is reflected the image of Philip IV and his second wife María Ana.

When we notice this mirror the firm ground of pictorial realism begins to slip away from us. The vertigo produced by this slippage is increased when we reflect on the relations between the mirror and two other puzzling aspects of the picture: the eyes of six of the principal characters of the picture, as well as the eyes in the mirror, are all focused at a point outside the picture, the point at which we, the observers, stand; and second, the face of the canvas on which Diego Velázquez is working, a canvas which is immense and prominent in the picture, is invisible to us. At one level the picture is indeed about Margarita and her entourage; at another level the picture is about two things, one of which lies outside the picture and the other of which is invisible.

2

The general problem of meaning is how the mind imposes intentionality on entities that are not intrinsically intentional. Our beliefs, fears, hopes, desires, perceptual experiences, and intentions are intrinsically intentional; they are directed at objects, events, and states of affairs in the world. But our utterances, writings, and pictures are not in

4. *"Las Meninas" y sus personajes* (Barcelona, 1943), pp. 14–27.

that way intrinsically intentional; they are physical phenomena in the world like any other physical phenomena. And the central problem of the philosophy of language is to explain how the physical can become intentional, how the mind can impose intentionality on objects that are not intentional to start with, how, in short, mere things can *represent*.

All forms of intentionality are under an aspect or aspects of the things represented. Nothing is ever represented *tout court,* but only under some aspect or other. In the case of classical pictorial representation, objects are represented under their *visual* aspects, and a crucial element in their representation is a visual resemblance between the representation and the thing represented, in precisely those aspects under which the thing is represented. A realistic portrait of a man represents him as looking like *this* because this picture looks like him in *this respect.* I do not wish to imply by these brief remarks that such notions as resemblance and aspect are unproblematical. Quite the contrary—they seem to me immensely complicated and subtle. Nor do I wish to imply that pictures can represent only visual aspects. On the contrary, such aspects of an object or person as that the object is heavy or the person is sad can be represented pictorially. My point is rather that insofar as the representation is classical pictorial representation it must represent an object under visual aspects, and the other features represented are represented by way of these visual aspects.

Now visual representations of visual aspects of objects have certain special features not common to other forms of intentionality, and these features derive from the special features of vision itself. Most notably, all vision is from the point of view of one's body in space and time relative to the object being perceived. The aspect under which the object is perceived is altered if one alters one's point of view. But this feature of vision, that it is from a point of view in space and time, has important consequences for visual resemblance. Perception of a visual resemblance between any two objects will always be relative to a point of view: *this* object seen from this point of view looks like that object seen from *that* point of view. And since the intentionality of pictures, at least within the conventions of classical pictorial representation, relies on resemblance between the picture and the object depicted, the form of intentionality that exists in pictorial representation is crucially dependent on point of view.

The way that classical pictorial representation combines resemblance, aspect, and point of view is as follows: the artist (or camera) sees an object or a scene from a point of view, and that point of view must lie outside what is seen, since we cannot see the eye with which we are seeing; the artist then produces on a flat surface an object such that if the observer has the appropriate point of view in front of the flat surface he will have an experience like the visual experience the artist had.

Diagrammatically:
 O = object or
 scene depicted P = painted surface

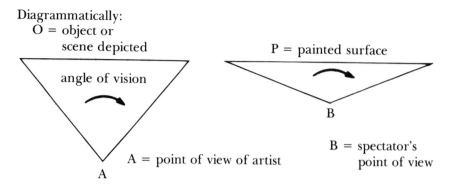

A = point of view of artist

B = spectator's
 point of view

The picture P looks to the spectator at B the way the scene looked to the
artist at A, under those aspects F (that is, visual aspects) under which the
scene is depicted by P. A is to O under F, as B is to P under F. The ideal
artist sees the scene from point A in the real world space, and the ideal
observer stands at B outside the picture space and relative to it in such a
way that P from B looks like O from A under aspect F. This gives the
picture its illusionist reading—the observer sees the picture *as if* he were
seeing the original scene; and its illusionist reading is the basis of its
representational reading—the observer sees the picture as a *representa-
tion* of the scene in virtue of the imposition of intentionality on its il-
lusionist elements which are at the basis of the representational ele-
ments. Notice that it is a consequence of this analysis that for every
standard representational picture there is a point of view B from which it
is supposed to be seen, and B on the illusionist reading is as if it were
identical with A. That is, we are to think of ourselves as if we were seeing
the scene from the point of view of the artist, and this makes possible the
representational reading where we see the picture as a representation of
the original scene. And this is why incidentally the angle at which B
subtends P will normally be more obtuse than the angle at which A
subtends O. For most pictures we are supposed to look at the picture
from much closer than the artist looked at the original scene. Further-
more it is a tacit convention of the institution of classical pictorial repre-
sentation that, for example, we do not look at pictures while standing on
our heads or with our noses pressed against the canvas. This convention
can be violated, as in the various examples of anamorphosis,[5] where in
order to see the picture as resembling the object, we need to look at it
from some weird angle, and not from in front.

Ambiguous pictures often derive their ambiguity from an ambiguity
in point of view. Even though our location in front of the Necker cube
pictured below is fixed, there are two positions the cube can be seen as

5. For interesting examples and a discussion of anamorphosis, see Fred Leeman, *Hid-
den Images* (New York, 1975).

occupying relative to us and hence two points of view:

Formally speaking, to repeat, in classical pictorial representation the relations are as follows: O looks from A under F as P looks from B under F. This has the consequence that to see P from B under F is as if one were seeing O from A under F. And this in turn underlies our ability to see P as a pictorial representation of O under F. In the case of fictional or fictionalized pictures the artist need not have actually seen the object he is painting. Indeed the object may not exist, as when he paints a purely mythological figure, or even when he paints actual persons and objects he need not have seen them in the situations in which he depicts them. In such cases the artist paints *as if* he had seen such objects or had seen them in the situation in which he paints them.

What I have described above is so to speak part of the axiom system of classical illusionist representative painting. The problem with *Las Meninas* is that it has all the eyemarks of classical illusionist painting but it cannot be made consistent with these axioms.

3

The simplest of its paradoxes is that we see the picture not from the point of view of the artist but from that of another spectator who also happens to be one of the subjects of the picture. It is the first painting as far as I know to be painted from the point of view of the model and not from that of the artist. On the illusionist reading it is as if we were identical with Philip IV and his wife María Ana, who are posing for the painter (standing at his big canvas) and looking at the scene which includes an image of ourselves in the mirror. It is not as if B equals A but as if B equals some other point C from which one of the characters in the picture is watching himself in a mirror in the picture being painted by the artist on the left. Or to put it another way, it is indeed as if B equals A (the artist's point of view), but the artist has moved away from A and allowed one of the characters in the picture to move into A. The full import of the fact that A is occupied by the model and not by the artist is that the artist can't occupy the position he has to occupy according to the axioms of pictorial representation because the position is already taken. Imagine any artist you like painting this picture—or any camera taking it for that matter—and you have to imagine the artist or camera at point A; but in this painting they can't be at point A because that point is already occupied by the models Philip IV and María Ana.

Point A, which must lie outside any scene, just as point B must lie outside any picture, is in an important sense the subject of this painting.

Six of the characters and the two mirror images are all looking at it. Isabel is not curtsying, she is leaning over to reduce parallax. She is leaning forward, just as Velázquez is leaning backward, to reduce the angle at which she perceives us, Philip IV and María Ana, as we stand at point A perceiving ourselves in the mirror.[6]

This paradox becomes deeper if we ask the next obvious question: What is the artist painting on the big canvas whose working surface is invisible to us? But before answering that I want to contrast *Las Meninas* with two other sorts of paintings which bear some similarities to the Velázquez but where the axioms of pictorial representation are not violated. The point of the comparisons is to show that the resolution of apparent paradoxes in these other paintings will not work for *Las Meninas.*

First, when an artist using a mirror paints a self-portrait of a familiar and conventional kind, none of the axioms of classical representation are violated: though artist and object are identical on the illusionist reading, it is still as if A equals B; we see the artist in the picture as he saw himself in the mirror. This is made possible by the introduction of another representing device, the mirror; and in a sense the mirror image becomes the subject of the painting. The artist represents a representation. But the mirror in *Las Meninas* does not play this role—on the contrary, it makes this interpretation impossible because it shows point A already occupied by people other than the artist.

An interesting variation on the mirror self-portrait genre is the van Eyck of Arnolfini and his bride. We see van Eyck in the mirror but he is not in the act of painting, he is witnessing the wedding. Here we are, so to speak, halfway to the *Meninas,* because in order to resolve the paradox we have to suppose the picture was painted as the artist remembers the scene, or as he would have painted it if he had been painting what he was witnessing. Velázquez must surely have seen the van Eyck since it was in the Spanish Royal collection at the time; and though I know of no independent evidence, it is quite possible that it was one of the inspirations for *Las Meninas.*

A second type of representation of a representation is where we see a picture of an artist painting, and the picture is painted as if from the point of view of a second artist. When, for example, Courbet painted *L'Atelier du peintre, allégorie réelle déterminant une phase de sept années de ma vie artistique,* the axioms are not violated because we see the scene as if it were painted by another painter. But this resolution is precluded in *Las Meninas* because the persons in the mirror are not painters and they are

6. The fact that Isabel is interested in parallax and not deference was, as far as I know, first pointed out by Jonathan Miller, *Sunday Times* (London), 1975. X-ray photographs, by the way, show that in an earlier version of the picture on this same canvas Velázquez was leaning forward toward the canvas he is working on and not away from it as in the final version.

not painting. On the contrary, the royal couple is clearly posing for their picture to be painted.

Now, back to the picture. On the illusionist reading the spectators have become identical with Philip IV and María Ana. Given its position across the room and our position at the front of the scene, we would have to see ourselves in the mirror, but we see only the royal couple. Now what exactly is the painter on the left painting? Well it is quite obvious that he is painting us, that is, Philip IV and his wife. He looks straight at us, scrutinizing our features, before applying the brush to the canvas. We have plainly caught him in the very act of painting us. But in what sort of picture is he painting us? The standard interpretation is that he is painting a full-length portrait of what we see in the mirror. But there is an objection to that interpretation which seems to me fairly convincing. The canvas he is painting on is much too large for any such portrait. The canvas on which he is painting is indeed about as big as the one we are looking at, about 10 feet high and 8 feet wide (the dimensions of *Las Meninas* are 3.19 meters by 2.67 meters). I think that the painter is painting the picture we are seeing; that is, he is painting *Las Meninas* by Velázquez. Although this interpretation seems to me defensible on internal grounds alone, there are certain bits of external evidence: as far as we know, the only portrait Velázquez ever painted of the royal couple is the one we are looking at, *Las Meninas.* Velázquez is plainly painting us, the royal couple, but there is no other picture in which he did that; and indeed he seldom used such large canvases for interiors. *The Spinners* is a large-scale interior but most of his big canvases are equestrian portraits of Spanish royalty.

We have already seen that the picture is paradoxical because point A is occupied not by the artist but by the model; and the full import of that is that the artist can't occupy the point he has to occupy because the position is already taken. We can't think an artist into the position as we can with the Courbet or with a standard self-portrait with a mirror because the position is filled with two people posing for the picture we are seeing but standing outside it at the point of view A. But now we uncover a second paradox. The artist has a point of view but it is an impossible one; he is inside the scene looking out at point A and painting the very same picture we are seeing from point A (that is, from point B which is identical with A on the illusionist reading).

One way to see the force of these paradoxes is to imagine changes in the picture that would remove them. Imagine that the royal couple and the painter trade places. We see Velázquez in the mirror working on the picture and the king and queen off to the left. Such a picture would be a conventional mirror self-portrait with a rather large supporting cast. The artist is back at point A where he belongs and the models are in zone O, where they are conceptually harmless. Or suppose we saw Philip IV in the mirror working on a canvas with a paintbrush in his hand. Then we

would have had a picture by Philip IV of Velázquez painting Philip IV painting Velázquez. Philip IV would then be at point A painting Velázquez painting Philip IV. The iteration makes that a complicated picture but not one that violates the axioms of pictorial representation. Yet a third way to remove the paradoxes is to take away the mirror altogether. Then we would be in exactly the situation we are in with the Courbet. One painter (imagined) is at point A painting another painter.

What these three fantasies demonstrate is that the heart of the paradox presented by the *Meninas* is in that mirror. The mirror shows us point A but it shows it occupied by impossible tenants. If we change the tenants, or change what the tenants are doing, or eliminate the mirror altogether, we remove the paradoxes and incidentally make it a much less interesting painting.

Some writers have suggested that we can resolve the paradoxes by supposing that the artist is looking in a second mirror behind the king and queen and is painting the scene as there reflected. But that won't work, because any such mirror would have to show the king and queen from behind. We would have to see their backs in the painting.

I conclude then that there are two levels of paradox in *Las Meninas*. The following three propositions describe the first level.

1. The picture is painted from the point of view of the subject, not the painter.

2. We the spectators are seeing ourselves in that mirror and hence we are Philip IV and María Ana, in the illusionist reading.

Neither of these propositions would need to bother us much if they were not underlain by a third.

3. The artist, and indeed any artist, is precluded from occupying point A.

The second level comes from interpreting the painting in the picture as *Las Meninas;* then—

4. The painter having lost his point of view A is painting the picture from another point of view inside the picture zone O. From that point of view he is painting O, but he can't be painting O from that point of view because the point of view which defines O is A: strictly speaking O only exists relative to A. He is painting the scene we see, but he can't be because he is in it. From where he is in the picture, he can see and paint a different scene but not the scene represented in *Las Meninas*.

4

We know that the paradoxes must have a simple resolution because we know that the scene depicted is a visually possible scene. The painted surface represents a possible arrangement of objects in the world in a way that is not true of, for example, many of the pictures by Escher and

Steinberg or such puzzle pictures as that of the three-pronged object with only two bases. What part then of the classical axioms are we being asked to give up in order to render the picture unparadoxical? As soon as we have said that the picture depicts what the scene O would have looked like to the royal couple we have implicitly said that the resolution of the paradoxes is to abandon the connection between the creator and point A. With the classical axioms the painter paints what he sees or what he saw or what he could have seen or what he can imagine himself as having seen, and so on, and at least part of the puzzle I have been alluding to in this picture derives from the fact that the painter cannot satisfy this condition for this picture.

In the classical conception there is a connection between what is painted and the possibility of painting it, for the whole conception of art as imitation was a conception of the artist producing an imitation of what he saw. Leonardo, for example, goes to great lengths to explain to his readers how to paint pictures that look as much as possible like objects they see. And Pacheco, who was both Velázquez's teacher and his father-in-law, minces no words in his textbook on art in telling us that the aim of art is imitation. "Pintura es arte que enseña á imitar con líneas y colores. Esta es la definicion";[7] but in the case of the *Meninas,* what is imitated is not what the artist saw or could have seen but what the subject saw or could have seen. When we break the connection between point A and the painter we break the connection between what the picture is of and the act of painting it. Analogous dissociations between the point of view and the source of the representation are possible in other forms of representation as well. Just as every picture contains an implicit "I see," so according to Kant every mental representation contains an implicit "I think," and according to speech-act theory every speech act can be accompanied by an explicit performative, for example, "I say." But just as in thought the "I" of the "I think" need not be that of the self (in fantasy, for example) and in speech acts the "I" of the "I say" need not be that of the speaker or writer (in ghostwriting, for example), so in the *Meninas* the "I" of the "I see" is not that of the painter but of the royal couple. Point A is after all not a natural point in the world; it is defined relative to whatever it is that can be seen. Thus any classical representational picture is already a representation of A; or rather since A is not in the picture, it is not represented by the picture but is still implied by the picture. In the *Meninas* A is reflected in the mirror and reflected in a way that breaks the connection between the "I see" of the picture and the "I see" of the painter of the picture. The artist stands outside A in the picture space O and paints the scene as seen from A. A is reflected in the mirror and six pairs of eyes are on A. It is because of these facts that in the *Meninas* A is in an important sense the subject matter of the picture.

7. Pacheco Francisco, *Arte de la pintura,* 2 vols. (Madrid, 1866), 1:11.

What then is the picture of? Not just of a scene but of how the scene looked or could have looked to the royal couple. But what scene? Well, the scene that includes Velázquez painting a picture of the scene. And what scene is he painting? Well, the scene that includes Velázquez. . . . As with self-referential forms of representation generally we get a regress if we try to specify the content of the representation. But it is not a vicious regress. There is no way to answer the question What is the picture a picture of? that does not include reference to the picture. But that is simply a consequence of the fact that the picture is self-referential. On the representational reading, its conditions of satisfaction include it.[8]

8. I am indebted to several people for discussion of this picture and I especially want to thank S. Alpers, L. D. Ettlinger, A. Hannay, and D. Searle.

Musical Time/Musical Space

Robert P. Morgan

There is no question, of course, that music is a temporal art. Stravinsky, noting that it is inconceivable apart from the elements of sound and time, classifies it quite simply as "a certain organization in time, a chrononomy."[1] His definition stands as part of a long and honored tradition that encompasses such diverse figures as Racine, Lessing, and Schopenhauer. Schopenhauer, putting the case in its strongest terms, remarks that music is "perceived solely in and through time, to the complete exclusion of space," thus making explicit the opposition between time and space and ruling out the latter as a possible area for legitimate musical experience.

Yet anyone familiar with the philosophical and theoretical literature dealing with music must be struck by the persistence with which spatial terminology and categories appear. Indeed, it would seem to be impossible to talk about music at all without invoking spatial notions of one kind or another. Thus in discussing even the most elementary aspects of pitch organization—and among the musical elements, only pitch, we should remember, is uniquely musical—one finds it necessary to rely upon such spatially oriented oppositions as "up and down," "high and low," "small and large" (in regard to intervallic "distances"), and so on. Space, then, *pace* Schopenhauer, apparently forms an inseparable part of the musical experience.

The extent to which music can properly be said to be "spatial"—or,

1. Igor Stravinsky, *Poetics of Music in the Form of Six Lessons*, trans. Arthur Knodel and Ingolf Dahl (Cambridge; Mass., 1947), p. 28.

Reprinted from *Critical Inquiry* 6 (Spring 1980): 527–38

put differently, the question of the existence and attributes of something called "musical space"—is a problem that has long concerned aestheticians.[2] My own concern is to look at the matter specifically from a musician's point of view. For it seems to me that the most fruitful approach to the problem of spatiality in music is to consider not only the "materials" of music but also the way these materials are shaped to produce concrete works of art.

We may begin with the sensation, experienced by all who listen to music, that musical sounds possess a quality of volume or density. Such sounds seem to occupy—to "fill up" to a greater or lesser degree—some sort of "available space," so that one can distinguish, for example, "thick" sounds from "thin" ones. This quality of volume stems principally, I suspect, from the fact that two or more distinct musical events—whether individual tones, chord complexes, or entire phrases—can occur simultaneously without mixing into a fundamentally new and different substance; even in combination they retain a significant degree of individuality and differentiation. The combination of simultaneous events produces what musicians call "texture" (a term clearly betraying a spatial bias), and musical textures are characterized by, among other things, their degree of density—by the number and complexity of their component parts.

Variations in texture constitute one of the most important and readily observable features of musical development, and they produce an effect that is unmistakably "spatial" in quality. Not only do listeners perceive changes in density and volume, they are conscious of different "locations" within the available tonal range. This range, understood as an abstract indication of the range of humanly perceptible pitches, is in fact commonly referred to by musicians as "tonal space," a designation that corresponds to our perception of music as moving *through* something—for example from a higher position to a lower one. Tonal space plays an essential role in enabling us to distinguish between simultaneous musical events. To take a simple example, melody and accompaniment do not simply merge into a single temporal continuum but

2. Two relatively recent studies that discuss musical space are Susanne Langer's *Feeling and Form* (New York, 1953) and Victor Zuckerkandl's *Sound and Symbol,* trans. Willard Trask and Norbert Guterman (New York, 1956), vol. 1, *Music and the External World.* See also Edward A. Lippman's "Music and Space" (Ph.D. diss., Columbia University, 1952).

Robert P. Morgan, professor of music at the University of Chicago, is a composer as well as the author of several articles on contemporary music.

appear to occupy different spatial locations, thus maintaining both individuality and a clear mutual relationship. And neither their individuality nor their relationship can be adequately defined, or accounted for, in purely temporal, or durational, terms.

Moreover, tonal space as just described forms only part of a more generalized musical space that incorporates not only matters of texture but all the elements of compositional structure. Each musical composition embodies a system of interrelationships that is, to a significant extent, independent of the time within which the composition unfolds. And anyone wishing to understand these relationships will find it necessary to compare musical segments that are widely separated within the actual sequence of the work. Music analysts thus find it useful, at least at some stage of their work, to view a composition as a fixed set of synchronic connections, independent of their specific temporal location. If, as in the physical sciences, one thinks of space as an ordering of individual events in relation to one another rather than as an absolute physical medium, then clearly the spatial model is eminently, and inescapably, applicable to music. The fact that musical events appear in temporal sequence and undergo significant transformations as they progress (as do, for that matter, physical events) in no way compromises this applicability.

Of course the spatial model is useful primarily with respect to the "aggregate" quality of musical relationships viewed as a totality, a quality that is admittedly conditioned by the specific order in which these relationships occur. The music analyst, then, is not only concerned with defining the relevant musical space of a composition—that is, its total set of relationships—but with the way these relationships occur sequentially. For a musical composition not only defines its own space, but does so by moving through this space in its own unique manner. Musical space is thus inseparable from musical time, just as musical time is inseparable from musical space. Indeed, the most salient characteristic of musical time, as distinct from ordinary, "psychological" time, is precisely its pronounced spatial—that is, structured—quality. Musical space is the framework within which, and through which, the actual sequence of musical events is shaped. Moreover, without some such notion of a more stable and fixed background, the idea of musical sequence must inevitably remain random and chaotic.

Musical space, then, is a space of relationships. Any discussion of the nature of these relationships should begin with the fact that there is, within all musical cultures, an accepted set of possible, or "allowable," musical relationships that exists prior to any given composition—a system of structural conventions not unlike those of the grammar of a language. An example is the set of conventions called "common-practice tonality," which provided the structural framework for virtually all

Western music for some two hundred years (ca. 1700 to 1900), and which continues to exist up to the present, if less exclusively than before.

It is impossible to describe the features of this tonal system without invoking spatial terminology on an almost constant basis. The concept of the octave, for example, one of tonality's most basic assumptions, provides for the division of the total pitch range into a series of "compartments," each covering an equal segment of tonal space and defined by the appearance of the "same" pitch in different registers. Moreover, the space within each octave is further subdivided into twelve smaller increments, which are also equal in extent. Thus one can speak of a total space subdivided into a number of equal segments, each of which contains the same twelve pitches, these pitches recurring regularly throughout the entire range. There is absolutely nothing temporal about this space; it is an abstract system of mutual relationships, existing prior to and logically independent of a particular compositional ordering.

Tonality also structures tonal space by positing a central pitch that acts as a focus for the other pitches, whose interrelationships are defined primarily by their position in respect to this tonal "center" (once more a spatial term). Moreover, of the twelve possible pitches available within the system, a subgroup of seven is assumed as a "diatonic" (as opposed to "chromatic") norm, and among these seven there exists a set of hierarchical relationships, defined relative to the central tonal axis, that remains constant for that center (except under certain conditions, also of a conventional nature, such as those effecting a temporary modulation to another center). Tonality, then, defines a highly structured and largely conventional "musical space" within which the composer works. The uniqueness of any given composition is thus primarily a function of the particular "route" along which it moves temporally through this prescribed space. In other words, although the possible relationships within the tonal system are to a large extent determined, the ways in which these relationships can be realized and the sequence in which they occur are open to infinite variation. Again we come back to the essential point: any meaningful concept of musical space must incorporate, at some level, the factor of musical time; and equally, a meaningful concept of musical time must include that of musical space.

This sketchy presentation of certain basic features of the tonal system, familiar to anyone with a modest musical background, serves to illustrate that even the most rudimentary systematic characteristics of a musical "grammar" necessarily encompass a group of relationships that are, in an important sense, independent of time. There exist, in other words, certain conventional relationships that are "precompositional"; they exist *in abstracto,* in a synchronic, always present configuration. Of course only their specific "composing out"—to use the literal English equivalent of the term *Auskomponierung* coined by the early twentieth-

century Austrian theorist Heinrich Schenker—enables them to become music. But there is no antagonism or inconsistency between these two aspects of musical structure, one spatial and one temporal. Indeed, as I have maintained, the two are completely dependent upon one another.

I have invoked Schenker with a purpose, for it seems to me that he has managed more successfully than any other theorist to indicate this necessary interconnection between the temporal and spatial aspects of tonal music. In fact, the entire history of tonal theory as it developed in the eighteenth and nineteenth centuries can be read as a progressive attempt to isolate and define the essential relationships of tonal music and to place them in a hierarchical structure that is systematic and atemporal in nature. But it was left to Schenker to develop an analytic method capable of revealing how the specific temporal structure of a given piece relates to the simultaneous, precompositional structure upon which it is based, and from which it derives both meaning and justification.

Schenker viewed all tonal motion as representing, ultimately, a linear unfolding of a single vertical chord—that is, the consonant triad whose fundamental (i.e., the pitch on which it is built) is the tonal center of the work in question; and his theory is, in essence, an elaborate mechanism for revealing how this unfolding takes place. Although the various technical facets of the theory need not concern us here, it is useful to consider its basic outlines. The most basic level of linear unfolding, called by Schenker the *Ursatz,* is a brief and primarily abstract pattern containing only the simplest and most direct motion through the tonal space defined by the tonic triad. Since it permits only the most direct routes of tonal motion, the *Ursatz* assumes only a very limited number of possible forms, all of which are closely related.

The *Ursatz* constitutes a primitive temporalization of the underlying triad and forms the first of a series of analytical layers, each of which adds content to, and represents an elaboration of, the preceding one. A Schenker analysis thus offers a succession of progressively more complex structural levels. At one extreme, the "background," there is the timeless underlying triad and its most basic prolongation, the *Ursatz;* at the other, the "foreground," there is, ultimately, the composition itself. In between are one or more "middleground" levels that mediate between these extremes and indicate how the simpler structures of the background are transformed to produce the actual details of the compositional surface. Such an analysis is not, of course, an explanation of compositional process. Schenker does not claim that composers actually write music by starting with a triad and then working progressively through more foreground levels until finally arriving at a finished composition. Schenker's method, in other words, is directed toward the work itself, not toward the chronology or psychology of its genesis. It provides an explanatory technique through which the complexities of the compo-

sitional surface can be related to, and understood in terms of, simpler musical structures from which they are derived. A Schenker analysis thus might be said to define the "logical space" of a musical composition, as the connections among its layers are purely formal in nature, rather than temporal, and are accounted for by a limited number of operations defined within the theory.

Schenker's theory enables one to understand the notion of musical space in a fresh and more powerful way. It defines this space in terms of a conventionalized, unchanging vertical background that is rendered linear through a set of equally fixed operations, ultimately producing the richness and relational complexity of a particular musical composition. Viewed from the perspective of the finished composition, it provides a way of understanding—and this is perhaps Schenker's single most important contribution—the relationship of the temporal sequence of a work to the synchronic conventions upon which it is based. Schenker, then, offers a theoretical model for the way a tonal composition moves through, and thereby defines, its own musical space—a space that is at once unique, in that it encompasses the particular set of structural-temporal relationships found in that single work; and general, in that these relationships are shown to derive from and exist within the unchanging space of the background.[3] While the general space acquires aesthetic significance solely through its particular individualizations, the unique space of the given composition owes its meaning and comprehensibility to its derivation from the compositional background. Schenker explains what *is* (i.e., the composition) by relating it to what *can be*—to what is possible within the particular musical environment called tonality.[4]

Although Schenker's theory of tonality is unprecedented in methodological consistency and range of applicability, it does not represent a wholly new way of thinking about music. At the center of his thought is the idea of musical ornamentation—that is, the expansion of a

3. Thus the criticism of Schenker's theory, made by Leonard B. Meyer among others, that it leads to a "static interpretation of the musical process," is unfounded. The concept of music as "a single sound term interpreted as a stable whole" (to borrow another phrase from Meyer) forms only one part of Schenker's theory, the main body of which is concerned precisely with its linear motion—with the way music *progresses through* the "single, stable sound." See Meyer, *Emotion and Meaning in Music* (Chicago, 1956), pp. 52–54.

4. I have described Schenker's theory largely in my own terms in order to indicate its relevance to the problem of musical space. Nevertheless, Schenker himself often uses the words *Raum* ("space") and *Tonraum* ("tonal space") in reference to the intervallic boundaries within which linear motions take place. The most comprehensive statement of Schenker's theory is *Der freie Satz* (Vienna, 1935; rev. ed., 1956), unfortunately left incomplete at the time of his death (a fact which contributes greatly to its difficulty, already formidable due to the highly technical and often abstract nature of its presentation). An English version, translated by Ernest Oster, has recently appeared (New York, 1979).

stable structural core, such as an interval or series of intervals, through various kinds of elaborations. And ornamentation has always been an essential feature of Western music and has consistently concerned its theorists. Schenker, then, is only a recent and unusually systematic and comprehensive representative of a long tradition of theorists who have addressed this problem; the musico-spatial characteristics of his theory do not comprise a uniquely "modern" interpretation of musical structure but rather a new method for addressing an age-old concern among those interested in the nature of musical organization.[5] The concept of ornamentation, encompassing the assumption of a more changeable and varied musical surface that can be peeled away to reveal a stable background, is fundamentally "spatial" in orientation and accounts for an important way in which music produces a spatial impression: in the moment of experiencing the elusive, constantly evolving transformations of the note-by-note succession of a composition, the listener—instinctively or otherwise—perceives its relationship to a more fundamental and "orderly" basis. It is this basis, this still and unchanging structure that rests "silently" beneath the surface, supplying a system of coordinates by means of which the musical direction is guided, that lends coherence to even the most complex and apparently rhapsodic sounds. This accounts for the fact that so much musical analysis is concerned with "reduction," that is, with the removal of surface details to uncover the firmer ground in which they are rooted. From the point of view of musical understanding, the underlying structure is as important to the listener as the time-bound realities of the compositional surface.

I have so far confined myself to discussing the relevance of musical space to music of the eighteenth and nineteenth centuries. This may seem surprising, as the spatial metaphor has been more commonly applied to twentieth-century music; but my point was to emphasize that the spatial category transcends a particular musical style or period. Yet admittedly, the notion of musical space seems especially appropriate to much recent music, although there is an essential difference in the way the quality of space is communicated in most modern works. If, as I have argued, the most forceful representation of musical space in the tonal tradition resides in the "grammatical" attributes of an underlying musical system, in modern music the spatial characteristics appear much more "on the surface" and are, in fact, more closely related to those textural matters with which our discussion began.

5. See my "Schenker and the Theoretical Tradition: The Concept of Musical Reduction," *College Music Symposium* 18, no. 1 (Spring 1978): 72–96. The particular structure of Schenker's theory is nevertheless distinctly modern. One thinks especially of similarities to recent developments in linguistic theory, especially Chomsky's idea of a "transformational grammar" which was anticipated by Schenker, as applied to music, by more than a quarter of a century.

This shift in modern music from the background to the foreground, from substructure to surface, was the result of necessity.With the loss, shortly after the turn of the century, of a structural framework provided by a widely accepted set of compositional conventions, composers had to accommodate themselves to a fundamentally new and different kind of framework—one that changed from composition to composition. Each work had to define its own system, as it were, and consequently the system (if that is still the proper word) had to be relocated closer to the compositional surface. This presented the composers with a difficult problem, for—to put the matter in Schenker's terms—it upset the delicate balance between a complex foreground and stable background. In response to this problem, the most common strategy was simply to limit the available pitches to a very small number and to maintain these throughout a section or, in some cases, the entire composition. This results in a fixed underlying structure; but unlike that of the tonal system, where the component parts already possess, at a precompositional level, a system of relationships that can then be manipulated by the composer, the substructure is here defined solely by its content. There are no preordained relationships among its parts; thus all relationships must be defined contextually, by the composition itself. Such compositions normally have a markedly "assertive" quality, since their essential relationships are defined by surface emphasis of one kind or another (particularly repetition). The structure seems "frozen." It is as if a distinct segment of musical space is carved out for the purposes of a particular musical statement, which seems to hang motionless within it. Musical progression becomes largely a function of rhythm and surface manipulations of the available pitch fund. Structural motion, however, at least in the traditional sense, is suspended; the music "moves" only through opposition: one fund is abruptly replaced by another, with no real mediation or "modulation." An "art of transition" (to borrow Wagner's famous phrase) is replaced by one of "juxtaposition." Such music, cutting back and forth among essentially static "blocks" of sound, produces a pronounced spatial effect.

A number of composers—Stravinsky and Bartók among them—could be chosen to illustrate this phenomenon, but perhaps the most striking instance is Edgard Varèse. Characteristic of Varèse's music is the constant repetition of small groups of pitches. To compensate for the resulting lack in pitch motion, Varèse strongly emphasizes such matters as the registral placement of pitches, their timbre, dynamic attributes, and rhythmic articulation. It is indicative of a new compositional orientation that Varèse himself largely relied upon spatial terms in discussing his own music, describing his compositional procedures with such words as "collision" and "penetration." He often remarked that he conceived of his musical materials as "objects," as "sound masses" to be manipulated in the manner of a sculptor constructing a mobile. With

Varèse, then, the spatial metaphor has come to the surface, both musically and verbally.[6]

This new spatial orientation in twentieth-century music is also evident in the frequent use of certain technical procedures, such as "retrograde" structures of one kind or another. One thinks of those works, or sections of works, by Webern and Berg (naming only two of the earlier practitioners) in which the music moves to a midpoint and then reverses direction, eventually returning to its point of origin—a forceful image for the negation, by reversal, of the flow of musical time.[7]

Yet the absence of a "deeper" dimension of musical space, a system of substructural coordinates, no doubt accounts for the somewhat "shallow" quality of much twentieth-century music: all the action seems to take place on the surface. And it is not surprising that many composers felt the need to construct a new precompositional framework in some way analogous to the tonal system. The most comprehensive attempt, and the most historically significant, was the twelve-tone system developed by Arnold Schoenberg during the late teens and early twenties of this century.

Schoenberg clearly thought of the twelve-tone system—in his words, "a new procedure in musical construction which seemed fitted to replace those structural differentiations provided formerly by tonal harmonies"—as the legitimate heir of the older system, a new musical grammar which, historically considered, developed out of tonality and would ultimately take its place. His conviction is understandable; for from a purely formal point of view, the parallels with tonality, especially as conceived by Schenker, are striking. The twelve-tone system assumes a particular ordering of the twelve chromatic pitches (the so-called twelve-tone row or series), which is determined uniquely for each composition but then remains "normal" for that work. This series represents a fixed, atemporal background from which the specific events of the composition—in Schoenberg's terms, the "musical ideas"—acquire their structural validity and justification. The series, then, is not unlike an *Ursatz*. It, too, must be converted into actual music through various types of rhythmic elaboration and transformational operations. (The latter include such techniques as transposition of the series, the use of its "mirror" forms—i.e., its inversion, retrograde, and retrograde-inversion—and the division of the row into quasi-independent subgroups

6. A more detailed discussion of Varèse's spatial conception of music can be found in the second part of my "Rewriting Music History: Second Thoughts on Ives and Varèse," *Musical Newsletter* 3, no. 2 (April 1973): 15–22.

7. I have examined a number of additional twentieth-century spatial techniques, illustrated in the work of a single composer, in "Spatial Form in Ives," in *An Ives Celebration*, ed. H. Wiley Hitchcock and Vivian Perlis (Urbana, Ill., 1976), pp. 145–58. For an extremely interesting, though critical, discussion of spatial characteristics in Stravinsky, see Theodor W. Adorno, *Philosophie der neuen Musik* (Tübingen, 1949), pp. 173–78.

that can be variously combined to complete the required twelve-tone aggregate.)

The twelve-tone system, then, like the tonal system, forms a unified, consistent, and self-sufficient structure that is atemporal, existing independent of its specific transformations in a composition. In his first article on the new system, Schoenberg introduces it in reference to what he calls, significantly, "the two-or-more dimensional space in which musical ideas are presented," a space that "demands an absolute and unitary perception." Moreover, this space is unmistakably "simultaneous" in character: "All that happens at any point of this musical space has more than a local effect. It functions not only in its own plane, but also in all other directions and planes, and is not without influence even at remote points."[8]

Yet there is one fundamental sense in which the twelve-tone system has proved to be unlike the tonal system: it has failed, at least to date, to become a "convention" accepted by even a majority of composers; it has not become a "musical language" spoken and understood by a large and varied musical community. And this significantly restricts the sense in which it can be said to offer a spatial dimension analogous to that of tonality. From the listener's point of view, this means that it is extremely difficult to grasp the relationship of the surface to the silent background that could lend it spatial depth. One is forced to depend largely upon foreground connections as guides to musical comprehension.

If, as I have argued, some sort of spatial dimension is a necessary prerequisite for music, then it is not surprising that twentieth-century composers have in general relied so heavily upon surface spatial effects to replace those associated with tonality. In closing, I would like to mention briefly two spatial facets that have been especially exploited in recent music. The first is the actual physical space in which music is performed. Sounds, of course, have physical sources, whose locations are to at least some extent perceptible to the listener. Yet traditionally, Western music has made little use of spatial direction as a compositional resource. There are exceptions, such as the polychoric music of late-Renaissance Venice, for which separate choirs were placed on opposite sides of Saint Mark's and heard alternately, creating a spatial analogy to the responsive structure of the music. But only in the nineteenth century does the placement of performing forces begin to assume widespread significance. Berlioz was fascinated by the possibilities of multidirectional sound sources; the *Requiem,* for example, distributes four subsidiary orchestras in the four corners of its performing space. And one finds similar effects in many other composers, including Beethoven, Wagner, and Mahler.

8. Schoenberg, "Composition with Twelve Tones," *Style and Idea,* ed. Dika Newlin (New York, 1950), p. 109.

That this increased interest in performance space coincided with the gradual undermining of tonal conventions in the nineteenth century is, I suspect, hardly coincidental. A weakening of one kind of musical space was countered by a strengthening of another, more literal one. Indeed, the more removed a composition is from the older conventions, the more likely it is that the performance space will be incorporated into its overall conception. Thus the division of performing forces into separate groups, with specific indications for their relative placement, has become ever more frequent in music of the present century. It already acquires fundamental importance in Charles Ives, perhaps the least conventional of the major composers of the first half of the century; and since the 1950s it has become a commonplace.

Finally, there is what might be called the "notational space" of music. This is not the place to examine in depth the recurring question of whether musical compositions exist solely in individual performances or enjoy a more substantial life in notated form. But clearly the score, the physical embodiment of a work, transcends the essentially ephemeral nature of its events as sound. In score form the work becomes a timeless object, capable of consideration apart from its temporal sequence.[9]

The actual physical shape of a score and the relationship of this shape to the music it embodies are matters of considerable interest to the question of musical space. Traditional Western notation is two-dimensional: it contains a "time" dimension, read from left to right, which presents the unfolding sequence of the composition; and a "space" dimension, read vertically (i.e., simultaneously), which reveals the temporal coincidence of the different textural components. Thus many of the surface aspects of musical space are immediately apparent from the visual format of the score.

Traditional notation, since it is performance-oriented, is not concerned with displaying the music's underlying structural framework. Schenker, however, developed a graphic method for presenting the synchronic-structural aspects of a composition, using traditional notational symbols that are modified to serve an analytic function. These symbols are literally deprived of their temporal significance; their meaning becomes purely formal. To offer a simple example, in Schenker's notation what looks like a half note is not "longer" than a quarter note but is rather of greater structural importance. In addition, Schenker expands the vertical, or synchronic, dimension through a series of layers *(Schichten)*, notated one above the other, to represent different levels of structural importance, from the compositional background to the com-

9. Having studied scores most of my life, and observed others doing so on countless occasions, I can testify that by far the most common way of reading is to move constantly back and forth through the work, comparing stretches of music that, measured by performance time, are greatly separated from one another. A reading "straight through"—although obviously essential for some purposes—is very much the exception.

positional foreground. (As the top level—that of the composition itself—is approached, the notational symbols tend to reacquire their normal durational meanings.) Since the layers exist simultaneously, their interconnections are purely logical and formal rather than sequential and developmental.

Only in more recent, nontonal works, however, have the spatial aspects of notation been fully exploited by composers as part of the compositional process. Indeed, in many recent works the score must be thought of as a kind of "picture" whose graphic qualities are as important as the auditory results. Many graphic scores, like the "musical mobiles" of such composers as Roman Haubenstock-Ramati, are designed to be read in more than one direction. In such cases the music is indeterminate in respect to the sequence of its parts, which are playable in various orders. Here again, a new kind of spatial framework is applied to music; the individual composition forms a simultaneous collection of separate units which acquire a temporal order only in the moment of performance, by decision of the performer.

But unusual spatial layouts in modern scores are not necessarily related to compositional indeterminacy. In George Crumb's scores, for example, which normally have high visual interest, more or less traditional musical notations are occasionally placed on the page to form basic visual symbols, such as a circle or a cross. Here the visual aspect reflects the structure of the music—or vice versa, for it is difficult to say in these cases which comes first, sound or symbol. Thus in the third song of *Ancient Voices of Children,* Crumb uses a circle to notate a recurring cycle of musical events, each revolution of which returns to its point of departure. Again, an explicit visual image seems to have been chosen to provide the work with a kind of literal spatial framework.

These considerations suggest that music is apparently unthinkable without the presence of some spatial, extratemporal dimension, although the particular form that the spatial dimension takes may vary widely from one work or historical period to another. In those rare cases when a composer, such as John Cage in his more extreme moments, has attempted to transcend the spatial framework entirely, allowing music to unfold in time totally without restriction, the results seem peculiarly "unmusical." Indeed, in Cage's most consequential experiments in this direction, a performer is simply provided with a unit of time within which anything—or nothing—can be done: musical time then becomes indistinguishable from ordinary time. But if that is so, in what sense can this time be said to be musical at all?

Spatial Form in Literature:
Toward a General Theory

W. J. T. Mitchell

A picture held us captive. And we could not get outside it, for it lay
in our language and language seemed to repeat it to us inexorably.
　　　　—Ludwig Wittgenstein, *Philosophical Investigations*

The waves of the sea, the little ripples on the shore, the sweeping
curve of the sandy bay between the headlands, the outline of the
hills, the shape of the clouds, all these are so many riddles of form,
so many problems of morphology.
　　　　—D'Arcy Thompson, *On Growth and Form*

The concept of spatial form has unquestionably been central to modern
criticism not only of literature but of the fine arts and of language and
culture in general. Indeed, the consistent goal of the natural and human
sciences in the twentieth century has been the discovery and/or construc-
tion of synchronic structural models to account for concrete phe-
nomena. The difficult questions arise when we try to relate these various
kinds of models: Is the morphology of the folktale commensurate at any
level with the designs of crystalline growth, the structures of syntax, the
patterns of social organization, the morphogenetic fields of topology?
Are all these analytical models properly regarded as "spatial forms," or is
the term applied literally in some cases and metaphorically in others? If
we could discriminate literal from metaphoric usage (are scientific mod-
els free of metaphor?), how would this discrimination affect the
explanatory value of those models deemed "merely metaphoric"?[1] Are

　1. As will become evident in the following pages, I do indeed regard all these diverse

Reprinted from *Critical Inquiry* 6 (Spring 1980): 539–67

some spatial forms "really there" in the world while others exist only as arbitrary and artificial constructs which might be replaced by any number of other models?[2]

These larger questions cannot be answered until we have reflected on the function of spatial form as an explanatory device and experiential phenomenon in the various fields to which it has been applied. The following essay concentrates on the problem of spatial form in literature and the languages of criticism with the aim of clarifying its role in reading and literary analysis and with the hope of relating the notion of

models as "spatial forms," and I suspect that the discrimination between literal and metaphoric, real and artificial, can only be made provisionally and relatively. As Paul de Man has noted recently, "metaphors, tropes, and figural language in general have been a perennial problem and, at times, a recognized source of embarrassment for philosophical discourse . . ." (*Critical Inquiry* 5 [Autumn 1978]: 13). De Man locates this embarrassment in our inability to purify discourse of metaphor or even to find a way of "delimiting the boundaries of its influence and thus restricting the epistemological damage that it may cause." Throughout this essay, then, when I raise the problem of the "merely metaphoric" applicability of spatial form to literature, I will be treating it in something like Nelson Goodman's terms in *The Languages of Art* (Indianapolis, 1976)—as a provisional distinction within the realm of the actual:

> Metaphorical possession is indeed not *literal* possession; but possession is actual whether metaphorical or literal. The metaphorical and the literal have to be distinguished within the actual. Calling a picture sad and calling it gray are simply different ways of classifying it. That is, although a predicate that applies to an object metaphorically does not apply literally, it nevertheless applies. Whether the application is metaphorical or literal depends upon some such feature as its novelty. [Pp. 68–69]

2. On the related question of spatial form as a quality of things as opposed to an explanatory model, I will work from a similarly provisional standpoint; that is, I recognize that the outline of a tree, the outline drawing which represents a tree, and a tree diagram representing genealogical patterns or syntactic structures are radically different kinds of things. This does not negate, however, the significant fact that all these forms are, in some sense, spatial constructs which permeate experience as well as the analysis of experience and that the particular nature of each can best be defined in the context of a theory which recognizes what they have in common. In discussions of the arts, moreover, the distinctions between "properties" of works and explanatory models become even more difficult to maintain (is "organic form" a feature of works or an explanatory hypothesis?), and it thus becomes even more crucial to situate these distinctions in the context of a general theory. I do not, in other words, want to blur the differences between various kinds of spatial forms but to find a general basis from which multiple differences may be defined without the reification of binary oppositions such as "literal" versus "metaphoric" or "quality of the thing" versus "quality only of the model." If I may adopt a spatial metaphor, the purpose of this essay is to shape out an infinitely differentiated continuum rather than to divide things down the middle.

W. J. T. Mitchell, editor of *Critical Inquiry,* is the author of *Blake's Composite Art.*

literary or verbal space to the general problem of epistemological structures.

Although the notion of spatiality has always lurked in the background of discussions of literary form, the self-conscious use of the term as a critical concept is generally traced to Joseph Frank's seminal essay of 1945, "Spatial Form in Modern Literature."[3] Frank's basic argument is that modernist literary works (particularly by Eliot, Pound, and Joyce) are "spatial" insofar as they replace history and narrative sequence with a sense of mythic simultaneity and disrupt the normal continuities of English prose with disjunctive syntactic arrangements. This argument has been attacked on several fronts. An almost universal objection is that spatial form is a "mere metaphor" which has been given misplaced concreteness and that it denies the essentially temporal nature of literature. Some critics will concede that the metaphor contains a half-truth, but one which is likely to distract attention from more important features of the reading experience. The most polemical attacks have come from those who regard spatial form as an actual, but highly regrettable, characteristic of modern literature and who have linked it with antihistorical and even fascist ideologies.[4] Advocates of Frank's position, on the other hand, have generally been content to extrapolate his premises rather than criticize them, and have compiled an ever-mounting list of modernist texts which can be seen, in some sense, as "antitemporal." The whole debate can best be advanced, in my view, not by some patchwork compromise among the conflicting claims but by a radical, even outrageous, statement of the basic hypothesis in its most general form. I propose, therefore, that far from being a unique phenomenon of some modern literature, and far from being restricted to the features which Frank identifies in those works (simultaneity and discontinuity), spatial form is a crucial aspect of the experience and interpretation of literature in all ages and cultures. The burden of proof, in other words, is not on Frank to show that some works have spatial form but on his critics to provide an example of any work that does not.

We must begin, however, by removing one of the major obstacles to any comprehension of the problem—the notion that spatial form is

3. Frank's essay first appeared in *Sewanee Review* 53 (Spring, Summer, Autumn 1945) and was revised in his *The Widening Gyre* (New Brunswick, N.J., 1963). Frank's basic argument has not changed essentially even in his most recent statements; he still regards spatial form "as a particular phenomenon of modern avant-garde writing." See "Spatial Form: An Answer to Critics," *Critical Inquiry* 4 (Winter 1977): 231–52. A useful bibliography, "Space and Spatial Form in Narrative," is being compiled by Jeffrey Smitten (department of English, Texas Tech University).

4. This charge generally links the notion of spatial form with Wyndham Lewis and Ezra Pound, the imagist movement, the "irrationality" and pessimistic antihistoricism of modernism, and the conservative Romantic tradition. Frank discusses the complex motives behind these associations in the work of Robert Weimann and Frank Kermode in his "Answer to Critics," pp. 238–48.

properly defined as an antithesis or alternative to temporal form and that literary works achieve "spatiality" only by denying temporality, usually defined as some form of sequence or continuity. The fact is that spatial form is the perceptual basis of our notion of time, that we literally cannot "tell time" without the mediation of space.[5] All our temporal language is contaminated with spatial imagery: we speak of "long" and "short" times, of "intervals" (literally, "spaces between"), of "before" and "after"—all implicit metaphors which depend upon a mental picture of time as a linear continuum. If we are going to dismiss these expressions as mere metaphors, we had better abandon our clocks and their metaphors of circular time as well.[6] A more sensible solution is to note that we experience time in a wide variety of ways and that we consistently use spatial imagery to describe these experiences.[7] In literature, our sense of continuity, sequence, and linear progression is not nonspatial because it is temporal. Continuity and sequentiality are spatial images based in the schema of the unbroken line or surface; the experience of simultaneity or discontinuity is simply based in different kinds of spatial images from those involved in continuous, sequential experiences of time. Geometry has no difficulty in "mapping" both continuous and discontinuous functions in spatial coordinates, nor does it restrict one kind of function to space, the other to time. Readers do a similar kind of mapping, if less methodically, when they begin to construct images of temporal or other organizational patterns in any work of literature.

The common mistake of regarding space and time as antithetical modalities is reflected in the tendency of literary critics to speak of spatial form as "static," or "frozen," or as involving some simultaneous, instantaneous, and wholistic impression of that which is "really" temporal. It would require a lengthy excursion into the history of scientific philosophy to explain why spatial form has come to be thought of as a static, atemporal phenomenon; it is evidence at the very least of Newton's

5. See Rudolf Arnheim, "Space as an Image of Time," in *Images of Romanticism*, ed. Karl Kroeber and William Walling (New Haven, Conn., 1978), pp. 1–12. The psychological and historical priority of spatial concepts is argued at length by Max Jammer in his *Concepts of Space* (1954; New York, 1960), pp. 3–4.

6. Wayne Booth has raised a cagey objection to this point: What if we replace the circular clock face with a digital clock that displays nothing but a succession of numbers? Have we not then eliminated any need for spatial mediation of time? I fall back here on Bergson's claim that "we cannot form an image or idea of number without the accompanying intuition of space" (*Time and Free Will* [1910; New York, 1960], p. 78).

7. Jacques Derrida makes this point in an extreme form: "(Time, the form of all sensible phenomena, internal *and* external, seems to dominate space, the form of external sensible phenomena; but it is a time that one may always represent by a line . . .)" (*Of Grammatology*, trans. Gayatri Chakravorty Spivak [Baltimore, 1976], p. 290). We need not restrict ourselves, however, to linear representations of time. An impressionist painter could argue that the properly coded combinations of color, light, and shadow might serve as a rather exact index to diurnal time.

continuing sway over the Western imagination that his abstract and counterintuitive notion of absolute space has become as firmly implanted as the "prejudices" he sought to erase:

> I do not define time, space, place, and motion, as being well known to all. Only I must observe, that the common people conceive those quantities under no other notions but from the relation they bear to sensible objects. And thence arise certain prejudices, for the removing of which it will be convenient to distinguish them into absolute and relative, true and apparent, mathematical and common. . . .
> Absolute space in its own nature, without relation to anything external, remains always similar and immovable. Relative space is some movable dimension or measure of the absolute spaces; which our senses determine by its position to bodies; and which is commonly taken for immovable space.[8]

What is striking here is the uncanny (and unintentional) way that Newton prophesies the usurpation of the common "sensible" view of space by his own view of an absolute, immovable system. Relative space, he notes, "is commonly taken for immovable space"; the "movable dimension" of our local experience is abstracted from sensation, and from time, and rendered absolute and immovable.

We do not have to invoke modern physics to find an alternative to Newton's conception of space. Leibniz's definition, *"spatium est ordo coexistendi"* ("space is an order of coexistent data"), though it lost out to Newton's in the solution of certain eighteenth-century experimental problems, has proved durable enough to draw the interest of modern science, and seems more congenial to our intuitive, premetaphysical imaginings.[9] More precisely, from the standpoint of poetics, all theories of space are equally metaphoric, equally fictive, even those which make the supremely fictional claim to absolute authority. Leibniz's notion seems useful because its spatial conceptions are both relational and kinematic, allowing for multiple orders of data in complex relationships, and it refuses to abstract itself from the temporal modality. If we combine Leibniz's model of physical space with a psychological model, such as Kant's idea of space as a mode of intuition, then we have at least identified the philosophical tradition in which a poetics of space ought to be situated.[10]

8. *Sir Isaac Newton's Mathematical Principles*, ed. Florian Cajori (Berkeley, 1934), p. 6.
9. Leibniz's definition appears in his *Initia rerum metaphysica*, quoted in Jammer's *Concepts of Space*, p. 4.
10. Among the enormous literature on the philosophical issues of time and space, the following books are particularly useful: Adolf Grunbaum, *Philosophical Problems of Space and Time* (New York, 1963); Hans Reichenbach, *The Philosophy of Space and Time*, trans.

It might seem at first glance that Leibniz's key terms, "order" and "coexistent," ter.¹ to reintroduce the element of wholistic simultaneity to spatial form. But nothing in the definition requires that this simultaneity be directly experienced. If we examine our experience of such unquestionably literal spatial forms as paintings, statues, buildings, and landscape gardens, we readily acknowledge that it takes time to experience and "decode" them, that we never apprehend space apart from time and movement.[11] Even if we freeze a single frame from a moving cinematic sequence, the single arrested image is one over which our eye and mind must *move*. In the case of reading, this movement is more strictly prescribed, following (with a considerable range of leaping forward and backward) the linear track of the script. And this "track," it must be insisted, is literally a spatial form, and only metaphorically a temporal one. I know before I open a book that all the words are already there and that the text is therefore a spatial form in Leibniz's sense. This coexistent order may or may not be amenable to a sense of temporal sequence and continuity. The reading experience may produce in us the sense that no real time is passing, that we are in an eternally timeless realm where everything occurs simultaneously. Or it may produce the illusion of temporal sequence, with distinct stages like beginning, middle, and end. What we need to keep in view is the fact that both of these experiences rise out of our decoding of a spatial form (the text) and both involve a sense that time has a pattern or structure, however various those structures might be.[12]

The argument, then, that literature differs from the plastic arts by its "reading time" and by its presentation of narrative or fictive time crumbles on any close inspection. The parallel claim that spatial forms are static, closed systems which can be completely apprehended in zero time is similarly fallacious. We cannot experience a spatial form except in time; we cannot talk about our temporal experience without invoking spatial measures. Instead of viewing space and time as antithetical modalities, we ought to treat their relationship as one of complex interaction, interdependence, and interpenetration. The traditional comparison of space and time to body and soul seems worth keeping in mind for it expresses in a concise way the main elements of our experience of both

Maria Reichenbach and John Freund (New York, 1957); J. J. C. Smart, *Problems of Space and Time* (New York, 1964); and Richard Swinburne, *Space and Time* (London, 1968).

11. For an elaboration of this point, see Etienne Souriau, "Time in the Plastic Arts," *Journal of Aesthetics and Art Criticism* 7 (June 1949).

12. One consequence of a general theory of literary space, then, is that the useful aspect of Frank's distinctions may be preserved and reformulated in more precise ways. Instead of lumping together all modernist works that defy ordinary plot, story, and style under the notion of antitemporal space, we can try to sort out the wide variety of ways that time may be organized and represented through spatial form in literary works.

modalities. Space is the body of time, the form or image that gives us an intuition of something that is not directly perceivable but which permeates all that we apprehend. Time is the soul of space, the invisible entity which animates the field of our experience.[13]

The tendency of spatial thinking to creep into the work of even the most resolutely "temporal" critic is seen in J. Hillis Miller's attack on spatial form in *The Form of Victorian Fiction:*

> Temporality . . . is therefore constitutive for fiction in a way that it can never be for the epic or for literature of the ages of belief in an independently existing eternal realm.
>
> If this is true, one may identify a further damaging distortion introduced into the criticism of fiction by the concept of spatial form. A spatial structure is easiest to think of as an assemblage of elements, each with its separate meaning, all arranged in a fixed pattern to establish a total significance. This conception of form falsifies the actual mode of existence of a novel, the way in which it is a temporal structure constantly creating its own meaning.[14]

We might note first that Miller would evidently have no objection to applying spatial concepts of form to works written during the "ages of belief" when presumably everyone (Petronius? Montaigne? Cervantes?) had a simple, unproblematic faith in an "independently existing eternal realm." Assuming, then, that we have won back for spatiality pre-eighteenth-century literature (and *all* poetry and drama, one supposes, since "temporality" is only "constitutive for fiction"), can we make any further inroads? It is clear from Miller's characterization of spatial form that he regards it as fixed, static, and closed, in contrast to temporality, which is none of these things. If spatial form were the way Miller describes it, however, he would never be able to walk across the street or read a paragraph. All the flow and movement that he celebrates in fiction is inconceivable without a space in which, *as* which, to experience it. Miller's final phrase reveals the inescapable spatiality of our thoughts about time: he must speak of a "temporal *structure* constantly creating its own meaning" (italics mine). When he goes on to develop this structure in terms of a musical analogy, the game is blown wide open, as will

13. This comparison is most systematically developed by the apologists for Renaissance emblem literature, who regarded the verbal and pictorial aspects of their books as ways of uniting spirit and body, time and space, intellect and sensation. See Mario Praz, *Studies in Seventeenth-Century Imagery,* 2 vols. (London, 1939), 1:155 ff., and Jean Hagstrum, *The Sister Arts* (Chicago, 1958), pp. 94–96, for classic treatments of this matter. The whole debate over spatial form, I suspect, ultimately derives from the debate over the claims of spirit and matter and word and image in these early aesthetic treatises.

14. J. Hillis Miller, *The Form of Victorian Fiction* (Notre Dame, Ind., 1968), p. 46.

become evident if one underscores the spatial images in the ensuing passage:

> music provides a useful analogy for this *aspect* of fictional *form.* While a *piece* of music is going on the *pattern of the whole* in its incompleteness is *held out in the open.* A constantly changing rhythm of references and cross-references is sustained in living movement, each new movement of the music constituting itself as the *center of the whole,* or, rather, since the *form* is not yet finished, constituting itself as the failure of any moment to be the perfect *center,* the *point* around which the *whole* can organize itself in a complete *circular pattern.*[15]

Miller seems to have realized in midsentence that he was falling back into the rhetoric of spatiality ("center of the whole") and tried to save his case by treating his incipient spatial form as "not yet finished," the "failure" to become "a complete circular pattern." But this adjustment does not deny the pertinence of spatial form; it only suggests that a fragmentary, incomplete, and mobile spatial form is the proper image to contemplate in relation to Victorian fiction. The musical analogy mustered in the name of temporality falls back into the realm of space, a result that would become increasingly clear if the analogy were pursued systematically into the textual and aural experience of music, where "high," "low," "long," "short," and the whole vertical-horizontal structure of musical notation give spatial form to a temporal art.[16]

Everything points to the conclusion, then, that spatial form is no casual metaphor but an essential feature of the interpretation and experience of literature; this conclusion could be dismissed as "true but trivial" if it were not for the fact that so much ink has been spilled to prove that spatiality exists nowhere in literature or only at certain times and places which the critic wants to praise or blame. Frank's essay on this subject was seminal because he refused to make spatial form the grounds of any value judgment; he simply tried to examine a peculiar phenomenon that seemed to link a number of writers at stylistic, formal, and thematic levels. The next step is to attempt a synthetic overview of spatiality in literature, sorting out those aspects of literary experience which insist on being regarded in spatial terms and submitting those terms to an analysis informed by wide acquaintance with the space-time nexus in other arts and sciences. We should not rest content with the observation

15. Ibid., p. 47; italics mine.
16. The application of spatial form to music has in fact been systematically explored by Edward A. Lippman in "Music and Space" (Ph.D. diss., Columbia University, 1952). For more recent work in this area see Robert P. Morgan's "Spatial Form in Ives," in *An Ives Celebration,* ed. H. Wiley Hitchcock and Vivian Perlis (Urbana, Ill., 1976), and his essay in the present volume.

that some works have spatial form but should seek a precise understanding of the ways in which spatiality occurs and of the ways in which it relates to other aspects of literary art.

We might begin with an inventory of the terms in normal critical discourse which imply spatial imagery. Clearly the entire vocabulary of formalism is riddled with spatial concerns, from the central notions of form, structure, plot, and imagery to the more special arguments for the existence of verbal "icons." If space were constructed by vision alone we might suspect that literary space is defined by what Northrop Frye calls "opsis," "the spectacular or visible aspect of drama; the ideally visible or pictorial aspect of other literature."[17] But we also construct space through other senses, such as touch, and embody this dimension in the implicitly tactile metaphor of a "text" (literally, that which is woven; web, texture), hardly a casual metaphor for the reader of braille. From a spatial perspective, all the iconoclastic attempts to go "beyond formalism" and "deconstruct" literary form are not denials of spatiality but affirmations of new, more complex, mobile, or open spatial forms, such as those which J. Hillis Miller finds himself invoking when he compares fiction to music. A sign of the covert amity between iconoclasts and iconophiles on the issue of spatial form is the ubiquity of the word "vision" in the vocabularies of critics of all persuasions in the last twenty years. This term has become popular, I suspect, because it allows us to employ a wide range of spatial metaphors without succumbing to the widely feared threat of "reifying" the literary work.[18] The rhetoric of vision has the advantage of uniting a moral, prophetic stance (that of the visionary or seer) with the scientific, philosophical language of perception and epistemology, and it focuses attention on the process by which spatial form is created and perceived, rather than objectifying that form.

There is a whole class of terms in our critical lexicon formed by

17. Northrop Frye, *Anatomy of Criticism* (Princeton, N.J., 1957), p. 367.

18. See Earl Miner, "That Literature Is a Kind of Knowledge," *Critical Inquiry* 2 (Spring 1976): 511–12, for an exemplary attack on "reified notions of literature," including spatial form. Miner sees "a chief benefit of cognitive criticism" as "depreciation of those concepts" which stress the objectivity, autonomy, or substantiality of the text. It is difficult for me to see any benefit in the depreciation of these useful and hard-won concepts, except in their most naive, debased forms. No one seriously argues that a poem is *nothing but* its physical existence as a text, or an aggregate of words, but neither should we utterly detach the ontology of literature from its material incarnation. A more curious feature of Miner's quarrel with the concept of literary space is its occurence in an essay which tries to ground literary cognition in the hemispheric theory of the brain. This theory links the verbal, propositional aspect of literature with the left hemisphere and links wholes, spatial elements, and metaphor with the right hemisphere (see Miner, p. 504). It would seem that the nonpropositional aspect of literature would be grounded in the activity of the right hemisphere and that Miner's cognitive theory would provide a physiological basis for the reality of spatial form in literature, not grounds for its depreciation.

migrations back and forth between literature and the visual arts: imitation, representation, expression, and style are four that spring immediately to mind, but a case could be made for concepts such as perspective, background and foreground, the picturesque, local color, and so forth.[19] Some terms seem to change sides in ways that reflect large cultural transformations: the sublime, for instance, begins as the name for a kind of rhetoric, becomes the label for a certain kind of landscape in nature and art, and maintains throughout its history a link with prevailing assumptions about psychology so that the Longinian and Romantic sublime can, in retrospect, be illuminated by the concept of Freudian sublimation.[20]

One term whose history illustrates not only the transactions of verbal-visual and temporal-spatial patterning but also the reversibility of literal-metaphoric distinctions is that of "rhythm." We generally suppose that this term applies literally to temporal phenomena such as speech and music and is a mere metaphor when used in discussions of sculpture, painting, or architecture. In the eighteenth and nineteenth centuries this primarily temporal notion of rhythm was sustained by the derivation of ῥυθμος (rhythmos) from ῥέω (rheō), with the associated images of "flow" and "repetition."[21] Modern studies of the term in the earliest Greek texts have suggested, however, that it is derived from the root ερυ- (ery), which suggests the action of "drawing" (cf. the German "ziehen") and which plays on the same double meaning as do "draw" and "drawing" in English. "Rhythmos" was based, then, in the physical act of drawing, inscribing, and engraving and was used to mean something like "form," "shape," or "pattern." J. J. Pollitt suggests that the transference of the term to temporal arts occurred in descriptions of the dance:

> ῥυθμοί were originally the "positions" that the human body was made to assume in the course of a dance, in other words the patterns or *schemata* that the body made. In the course of a dance certain obvious patterns or positions, like the raising or lowering of a foot, were naturally repeated, thus marking intervals in the dance. Since music and singing were synchronized with dancing, the recurrent positions taken by the dancer in the course of his

19. Each of these terms, of course, undergoes fundamental changes in meaning when it moves from one discipline to another. I am not proposing their reduction to simple equivalences but rather the systematic analysis of their transformations in intellectual history and in their application to different art forms. For an excellent example of such an analysis, see Claudio Guillen's "On the Concept and Metaphor of Perspective," in *Comparatists at Work,* ed. Stephen Nichols and Richard Vowles (Waltham, Mass., 1968), pp. 28–90.

20. The basic study of the "sublime" in eighteenth-century critical theory is Samuel Holt Monk's *The Sublime* (New York, 1935). See also Walter J. Hipple, *The Beautiful, the Sublime, and the Picturesque in Eighteenth-Century Aesthetic Theory* (Carbondale, Ill., 1957).

21. The following discussion of rhythm is drawn largely from J. J. Pollitt's *The Ancient View of Greek Art* (New Haven, Conn., 1974), pp. 133–43.

movements also marked distinct intervals in the music. . . . This explains why the basic component of music and poetry was called a πούζ, "foot."[22]

It also explains why early art historians like Winckelmann felt that the metaphoric application of rhythm to the plastic arts was somehow justified. In retrospect it can be seen as a literal application of the term, but one which derived its critical energy from an apparent transgression of the boundaries between space and time. The metaphoric "trespass" turns out to have been a lawful reclamation of lost territory.

Such transgressions, and the hidden laws which they violate and/or confirm, seem absolutely fundamental to the theory and practice of literary history. We are all familiar with the use of labels for period styles (baroque, mannerist, rococo, Gothic, Romantic), many of which originate as derogatory terms in art history and wind up serving as fundamental concepts in literary history. The formulaic recital of apologies and disclaimers which always accompanies the introduction of these terms into a critical discussion betrays our unease with their unsystematic nature and our inability to avoid bringing them up. I make no brief here for adopting all the facile analogies between the arts based on reductive applications of period terminology. But it does seem that we are faced with a crucial choice in the use of these terms. We can continue complaining about illegitimate analogies and transferences from one art form to another and continue to apologize for the ad hoc nature of some of the key terms in the historical and critical study of literature, or we can accept these "contaminations" as an inescapable part of literature and the languages of criticism and work for a systematic understanding of the ways in which the infections are carried.

If we turn our attention from the seemingly hopeless tangle of spatial metaphors which riddle the languages of criticism and focus our attention on that problematic object, "the work itself," we note that spatial metaphors intrude at the outset. The ontology of the work, either as a unique object (the autonomous icon of formalism) or as a member of a class (the concentrically arrayed "backgrounds" of contextualism) is elucidated by regarding it as an object in an appropriate field of relationships.[23] A closer look at this curious object inevitably reveals it as a complex field of internal relationships, the most common of which is the phenomenon of stratification, or what is usually called "levels" in litera-

22. Pollitt (pp. 138–39) is here summarizing the analysis of *rhythmos* by Eugen Petersen, "Rhythmus," *Abbandlungen der Kön. Gesellschaft der Wissenschaften zu Göttingen, Phil.-Hist. Klasse*, N.F. 16 (1917): 1–104.

23. Probably the best-known use of spatial form in this sense is T. S. Eliot's concept of "tradition" as a timeless order of works whose structure is altered slightly by the creation of each new significant work. See "Tradition and the Individual Talent," *Selected Essays* (London, 1932).

ture. We usually discern at least two levels in any literary work, labeled by such binary oppositions as literal and figurative, or explicit and implicit, but there seems to be a tendency to want more strata than this as a way of fulfilling some hierarchical model of inclusiveness, importance, or ideality. We never read a poem merely at the (low) literal level but work for a "higher" criticism that engages a more sublime, rarefied, or valuable aspect of the work. If an archaeological image is lurking in the background, our hierarchy of strata may move in the other direction, taking us "deeper" beneath the surface of the work to its hidden core where the most profound meanings reside. It seems clear that we can construct (and do in fact employ) a wide variety of multiple-level models of literature based on implicit conceptual-spatial hierarchies and that the terminology of levels is vulgar and debased only insofar as it is employed without self-consciousness, as if every literary work had the same system of levels placed there by the author without any help from his reader. Our sense that literature, like consciousness itself, is a complex structure with multiple dimensions, aspects, or strata needs to be explicated in conjunction with our perception of these forms in any particular work.

One of the most enduring stratifications of literary experience has been the four-level system of medieval allegory, a structure which was given new life by Frye in *Anatomy of Criticism*. If we adopt this system as a heuristic device for discriminating varieties of spatial form in literature, we note that the literal level, the physical existence of the text itself, is unquestionably a spatial form in the most nonmetaphoric sense. The physical text is an "order of coexistent data," and the reading process is a conventional procedure for transforming this spatial form into a temporal one. This procedure varies with the syntactic conventions peculiar to each language and with the nature of its verbal signs (literature in a pictographic script like Chinese highlights the experience of spatial, pictorial form at the primary level of deciphering, while phonetic alphabets tend to "background" the spatial dimension, bringing it to the fore only in special experiments like concrete poetry). The spatiality of English texts as physical objects is normally backgrounded, but that does not negate the significance of this aspect of their existence. What might we learn, for instance, about the history of Chaucer's reception if we paid more attention to the development of typography in Chaucerian texts printed from the Renaissance to the nineteenth century? How do the physical details of publication (style of type, size of page, locations of glosses, presence or absence of illustrations, even texture of paper) reflect the cultural status of the text, and how do they affect the reader's experience?[24] The postulate of literal or physical spatiality encourages us

24. These questions are raised and answered in very interesting ways by Alice Miskimin in "The Illustrated Eighteenth-Century Chaucer," *Modern Philology* 77 (August 1979): 26–55. A wealth of material on this aspect of literary space may be found in *The Journal of Typographic Research* (recently renamed *Visible Language*), which publishes articles

to view every text in terms like those we apply to concrete poetry. With poets like Herbert or Blake, this postulate will lead us to reconstruct intentions, since each poet has exerted considerable control over the physical space of his work; with novelists, on the other hand, intentionality will generally recede from view, and other matters (such as the economics or technology of production and marketing) will emerge. These are not, it should be noted, startlingly novel questions but part of normal critical procedure. What is not usually observed is that this sort of inquiry into the physical spatiality of texts may be related to a host of other spatial dimensions in literature and that these particular questions might be better posed in the framework of a general theory of literary spatiality.

If some version of spatial form is undeniably an aspect of the literal level of literature, it is more obviously a crucial element of what Frye calls the "descriptive" phase, in which we attend to the world which is represented, imitated, or signified in a work. Now this is clearly a spatial realm that has to be constructed mentally during or after the temporal experience of reading the text, but it is none the less spatial for being a mental construct. The world of "real" space, as perceptual psychologists have shown, is also inseparable from mental constructions and is also revealed to us in time.[25] This is not to say that every literary work presents a fixed, static space as part of its imaginative illusion. The space of a literary work may be enveloped in temporality in the manner of the landscapes described in Wordsworth's "spots of time." It may include an entire image of the cosmos, as in Milton, or confine itself to a tiny region of the English countryside, as in Jane Austen. It may be presented as metamorphic, irrational, heterogeneous, fragmentary, or stable, solid, and reassuring. It may be a crucial aspect of the fiction (as landscape is in Hardy), or it may be negligible, so far into the background that it scarcely draws attention. And it need not be confined to what we normally consider under the rubric of setting; insofar as a work *describes* anything in relation to anything else, it renders an "order of coexistent data," whether that data is comprised of characters, objects, images, sensations, or emotions. Whatever our reading leads us to "see" not simply in the visual sense but in the entire field of perception is part of the field of descriptive space in literary experience.

The third level of spatial features in literature is the one I have already touched on in the problematics of "structure" and "form." I trust it is clear by now that the term "spatial form" is a kind of emphatic

on concrete and shaped poetry, graphics, typographic design, and language in the visual arts.

25. Ernst Gombrich's *Art and Illusion* (Princeton, N.J., 1960) provides the best guide to the intricate play of artifice, convention, and "natural" or "direct" vision in the act of perception.

redundancy and that all notions of form or structure carry spatial connotations.[26] "Temporal form," then, is not the antithesis of spatial form but the term we apply to a temporal experience whose spatial pattern or configuration has been discerned. Any time we feel that we have discovered the principle which governs the order or sequence of presentation in a text, whether it is based in blocks of imagery, plot and story, the development of character or consciousness, historical or thematic concerns—any time we sense a "map" or outline of our temporal movement through the text, we are encountering this third level of spatiality.[27] This is not to argue that any fixed map or other spatial form will finally account for all the details of the text. Our patterns of coherence may be continually frustrated by reversals of expectation and by developments which cannot be reconciled in any larger, embracing pattern.[28] Nevertheless, the search for and momentary imposition of spatial pat-

26. The corollary to this is that all notions of space carry formal connotations, at least in Leibniz's theory. The Newtonian concept of absolute space, by contrast, tends to separate space (which is the absolute, unknowable ground of being) from particular spatial forms.

27. Perhaps the most important spatial metaphor in narrative analysis is imbedded in the notion of "plot," which suggests a cultivated patch of ground or a devious, intricate design. Eric S. Rabkin addresses the problem of "Spatial Form and Plot" (*Critical Inquiry* 4 [Winter 1977]: 253–70) in a way that seems generally to bear out my contention that spatial form is crucial to narrativity. Rabkin argues that "all reading of narrative is both diachronic and synchronic, and . . . all narratives have always played on both perceptual modes" (pp. 253–54). But he reverts to the tendency to see time and space as antithetical modes when he tries to drive a wedge between "story" (the temporal sequence of events or "action" in a narrative) and "plot" (the rearrangement of this sequence by the narrator in his telling) in terms of synchronic versus diachronic experience. Rabkin sees "story" as a spatial form, "a synchronic context" which the reader constructs "to make sense of the words he is reading diachronically." Plot, on the other hand, "is actual only in the diachronic reading" (p. 256). Thus, if a story contains the sequence of events A-B-C-D-E, its plot might present these events in the order D-C-A-B-E (see Rabkin, pp. 255–56, for detailed presentation). The distinction here seems to me better described as the contrast between two spatial forms, both of which refer to temporal arrangements, one defined as a rearrangement or transformation of the other. Plot is *not* "actual only in the diachronic reading"; it is actual as a synchronic order which we can, as Rabkin demonstrates, compare to the synchronic order of the story. It is the recognition of this artful "plotting" or calculated ordering of temporal sequence that gives rise to the spatial metaphor of plot; our normal prejudices would, I suspect, assign the diachronic, temporal dimension to "story," the element which Rabkin sees as synchronic. The real power of the story-plot distinction is that it allows us to make sense of our common feeling in narrative that a double time-order is at work, the order of the telling and the order of the told. Our method of making this sense is to reconstruct the two orders as parallel spatial forms which can be compared. Neither of the two orders, strictly speaking, is "actual" in the diachronic reading; what is actual is a complex, probably unnameable, interaction between two distinct patterns in the virtual space-time of narrative.

28. A witty argument for the formal incoherence of all interesting post-Romantic works is made by James R. Kincaid in "Coherent Readers, Incoherent Texts," *Critical Inquiry* 3 (Summer 1977): 781–802.

terns on the temporal flow of literature is a central aspect of reading; the lively, unpredictable "incoherence" which the deconstructionists celebrate loses all its energy and vertiginous terror without patterns of coherence to lull us into security before our inevitable fall.

The fourth level of spatiality in literature is difficult to discuss because it approaches that point where the interpretation of literature (presumably a rational, sequential activity) converges with the experience of it. What does Conrad mean when he tells us that his purpose is to make us *see?* Partly, of course, he means that he wants us to see in our mind's eye the world he presents in his fiction, what is defined here as descriptive spatiality. But presumably he also wants us to see beneath the exotic scenery, the multifarious sensory descriptions, to the fundamental patterns that lie beneath his fictive world. And those patterns are not merely the formal principles which govern the temporal unfolding of his story but the very metaphysics which lies behind a story told about *this* world in *this* particular way. What Conrad wants us to see is much like what we experience when we "see" what someone (or something) means. We are tempted, of course, to label this as the "meaning" of the work and consign it to the cubbyhole where we file "themes" that have been abstracted from literature. But everyone knows that any essay which claimed to state "The Meaning of *Lord Jim*" would be much longer than any abstract statement of the novel's theme and that it would probably conclude with some admission that the meaning still eludes us.

This familiar pattern in literary criticism—the claim that we do, at least for a moment, "see the meaning" of a work, coupled with our inability to state it in a verbal paraphrase—seems to me a phenomenon that rises out of a spatial apprehension of the work as a system for generating meanings. Frye refers to this phenomenon when he suggests that "the word meaning or *dianoia* conveys, or at least preserves, the sense of simultaneity caught by the eye. We *listen to* the poem as it moves from beginning to end, but as soon as the whole of it is in our minds at once we 'see' what it means. More exactly, this response is not simply to *the* whole *of* it, but to *a* whole *in* it: we have a vision of meaning or *dianoia* whenever any simultaneous apprehension is possible."[29] We should note

29. Frye, *Anatomy of Criticism*, pp. 77–78. The pervasiveness of this assumption in practical criticism is suggested by Stanley Fish's attack on the Milton *Variorum Commentary* for its "assumption that there *is* a sense, that it is embedded or encoded in the text, and that it can be taken in at a single glance. These assumptions are, in order, positivist, holistic, and spatial . . ." (see "Interpreting the *Variorum*," *Critical Inquiry* 2 [Spring 1976]: 473). Fish is attacking spatial form, of course, because he feels that it causes "the reader's activities to be ignored and devalued" (pp. 473–74). But there is nothing in the concept of spatial form that requires some univocal image to be "embedded" in the text. My point, which I suspect Fish might assent to, is that *readers* participate in the creation of literary space and that the formation and dissolution of spatial forms is a crucial aspect of the reading process, not to be exclusively equated with an interpretive product.

here that Frye explicitly disclaims the idea that he is arguing for a single, fixed spatial pattern as the key to a literary work. On the contrary, he seems to be suggesting at most a structural hypothesis about a work which will explain only a portion of the text (not "*the* whole *of* it," but "*a* whole *in* it"). There is nothing, of course, to require that we wait until the end of a text to formulate this kind of spatial form; I would argue that we begin doing it in the very first sentence as we attempt to guess, before we get there, where the work is going. And nothing requires that this spatial form remain fixed and static; a "vision" of the whole may be one of those valuable but ephemeral flashes of insight, and it may fade with the next rereading—or it may generate rational, falsifiable hypotheses to test against the order of textual particulars.

But surely, it will be objected, all this "spatial form" is merely metaphoric. We don't *really* have diagrams in our heads which somehow correspond to the form or meaning of literary works. This is the point where we must suspend our disbelief if we are to make progress and remind ourselves that every act of knowledge involves a metaphoric leap. If there were spatial forms in works of literature, what would they look like? How could we verify their correspondence to any given text? And what use would they be?

Let us take the easiest question first and, for convenience, restrict ourselves to geometric or abstract linear patterning. It seems obvious that these forms would look like any other geometric pattern; their significance would simply be coordinated with a stipulated aspect of the work to which they are to apply, just as the pure forms of geometry may be employed to refer to anything from electrical circuitry to geographical surveys to purely imaginary, nonreferential constructs. The "map" of a novel might be as unpredictable and irrational as the wildly digressive pattern of *Tristram Shandy* (see Sterne's diagram, fig. 1), or it might be the "right line" of moral rectitude that Sterne promises to follow in his last volume. The fact that Sterne is joking here is, like the "merely metaphoric" nature of spatial form, a device for allowing us to perceive and articulate what cannot be said about literature in other ways. It is clear, moreover, that Sterne understands the stipulative nature of his spatial form: the line can represent not just the progress of narrative time but the moral status of the narrator. The lovely irony of the novel is that Sterne's continuous pose as an honest, "straightforward" narrator who must tell all, including all his difficulties with the techniques of narration, continually prevents him from following the "right line" of straightforward narrative. One aspect of the structure of *Tristram Shandy,* regarded as an abstract spatial form, is that its insistence on a straight line at one level (the "rectitude" of the narrator) must generate an eccentric, digressive line at another level (the unfolding of the narrative).

It is not difficult to think of other stipulated correspondences which are commonly invoked in the implicit geometry of narrative. If a literary work presents a visualizable world, we can often "map out," quite literally, our progress through the verbal form as a track in space, as we do with the road images of *Pilgrim's Progress*. In picaresque fictions where the hero rarely revisits the scene of a past exploit, the spatial and temporal lines described by the narrative will tend to be congruent. Symbolic or allegorical fictions will play off spatial-temporal topography against thematic imagery: a spatial *place* may correspond to a temporal *phase* in the unfolding of an ideational *schema* for the development of a character,

These were the four lines I moved in through my first, second, third, and fourth volumes.——In the fifth volume I have been very good,——the precise line I have described in it being this:

By which it appears, that except at the curve, marked A. where I took a trip to *Navarre*,——and the indented curve B. which is the short airing when I was there with the Lady *Baussiere* and her page,——I have not taken the least frisk of a digression, till *John de la Casse*'s devils led me the round you see marked D.——for as for c c c c they are nothing but parentheses, and the common *ins* and *outs* incident to the lives of the greatest ministers of state; and when compared with what men have done,——or with my own transgressions at the letters A B D——they vanish into nothing.

In this last volume I have done better still——for from the end of *Le Fever*'s episode, to the beginning of my uncle *Toby's* campaigns,——I have scarce stepped a yard out of my way.

If I mend at this rate, it is not impossible——by the good leave of his grace of *Benevento*'s devils——but I may arrive hereafter at the excellency of going on even thus;

which is a line drawn as straight as I could draw it, by a writing-master's ruler, (borrowed for that purpose) turning neither to the right hand or to the left.

This *right line*,——the path-way for Christians to walk in! say divines[2]——

——The emblem of moral rectitude! says *Cicero*[3]——

<div align="center">Fig. 1.</div>

progress of a civilization, completion of a rhetorical, historical, or metaphysical pattern. In ironic, self-conscious fictions, as noted with Sterne, temporal, spatial, and thematic lines may display sharp incongruencies and disjunctions.

There is no question, then, of using geometry to reduce literary works to some univocal pattern; the idea is to make explicit the patterns we already use in an unsystematic way and to heighten our awareness of the relations between patterns which have different stipulated correspondences.[30] Some patterns will be so simple as to seem self-evident, virtually identical with the genre of a work. One of our most common spatial equivalents for literary action is the image of a wheel whose revolutions mark not just the time-line but the fortunes of the hero. A line descending to "low" fortune or a "fall" of some sort and then re-ascending is a simple map of comedy and corresponds to the pictorial gestalt of the smile. A line ascending to "high" fortune and then falling is the classic shema of tragedy and the gestalt of the frown. These "smile" and "frown" schemata which link narrative patterns to basic emotional stereotypes linked with comedy and tragedy tell us almost nothing about any particular literary work and serve only as the crudest sort of graphic or iconic equivalent of genre, abstractions of the expressions on the masks which commonly symbolize comedy and tragedy.

More specific spatial forms would display overlapping or intersecting patterns, some referring to principles of movement through the text, some governed by patterns of imagery or ideas that reflect authorial assumptions about world order. We are reminded here of the geometrical and numerological harmonies and symmetries which pervade the structures of art, architecture, music, literature, and cosmology until the eighteenth century.[31] But where do these elaborate spatial forms come from, and what were they for? Are they spontaneous creations of some Platonic reservoir in the human imagination? Or do they represent empirical generalizations, abstracted from the spatial experience of a culture? The classical answer for Western artists has been some version of inspiration: the forms of art are provided by the muses. But the muses are, of course, the Daughters of Memory (Mnemosyne), the mental power which preserves and orders the phenomena of experienced time. This method of ordering is, as Frances Yates has shown, a spatial and visual "art of memory" which was developed by poets and orators to

30. Rabkin provides a good example of multiple patterning when he reduces a simple romance narrative to the synchronic representation of a circle and the diachronic representation of a sinusoidal curve ("Spatial Form in Plot," pp. 261–62). What Rabkin fails to see is that his sinusoidal curve is no less spatial and "synchronic" for being a representation of a temporal element in the narrative. It is simply a *different kind* of spatial form from the circle (which also signifies a temporal aspect in Rabkin's analysis), disclosing a different shape and a different reference in the text.

31. For a recent general discussion of these patterns, see R. G. Peterson, "Critical Calculations: Measure and Symmetry in Literature," *PMLA* 91 (May 1976): 367–74.

memorize their "texts" prior to the invention of writing.[32] As Cicero describes it:

> persons desiring to train this faculty (of memory) must select places and form mental images of the things they wish to remember and store those images in the places, so that the order of the places will preserve the order of the things, and the images of the things will denote the things themselves, and we shall employ the places and images respectively as a wax writing-tablet and the letters written on it.[33]

This connection between mnemotechnics and the construction of mental space survives in the notion that discourse can be seen as an order of "topics" (literally, τόποι or "places") in the temporal flow of language. It is significant that the legendary inventor of spatial memory systems, Simonides of Ceos, is also credited with the invention of the *ut pictura poesis* tradition.[34] The pictorial aspect of poetry is not simply its imagery but the patterns of order which allow its storage and retrieval in the mind.

With the proliferation of writing and printing, of course, the utility of spatial mnemotechnics in poetry and oratory is diminished. Yates contends, however, that the systems persist in a sublimated and trans-formed manner, as forms for the exercise of mystical memory disciplines which link cosmic structures with meditative, aesthetic, and cognitive patterns:

> Dante's *Inferno* could be regarded as a kind of memory system for memorising Hell and its punishments with striking images on or-ders of places. . . . If one thinks of the poem as based on orders of places in Hell, Purgatory, and Paradise, and as a cosmic order of places in which the spheres of Hell are the spheres of Heaven in reverse, it begins to appear as a summa of similitudes and exempla, ranged in order and set out upon the universe.[35]

It is worth noting at this point that the literary architecture based in the imagery of memory systems does not declare itself univocally as either a quality of the work that is "really there" or as an explanatory, interpre-tive model. I would argue that it can be seen as serving both functions, and that it illustrates the tendency of spatial form to unite (while preserv-ing the relative distinction between) analytical and experiential aspects of reading.

It is a cliché of historicism that these structures, and the unified

32. Frances Yates, *The Art of Memory* (Chicago, 1966).
33. Cicero, *De oratore*, quoted by Yates, p. 2.
34. Yates, p. 28.
35. Ibid., p. 95.

sensibility that they embodied, began to disintegrate sometime between the Middle Ages and the nineteenth century; usually the crisis just happens to occur in the center of the period in which the critic is a specialist. This disintegration used to be described as an abandonment of form in favor of "mere content" or self-expression. Then, when it became evident that Romantic literature did have some sort of form, the change was reformulated as a movement from an eternal, spatial, "closed" sense of form to a historical, temporal, "open" sense of form.[36] Open versus closed may seem a rather slight advance in precision on the categories of formless versus formed, but it at least reflects an awareness that the phenomenon of spatial form is a constant in literary history and that our problem is to describe the history and significance of changes in spatial form, not to assign it to one period, and temporality to another. If we think about the problem further, it seems likely that crude differentiae like open and closed can be made to apply to almost any literary work; if we want to preserve any right to talk about a history of forms in literature, we need to move the whole inquiry to a new level of precision. Instead of contrasting neoclassical and Romantic literature with rhetorical and spatial antitheses, we might study the persistence of certain formal patterns in the arts and inquire into their function and meaning in particular works and artists. The pattern of the spiral, vortex, or serpentine line, for example, crops up everywhere in the plastic arts of the eighteenth century, most notably in the rococo and in the aesthetics of Hogarth's *Analysis of Beauty*.[37] It is also a highly resonant image in nineteenth-century literature and art, from Blake's vortices of vision to the maelstroms and whirlwinds that ravage the landscapes of Turner, Shelley, and Poe. As a preliminary generalization we note that the spiral functions primarily as an ornamental, decorative device on a stable (usually pyramidal or rectangular) structure in the eighteenth century, and that it is often linked with the aesthetics of beauty as variety. In the nineteenth century, on the other hand, the spiral seems to be reserved for moments of catastrophe in which it serves as a structural pattern rather than as a decorative motif, and it is frequently associated with the aesthetics of sublimity. Can we go on to explore the role of this form in literary as well as pictorial space? It certainly functions at the descriptive level of imagery and setting, but can we speak intelligibly of its presence in literary *form*? Are the decorative circumlocutions of periphrasis, like baroque ornamentation in music, to be seen as implicit "curls" or "turns"

36. Peterson (p. 374) repeats a version of the usual historicist line when he suggests that "various theories of nonsymmetrical ('organic') literary form did appear with Romanticism, but they seem to have been successfully realized in only a few cases"; his remark betrays the continued difficulty critics have in thinking of spatial form in open or nonsymmetrical ways.

37. The following discussion of the spiral form is a highly condensed version of an essay now in progress, "Metamorphoses of the Vortex from Rococo to Romanticism."

in rhetorical space? Does the closure of the heroic couplet provide a stable structure for these ornaments, in contrast to the flowing "serpentine" enjambment of the Romantic conversation poem which, in Wordsworth's hands at least, eschews the traditional ornaments and turns of poetic diction? Can we go further and claim with one recent critic that, in contrast to the "continuous field" of modern and eighteenth-century poetry, the characteristic pattern of the nineteenth-century lyric "is the combined circle and sequence, some aspect of the spiral"?[38]

These are not, I hope, merely rhetorical questions devised as covert ways of affirming these propositions without taking responsibility for them. What I would like to affirm is the necessity for developing a systematic way of answering this sort of question, and rescuing this mode of analysis from a loosely analogical and impressionistic methodology. It seems to me at this point that three main elements would emerge in a method of spatial analysis: (1) a consistency of the *stipulated correspondence* between a spatial form and some aspect of a given work; if a line represents story time, reading time, plot sequence, or the fortunes of the hero, it must do so consistently; (2) the spatial forms associated with a work ought to have an *internal origin* in the sense that they arise from a close analysis of the work in its own terms and are not imposed from some alien frame of reference;[39] (3) when comparisons are drawn with spatial forms in other arts, the comparisons ought to be developed in terms of *whole structures* and not in terms of parts chosen because of their isolated similarity. The presence of the spiral form in literary space must, in other words, be defined in terms of the particular aspect of the work to which it refers; it should arise from an analysis of the work in its own frame of reference; and it should be clearly defined as to its function and significance in the whole.

The wholistic emphasis of spatial form should not distract us, however, from the great power of this metaphor at "microscopic" and local levels of literary attention. The study of meter and style, for instance, is based on the assumption that stable patterns (verse designs, recurrent sentence types) govern the temporal stream of language. These patterns

38. James Bunn, "Circle and Sequence in the Conjectural Lyric," *New Literary History* 3 (Spring 1972): 512. On the comparison between spatial, especially rhetorical, figures and rhetoric, see David Summers, "*Maniera* and Movement: The *Figura Serpentinata*," *Art Quarterly* 35 (1972): 269–301.

39. The concept of "internal origin" is, of course, an extremely problematic spatial metaphor which defines reading as a process that goes inside and brings something out (hence, *ex*plication and *ex*egesis). We must remind ourselves, however, that part of what is "internal" to the work is ourselves, exploring the textual labyrinth, playing the game with rules we may have learned in other texts, and with competencies that may or may not be genetically innate. Arguments based on "internal evidence," then, must be accompanied by an examination of the text's assumptions about its own closure and interiority, its sense of relation to "outsides" such as the world, the reader, or other texts.

seem most evident in oral narratives and folk songs which do not have any "literal" spatial form (that is, a text) to stabilize their temporal order. The ballad, as Mark W. Booth observes, is a particularly interesting form for exhibiting the various scope of patterning systems "because it adds together the short-range patterning common to all versification, the long-range patterning of skillful oral construction, and the intermediate range of shapely melody."[40] A familiar problem in logic and terminology arises, however, when these aural-musical patterns are set in oppositional contrast to narrative patterns and used to suggest that the nonliterate person's "mode of apprehension is spatial as well as linear and sequential."[41] We have encountered the same distinction before in many guises: as a generic opposition (the novel is linear in contrast to the spatiality of poetry or drama); as a historical "progression" (nineteenth-century literature is linear and temporal in contrast to modern or eighteenth-century literature which is spatial); as an intrageneric distinction (novels of plot and story are linear while lyric novels are spatial). The final step in this sort of logic would be to claim that literature is distinguished from language in general by its tendency to display aesthetic (that is, spatial) *form,* and "mere" prose, plain speech, and philosophical language is characterized by straightforward (linear) procedures. Aside from the obvious fact that linear forms are themselves spatial, and can no more be contrasted to space than shells can be contrasted to eggs, there is a fundamental problem in stipulated correspondence. Neither linear nor spatial phenomena in literary forms are *literally* spatial; both are ways of organizing time in a coherent image— the first (in discussions of ballad structure) refers to narrative time, the second to musical. What we need, clearly, is a replacement for "spatial" in our system of oppositions. I propose the term "tectonic" to suggest the global, symmetrical, gestalt-like image that is generally associated with so-called spatial effects.

The difference between linear and tectonic could be visualized, then, as something like the difference between a picturesque and a formal garden, the first laid out around a linear, asymmetrical, serpentine structure, the second designed as a symmetrical grid (see fig. 2). It must be insisted, however, that neither of these forms is more spatial (or temporal) than the other but that each provides a distinct set of expe-

40. Mark W. Booth, "The Ballad and the Brain," *Georgia Review* 32 (Summer 1978): 380. Booth connects the presence of spatial patterning in oral literature with the hemispheric theory of the brain, of which I will have more to say shortly. The assumption that "spatial thinking," associated with the nonlinguistic right hemisphere, is somehow the definitive characteristic of primitive, esoteric, and mystical consciousness, is based primarily on popularizers of the hemispheric theory like Julian Jaynes in *Origin of Consciousness in the Breakdown of the Bicameral Mind* (Boston, 1976), and Robert Ornstein, *The Psychology of Consciousness* (San Francisco, 1972).

41. Booth (pp. 379 and 383) is quoting with approval here from David Buchan's *The Ballad and the Folk* (London, 1972), p. 53.

Fig. 2.—"Linear" and "tectonic" images of spatial form.

riential and analytic images for what a physicist would call "space-time." Neither form can claim exclusive rights to the representation of narrative or musical phenomena. Ballad analysts may link the linear form to narrative, the tectonic to musical form, but there is nothing to prevent artists from constructing tectonic narratives accompanied by serial music. Nor is there anything to prevent artful combinations of the two patterns in a single form, a phenomenon which actually occurs in many landscape gardens.

A tendency in some recent studies of literary spatiality has been to link the linear-spatial (that is, linear-tectonic) opposition to the bicameral or hemispheric theory of the brain, and to equate narrative linearity, language, and temporality with the left hemisphere, spatial, pictorial, and atemporal consciousness with the right.[42] The whole hemispheric theory seems to be slightly suspect, however, insofar as it repeats uncritically the temporal-spatial, verbal-visual oppositions that riddle the criticism of the arts. If modern linguistics has taught us anything, it is surely that the notion of "structure" is central to all levels of linguistic competence. And if this essay has had any success, the reader will find it very difficult to detach the notion of structure from that of space. The verbal competence which remains in a person whose right (visual or spatial) hemisphere has been anesthetized is itself dependent on certain kinds of spatial thinking—at a minimum, the ability to recognize and produce proper syntactic order. Experiments which begin with the assumption that the brain and/or mind is divided into watertight compartments will no doubt produce confirmatory "evidence" (just as literary theories based on the same opposition produce evidence). What they will not show is anything very particular about the competencies under examination. A more fruitful line of inquiry is to cut across the grain of these oppositions, to inquire into the linguistic capacities of the right hemisphere, the spatial abilities of the left, and the ability of either side to adapt to functions which a rigidly binary model could not predict. The

42. See Earl Miner and Mark W. Booth for examples mentioned in this essay.

bicameral brain is a misleading metaphor if it suggests two houses of congress that never meet in full session. The proper relation between linguistic and spatial consciousness may be glimpsed in the interplay between Paul Valéry's assertion, "il n'y a pas de géométrie sans langage," and the reply of the mathematician, René Thom, "it is no less true . . . that there is no intelligible language without a geometry, an underlying dynamic whose structurally stable states are formalized by the language."[43]

Our search for literary patterning is not restricted, of course, to the realm of geometry and schematic, diagrammatic models. Blake compared a witticism to a point of light, and Wordsworth regarded his total *oeuvre* as a kind of Gothic cathedral, with *The Prelude* serving as the "antechapel" to *The Recluse,* the main body of the church, and the "minor pieces" serving as "the little cells, oratories and sepulchral recesses, ordinarily included in those edifices."[44] J. Hillis Miller, in an apparent departure from his earlier hostility to spatial criticism, has recently suggested that exhaustive attention to the linear aspect of literature ultimately discloses the text as both the labyrinth and the "clue" or thread which leads us through the labyrinth.[45] We must suspect that the most complex and vividly imagined spatial form in literature is finally the labyrinth of ourselves, what Cary Nelson calls the "theater of [the] flesh" in which "the verbal events of literature are dispersed in the body of the reader," and "verbal space becomes an emblem for the physical structure we inevitably carry with us."[46] At this point, the spatial form of literature becomes the Logos or incarnate word, and the criticism which reveals this form becomes itself a literary, metaphoric creation, like the voice of Blake's Bard, whose poetry depends upon his having *heard* a word and sensed the presence of its living, incarnate form:

> whose ears have heard
> The Holy Word
> That walk'd among the ancient trees

43. Thom, *Structural Stability and Morphogenesis,* trans. D. H. Fowler (Reading, Mass., 1975), p. 20.

44. The comparison of the literary *oeuvre* to a cathedral (a metaphor indulged in by the two great poets of memory, Wordsworth and Proust) may be more than casual if the following speculation by Frances Yates has any foundation: "The high Gothic cathedral . . . resembles a scholastic summa in being arranged according to 'a system of homologous parts and parts of parts'. The extraordinary thought now arises that if Thomas Aquinas memorised his own *Summa* through 'corporeal similitudes' disposed on places following the order of its parts, the abstract *Summa* might be corporealised in memory into something like a Gothic cathedral full of images on its ordered places" (*The Art of Memory,* p. 79).

45. Miller, "Ariadne's Thread: Repetition and the Narrative Line," *Critical Inquiry* 3 (Autumn 1976): 60.

46. Cary Nelson, *The Incarnate Word: Literature as Verbal Space* (Urbana, Ill., 1973), p. 5.

We have now answered the easy questions. We know what some of the spatial forms of literature might look like, and procedures have been suggested for verifying their presence in a text. We still need to know what use they would be. This brings us to the historical, ethical basis of the attack on spatial form in criticism, the charge that a concern with space occurs at the expense of time, that it alienates us from concrete reality, and that it reifies and objectifies literature in a tyrannical, reductive fashion. I would hope the groundlessness of these charges is now evident.[47] Spatial form, as conceived of in this essay and as tacitly employed in much of our practical criticism, is our basis for making history and temporality intelligible; it abstracts us from reality only insofar as any explanation is necessarily abstracted from that which it explains. And it "reifies" or "objectifies" only in the best and most useful senses, in that it helps us to *see* more vividly and concretely the substance of literary experience and provides us with a core of shareable data on which to test and compare our interpretations. It cannot do everything, of course. It will not tell us what the theme of a work is, or whether to trust a narrator, or what a symbol means. But it may help us to see how a theme is embodied, where a narrator stands in relation to his story, what structure of imagery provides the grounds for symbolic meaning. The contradictory nature of the complaints against spatial form, that it unduly concretizes on the one hand while unduly abstracting on the other, reveals the real power of this metaphor to operate at both the experiential level of literature (the work as "realized" in imaginative reading), and at the analytic level (the work explained and interpreted).

But these literature-centered functions of spatial form, which admittedly do not go one step beyond formalism, are even more interesting when we consider their potential use in comparative studies. The exploration of spatial form in literature has its counterpart in the increasing interest in the visual arts as language systems and in the efforts to construct a general theory of signs which will account not just for literature and the visual arts but for all the codes we use to construct our world. Whether we start from the nominalism of Nelson Goodman, the realism of Rudolf Arnheim, or the subtle and intricate compromises of Ernst Gombrich, we find on all sides a convergence on the problems of language, representation, signification, or, in the most general terms, semiosis. The period of involuted specialization in which disciplines turned in upon themselves seems to be coming to an end. In one sense this whole discourse on spatial form has been an exercise in involution,

47. This is not to deny that a good deal of nonsense can be found marching under the banner of an ill-conceived notion of spatial form or of any other widely used and abused term in our critical vocabulary (cf. deconstruction, vision, structure, rhetoric, *ad nauseam*). I confess to feeling a shudder of doubt when I hear the concept of space employed as a crucial cant term in the "consciousness-tripping" of the seventies (e.g., "getting into one's own space").

an explication of one class of metaphors that pervades normal critical procedure. But it has, I hope, also pointed outward to possible links with other disciplines. There will be a proper dialectical resistance to these linking metaphors. For every Wittgenstein who argues that "a [verbal] proposition is a picture" which "reaches right out" to reality in order to represent "a possible situation in logical space," another will retract or qualify this iconic realism and retreat to a view of signification as an arbitrary, playful activity.[48]

Whether we identify ourselves with synthetic realists or analytic nominalists, one thing seems clear: we will never be able to return to the neat compartmentalization of pictorial and verbal signs under the opposed categories of "natural" versus "artificial" or "imitative" versus "conventional." Instead of regarding pictorial representation as radically distinct from language, we may approach it as a subset of the linguistic system and define it as a language which is incapable of expressing negation or which resists separation of the signifier and signified.[49] These definitions treat picturing as an impoverished language and might be balanced against an approach to language defined in terms of picturing, as Wittgenstein proposed in his early work. The poststructuralist emphasis on language as referential discourse may lead us, as Paul Ricoeur suggests, "to return to the problem of writing as a chapter in a general theory of iconicity."[50] In this wider context, traditionally

48. Wittgenstein, *Tractatus Logico-Philosophicus*, trans. D. F. Pears and B. F. McGuinness (London, 1961), p. 39, paragraph 4.021; p. 15, paragraph 2.1511; and p. 17, paragraph 2.202. It is significant that Wittgenstein can be identified with both sides of this central issue in the philosophy of language, espousing a sort of mimetic or iconic formalism in his early work, and a ludic, nominalist view of language in the later *Philosophical Investigations*. Philosophers generally regard his "picture theory of meaning" as one which Wittgenstein abandoned (or should have abandoned) in the later work (see E. Daitz, "The Picture Theory of Meaning," in *Essays in Conceptual Analysis*, ed. Antony Flew [New York, 1966], pp. 53–74). While it seems evident that the earlier theory is more congenial to poetics, especially a poetics of spatial form (which is what Wittgenstein really means by a "picture"), the later view constitutes a kind of permanent friendly opposition that must be taken seriously by aesthetics.

49. Kenneth Burke, for instance, argues that "though idea and image have become merged in the development of language, the negative provides the instrument for splitting them apart. *For the negative is an idea;* there can be no image of it. *But in imagery there is no negative*" (*Language as Symbolic Action* [Berkeley, 1968], pp. 429–30). Burke's argument, however, could be used to demonstrate just the opposite of what he claims here, for the existence of "negative images" seems not only obvious in several senses but results from the inseparability of idea and image, as Burke suggests when he goes on to say that the negativity of a photographic image "derives from our *ideas* of its place in a total purposive process." The only image incapable of expressing negation, it turns out, is what Burke calls "sheer sensory perception," a version of the "innocent eye" gambit that restores the property of negativity to all other images from pictures to percepts (see p. 460 n.6).

50. Paul Ricoeur, *Interpretation Theory: Discourse and the Surplus of Meaning* (Fort Worth, Texas, 1976), p. 40. This emphasis would be reversed by Jacques Derrida, who would no doubt see the problem of iconicity as a chapter in a general theory of writing.

"deviant" or "experimental" phenomena such as emblems, hiero-glyphics, pictograms, and concrete poetry may well appear as the anomalies which suggest and require new paradigms for understanding verbal space in general. Any iconic theory of language would, of course, have to confront its natural opponent, a linguistic theory of icons which finds its roots in Panofsky's notion of iconology and in Gombrich's con-clusion "that the phrase 'the language of art' is more than a loose metaphor."[51] Such an iconology would explore, among other things, the ways in which temporal form is experienced and understood in the plastic arts at the basic levels of taking in forms, identifying represented objects, inferring movement and narrativity, and "reading" imagery for symbolic content. If every sentence is a picture or spatial form in the mind's multisensory "eye," true reading is visionary (not merely visual) experience. If every picture is a sentence, true vision is not in the in-nocent or ignorant eye but in the reading of the informed mind.

We must resist, however, the temptation of regarding our field of signs or artistic codes as exhaustively described by a symmetrical opposi-tion between time and space as embodied in verbal and plastic con-structs. Literature most naturally seems placed at some median point between music and the visual arts, participating in the former's tem-poral, aural aspect, in the latter's spatial, visual aspect. Instead of Lessing's strict opposition between literature and the visual arts as pure expressions of temporality and spatiality, we should regard literature and language as the meeting ground of these two modalities, the arena in which rhythm, shape, and articulacy convert babbling into song and speech, doodling into writing and drawing.[52] At the moment, the arbi-trary, ludic, anti-iconic aspect of language would seem to have the upper hand in literary criticism, with vision and spatial form treated as "merely metaphoric" aspects of literature. This imbalance cannot persist in-definitely in the face of the mounting evidence that consciousness is not simply a stream of verbal language accompanied by inchoate, formless

Derrida's renewal of the ancient trope of the world as text necessarily relates the question of spatial form in literature to the transcendental issue of space—"the world as space of inscription" (*Of Grammatology*, p. 44). Derrida's space is, of course, not absolute but a relational "habitation" for the sign systems which structure our world. We can never encounter the mythical "uninhabited world" (cf. Burke's "sheer sensory perception" above, n. 49) but exist in a universe of inscriptions "producing the spatiality of space" (pp. 290–91). This seamless web of traces and signs links "the place of writing . . . to the nature of social space, to the perceptive and dynamic organization of the technical, religious, eco-nomic, and other such spaces . . ." (p. 290).

51. Gombrich, *Art and Illusion*, p. 87. See Panofsky's *Meaning in the Visual Arts* (Garden City, N.Y. 1955), pp. 31–32, for a discussion of iconology and its distinctiveness from iconography.

52. See Frye's *Anatomy of Criticism*, pp. 274–75, for a discussion of "babble" and "doodle" in relation to the more respectable notions of *melos* and *opsis*.

feeling. At least half of our brain is occupied in systematic thinking based in spatial forms that organize consciousness at the level of basic perception (Gestalten), conceptual patterns (Ideas), and poetic structures (Images).[53]

The usefulness of exploring spatial form, then, is inseparable from the usefulness of making intelligible and explicit the underlying patterns of anything we find ourselves doing willy-nilly. We cannot think about literature or anything else without using spatial metaphors, whether they function in "the pragmatic space of physical action, the perceptual space of immediate orientation, the existential space which forms man's stable image of his environment, the cognitive space of the physical world," or "the abstract space of pure logical relations."[54] Even the most abstract argument betrays implicit spatial dimensions the moment it tries to construct a field of relationships among key ideas or terms;[55] the abstract terms themselves are often hidden metaphors or images, as the word "abstract" itself suggests the act of "drawing off" or "removing" a simplified skeleton from a complex, concrete entity. Perhaps our distrust of dialectical arguments stems from our sense that their implicit rhetorical space is too predictably symmetrical, lacking the picturesque surprises and asymmetries that we associate with truthful complexity. For every verbal tick we encounter a corresponding tock, generally signaled by some dead metaphor like "on the other hand."

On the other hand, we cannot live without dialectic, at least at the human level of dialogue. It may be true that there are only two kinds of people in the world, those who believe in binary opposition and those who do not. Whatever the truth is, we need spaces in which to look for it together, forms to unite us beneath the verbal threshold. The great virtue of perceiving spatial form in literature is not that we can hold up a spiral and say, "There it is, *The Iliad* in a nutshell!" The idea is to put the form back into the fiction and see the way it moves and submerges in the texture of the work, and implicitly in the texture of life. It is to see the fiction, like the life it criticizes and represents, as an ecosystem, an or-

53. I refer here again to the hemispheric theory of the brain and its implications for theories of spatial form. For a good introduction to research on the "dual coding hypothesis" and other aspects of the hemispheric theory, see Gillian Cohen, "Visual Imagery in Thought," *New Literary History* 7 (Spring 1976): 513–24.

54. Christian Norberg-Schultz, *Existence, Space and Architecture* (New York, 1971), p. 6.

55. Gombrich suggests the pervasiveness of dialectical space when he remarks that "we always place any concept into a structured matrix . . . the 'semantic space' of which the basic dimensions are 'good and bad,' 'active and passive,' 'strong and weak'" (*Art and Illusion*, p. 371). For an elaboration of the connection between spatial, specifically pictorial, form, and "pre-propositional" conceptual structures on the order of Thomas Kuhn's "paradigms," see Andrew Harrison's "Representation and Conceptual Change," in *Philosophy and the Arts,* Royal Institute of Philosophy Lectures, vol. 6 (New York, 1973), pp. 106–31.

ganism, a human form, or to glimpse what Gaston Bachelard describes as "the transsubjectivity of the image," a language of vision which may tell us things about ourselves and our poems that words alone cannot touch.[56]

56. Gaston Bachelard, *The Poetics of Space,* trans. Maria Jolas (1958; Boston, 1969), p. xv.

Index

Abstract painting, 28, 31, 33–36, 235
Adam and Eve, images of: in Michelangelo's Sistine Ceiling, 111–17; in Quarles' *Emblemes*, 73–76
Aesthetic totality, ideal of 41–42
Alberti, Leon Battista, 61; *De Pictura*, 231n.7, 232, 235–46. *See also* Perspective; Visual perception
Allegory, 18, 61, 282. *See also* Emblem art
Alphabet, 11–12
Anamorphosis, 252
Anatomy, 20–21
Animated films, 132
Anthropology, 27
Applied arts, 20
Archeology, 27
Architecture, 18, 20, 195
Aretino, Pietro, 103, 104
Aristotle: *De Anima*, 244
Armory Show, 11
Arrested images, 181. *See also* Pictures, realism of
Ars memorativa, 61
Artifacts, American Indian, form in, 25–31
Artistic copies, value of studying, 17, 85–91, 109, 114. *See also* Michelangelo
Artistic creation, 16–17
Artistic medium as aesthetic determinant, 40
Arts, relationship between, 37. *See also* Poetry and painting, relationship between
Augustine, 62, 63
"Avant-garde," use of term, 35
Avant-garde films, 130

Bachelard, Gaston, 299
Bacon, Roger, 244n.20
Balázs, Béla, 151
Ballad, 292, 293
Ballad of a Soldier, The, 160, 163, 164
Barr, Alfred: *Cubism and Abstract Art*, 34

Barrère, Jean-Bertrand, 54
Barthes, Roland, 44, 165
Bartholomew, Saint, 97. *See also* Michelangelo
Bartók, Béla, 266
Baudelaire, Charles, 32–33, 35–58; on Delacroix's art, 44, 49–50, 54–55; imagery in *Les Fleurs du Mal*, 50–51; imagery in "L'Invitation au voyage," 52–58; on relationship between the arts, 42, 50. *See also* Delacroix, Eugène
Bazin, André, 131, 152n
Beauty, 41
Benjamin, Walter, 60
Berengo-Gardin, Giovanni: *Viaggio in Toscana*, 214–16
Berg, Alban, 267
Berlin: The Symphony of a Great City, 130
Berlioz, Hector, 268
Biograph films, 134, 146, 149
Bitzer, Billy, 134, 139
Blake, William, 84, 283, 290, 294
Blount, Thomas, 61
Body-soul dichotomy, 276–77
Bonaventura, Saint, 71
Booth, Mark W., 292
Booth, Wayne C., 274n.6
Bradford, William, 60
Bradstreet, Anne, 60
Brain, hemispheric theory of, 178, 292n.40, 293
Brunelleschi, Filippo, 22, 193–95
Bruner, Jerome S., 172
Bunyan, John: *The Pilgrim's Progress*, 287
Burke, Edmund, 41
Burke, Kenneth, 296n.49
Byzantine art, 237

Cabinet of Doctor Caligari, The, 129–30
Cage, John, 270
Calosso, Achille Bertini, 121n.12, 123n.25
Camera, invention and development of, 230–34. *See also* Photography

Camera obscura, 188, 232–34. *See also* Photography
Cappela Paolina (Vatican), 88, 91, 95, 110
Cardano, Girolamo, 232
Cassirer, Ernst, 16
Catholicism, 108. *See also* Jesuit emblem artists
Cavalieri, Giovanni Battista de, 86, 89
Cave art, 11–12
Caylus, Claude-Philippe de Tubières, 32, 34
Cesariano, Cesare, 232
Chapon, L. L., 100
Chaucer, Geoffrey, 282
Chess, visual thinking in, 176
Chevalier, Charles, 233
Christ, 65; image of, in Michelangelo's *Last Judgment,* 105, 109, 110; images of, in Quarles' *Emblemes,* 79–82
Chukhraï, Grigori, 160
Cicero, 289
Cinema. *See* Film
Classical art as mythic conception, 16, 22. *See also* Painting
Cocteau, Jean, 156
Cognition, 171–79; intuitive and intellectual modes of, 176–79
Coleridge, Samuel Taylor, 41, 45, 54
Color: calibration in scientific photography, 185; in Delacroix's paintings, 47–48, 52; imagery of, in Baudelaire's poetry, 50–51
Comedy, 288
Comolli, Jean Louis, 153
Concrete poetry, 283, 297
Conrad, Joseph, 285
Corot, Jean Baptiste Camille, 33
Courbet, Gustave, 254
Cranach, Lucas, 97, 121n.14
Crashaw, Richard, 64, 109
Crin blanc, 158
Criticism, 33–36, 44
Crumb, George: *Ancient Voices of Children,* 270
Cubism, 247
Culler, Jonathan, 45n.16
Cunego, Domenico, 114
Curione, Celio Secondo, 124n.33

Dance, 280–81
Dante: *Inferno,* 289
Decoration, 29–30
Delacroix, Eugène, 32, 37–58; art

theories of, 42, 46–47, 55; balance of dynamism and form in paintings, 48–49, 57; use of color in paintings, 47–48, 52. *See also* Baudelaire, Charles
Derrida, Jacques, 274n.7
Descartes, René: *Dioptrics,* 219–20; *Meditations,* 171
Determinism, 174
Diagrams, 12
Dianoia, 285–86
Diatonic scale, 262
Dickens, Charles, 149
Diderot, Denis, 41n.5
Duccio, 18–19, 237, 238
Dutch painting, 54

Eco, Umberto, 150
Emblem art, 297; criticism of, 59–60; English, antivisual philosophy in, 63–64; Jesuit, 62, 64–65, 66; linguistic concept of image in, 61–63. *See also* Quarles, Francis: *Emblemes*
Encounters: Essays on Literature and the Visual Arts, 38
English poets, 63–64. *See also* Emblem art
Engraving, 219. *See also* Emblem art
Eros, 21–22
Escamotage d'une dame, L', 156
Evans, Walker: *Hotel Porch, Saratoga Springs, N.Y.,* 225–30 passim
"Eye-witness principle," 190. *See also* Pictures, realism of

Ficino, Marsilio, 61, 62
Fiction, analysis of, 45
Fiedler, Konrad, 34
Film: chase-rescue sequences in, 138–49; and commercialism, 132; image track in, 151–52; realism in, 129–33, 166–68. *See also* Trucage
Fish, Stanley, 285n.29
Flaubert, Gustave, 33
Form: as level in literature, 283–85; as image, 16, 20, 22; of Indian artifacts, 25–31; in Romantic literature, 290. *See also* Spatial form in literature; Spatial form of music
Formalism, 37, 38–39, 279, 295
Foucault, Michel: *Les Mots et les choses,* 247
Fowler, Alastair, 38

Frank, Joseph: "Spatial Form in Modern Literature," 273, 378
Frederick the Wise, 97
Freeman, Rosemary, 59, 84
Free will, imagining, 174–75
Freud, Sigmund, 22, 34, 163
Frey, Karl, 101–2
Frye, Northrop: *Anatomy of Criticism*, 279, 282, 283

Gainsborough, Thomas, 21, 211
Gautier, Théophile, 33; *Albertus*, 54
Geistesgeschichte tradition, 37, 38, 43
General Line, The, 160, 162
Geometry, 274, 286
Gesamtkunstwerk, 42
Gibson, J. J., 187–90, 209
Giotto, 230, 237, 238
Giovanni, Bertholdo di, 108
God, image of, in Michelangelo's *Creation of Adam*, 111–13
Gombrich, E. H.: *Art and Illusion*, 38, 183, 185, 204, 210; on Michelangelo's symbolism, 94–95; on painting and language, 11–12, 38, 297; on painting and perception, 220–21, 222; *The Sense of Order*, 202; on technical images, 20
Goodman, Nelson, 223, 272n.2
Gordon, D. J., 64
Gould, Cecil, 127n.44
Greco, El, 209
Greeks, ancient, paintings of, 190–91
Grien, Hans Baldung, 97, 121n.14
Griffith, D. W., 134, 149
"Gusto," 42

Hagstrum, Jean, 39
Haubenstock-Ramati, Roman, 270
Hawkins, Henry: *Parthenia Sacra*, 66
Hazlitt, William, 41–42
Hecht, Federico, 214
Hegel, Georg Wilhelm Friedrich, 42
Hellenistic painting, 191, 237
Helmholtz, Hermann von, 204
Herbert, George, 59, 63, 77
Herder, Johann Gottfried, 40
Her First Adventure, narrative continuity in, 134–49. *See also* Film
Hieroglyphics, 13, 61–62, 296–97
Hoffmann, Richard, 123n.27
Hogarth, William, 202; *Analysis of Beauty*, 290
Homologues, 43–44

Horapollo manuscript, 61
Howard, Alan B., 59
Hugo, Herman: *Pia Desideria*, 66, 80
Hugo, Victor, 32–33, 49

Iconography, 16, 18, 45. *See also* Iconology
Iconology, 15–23; and artistic form, 20, 22; of language, 296–97; "re-creative synthesis" in, 18
Imagination: as component of perception, 230, 240, 244 (*see also* Visual perception); and evocative function of painted image, 211–13; as source of art, 40–41, 43, 44; visual, as thinking, 171–79
Impressionism (painting), 204–5
Ingres, Jean Auguste Dominique, 32, 33, 48, 49
Intentionality in painting, 250–51
Ives, Charles, 269

Jakobson, Roman, 45n.16, 63
Jesuit emblem artists, 62, 64–65, 66–68. *See also* Emblem art
Job, Book of, 108
Jones, Inigo, 64
Jonson, Ben, 64

Kandinsky, Wassily, 34
Kant, Immanuel, 257, 275
Kracauer, Siegfried, 129–50 passim. *See also* Film
Krautheimer, Richard, 18
Kritische Wälder (Herder), 40
Kunstwollen, 34
Kurosawa, Akira, 154

La Cava, Francesco, 97, 102, 104
Lamorisse, Albert, 158
Landscape painting, 19, 233. *See also* Painting
Language: philosophy of, and intentionality, 251; signifying systems in, 44; spatiality of, 282, 295–98 (*see also* Spatial form in literature); origin of, 12; in Quarles' *Emblemes*, 69; and thinking, 172, 173, 175
Lebel, Jean Patrick, 168
Lee, Vernon, 33
Leibniz, Gottfried Wilhelm, 171, 275–76
Lessing, Gotthold Ephraim, 32, 38, 39–40, 46, 297

Lévi-Strauss, Claude, 43
Light: imagery of, in Baudelaire's poetry, 50–51; physical behavior of, 195, 200, 238, 239, 240–41, 244
Lionnais, François le, 13
Literature: levels of meaning in, 282–86 (*see also* Spatial form in literature); realism in, 133; science of, 45; as temporal art, 49; and visual arts, 11–13, 31–36
Lorrain, Claude, 42; *The Sermon on the Mount,* 202
Lucchese, Michele, 86, 87
Lumière, Louis, 129–30, 131, 132
Luther, Martin, 97; *Theses,* 65

Madonna with Child (theme), 18–19, 20, 22. *See also* Michelangelo
Malevitch, Kasimir, 34, 36
Man, Paul de, 271n.1
Mannerism, 15
Manwaring, Elizabeth, 39
Maps, 12
Marcuse, Herbert, 21–22
Maritain, Jacques: *Creative Intuition in Art and Poetry,* 38
Mars, photography of, 184–85
Mast, Gerald, 153 n
Méliès, Georges, 129–30, 131, 132, 156, 159–60
Meter (poetry), 291
Metropolis, 130
Metz, Christian, 131–32, 133
Meyer, Leonard B., 264n.3
Michelangelo, 22, 85–120; *Crucifixion of Peter,* 86–91, 100, 120; Duomo *Pietà,* 91; *Last Judgment,* 95–110, 118; *Manchester Madonna,* 117–20; Sistine Ceiling, 98, 110–17, 118
Michelson, Annette, 132
Middle Ages, 16, 290; art and vision theories of, 192, 236, 237–38
Milizia, Francesco, 32
Miller, J. Hillis, 294; *The Form of Victorian Fiction,* 277–78, 279
Milton, John, 59, 64, 76, 283
Mimesis, 190
Miner, Earl, 279n.18
Minos, image of, in Michelangelo's *Last Judgment,* 105–7
Mise en scène, 152. *See also* Film
Mnemotechnics, 288–89
Modernism: in art, 18; in literature, 273; in music, 265–68

Molanus, Johannes, 121
Mondrian, Piet, 34
Montage, 165–66
Museum of Modern Art, 35
Music, 13, 39, 40, 47, 280–81. *See also* Spatial form of music
Musical texture, 260
Myth, 16, 31

Narrative: in films, *see* Film; spatial form of, 286–88 (*see also* Spatial form in literature)
Naumann, Francis, 115
Nazarenes, 32
Nelson, Cary, 294
New Literary History, 38
Newton, Isaac, 274–75
Nieto, José C., 124n.33
Novel, 283

Open City, 129
Ornamentation, musical, 264–65
Orphée, 156

Pacheco, Francisco, 257
Painting: ancient Greek, "eye-witness principle" in, 190–91; historical events in, 32; as language, origin of, 11–12; literary values in, 31–36; and Lumière's films, 129; perspective, *see* Perspective; and photography, development of, 230–34 (*see also* Photography); scientific rationale for, 234; self-expression in, 34. *See also* Michelangelo; Pictures, realism of
Panofsky, Erwin; iconological method of, 15–23; on painting, 131, 237–38, 239–40, 243, 245; on perception, 196
Park, Roy, 41n.4
Paul, Saint, 67, 79
Pecham, John, 240n.16
Perception. *See* Visual perception
Perspectiva, 231, 238, 239, 242, 244–45. *See also* Visual perception
Perspective, 192–200, 219, 221; development of, by Alberti, 235–37; of disappearance, 200–2; iconology of, 16, 20–21. *See also* Painting; Visual perception
Photography: compared to film, 164–68; dissimilarity with visual perception, 205–6, 225, 228–30 (*see*

also Visual perception); evocative role of images in, 211–17; granularity of, 191–92; influenced by realistic painting, 230–34 (*see also* Painting); "natural" production of images in, 224–28; panoramic, 196–97; scientific objectivity of, 182–85. *See also* Pictures, realism of

Picasso, Pablo, 247

Pictures, realism of, 133, 219–46; ambiguity of viewpoint and, 252–53; and attempts to render visual selectivity, 202–9; copy theories of, 220; Descartes on, 219–20; evocative function of image in, 210; Gombrich on, 220–21; in Greek painting, 190–91; and intentionality, violations of, 247–58; movement and, 202; photographic, *see* Photography; in Renaissance painting, 192–95 (*see also* Perspective); and window analogy, 238–39, 242, 245. *See also* painting; Visual perception

Piles, Roger de, 202

Pinhole images, 231–32

Pitch, musical, 262. *See also* Spatial form of music

Pitti, Don Miniato, 98

Plot, 284n.27

Poe, Edgar Allan: "Philosophy of Composition," 33

Poetry, levels of meaning in, 282, 285

Poetry and painting, relationship between, 9–13, 33–34, 37–58; Delacroix on, 46–47; Herder on, 40; and ideal of aesthetic totality, 41–42; of shared subject matter, 10–11; as "sister arts," 39–40; structuralist view of, 43–46. *See also* Baudelaire, Charles; Emblem art

Pollitt, J. J., 280

Porta, Giovan Battista della, 233

Portrait painting, 19, 233. *See also* Painting

Potemkin, 129

Praz, Mario, 59

Proportion, iconology of, 16, 20–21

Protestantism, 63–66. *See also* Emblem art

Proust, Marcel, 13

Psychology: of art, 33–34; and iconology, 22–23

Punch, 181

Puritanism, 60

Quarles, Francis: *Emblemes*, 59–84; antivisual philosophy of, 63–65, 69–79; hieroglyphic tradition of, 62; Jesuit source of engravings, 64–68. *See also* Emblem art

Rabkin, Eric S., 284n.27, 288n.30

Raphael: *Disputa* fresco, 120n.1; Madonna theme and, 18–19, 20, 22; *Saint Paul Preaching at Athens,* "eyewitness principle" in, 192, 202

Rationalization of space, 192. *See also* Painting; Perspective

Reading experience, spatial form of, 276, 282. *See also* Spatial form in literature

Realism, cinematic, 133, 166–68. *See also* Pictures, realism of

"Re-creative synthesis," 18

Renaissance: antique symbolism in art of, 15–16; linguistic conception of image in, 61; painting, scientific basis for, 234–35; "sister arts" tradition in, 39. *See also* Painting

Rescued by Rover, narrative continuity in, 134–49. *See also* Film

"Resurrection of the Just," 108

Reynolds, Sir Joshua, 211

Rhythm, 280–81

Ricci, Corrado, 103

Richardson, Tony, 154

Ricoeur, Paul, 296

Riegl, Alois, 23

Riffaterre, Michael, 45n.16

Rolland, Romain, 123n.26

Roman painting, 237

Romantic era, 39, 290. *See also* Poetry and painting, relationship between

Rubens, Peter Paul, 36, 48

Ruhemann, Helmut, 127n.44

Ruina, Gaspare, 126n.40

Ruskin, John, 200, 209

Saussure, Ferdinand de, 44

Schenker, Heinrich, 262–65, 266, 269. *See also* Spatial form of music

Schoenberg, Arnold, 267–68

Schopenhauer, Arthur, 259

Scientific method, 177, 179

Sculpture, 32

Sensus communis, 244

Seven Samurai, The, 154–55

Seybond, Raymond, 65

Shakespeare, William, 149

Shepard, Roger N., 172
Sibbes, Richard, 83
Signs: aesthetic, and form, 40; natural and conventional, in cinema, 134 (*see also* Film)
Simonides of Ceos, 289
Skinner, B. F., 179
Sound, evocation of color by, 52
Souriau, Etienne, 151
Space, theories of, 274–76. *See also* Spatial form in literature
Spatial form in literature, 271–99; linear-tectonic distinction in, 292–93; in modernism, 273; narrative patterns in, 286–88; relation to temporal form, 273–77
Spatial form of music, 259–70, 278, 297; modern, 265–68; notational, 269–70; in performance, 268–69; tonal, 261–65
Special effects (film). *See Trucage*
Spiegler, Gottfried, 183
Statistical treatment of experimental data, 179
Stendhal, 41n.5
Sterne, Laurence: *Tristram Shandy*, 286–87
Still-life painting, 19–20. *See also* Painting
Stravinsky, Igor, 259, 266
Structuralism, 43–46, 58
Style, 20
Sublime, 280
Surrealism, 44, 247
Swing Time, 129
Symonds, John Addington, 122n.18
Syntax in film, 152. *See also* Film
Sypher, Wylie, 43

Taxemes, 153–55. *See also Trucage*
Taylor, Edward, 60
"Technical" images, 20. *See also* Iconology
Thanatos, 21–22
Theater, narrative continuity in, 146–49
Thinking. *See* Cognition; Imagination
Thompson, D'Arcy, 271
Titian, 19, 103
Tolnay, Charles de, 104, 124n.32
Tom Jones, 154
Tonality, 261–65
Tragedy, 42, 288
Trauerspiel, 60

Trent, Council of, 105
Trucage, 151–69; accelerated motion as, 151, 160, 162; blurred focus as, 156; and denial of perception, 163–64; "fade" as, 151, 152, 153–54, 155; of "invisible man" illusion, 158, 161, 162; and special effects, concept of, 153, 159; superimposition as, 153, 160, 163; use of stunt men as, 156, 157; "wipe" as, 151, 154–55; *See also* Film
Turner, J. M. W.: *The Dort Packet-Boat from Rotterdam Becalmed*, 200
Twelve-tone system, 267–68
Typography, 282–83
Typus Mundi, 62, 66, 67

Ucello, Paolo, 192
Uncle Tom's Cabin (Stowe), narrative continuity in, 146–49
Unconscious, 16–17, 21–22
Universals in sense perception, 212
Ursatz, 263, 267
Ut pictura poesis, 32, 40, 61–64, 289. *See also* Poetry and painting, relationship between

Valdes, Juan de, 108
Valéry, Paul, 294
Varèse, Edgard, 266–67
Vasari, Giorgio, 94, 95, 98–99, 109, 111, 125n.37, 126n.40
Vaughan, Henry, 63
Velázquez, Diego: *Hilanderas*, 200; *Las Meninas*, paradoxes in, 247–58
Venusti, Marcello, 98, 105
Vermeer, Jan, 230
Victorian fiction, 277–78
Vinci, Leonardo da, 200, 202, 257
Virgin, image of, in Michelangelo's *Manchester Madonna*, 117–18
Visual arts, imagery of, in literature, 280. *See also* Painting
Visual perception: Alberti's analysis of, 235–37, 238–46; binocular, 240n.16; distance-size relationship in, 185–86, 245; flow of information in, 188–89; and literary space, 279; meaning judgments in, 221; mistrust of, by English emblem writers, 63–65, 69–79; and perspective, 196–99; as "pictorial," 223–24, 234; selectivity of, 202–10, 229. *See also* Painting;

Perspective; Photography; Pictures, realism of
Vitruvius; *Treatise on Architecture*, 232
Vlaminck, Maurice de, 10

Wagner, Richard, 42
Walkup, Lewis E., 173
Warren, Austin, 40
Watteau, Antoine, 126n.40
Webern, Anton, 267
Wellek, René, 37, 40
Wheeler, J. A., 95
Wind, Edgar, 123n.28
Wittenberg (city), 97

Wittgenstein, Ludwig, 271, 296
Wittkower, Rudolf, 18, 102
Wölfflin, Heinrich, 17, 120n.1
Wordsworth, William, 283, 291, 294
Worringer, Wilhelm, 28, 33–34
Writing, origin of, 11. *See also* Literature

X-ray photography, 183–84

Yates, Frances, 288–89

Zorn, Anders, 204–5